MODERN PHILOSOPHY
OF LANGUAGE

MODERN PHILOSOPHY OF LANGUAGE

Edited by
MARIA BAGHRAMIAN
University College Dublin

COUNTERPOINT
WASHINGTON, D.C.

Consultant editor for this volume:
David Berman, Trinity College, Dublin

First American edition © 1999 by Counterpoint

First published in Great Britain in 1998
by J.M. Dent

Introduction, chronology and selections
© J.M. Dent

Library of Congress Cataloging-in-Publication Data
Modern philosophy of language / edited by Maria Baghramian. — 1st
American ed.
p. cm.
Originally published: London : J.M. Dent, 1998.
Includes bibliographical references and index.
ISBN 1-58243-042-X (alk. paper)
1. Language and languages—Philosophy. I. Baghramian, Maria.
P106.M558 1999
401—dc21 99-31592
CIP

COUNTERPOINT
P.O. Box 65793
Washington, D.C. 20035-5793

Jacket design by Amy Evans McClure

10 9 8 7 6 5 4 3 2 1

CONTENTS

NOTE ON THE EDITOR

MARIA BAGHRAMIAN is a lecturer in the Department of Philosophy, University College Dublin. She studied at Queen's University, Belfast, and Trinity College, Dublin, where she also taught for a number of years.

Her main interests are in philosophy of language and contemporary American philosophy. As well as a number of articles in various journals, she is the author of *The Problems of Relativism* (to be published by Routledge) and Review Editor of the *International Journal of Philosophical Studies*. She is currently working on a book on Hilary Putnam in the Key Contemporary Thinkers series (Polity Press).

NOTE ON THE TEXTS

These essays appear in the following publications:
1. Gottlob Frege, 'On Sense and Reference', in *Translations from the Philosophical Writings of Gottlob Frege*, edited by Peter Geach and Max Black, translated by Max Black (Oxford: Blackwell, 1952).
2. Bertrand Russell, 'Descriptions and Incomplete Symbols' from 'The Philosophy of Logical Atomism' in *Logic and Knowledge: Essays, 1901–1950* (London: Allen & Unwin, 1956).
3. Alfred Tarski, 'The Semantic Conception of Truth and the Foundations of Semantics', *Philosophy and Phenomenological Research*, 4 (1944).
4. Rudolf Carnap, 'Empiricism, Semantics, and Ontology', in *Meaning and Necessity* (Chicago: University of Chicago Press, enlarged edition, 1956). First appeared in *Review Internationale de Philosophie*, 4 (1950).
5. Ludwig Wittgenstein, extract from *Philosophical Investigations*, translated by G. E. M. Anscombe (Oxford: Blackwell, 1958).
6. J. L. Austin, 'Performatives and Constatives' (chapter I) and 'Conditions for Happy Performatives' (chapter II) in *How to do things with Words* (Oxford: Clarendon Press, 1962).
7. H. P. Grice, 'Meaning', in *Studies in the Way of Words* (Cambridge, MA: Harvard University Press, 1989). First appeared in *Philosophical Review*, 66 (1957).
8. W. V. O. Quine, 'Two dogmas of Empiricism', in *From a Logical Point of View* (Cambridge, MA: Harvard University Press, 1953). First appeared in *Philosophical Review*, 60 (1951).
9. Donald Davidson, 'Belief and the Basis of Meaning', in *Inquiries into Truth and Interpretation* (Oxford: Clarendon Press, 1984). First appeared in *Synthése*, 27, (1974).
10. Keith S. Donnellan, 'Reference and Definite Descriptions', *Philosophical Review*, 75, (1966).
11. Saul Kripke, extract from chapter 1 of *Naming and Necessity* (Oxford: Blackwell, 1980); the first of three talks which Kripke gave at Princeton University in January 1970.

12. Hilary Putnam, extract from 'The Meaning of "Meaning"', in *Mind, Language and Reality: Philosophical Papers*, vol. I (Cambridge: Cambridge University Press, 1975).
13. Gareth Evans, extract from 'Proper Names', chapter 11 of *The Varieties of Reference*, edited by J. McDowell (Oxford: Clarendon Press, 1982).
14. Ruth Barcan Marcus, 'Some Revisionary Proposals about Belief and Believing', in *Modalities: Philosophical Essays* (New York; Oxford University Press, 1993). First appeared in *Philosophy and Phenomenological Research*, L (Supplement, 1990).
15. Noam Chomsky, 'Form and Meaning in Natural Languages', in *Language and Mind* (New York: Harcourt, Brace, Jovanovich, revised edition, 1972).
16. Michael Dummett, 'What do I Know when I Know a Language?', in *The Seas of Language* (Oxford: Clarendon Press, 1993); first published as a paper presented at the Centenary Celebrations, Stockholm University, May 1976.
17. Tyler Burge, 'Wherein is Language Social?', in Alexander George (ed.), *Reflections on Chomsky* (Oxford: Blackwell, 1989).
18. Ruth Garrett Millikan, 'Epilogue' to *Language, Thought, and Other Biological Categories* (Cambridge, MA: MIT Press, 1984).

CHRONOLOGY OF MODERN PHILOSOPHY OF LANGUAGE

Events in the History of Modern Philosophy of Language and Related
Year *Fields*

1892 Gottlob Frege publishes 'On Sense and Reference' and 'Concept and Object'

1893 Frege, *The Basic Laws of Arithmetic*, vol. 1; F. H. Bradley, *Appearance and Reality*

1900 Edmund Husserl, *Logical Investigations*. Bertrand Russell meets Giuseppe Peano in Paris at the First World Congress of Philosophy.

CHRONOLOGY OF MODERN
PHILOSOPHY OF LANGUAGE

Year	Scientific, Artistic and Cultural Events	Historical and Political Events
1892	Hendrik Lorentz and George FitzGerald establish the principle of contraction of objects at high speed. First automatic telephone exchange is opened in USA. Rudolf Diesel patents a new type of internal combustion engine. Ruggero Leoncavallo's opera *I Pagliacci*. Maurice Maeterlinck, *Pelléas et Mélisande*, incidental music by Claude Debussy. Claude Monet begins his series of paintings of Rouen Cathedral	Gladstone forms a Liberal government in Britain. Grover Cleveland wins US presidential election
1893	Karl Benz's four-wheeled car. Egbert Judson invents the zip fastener. Oscar Wilde's play, *A Woman of No Importance*	Independent Labour Party established under Keir Hardie. France extends its colonies to Ivory Coast and French Guinea and acquires protectorate over Laos. The second Irish Home Rule Bill is rejected by the House of Lords
1900	Quantum theory initiated by Max Planck. Gregor Mendel's 1860s work on genetics is rediscovered and initiates the new science of genetics. Sigmund Freud, *The Interpretation of Dreams*. Oscar Wilde dies	Boxer Rebellion begins in China. William McKinley wins American presidential election

Year	*Events in the History of Modern Philosophy of Language and Related Fields*
1902	Russell informs Frege in a letter that the fifth axiom used in his *Groundwork of Arithmetic* makes the system inconsistent. Alexius von Meinong publishes *On Assumptions*
1903	Frege publishes the second volume of *The Basic Laws of Arithmetic*, with a hasty response to Russell's paradox added as an appendix. Russell, *Principles of Mathematics*; G. E. Moore, 'Refutation of Idealism' and *Principia Ethica*
1905	Russell, 'On Denoting'; Ernst Mach, *Knowledge and Error*; Meinong, 'Theory of Objects'
1907	William James, *Pragmatism*. Otto Neurath, Hans Hahn (a mathematician) and Philip Frank (a physicist) initiate a discussion group about philosophy, science and methodology which eventually becomes known as the Vienna Circle
1910	Russell and A. N. Whitehead, *Principia Mathematica*, vol. I
1912	Ludwig Wittgenstein, on the advice of Frege, begins studying with Russell in Cambridge. Luitzgen Brouwer, *Intuitionism and Formalism*
1914	Russell, *Our Knowledge of the External World*; F. H. Bradley, *Essays on Truth and Reality*; C. D. Broad, *Perception, Physics, and Reality*
1915	Ferdinand de Saussure, *Course in General Linguistics*

Year	Scientific, Artistic and Cultural Events	Historical and Political Events
1902	Ernest Rutherford and Fredrick Soddy, *The Cause and Nature of Radioactivity.* Gustav Mahler, Symphony No. 5. Joseph Conrad, *Heart of Darkness.* *The Times Literary Supplement* starts publication	The Boer War, which had begun in 1989, ends. Trotsky and Lenin meet in exile
1903	The Wright brothers conduct the first successful powered aeroplane flight. Bernard Shaw's play, *Man and Superman*	Emmeline Pankhurst founds the Women's Social and Political Union in Britain
1905	Albert Einstein publishes his Special Theory of Relativity. Pablo Picasso, *Acrobat and Young Harlequin, Boy With Pipe*; Paul Cezanne, *Les Grandes Baigneuse.* Debussy, *La Mer.* The Bloomsbury Group of intellectuals comes into existence and is influenced by G. E. Moore's *Principia Ethica*	Unrest in Russia, including the 'Bloody Sunday' in St Petersburg and mutiny of sailors on the battleship *Potemkin*, culminates in a general strike and the formation of the first Soviet
1907	Cubist exhibition in Paris. Rainer Maria Rilke, *Neue Gedichte* (New Poems). J. M. Synge's play *The Playboy of the Western World*	Irish nationalist party, Sinn Féin, is formed
1910	Marie Curie publishes *Treatise on Radiography.* Igor Stravinsky, *The Firebird.* E. M. Forster, *Howard's End*	Revolution in Portugal which leads to the declaration of a republic. Japan formally annexes Korea
1912	Alfred Wegener proposes the theory of continental drift. Robert Falcon Scott reaches the South Pole. Arnold Schoenberg, *Pierrot Lunaire*	Provisional republic established in China. War between Turkey and the Balkan states
1914	Ernest Rutherford discovers the proton. James Joyce, *Dubliners*	Archduke Franz Ferdinand of Austria and his wife assassinated at Sarajevo. First World War begins
1915	Einstein publishes his General Theory of Relativity. Pablo Picasso, *Harlequin.* Ezra Pound, *Cathay* (poems)	Turkey begins the systematic genocide of its Armenian minority population

Events in the History of Modern Philosophy of Language and Related
Year *Fields*

1918 Russell, *The Philosophy of Logical Atomism*

1921 Wittgenstein, *Tractatus Logico-Philosophicus*; John McTaggart, *The Nature of Existence*, vol. I

1922 Moritz Schlick takes up the Chair of Philosophy in Vienna and gives stronger direction to the Vienna Circle. English translation of *Tractatus Logico-Philosophicus*; G. E. Moore, *Philosophical Papers*

1927 Martin Heidegger, *Sein und Zeit*; Russell, *The Analysis of Matter*

1928 Rudolp Carnap, *The Logical Structure of the World*; David Hilbert, *Principles of Mathematical Logic*; Hans Reichenbach, *The Philosophy of Time and Space*

1929 Wittgenstein returns to Cambridge; Carnap, Hahn and Neurath publish the logical positivist manifesto, *The Scientific World View: the Vienna Circle*; John Dewey, *Experience and Nature*; C. I. Lewis, *Mind and the World Order*

Year	Scientific, Artistic and Cultural Events	Historical and Political Events
1918	Stravinsky's ballet, *Histoire du Soldat*. Picasso, *Harlequin with Guitar*. Rupert Brooke, *Collected Poems* (posthumously)	First World War ends. Tsar Nicholas II and his family are executed by the Bolsheviks who gain control of the government. The British government announces the abandonment of Home Rule in Ireland
1921	Discovery of insulin by Frederick Banting and C. H. Best. Sergey Prokofiev's opera, *The Love of Three Oranges*. J. M. Keynes, *A Treatise on Probability*. D. H. Lawrence, *Women in Love*. Luigi Pirandello's play, *Six Characters in Search of an Author*	Irish Free State established. Wartime Allies fix Germany's reparation payments at Paris Conference; Germany has difficulties in meeting these payments and faces economic and political crisis. 35 Fascists are returned in the Italian parliamentary elections
1922	James Joyce, *Ulysses*. T. S. Eliot, *The Waste Land*	The British–Irish Treaty is ratified in Dáil Éireann. A two-year civil war begins and the Irish leader, Michael Collins, is assassinated. Fascists march on Rome; Mussolini forms a government. Establishment of USSR
1927	Heisenberg's Uncertainty Principle. Marcel Proust, *Le Temps Retrouvé* (posthumously); Virginia Woolf, *To the Lighthouse*	Trotsky is expelled from Russian Communist Party. Adolf Hitler, *Mein Kampf*, vol. 2 (vol. 1 published 1925)
1928	Dirac's Equation combines quantum mechanics with special relativity. Alexander Fleming discovers penicillin. Geiger and Müller construct the Geiger counter. Arthur Eddington, *The Nature of the Physical World*. D. H. Lawrence, *Lady Chatterley's Lover*	Chiang Kai-shek elected President of China. Herbert Hoover becomes President of USA
1929	Werner Heisenberg and Wolfgang Pauli propose quantum field theory. Second Surrealist Manifesto; Salvador Dali joins the group. Virginia Woolf, *A Room of One's Own*	Wall Street stock market collapses, leading to economic depression in America and Europe. Labour wins the first general election held under universal adult suffrage in Britain

	Events in the History of Modern Philosophy of Language and Related
Year	*Fields*

1931 Alfred Tarski, 'The Concept of Truth in Formalized Languages'. Kurt
 Gödel's incompleteness theorem is published in his paper 'On Formally
 Undecidable Propositions in *Principia Mathematica* and related systems'.
 Schlick, 'The Turning Point in Philosophy'; Neurath, *Empirical
 Sociology*

1932 Carnap, *The Unity of Science*

1935 Carnap emigrates to America and takes an academic position in Chicago
 in 1936. Karl Popper, *The Logic of Scientific Discovery*

1936 Schlick is assassinated by a student. A. J. Ayer publishes *Language, Truth
 and Logic* which popularizes logical positivism in Britain

1938 The Vienna Circle's branch in Vienna is officially dissolved. Carnap,
 'Logical Foundations of the Unity of Science'. J. L. Austin begins his
 ordinary-language philosophy programme in Oxford

1939 Carnap, *Foundations of Logic in Mathematics*

1945 Frege's *Nachlaß* is destroyed in a bombing raid on Münster

Year	Scientific, Artistic and Cultural Events	Historical and Political Events
1931	Karl Jansky pioneers radio astronomy through the discovery of radio emission from the Milky Way	Japan occupies parts of Manchuria
1932	James Chadwick discovers the neutron. Carl David Anderson discovers positrons. Aldous Huxley, *Brave New World*. Bertolt Brecht's play *The Mother*. Henri Matisse, *Dance I* and *II*.	Roosevelt elected US President. Famine in the USSR. Mahatma Gandhi returns to India and begins the civil disobedience movement
1935	Robert Watson-Watt's team of scientists develops first radar. Richter scale developed by C. F. Richter. Alban Berg, Violin Concerto. George Gershwin's opera *Porgy and Bess*. T. S. Eliot, *Murder in the Cathedral*	At the Nazi Party rally Hitler announces the anti-Jewish Nuremberg Laws. Italy invades Ethiopia
1936	Prokofiev's opera *Peter and the Wolf*. Alan Turing's paper, 'Computable Numbers'. J. M. Keynes, *A General Theory of Employment, Interest and Money*. W. H. Auden and Christopher Isherwood, *The Ascent of F6*	Germany reoccupies the Rhineland. Spanish Civil War begins with an army mutiny led by General Francisco Franco. Chiang Kai-shek declares war on Japan. Berlin–Rome axis announced by Mussolini. Germany and Japan sign anti-Comintern Pact
1938	The German physicists Otto Hahn and F. Strassmann discover nuclear fission by splitting the uranium atom	Germany invades and annexes Austria. Kristallnacht pogrom against Jews in Germany. Munich Agreement offers 'peace in our time'
1939	James Joyce, *Finnegans Wake*; John Steinbeck, *The Grapes of Wrath*	Second World War begins. Spanish Civil War ends with the defeat of the Republicans by General Franco's Nationalists
1945	First atomic explosion in the New Mexico desert. George Orwell, *Animal Farm*; Jean-Paul Sartre, *The Age of Reason* (English translation 1947)	US drops atomic bomb on Hiroshima and Nagasaki, ending Second World War

Year | *Events in the History of Modern Philosophy of Language and Related Fields*

1946 Ruth Barcan Marcus develops the first quantified modal logic

1947 Carnap, *Meaning and Necessity*

1951 W. V. O. Quine, 'Two Dogmas of Empiricism'. Wittgenstein dies in Cambridge

1953 Wittgenstein, *Philosophical Investigations* (posthumously); Quine, *From a Logical Point of View*

1955 Nelson Goodman, *Fact, Fiction and Forecast*

Year	Scientific, Artistic and Cultural Events	Historical and Political Events
1946	John Von Neumann's team builds one of the first electronic computers. Albert Camus, *The Outsider*	First meeting of the United Nations General Assembly. Winston Churchill delivers 'Iron Curtain' speech in Fulton, Missouri, which signals the onset of the Cold War. Italy becomes a republic. The Nuremberg Trials establish that individuals can be guilty of war crimes and crimes against the international law
1947	ENIAC (Electronic, Numerator, Integrator, Analyser, and Computer), electronic, multi-purpose digital computer produced at University of Pennsylvania. Camus, *The Plague*; Anne Frank, *The Diary of Anne Frank*. Tennessee Williams' play, *A Streetcar Named Desire*	India and Pakistan gain their independence. Communism takes hold in Hungary and Romania
1951	UNIVAC I computers made commercially available. Henry Moore, *Reclining Figure*. Stravinsky's opera, *The Rake's Progress*; Benjamin Britten's opera, *Billy Budd*. J. D. Salinger, *The Catcher in the Rye*; Sartre, *Le Diable et Le Bon Dieu*	North Korean and Chinese forces break the UN lines and take Seoul. Churchill returns as British Prime Minister after five years in opposition
1953	Francis Crick and James Watson discover the double helix structure of DNA. Dimitri Shostakovitch, Symphony No. 10. Arthur Miller's play, *The Crucible*	Joseph Stalin dies. Korean War ends
1955	Clyde Cowan and Fred Reines, at the Los Alamos Laboratory, detect neutrinos. Herbert Marcuse, *Eros and Civilization*. Vladimir Nabokov, *Lolita*. Samuel Beckett's play, *Waiting for Godot*	Agreement on European Union between France and Germany is ratified in Paris. Formation of the Warsaw Pact. Juan Peron resigns and is exiled from Argentina

Year | *Events in the History of Modern Philosophy of Language and Related Fields*

1957 Chomsky ushers in the new age of linguistics with *Syntactic Structures*. G. E. M. Anscombe, *Intention*

1959 Chomsky publishes his review of B. F. Skinner's *Verbal Behavior* which effectively puts an end to behaviourism; P. F. Strawson, *Individuals*

1960 Quine, *Word and Object*; A. J. Ayer, *Logical Positivism*

1961 J. L. Austin, *Philosophical Papers* (posthumously)

1962 Austin, *Sense and Sensibilia* and *How to do things with Words* (posthumously); Thomas Kuhn, *The Structure of Scientific Revolutions*

1963 J. J. Katz and Jerry Fodor, 'The Structure of a Semantic Theory'; Popper, *Conjectures and Refutations*

	Scientific, Artistic and Cultural Events	Historical and Political Events
Year		
1957	USSR launches Sputnik 1 and Sputnik 2 (carrying the dog Laika) into Earth orbit. Jack Kerouac, *On the Road*. Beckett's play, *Endgame*	Treaty of Rome establishes the European Economic Community
1959	Frank Lloyd Wright's Guggenheim Museum opens in New York. C. P. Snow, *The Two Cultures and the Scientific Revolution*. Günter Grass, *The Tin Drum*; William Burroughs, *The Naked Lunch*	Castro becomes President of Cuba. The Conservative Party, under Harold Macmillan, is re-elected in Britain
1960	Britten's opera, *A Midsummer Night's Dream*. John Updike, *Rabbit, Run*. Eugène Ionesco's play, *Rhinoceros*	John F. Kennedy elected President of USA. Sharpeville massacre in South Africa. The African National Congress and Pan-African Congress are banned
1961	Yuri Gagarin becomes the first human being to orbit the Earth. Michel Foucault, *Histoire de la folie l'âge classique*	The Berlin Wall is built by the East German Communist government. USA severs political relations with Castro's regime, following which US-trained Cuban exiles unsuccessfully invade the island. Adolf Eichmann is tried in Israel and condemned to death for crimes against Jewish people
1962	The drug thalidomide is established as the cause of congenital malformations. Britten, *War Requiem*. Henry Miller, *The Tropic of Capricorn*; Alexander Solzhenitsyn, *One Day in the Life of Ivan Denisovich*. Edward Albee's play, *Who's Afraid of Virginia Woolf?*	Cuban Missile Crisis. Algeria becomes independent of France
1963	Quasars are identified by Martin Schmidt. Jurgen Habermas, *Theorie und Praxis*	President Kennedy is assassinated in Dallas. The Profumo affair in Britain leads to Harold Macmillan's resignation

	Events in the History of Modern Philosophy of Language and Related
Year	*Fields*
1965	Chomsky, *Aspects of the Theory of Syntax*; Karl Hempel, *Aspects of Scientific Explanation*
1967	Donald Davidson, 'Truth and Meaning'; Jacques Derrida, *L'Ecriture et la différence*
1969	Quine, *Ontological Relativity and Other Essays*; John Searle, *Speech Acts*; David Lewis, *Convention*
1972	Saul Kripke, 'Naming and Necessity'; Popper, *Objective Knowledge*
1973	David Lewis, *Counterfactuals*; Hilary Putnam, 'The Meaning of "Meaning"'; Michael Dummett, *Frege: Philosophy of Language*

Year	Scientific, Artistic and Cultural Events	Historical and Political Events
1965	The big bang theory is confirmed through the discovery of its radio-wave remnants	The white minority government of Rhodesia declares its independence from Britain. US aircraft bomb North Vietnam. Martin Luther King heads a procession of civil rights demonstrators from Selma to Montgomery, Alabama. War between India and Pakistan. First anti-war 'flower power' rallies in American universities
1967	Christiaan Barnard performs first heart transplant in South Africa. S. Manabe and R. T. Wetherlan warn that increased levels of carbon dioxide can create a 'greenhouse effect'. Andy Warhol, *Marilyn Monroe*. Gabriel García Márquez, *One Hundred Years of Solitude* (English translation 1970)	Arab-Israel Six-day War. Civil war in Nigeria
1969	Neil Armstrong and Edwin Aldrin land on the Moon. Single gene first isolated by Jonathan Beck. Woodstock Music and Arts Fair is attended by half-a-million people. Philip Roth, *Portnoy's Complaint*	Britain sends troops to Northern Ireland. President de Gaulle resigns following protests by French students and workers in 1968
1972	First home video cassette recorders are introduced. Anthony Burgess, *A Clockwork Orange*	US bombs Haiphong and Hanoi in North Vietnam. Nixon visits China and USSR. Beginning of the Watergate political scandal in America. 'Bloody Sunday' in Northern Ireland, followed by a rise in terrorist and sectarian attacks
1973	Solzhenitsyn, *The Gulag Archipelago* (3 volumes, 1973–8); Graham Greene, *The Honorary Consul*	Military coup in Chile overthrows the democratically elected Marxist President Salvador Allende. North Vietnam and the USA sign a peace settlement. Yom Kippur War between Israel and the Arab countries. Arab oil embargo of the West

Year	Events in the History of Modern Philosophy of Language and Related Fields
1975	Fodor, *The Language of Thought*; H. G. Gadamer, *Truth and Method*
1978	Dummett, *Truth and Other Enigmas*; Nelson Goodman, *Ways of Worldmaking*; Daniel Dennett, *Brainstorms: Philosophical Essays on Mind and Psychology*
1980	Richard Rorty, *Philosophy and the Mirror of Nature*; Bas van Fraassen, *The Scientific Image*; Searle, 'Minds, Brains and Programs'; Donald Davidson, *Essays on Actions and Events*. Gareth Evans dies at the age of 34
1981	Hilary Putnam publishes *Reason, Truth and History*, which becomes a milestone in separating his earlier realist position from his later 'internal realism'
1982	Gareth Evans, *The Varieties of Reference*, edited by John McDowell (posthumously); Rorty, *Consequences of Pragmatism*
1984	Donald Davidson, *Inquiries into Truth and Interpretation*

Year	Scientific, Artistic and Cultural Events	Historical and Political Events
1975	Charles T. Kowal discovers the 14th moon of Jupiter. Pierre Boulez, *Rituel in memoriam Bruno Maderna*. Saul Bellow, *Humboldt's Gift*. Primo Levi, *The Periodic Table*	General Franco dies and monarchy is reinstated in Spain. Civil war in Lebanon begins. Khmer Rouge comes to power in Cambodia
1978	First case of successful in vitro fertilization. Greene, *The Human Factor*. Harold Pinter's play *Betrayal*	Uprising against the Shah in Iran. Camp David peace summit between President Begin of Israel and President Sadat of Egypt. A Pole, Karol Wojtyla, becomes Pope John Paul II
1980	Philip Glass's opera, *Satyagraha*. Joseph Brodsky, *A Part of Speech*. Umberto Eco, *The Name of the Rose* (English translation 1981)	Iran–Iraq war begins. The trade union opposition movement, Solidarity, becomes active in Poland. President Tito of Yugoslavia dies. Ronald Reagan wins the American presidential elections
1981	First flight of space shuttle Columbia. First cross-species transfer of genes. Brian Friel's play *Translations*. Salman Rushdie, *Midnight's Children*	President Sadat is assassinated. François Mitterrand becomes the first Socialist President of France. Martial law is imposed in Poland following unrest and strikes led by Solidarity
1982	Luciano Berio's opera, *La vera storia*. Milton Friedman, *Monetary Trends in the United States and the United Kingdom*. Thomas Keneally, *Schindler's Ark*; Isabel Allende, *The House of the Spirits* (English translation 1985)	Falklands War between Britain and Argentina. President Brezhnev dies and Yuri Andropov becomes the new First Secretary of Soviet Communist Party
1984	Alec Jeffreys' discovery that each person has a unique core sequence of DNA leads to genetic fingerprinting. Milan Kundera, *The Unbearable Lightness of Being*	Indian Prime Minister Indirah Gandhi is assassinated. Ronald Reagan re-elected as US President in a landslide victory

	Events in the History of Modern Philosophy of Language and Related
Year	Fields

1986 Chomsky, *Knowledge of Language*; Thomas Nagel, *The View from Nowhere*; Tyler Burge, 'Individualism and Psychology'

1989 Paul Grice, *Studies in the Ways of Words*

1991 Dummett, *Frege and Other Philosophers, Frege: Philosophy of Mathematics*, and *The Logical Basis of Metaphysics*

1992 Putnam, *Renewing Philosophy* and *The Many Faces of Realism*; Christopher Peacocke, *A Study of Concepts*; Crispin Wright, *Truth and Objectivity*

1994 John McDowell, *Mind and World*; Dummett, *Origins of Analytical Philosophy*; Robert Brandom, *Making It Explicit*

Year	Scientific, Artistic and Cultural Events	Historical and Political Events
1986	Discovery of 'Great Attractor', a point towards which a number of galaxies are moving. US space shuttle Challenger explodes on take-off. Halley's comet returns. Lucien Freud, *Painter and Model.* Vikram Seth, *The Golden Gate*	Chernobyl nuclear reactor explosion
1989	For the first time a foetus is successfully removed from its mother's womb, operated on, and returned to the womb. John Cage, *Europa III/IV*	Fall of the Berlin Wall. Communist regimes in Germany, Hungary, Bulgaria and Romania are dissolved or overturned. Ayatollah Khomeini declares that Salman Rushdie's *Satanic Verses* is blasphemous and condemns the author to death
1991	The discovery of the most distant object observed in the universe, a quasar. Angela Carter, *Wise Children*; Bret Easton Ellis, *American Psycho*; Jung Chang, *Wild Swans*	Break-up of Soviet Union. Former Soviet Republics, including Latvia, Lithuania, Estonia and Armenia, become independent. The Gulf War against Iraq ends with the liberation of Kuwait
1992	Iris Murdoch, *Metaphysics as a Guide to Morals*	Break-up of Yugoslavia and the beginning of the war between Serbia, Bosnia and Croatia. Bill Clinton is elected US President. The Vatican formally rehabilitates Galileo Galilei
1994	The Hubble telescope starts taking pictures of galaxies in their infancy. The cleaning and restoration of Michelangelo's paintings in the Sistine Chapel is completed. Solzhenitsyn returns to Russia after 20 years' exile in the USA	The African National Congress wins the first free non-racial election in the history of South Africa and Nelson Mandela is sworn in as President. Israel withdraws from Gaza Strip and parts of the West Bank. Yasser Arafat returns to the Palestinian territories. IRA announces a cease-fire in Northern Ireland

INTRODUCTION

Philosophy of language is an attempt to understand the nature of language and its relationship with speakers, their thoughts, and the world. Philosophers of language ask and attempt to answer abstract questions such as: What is language? What is its purpose? How do we manage to understand each other? Under what conditions is what we say meaningful? What gives the various components of language and our speech the meaning they have? What is meaning? Philosophers of language are also concerned with questions about the relationship between language and the world: Does language describe the world or does it, in some way, construct our picture of reality? Does language distort reality or does it enable us to give accurate accounts of what there is? Are the truth and falsehood of our statements determined by the world or by our linguistic conventions? What is the connection between names and the objects to which they refer?

Philosophy of language also explores the relationship between what we say and our mental states and intentions. Can we think without language? Are our patterns of thought determined by our language? Is there such a thing as 'a language of thought' that underlies all human languages? How do we come to learn a language? Do we have an innate linguistic faculty or do we learn to speak by observing the behaviour of other speakers?

The answers, or attempts to answer such questions, are the source of various philosophical theories about language, notable among them theories of meaning, reference, and interpretation.

A Brief Historical Outline

The history of philosophical concern with language is as old as philosophy itself. Plato, in *Cratylus* explored the relationship between names and things and engaged in what today would be recognized as philosophy

of language.[1] Most philosophers since Plato have shown some interest in language. René Descartes (1596–1650), the founding father of modern philosophy, for instance, believed in the existence of a universal language underpinning the diverse languages which human communities use and is seen by twentieth-century linguist Noam Chomsky as a precursor of the theory of the innateness of linguistic abilities.[2] Hobbes and Locke were interested in the relationship between language and thought or ideas. Hobbes wrote, 'Seeing then that truth consisteth in the right ordering of names in our affirmations, a man that seeketh precise truth had need to remember what every name he uses stands for, and to place it accordingly, or else he will find himself entangled in words, as a bird in lime twigs, the more he struggles, the more belimed.'[3] And Locke argued that 'The use of Words ... stand[s] as outward Marks of our internal *Ideas*'.[4]

In spite of the interest in language, the main preoccupations of philosophy until the beginning of the twentieth century were far from linguistic. The ancient philosophers, beginning with the Presocratics, established a tradition of metaphysical speculation that continued through the Middle Ages. They were primarily concerned with questions about the nature of existence, the categories of things that exist, their essences, their unity and diversity and so on. With Descartes, the locus of philosophical concern changed from the issue of what there is to what we know. The sceptical climate engendered by the Renaissance and the breakdown of old scientific and religious certainties gave urgency to questions such as 'How can we know anything at all?' and 'What justification have we for our claims to knowledge?'. Both the rationalist and the empiricist philosophers, from Descartes onward, were, in different ways, engaged in the project of establishing foundations for claims to knowledge, and so were primarily concerned with epistemological questions.

With the beginning of the twentieth century we witness a radical change. A preoccupation with language began to dominate philosophy and gave it its 'linguistic turn'.[5] This change involved not only a quantitative increase in interest in matters linguistic, but also the recasting of age-old philosophical questions in linguistic terms. Language thus came to be seen as the primary means of both understanding and solving philosophical problems.

The philosophers directly responsible for this paradigm shift, Gottlob Frege in Germany and Bertrand Russell and G. E. Moore in Britain, reacted against currents of philosophy prevalent in Germany and Britain at the end of the nineteenth century. The roots of what came to be known as 'the analytic revolution' can be found in Frege's revolt against German

psychologism and Russell's and Moore's rejection of British idealism.[6] These philosophers wanted to replace the prevailing Neo-Kantianism and idealism with rigorous philosophical realism. They were primarily concerned with the nature of truth, with reality and the connection between thought and the world, and they sought to gain knowledge of reality and its connections with human thought. However, they also believed that reality cannot be studied directly without also studying the main medium for thinking about it and describing it, i.e., language. Their concern was with language as an abstract entity that expresses thought and whose structure, if analysed correctly, can reveal the structure of reality and they had no, or very little, interest in the actual use of language in its social context.[7]

The main features of analytic philosophy, in its infancy, were: (a) the emphasis on rigorous argumentation and clarity, both as a goal and as methodology; (b) lack of interest in the history of the subject; (c) emphasis on the connections between philosophical concerns and those of the natural sciences (Russell voices the view of many analytic philosophers when he claims that philosophy is essentially one with science, differing from the special sciences only in the generality of its problems[8]); (d) belief in the importance of language as a means of understanding philosophical questions, including questions about the relationship between the world, or reality, and thought; (e) the adoption of the method of analysis and reliance on formal logic as a tool to analyse and clarify philosophical problems. Analytic philosophy was seen, at first, as a tool for dissecting thought and analysing it into its ultimate constituents, in the same way that chemistry analyses physical substances. The newly discovered logical tools were to be the instruments for the analysis, and language was the main medium through which thought was to be analysed.[9] Analysis of language would reveal hidden logical structures and, in the process, help us solve age-old philosophical problems, hence the term 'analytic philosophy'. Frege and Russell revolutionized logic by inventing new ways of representing the logical form of language in formal notations. These innovations led to the hope that logically perfect or ideal languages could be constructed, free of the ambiguities of ordinary languages, able to express scientific truths clearly and precisely.

Despite many similarities we can detect a change of approach in the work of the next generation of analytic philosophers. The philosophers of the Vienna Circle, known as the logical positivists (see chapter 4), took much of their inspiration from a somewhat simplified understanding of Ludwig Wittgenstein's ideas in the 1920s. They associated the meaning of a sentence with the conditions which would verify it.[10] Their most important contribution to philosophy of language was the emphasis put

on the connection between meaning and epistemic conditions, such as methods of verification. The verificationist theory of meaning distinguishes between analytic and synthetic statements, claiming that analytic statements, like statements of logic and mathematics, are true by virtue of the meaning of the terms contained in them and provide no information about the world. Synthetic statements, on the other hand, are about the world, and their meaning is their method of verification or confirmation by empirical means. As Tyler Burge has pointed out, 'The verificationist principle was supposed to explain why philosophy, particularly metaphysics, had failed. The idea was that, since philosophy associates no method of verification with most of its claims, those claims are meaningless. To be meaningful and produce knowledge, philosophy was supposed to imitate science in associating its claims with methods of testing them for truth.'[11] Thus, the logical positivists represent a typically ambitious move in philosophy of language, whereby a correct theory of meaning is seen as the means for solving, or rather dissolving, ancient philosophical problems. 'The positivist movement, influenced by Frege through Russell, Carnap and Wittgenstein, had propagated the view that the study of linguistic meaning was the proper starting point for philosophy. Language and meaning were supposed to elicit initial agreement better than other traditional starting points, such as the nature of concepts, or first metaphysical principles.'[12]

A common feature of early analytic philosophy of language was a mistrust of ordinary languages. Frege, for instance, had argued that 'someone who wants to learn logic from language is like an adult who wants to learn how to think from a child. When men created language, they were at a stage of childish pictorial thinking. Languages are not made to logic's ruler.'[13] He argued that philosophy should attempt to free thought from 'that which only the nature of the linguistic means of expression attaches to it'.[14] One of the many problems with ordinary languages, according to Frege, is that they are vague and contain predicates whose boundaries are not clearly drawn (e.g., is tall, is bald), and hence fail to refer. Frege hoped that, eventually, a perfect or ideal language would be devised, with the help of his logical notation, which would be capable of expressing thoughts in an accurate way. His *Begriffsschrift* (1989), and the logical notation invented therein, were steps towards the construction of such a precise, ideal language.

Russell, in a similar vein, dismissed the relevance of ordinary languages to the correct logical and scientific understanding of thought and the world. According to him, ordinary languages such as English can give rise to erroneous metaphysical beliefs and encourage a false view of the world, by giving 'metaphysical importance to the accidents of our own

speech'.[15] As we shall see (chapter 2), Russell was interested in analysing components of ordinary languages only to unmask the true logical form of linguistic expressions that had been distorted by their misleading grammatical form. Similarly, the logical positivists saw philosophy as a critique of language and were involved in the construction of an ideal language suitable for the expression of the results of scientific enquiry.

Beginning in the 1930s, the concerns with formal aspects of language and the construction of ideal languages were supplemented, and gradually replaced, by a new interest in the workings of ordinary languages. The focus of philosophy of language began to shift from analysing language in the abstract to looking at its day-to-day working in social contexts. Philosophers of language started concentrating more on what people do with language than on its abstract properties. While the earlier generation was concerned with semantical and syntactical questions, this new phase of philosophy of language concentrated on pragmatic questions. (These concerns are illustrated in chapters 5, 6, and 7 of this collection.)

This stark and ascetic conception of language began to be criticized, in the first place by Ludwig Wittgenstein, attacking the views he had expressed in his book *Tractatus Logico-Philosophicus* (1921) where he had ignored the multi-facetedness of linguistic usage and had concentrated on a single function of language, viz. its role in representing or picturing the world. Starting with his so-called *Blue and Brown Books* (1958),[16] which comprised notes dictated to his Cambridge students in the 1930s, Wittgenstein affected a sea change in philosophy of language. He rejected his earlier views on the conditions of meaningfulness and the relationship between language and the world, in particular his picture theory of meaning, which was based on the assumption of a relationship of correspondence or mirroring between propositions or the sentences of language and mind-independent facts. Now he favoured a view of meaning that was based on looking at language-use in its social and biological context, or what he called a 'form of life' (see chapter 5).

The ordinary-language approach developed further with the work of Oxford philosopher J. L. Austin (see chapter 6). Austin thought that inattention to the finer details of the working of language had led philosophers into major conceptual errors. By having too narrow a conception of language, by emphasizing the assertoric or the propositional aspect of linguistic utterances, philosophers had fallen into various errors, including what Austin called the 'descriptive fallacy': the assumption that words are used only to describe. Many of the traditional philosophical concerns and problems, for example, scepticism about the external world, the argument from illusion, free will versus determinism,

can be resolved or dissolved by painstaking analysis and attention to the correct use of terms.[17]

Wittgenstein and Austin, despite many differences, shared the common aim of looking at the actual uses of language and attention to the pragmatics of language, in order to find the sources for philosophical puzzles. They treated philosophy as an activity. For Wittgenstein in particular, this was a therapeutic activity, useful for dissolving as well as solving philosophical problems. Philosophical problems, they maintained, are often created by misuse of language (hence Wittgenstein's famous dictum: 'Philosophy is a battle against the bewitchment of our intelligence by means of language'[18]). They rejected the ambitious system-building and foundationalist projects that were the hallmark of earlier philosophical temperaments and adopted a quietist attitude which would have seemed alien to more traditional philosophers.

A further important figure engaged in ordinary-language philosophy in the 1940s and 1950s was Gilbert Ryle whose work has had its greatest impact on philosophy of mind. Ryle, like Austin and Wittgenstein, believed in the curative role of philosophy. His most significant and innovative contribution was the idea that certain philosophical doctrines (e.g., mind–body dualism) arise out of treating expressions that properly belong to one logico-linguistic category as if they belonged to a different category, for example, thinking that 'mind' belongs to the category of substantive things rather than dispositions to behaviour. Ryle, like Austin, was attempting to detect 'the sources in linguistic idioms of recurrent misconstructions and absurd theories'.[19] In this they were both following Moore's example by according priority to 'commonsensical' judgements and intuitions rather than to philosophical theorizing.[20]

The earlier generations of philosophers of language concentrated on language as primarily the medium for making true (or false) statements about the world. The ordinary-language philosophers, in contrast, emphasized the role of pragmatics and the communicative function of language, believing that the detailed study of how ordinary languages work can help solve many traditional philosophical problems. Here an important part of the disagreement between the ideal-language and ordinary-language philosophers can be located. Although both groups accepted that philosophical problems, at least to some extent, are created by the ambiguities and lack of clarity inherent in ordinary language, they adopted opposing strategies to try to deal with the perceived difficulties. The ideal-language philosophers proposed a total reform of our ordinary language by revealing the correct, underlying logical form of our assertions. The ordinary-language philosophers, on the other hand, advocated a deeper understanding of ordinary languages as they stand, but

did not feel the need to improve or reform them. The common link between these phases of analytic philosophy was the treatment of language as the starting point for philosophy, a lack of concern for the history of the subject, emphasis on clarity of the thought and expression, and interest in the method of analysis.[21] But while Russell, Frege, the early Wittgenstein and the logical positivists emphasized logical analysis, the ordinary-language philosophers, following Moore, were more interested in conceptual analysis, which involved looking at ordinary usage of language. As P. M. Hacker has pointed out:

> "Conceptual analysis" as practised in Britain after the war, was an heir to Moorean analysis, in which the term "analysis" was retained, but its implication of decomposition into simple constituents was jettisoned. Similarly, the term "concept" was preserved, but its Moorean realist or Platonist connotations were abandoned. "Conceptual analysis" thus conceived amounted, roughly speaking, to giving a description, for specific philosophical purposes, of the use of a linguistic expression and of its rule-governed connection with other expressions by way of implication, exclusion, presupposition, etc.[22]

The next phase of the linguistic turn in analytic philosophy can be dated from the publication of W. V. O. Quine's highly influential work 'Two Dogmas of Empiricism' (chapter 8) in 1951.

The Nazi take-over in Germany and Austria and the onset of the Second World War forced many philosophers affiliated with the Vienna Circle and logical positivism to flee to the United States. Notable among them were Rudolf Carnap, Alfred Tarski, Herbert Feigl and Kurt Gödel, whose arrival had an enormous impact on future developments in American philosophy. The philosophical school indigenous to the United States was Pragmatism, which had started with C. S. Peirce, William James and John Dewey and had been continued by C. I. Lewis. The Pragmatist philosophers James, Dewey and Peirce had concentrated on the connection between truth and what works or is useful. Truth, they maintained, is a property of the end result of successful scientific research which in turn enables us to have control over nature. They regarded the questions about meaning and truth as answerable only in terms of how things work out in practice. Many contemporary American philosophers have been influenced by Pragmatist conceptions of truth and knowledge, notably Wilhem van Orman Quine (chapter 8), Hilary Putman (chapter 9), particularly in his most recent writings, and Richard Rorty.[23] American philosophy of language, however, has largely been shaped by reactions to the work of the European originators of analytic philosophy.

Post-war American philosophy in general, and philosophy of language

in particular, is too heterogeneous to be comfortably summarized in the space available here. However, several features stand out. One important change of direction within the analytic tradition of philosophy of language in its American reincarnation was the rejection, or at least the abandonment, of the goal of analysis. Philosophy of language is no longer concerned with breaking down concepts into their most fundamental components, nor does it attempt to provide the necessary and sufficient conditions for the application or definition of philosophically significant terms or concepts. Philosophy of language since the 1950s has also largely abandoned its concern with syntactical questions, which have now become the domain of linguistics. Simultaneously, pragmatic considerations have been relegated to a secondary position, if not altogether ignored. The concern of contemporary American philosophers of language is with the methodical and somewhat abstract study of human languages, combining logical rigour with the aim to understand, rather than reform, ordinary language.[24] Contemporary American philosophy of language is also marked by two contradictory impulses. On the one hand, there is a quietist and deflationist mood. Under the influence of Quine, philosophers as diverse as Paul and Patricia Churchland and Richard Rorty have announced the end of philosophy, at least in its traditional mode.[25] To take one instance, Quine's denial of the analytic/synthetic distinction (see chapter 8) has led to the doctrine of indeterminacy of translation which, in turn, has resulted in questioning the very possibility of our being able to theorize or to say anything systematic about meaning. In an important sense, then, Quine's philosophy of language undermines the very possibility of philosophy of language as a distinct philosophical sub-discipline.

The second, and diametrically opposed, impulse in contemporary American philosophy of language, broadly conceived, is the willingness to engage in metaphysical theory-building. The philosophical approaches developed by Saul Kripke (chapter 11), Ruth Barcan Marcus (chapter 14) and David Lewis[26] have strong metaphysical ramifications. These philosophers have made use of considerations pertaining to formal modal logic and the theoretical tool of 'possible worlds' to discuss and solve various philosophical problems. In each case their approach has involved them in strong metaphysical commitments; essentialism in the case of Kripke and Ruth Barcan Marcus, and modal realism or a commitment to the reality and existence of possible worlds in the case of David Lewis. Such an outcome would have been wholly unwelcome both to the anti-metaphysical attitudes adopted by the logical positivists in the 1930s and to the ordinary-language philosophers in the 1940s.

A further, more recent departure from the original aims of the first

and second generations of analytic philosophers of language is a significant shift of emphasis from studying the connection between language and the world to that of studying the connection between language and the human mind. Analytic philosophers, in the first forty years of philosophy of language, emphasized the relationship between language and the world; the ordinary-language philosophers, on the other hand, concentrated on the relationship between speakers and their language. The past twenty years, however, have seen an increased interest in the connection between the human mind (and the physical brain) and language, partly because many of the questions posed by philosophers of language, which I enumerated at the beginning of this introduction, cannot be answered without a reference to the properties of the human mind. Philosophy of language, in the hands of American philosophers such as Jerry Fodor, Bill Lycan, Tyler Burge (chapter 17) and Ruth Millikan (chapter 18), is indistinguishable from philosophy of mind. Other philosophers, such as Donald Davidson (chapter 9), have developed their theories of language in tandem with their theories of the mind.

The articles and book extracts in this collection represent benchmarks in the development of philosophy of language. I have chosen them for their significance in shaping the trends and the direction of twentieth-century analytic philosophy of language. Where possible, my choice has been dictated by their accessibility as well as for the centrality of the work. Philosophy of language in the twentieth century is a highly technical field and consequently the best work in the area is not readily understood by non-philosophers. I have provided introductions to each text selected, to give some background information on the piece and its author. These introductions can be by-passed by those readers who are already familiar with the outlines of twentieth-century analytic philosophy. The individual bibliographies offer a selection of the more important works of each author, followed by a number of suggested titles broadly relevant to the work of the authors concerned. The glossary provides brief definitions for the more technical terms used in the texts.

The Issues

A common thread connecting the various selections is their preoccupation with the issues of reference and meaning – two core concerns of philosophy of language.

Theories of Reference

We often use language to describe how things stand in the world or to express our beliefs, desires and hopes concerning the world. If we believe that our thoughts do relate to the world, and it is difficult to see how we cannot, the way in which this relationship is established and maintained through language becomes important. Theories of reference set out to explain how particular components of any given language link up with the world. The most basic link is through names that stand for, or pick out, objects. If philosophers can explain the relationship between names and their bearers, then a first but most crucial step in understanding the connection between language and the world has been taken.

Interest in the question of reference goes back to Plato[27] and was also present in medieval philosophy.[28] In the nineteenth-century John Stuart Mill, relying on the work of medieval philosophers, and foreshadowing the preoccupation with questions of reference in the analytic tradition, distinguished between the denotation and the connotation of a term. According to Mill, the denotation of a term is all the objects to which the term applies; the connotation of a term, on the other hand, is the meaning of the term or the attributes that define that term. Proper names, Mill argues, are attached to objects and are not connotative.[29] Mill was proposing a version of what may be the simplest and in many ways most compelling view of reference: that names stand for or apply to things. This view of the relationship between names and objects, however, seems to suggest that for every name there must be an object to which the name corresponds and which fixes the meaning of the name. Such a position has several unwelcome consequences. In the first place, it renders us unable to account for the meaning of sentences that contain empty names – names that have no denotation or bearers. If empty names have no meaning, we would not find sentences such as 'Santa Claus has a white beard' intelligible, but this is not the case, so this simple account cannot be correct. Furthermore, Mill's theory of reference is unable to account for negative existential statements such as 'Santa Claus does not exist'. If the use of the name 'Santa Claus' commits us to the existence of Santa Claus, then the denial of his existence is self-contradictory. In general, a theory of meaning and reference should be able to explain how we can use language to speak meaningfully of things that do not exist, as well as of entities to whose existence we are committed. We need a theory of reference that renders the sentence 'Polar bears are white' meaningful and true and the sentence 'Unicorns are black' meaningful and false, and yet does not commit us to the existence of unicorns. We call this group of concerns for a theory of reference 'the problem of existence'.

A further difficulty arises from the common observation that one and the same object or thing can be named in many different ways. The sentence 'Superman is Superman' is a tautology and completely uninformative, while the sentence 'Superman is Clark Kent' is informative, even though they are both identity statements concerning one and the same object. The simple theory of reference outlined above cannot account for this puzzling feature of identity statements or 'the problem of identity'. (See the introduction to chapter 1 for a more detailed discussion of this issue.)

Theories of reference have been central to various debates in twentieth-century philosophy of language. The problems of existence and identity were the starting points for the earliest discussions of reference. The preoccupations that started with Frege and Bertrand Russell have continued with Keith Donnellan, Hilary Putnam, Saul Kripke, Gareth Evans and Tyler Burge. As we shall see in chapter 1, Frege, through his groundbreaking work, addressed both issues by distinguishing between the sense and the reference of a name. An object can be referred to in many ways: for instance, the names 'morning star' and 'evening star' are used to refer to one and same planet, Venus. These names, Frege argued, have different senses but a single reference. The distinction between sense and reference allows for the meaningful use of empty names such as 'Santa Claus', which has sense but no reference. It also shows that negative existential statements do not commit us to the existence of the things whose existence we are denying. Thus the distinction solves the problem of existence. It also solves the problem of identity, because it allows us to distinguish between identity statements containing terms with the same sense and reference, and those with the same reference but different senses.

Russell (chapter 2) attempted to address the problems of identity and existence without making use of the rather mysterious Fregean entities called 'sense'. Names, according to Russell, are often disguised descriptions. Many names, such as 'the present king of France', because of their grammatical form, give the impression of standing for something real. However, once their correct logical form is revealed through analysis it becomes clear that they do not refer. According to Russell, reference is achieved in one of two ways. There are the rare instances of direct reference, or reference by acquaintance, as in the case of 'I', 'this' (when used to pick out a sense datum), and 'now'. All other uses of referring terms, including reference with proper names, are accomplished by use of descriptions associated with the object to which we are referring.

Frege and Russell set the agenda for all subsequent discussions of

reference. Reactions to the questions raised by them fall into several broad categories. On the one hand, we see a clear disagreement between those philosophers who, following Frege and Russell, believe that meaning and reference should be explained in terms of the relationship between language and the world as opposed to those who believe that it is not names that refer but speakers who use that name in specific contexts. Peter Strawson[30] in 1950, for instance, challenged Russell's theory of descriptions by distinguishing between sentences, abstract linguistic entities that can be grammatical and meaningful, and statements that are asserted by individual speakers. Reference, according to Strawson, should be explained by what people do when they use words and sentences, at specific times and places, and not at the level of abstract statements. Many of the articles reproduced in this collection (e.g., chapters 10 and 13) have been written in the light of Strawson's criticism of Russell and represent one aspect of the tension between those philosophers of language who have concentrated on language as an abstraction, and those who have emphasized the study of language as used by speakers in specific contexts.

A somewhat different reaction to Frege's and Russell's theories of reference is evident in the work of Saul Kripke (chapter 11) and Hilary Putnam (chapter 12), who were influenced by Keith Donnellan (chapter 10). Donnellan was one of the originators of the view that, in order to explain reference, we have to take into account the way in which a name is connected to an object through successive uses of that name, by many speakers, through time. This idea received its full expression in Kripke's and Putnam's 'causal account of naming'. The causal account is a critique of one aspect of Russell's view of reference in that it denies that the reference of each proper name is fixed by a description.[31] It also denies the Fregean suggestion that the sense of a name both determines its reference and enables us to understand its meaning. According to this view, what determines the reference of a name is an initial act of baptism or dubbing through which a name becomes directly linked with an object or kind of object. If the name is used to refer to the same object on subsequent occasions the meaning of the name is preserved. From this perspective it is the world, rather than the beliefs and intentions of individual speakers, that determines reference and meaning. Elements of the causal account of reference were already present in the pioneering work of the philosopher of logic Ruth Barcan Marcus. Marcus proposed that the semantic role of a proper name is to tag, rather than to describe, an individual. Her work also foreshadowed Kripke's and Putnam's essentialism. The article by Ruth Barcan Marcus (chapter 14) appearing in this collection, however, presents a different strand of Marcus's work,

where she criticizes the language-centred views of belief such as that of Davidson (chapter 9).

Some of the most fruitful contemporary debates on the sources and determinants of reference and meaning fall under the headings of 'externalism versus internalism'. According to the externalists, what is thought or said is essentially dependent on objects and events in the external world. The internalists see the mental, 'narrow' content of the speaker's beliefs as the main determinant of his/her meanings. Chapters 13 and 17 are examples of some important aspects of this debate. Gareth Evans (chapter 13) has argued that a causal account of reference for a name should be supplanted by considerations about the beliefs and information associated with that name. Without such a move, Evans argues, we cannot make sense of cases where names change their meaning. The work of Tyler Burge (chapter 17) has introduced a new element to the discussion of externalism. According to Burge, social usage, and not just external objects, should be seen as an important source for determining the reference and meaning of names, as well as the means of individuating the content of thoughts and beliefs.

As Burge wrote:

> The main upshot of these [recent debates] on reference has been to portray reference as dependent on more than the beliefs, inferences, and discriminatory powers of the individual. Reference seems to depend on chains of acquisition and on the actual nature of the environment, not purely on the beliefs and discriminative abilities of the person doing the referring. This result suggests that reference cannot be reduced to psychological states of individuals, unless these states are themselves individuated partly in terms of the individual's relation to his community and/or physical environment.[32]

Theories of Meaning

Concern with questions of meaning and meaningfulness is the defining feature of philosophy of language. Theories of reference tell us how words relate to the world, but questions of meaning extend beyond the issue of reference. For instance, a theory of meaning should also provide us with an account of how words relate both to other words and to the beliefs and intentions of the speakers of those words.

We can distinguish between several contrasting approaches to meaning. One approach relates to the long-standing debate between the advocates of the study of ordinary language and those who prioritize the study of ideal languages and language in abstraction. This, as we saw in our historical survey, was a major point of disagreement between ordinary-language philosophers and the first generation of analytic

philosophers of language. Frege's distinction between sense and reference provided philosophy of language with a theory of meaning and reference. But Frege's concern was with language as an abstraction, rather than as a lived phenomenon. Chapters 5, 6, and 7, on the other hand, deal with questions of meaning raised in our use of ordinary languages. Wittgenstein emphasizes the public use of language; Austin introduces the rudiments of a speech act theory; Grice argues that linguistic meaning should be analysed and interpreted in terms of the intentions of persons engaged in an act of communication, and in so doing incorporates some of Austin's intuitions into the more theoretical frameworks favoured by the earlier generation of philosophers of language. What sets these philosophers apart from the preceding generation is their emphasis on the intentions, beliefs, and practices of flesh-and-blood speakers of ordinary languages.

Chapters 4 and 8 concern the logical positivist verificationist theory of meaning and its criticism by Quine; they also touch on the question of the very possibility of a theory of meaning. As we have seen, the logical positivists based their theory of meaning on the distinction between analytic and synthetic statements and the principle of verification. The principle of verification faces the difficulty of self-application. What is the status of the principle of verification? On the face of it, it is neither analytic nor verifiable by empirical means and thus, according to the logical positivist criterion of meaning, the logical positivist criterion of meaning is meaningless. Rudolf Carnap (chapter 4) proposed the most refined solution to this difficulty. According to him, the principle of verification is a proposal for clarifying the meaning of 'meaning'; it is a practical principle which is to be judged by its fruitfulness. Carnap advocated what he called 'the principle of tolerance' which allowed for various 'first principles' or 'frameworks' to be adopted purely on pragmatic grounds. The principle of verification, then, would count as analytic within certain linguistic frameworks.

Quine's publication of 'Two Dogmas of Empiricism' (see chapter 8) seriously undermined the logical positivist distinction between analytic and synthetic statements. His essay showed that philosophers' talk of analyticity (or truth by meaning only) was at best suspect. Quine argued that no hard-and-fast distinction can be drawn between truths of meaning and truths of fact, and dismissed the Carnapian distinction between theoretical postulates and conventional meaning postulates. The rejection of the notion of analyticity cast a shadow over all attempts to construct a theory of meaning. Quine shows that in effect we cannot draw a clear distinction between questions of meaning and questions of fact. He takes a thoroughgoing naturalistic view of language, arguing

that the only way to understand a language is to observe the patterns of stimulus and response discernible in the behaviour of the speakers of that language. Patterns of assent to, and dissent from, statements are the only relevant data for understanding a language; all other attempts to construct a 'theory of meaning' are bound to be futile.

Quinean linguistic behaviourism is in stark opposition to Noam Chomsky's innatist view of language acquisition. In a series of searching articles Chomsky has explored his differences with Quine.[33] According to him (chapter 15), language is in effect a component of the human brain and hence language acquisition, and our understanding of the speech dispositions of speakers, have very little to do with observing the behaviour of other speakers. Chomsky has argued, furthermore, that a study of language needs to allow for the existence of analytic statements, otherwise we would be unable to understand statements such as 'If John was chasing Jim, then Jim was being followed by John'. The understanding of such a sentence requires knowing some truths about meanings, for instance, the a priori truth that to be chased by x necessarily implies being followed by x, and not just truths of facts about the behaviour of John and Jim. For Chomsky, any philosophical discussion of meaning should take place in light of the data concerning the innate components of our linguistic abilities.

The influence of work by both Quine and Chomsky extends beyond that indicated in this collection. Quine's introduction of the thought experiment of a field linguist engaged in the radical translation of a hitherto untouched language has provided philosophers with a novel and interesting way of addressing questions about the relationship between a language, its speakers and the world they inhabit. (In chapter 9 Davidson explores some of the consequences of this approach.) Chomsky's work has inspired philosophers of language/mind, such as Jerry Fodor, to theorize about the 'language of thought'[34] that is innate to all human beings and is localized in the language module of the brain.

Theories of meaning are also concerned with the conditions and requirements for meaningfulness of sentences. With the linguistic turn, sentences or statements, rather than ideas or thoughts, have come to be seen as the bearers of truth and falsity. This change of perception has strengthened the connections between truth and linguistic meaning. According to one prominent line of thought, the meaning of a sentence is given by the conditions in which it is true, and hence to understand a sentence, or to know its meaning, is to know its truth-conditions. This assumes that language is a reflection of a mind-independent reality, that we use language to make true (or false) statements about that reality, and so statements get their meaning from being paired with conditions

that they are about. The most elegant statement of this view can be found in Ludwig Wittgenstein's *Tractatus* where he argues that a proposition is a picture or model of reality and has meaning only if it is possible, in principle, for it to be true or false.

Truth-conditional theories of meaning, however, face serious problems. Firstly, if assertions are meaningful only if they picture possible states of affairs, then any discussion of the relationship between language and the world is rendered nonsensical. Philosophers, then, have to find a way to speak meaningfully about the relationship between language and the world or accept, as Wittgenstein does at the end of the *Tractatus*, that all philosophy of language is non-sense. A second, related difficulty is to find a way to account for the meaning of sentences that on the face of it do not describe states of affairs and consequently are not true or false in the ordinary sense of the word.

Tarski's seminal work (see chapter 3) demonstrated how a formal account of the relationship between the components of language and components of the world can be given without throwing us into self-referentiality or violating the limits of meaningfulness. Tarski had not intended his theory to be a contribution to discussions of meaning in ordinary language, but his approach opened the way for dealing with the first of the above two problems. Donald Davidson's work (see chapter 9) is an attempt to provide a fully developed theory of meaning for natural languages by using Tarski's semantic conception of truth. Davidson takes truth as a basic notion and uses it to explain what meaning is, because, he argues, a theory of truth for a language enables an interpreter to understand every assertive utterance of the speaker whose speech he or she is interpreting. As we shall see in greater detail, Davidson's approach consists of looking at the ways in which speakers/interpreters work out the conditions under which a given sentence is true. Davidson is continuing the tradition set out by Frege and Russell, insofar as he studies language through the analysis of its logical form, but his analysis stops short of their original aspirations to reform ordinary language.

The truth-conditional theories of meaning are contrasted with a variety of views that fall under the umbrella label of 'use theories of meaning'. One major motivation behind the various use theories is the conviction that meaning cannot be evidence-transcendent. According to this view, our understanding of sentences or statements of any given language depends on our being able to grasp either (a) what counts as evidence for those sentences, or (b) what counts as correct use of the particular sentence in particular circumstances and contexts.

As we have seen, position (a) was held by the logical positivists who, using the principle of verification, argued that to know the meaning of a

sentence is to know the conditions or circumstances that will make it true. Thus the connection between meaning and truth is still maintained, but the all-important element of human knowing has also been brought into the picture. Position (b) was advocated by Wittgenstein in his later writings (see chapter 5). He contended that the meaning of an utterance is, at least in part, determined by the public, community-wide rules for its use in appropriate circumstances. This view provides a solution to the second problem facing truth-conditional theories of meaning, for the assertoric use of language is seen as only one of the many uses a language has and does not provide us with the model or paradigm instance of meaningfulness for the entirety of language.

The debate between truth versus use-oriented theories of meaning has crystallized, in recent years, under the heading of semantic realism versus anti-realism. A major figure in this debate is Michael Dummett (see chapter 16), whose version of anti-realism has drawn from both the logical positivists' and the Wittgensteinian views of language. The debate between the realists and anti-realists centres on the notion of truth and its connection with meaning. As we saw, the realist believes that truth is wholly mind-independent and that every sentence has either the value true or the value false, even if we do not know which (the principle of bivalence). Dummett has expressed grave reservations about any theory of meaning that makes use of a realist conception of truth because, he argues, such a theory would be unable to account for the conditions under which speakers come to understand their language. He argues that questions of meaning should not be separated from questions of understanding and of having justification or evidence for the use of particular utterances. Since realists treat truth as evidence-transcendent, they render meaning also beyond the human ken. He reiterates the point that if meaning is use, then a truth-conditional model of meaning is possible only if we make use of a notion of truth in such a way that the truth of a sentence would imply the possibility of our being, at least in principle, capable of recognizing its truth. Such a notion of truth does not obey the principles of bivalence, because bivalence entails that there will always be sentences whose truth or falsity we cannot recognize or assert. Dummett believes that this epistemic conception of truth and meaning has profound effects on how we understand the idea of an objective reality existing independently of our recognizing it. But such a profound metaphysical change is the cost, according to Dummett, of identifying meaning with use.

Current Trends

We have already noted the shift of emphasis in philosophy of language from a preoccupation with logical analysis and questions about the relationship between language and the world to the examination of the connections between language and thought or mind. 'Epilogue' (chapter 18) by Ruth Millikan is the work of a philosopher of mind/language who believes that language is a biological entity and that all its various aspects should be explained in evolutionary terms.

Several other interrelated topics are also the focus of current debates. Figuring prominently among them are philosophical issues surrounding semantic externalism, the a priori, and issues related to the normative aspects of meaning. Semantic and psychological, or content, externalism undermines the cherished Cartesian (and common-sense) view that each thinker is best positioned to know what he or she believes or means. If the meaning of our utterances and the content of our beliefs are determined by external social and natural causes, then we have no grounds for thinking that we are the masters of the content of our thoughts or of our meanings. Given the starting point of externalist theories of language and content such a conclusion, despite its counter-intuitiveness, seems inevitable. The consequences of this dilemma are currently being worked out by a number of younger philosophers of language.[35]

The dismissal of the analytic–synthetic distinction by Quine cast a heavy shadow on the topic of aprioriticity. In recent years there has been a revival of interest in the issues of analyticity and the a priori, particularly in relation to the question of normative aspects of meaning. Kripke's reworking of Wittgenstein's views on the rule-governed and public nature of language has also played a large part in the discussions of the normative elements involved in language and meaning.[36] Such views stand in opposition to Quine's purely naturalistic and starkly behaviourist account of language. In addition, Michael Dummett's approach of looking at the connections between meaning, justification and use is being pursued in an original fashion by the British philosopher Crispin Wright.[37]

Within the sphere of continental philosophy Hans-Georg Gadamer's hermeneutical approach to meaning and language and Jurgen Habermas's pragmatic 'speech act' theory are highly influential.[38] In France, the 'structuralists' and 'post-structuralists', who have made use of elements of structural linguistics set up by Ferdinand de Saussure, have been prominent. More recently, French post-modernist philosophers of language, such as Jacques Derrida, under the influence of Nietzsche and Heidegger, have developed a distinctive approach to texts which

questions the legitimacy of the traditional concerns with truth, meaning and reference. This approach, although highly influential in literary and cultural studies, has not yet had much impact on English-speaking philosophers of language.[39] One notable exception is Richard Rorty who, in a succession of books and articles, has exhorted philosophers to give up their ambitions to construct theories of language and meaning. He has identified many of the preoccupations of philosophy of language, from Frege onward, with the now defunct foundationalist tendencies and representationalist views of the mind. Rorty is dismissive of traditional philosophy which glorifies epistemology, truth, and metaphysics. Instead he advocates a deflationary account of philosophy where age-old philosophical disputes, such as the one between the semantic realists and anti-realists, are simply side-stepped. In a classic collection of articles on philosophy of language, *The Linguistic Turn*, which he edited in 1967, Rorty claimed that 'the problems of philosophy are problems of language.'[40] More recently he has announced that philosophers of language, such as the later Wittgenstein, Quine and Davidson, have brought about the death of philosophy as a subject matter with a distinctive method of its own. I believe Rorty in the 1990s is just as mistaken as Rorty in the 1960s was. The problems of philosophy are not problems of language, although a correct understanding of language can help us to ask better philosophical questions. Philosophy, including philosophy of language, is very much alive, and the contributions of critics such as Rorty ensure its continuing vitality. Fortunately for us, philosophy has retained its admirable habit of burying its undertakers.

Notes

1. *Cratylus*, 435 D, in Plato, 1961.
2. See the introduction to chapter 15 for a discussion of Chomsky's views and the references therein.
3. T. Hobbes, 1962, p. 23.
4. J. Locke, 1975, II, 11, 9.
5. See R. Rorty, 1967. Rorty attributes the term to Bergmann, p. 9.
6. See P. Hylton, 1990, for a detailed discussion of the origins of analytic philosophy in Britain.
7. A notable exception was G. E. Moore whose work influenced the 'ordinary language' approach to philosophy.
8. B. Russell, 1928, pp. 69–70. For bibliographical information, see the introduction to chapter 2.
9. See Dagfin Follesdal, 'Analytic Philosophy: what is it and why should one engage in it?', in H. Glock, 1997, pp. 1–16, especially p. 3.
10. The philosophers of the Vienna Circle, at least initially, were also concerned

with syntactical questions and mistrusted semantical concerns because of their perceived metaphysical implications. The work of Alfred Tarski on the semantic conception of truth (chapter 3) convinced Carnap (chapter 4), the most influential logical positivist, that semantical issues can have a legitimate role in philosophy.

11. T. Burge, 1992, p. 4.

12. Ibid., p. 11.

13. G. Frege, 'Letter to Husserl', dated 30 Oct.–1 Nov. 1906, in his *Philosophical and Mathematical Correspondence*, pp. 67 f. in H. Glock, 1997, p. 53.

14. Ibid.

15. B. Russell, 1921, p. 182. See note 8.

16. For bibliographical information on Wittgenstein, see the introduction to chapter 5.

17. J. L. Austin's discussion of the problem of other minds is a prime example of the attempt to untangle a traditional philosophical problem by applying insights gained from studying ordinary linguistic expressions and usage. J. L. Austin, 'Other Minds' in Austin, 1961.

18. L. Wittgenstein, 1953 and 1958, I, §109. For bibliographical information on Wittgenstein's works, see the introduction to chapter 5.

19. Ryle's best-known work is *The Concept of Mind* (London: Penguin, 1978), but also see G. Ryle, 1979.

20. See, for instance, G. E. Moore, 1993.

21. See T. Burge, 1992, p. 12, for a similar point.

22. P. M. S. Hacker, 'The Rise of Twentieth-Century Analytic Philosophy', p. 60, in H. Glock, 1997.

23. R. Rorty, 1980.

24. According to Tyler Burge's analysis, philosophy of language came of age in the 1960s and 1970s out of four primary sources: (a) appreciation of Frege's role; (b) combination of the strong points of ordinary language philosophy with that of 'logical constructionism'; (c) the perceived need to reinterpret the failure of the positivist's verificationist principle; and (d) the revival of interest in the question of reference. See T. Burge, 1992, p. 15.

25. Paul and Patricia Churchland's 'eliminative materialism' denies that there is any space for philosophy in a scientific discourse (see P. M. Churchland, 1988). Rorty, in a somewhat different way, also preaches the end of philosophy (see R. Rorty, 1980). All these philosophers acknowledge the direct influence of Quine's work.

26. D. K. Lewis, 1983 and 1986.

27. See *Theactetus*, in Plato, 1961.

28. See, for instance, William of Ockham, *Summa Logicae, Opera Philosophica*, I, p. 8.

29. J. S. Mill, 1961.

30. P. Strawson, 1950.

31. Kripke, and to a lesser extent Putnam, have at times failed to distinguish

between Frege's and Russell's theories of reference, evidenced by the opening sentence of 'The Meaning of "Meaning" ', chapter 12.

32. T. Burge, 1992, p. 25.
33. See, for instance, D. Davidson, and G. Harman, (eds), 1969.
34. J. Fodor, 1975.
35. A forthcoming collection of articles on the question of self-knowledge, edited by Crispin Wright et al. (Oxford University Press), contains the best sample of the recent thinking on these issues.
36. P. Boghossian, 1989, and also in B. Hale, and C. Wright, 1997; C. Peacocke, 1992.
37. C. Wright, 1987 and 1992.
38. For a detailed discussion of Habermas's pragmatics and its links with the views of various English-speaking philosophers of language, see M. Cooke, 1994.
39. A rare instance of a 'dialogue' between an analytic and a deconstructionist philosopher of language is the Derrida/Searle debate on Austin. The articles (Searle, Derrida, 1977), however, leave the impression that the two sides were talking past each other and that the 'debate' never took place.
40. See R. Rorty, 1992 (a revised edition of 1967), p. 371, for a critique of his earlier views of language.

References

Austin, J. L., *Philosophical Papers*. Oxford: Clarendon Press, 1961

Boghossian, P., 'The Rule Following Considerations', *Mind*, 83 (1989), pp. 507–49.

Boghossian, P., 'Analyticity', in Hale, B. and Wright, C. (eds), *A Companion to the Philosophy of Language*, pp. 331–68. Oxford: Blackwell, 1997.

Burge, Tyler, 'The Philosophy of Language and Mind: 1950–1990', *Philosophical Review*, 101, 1992, pp. 3–47.

Churchland, P. M., *Matter and Consciousness*. Cambridge, MA: MIT Press, 1988.

Cooke, Maeve, *Language and Reason: A Study of Habermas's Pragmatics*, Cambridge, MA: MIT Press, 1994.

Davidson, Donald, *Inquiries into Truth and Interpretation*. Oxford: Clarendon Press, 1984.

Davidson, Donald and Harman, Gilbert (eds), *Semantics of Natural Language* Dordrecht: Reidel, 1969.

Derrida, Jacques, 'Signature Event Context', *Glyph*, I. Baltimore: John Hopkins University Press, 1977.

Derrida, Jacques, 'Limited Inc. abc', *Glyph*, 2. Baltimore: John Hopkins University Press, 1977.

Dummett, Michael, *Origins of Analytical Philosophy*. London: Duckworth, 1993.

Fodor, Jerry, *The Language of Thought*. New York: Thomas Y. Crowell, 1975.

Gadamer, Hans-Georg, *Truth and Method*. London: Crossroads, 1985.

Glock, H.-J. (ed.), *The Rise of Analytic Philosophy*. Oxford: Blackwell, 1997.

Hale, B. and Wright, C. (eds), *A Companion to the Philosophy of Language*. Oxford: Blackwells, 1997.

Hobbes, Thomas, *Leviathan*, ed. K. Minogue. London: Everyman, 1994.

Hylton, Peter, *Russell, Idealism and the Emergence of Analytic Philosophy*. Oxford: Clarendon Press, 1990.

Lewis, David K., *Philosophical Papers* (2 vols). Oxford: Oxford University Press, 1983.

Lewis, David K., *On the Plurality of Worlds*. Oxford: Blackwell, 1986.

Locke, John, *An Essay Concerning Human Understanding*, ed. Goldie Merle. London: Everyman, 1993.

John Stuart Mill, *A System of Logic* (1867). London: Longman, 1961 (8th edn).

Moore, G. E., *Selected Writings*. London: Routledge, 1993.

Peacocke, Christopher, *A Study of Concepts*. Cambridge, MA: MIT Press, 1992.

Plato, *Collected Dialogues*, ed. E. Hamilton and H. Cairns. Princeton, NJ: Princeton University Press, 1961.

Rorty, Richard (ed.), *The Linguistic Turn: Recent Essays in Philosophical Method*. Chicago: Chicago University Press, 1967 and 1992.

Rorty, Richard, *Philosophy and the Mirror of Nature*. Oxford: Blackwell, 1980.

Ryle, Gilbert, *On Thinking*, ed. K. Kolenda. Oxford: Blackwell, 1979.

Searle, John R., 'Reiterating the Differences', *Glyph*, 2. Baltimore: John Hopkins University Press, 1977.

Strawson, Peter F., 'On Referring', *Mind*, 59 (1950), pp. 320–44.

Wright, Crispin, *Realism, Meaning and Truth*. Oxford: Oxford University Press, 1993 (2nd edn).

Wright, Crispin, *Truth and Objectivity*. Cambridge, MA: Harvard University Press, 1992.

Further Reading

The following introductory books give an overview of philosophy of language.

Ayer, A. J., *Philosophy in the Twentieth Century*. London: Unwin Paperbacks, 1982.

Blackburn, Simon, *Spreading the Word: Groundings in the Philosophy of Language*. Oxford: Clarendon Press, 1984.

Devitt, Michael and Sterelny, Kim, *Language and Reality*. Oxford: Blackwell, 1987.

Hacking, Ian, *Why Does Language Matter to Philosophy?* Cambridge: Cambridge University Press, 1975.

Passmore, John, *Recent Philosophers*. London: Duckworth, 1985.

Platts, Mark, *Ways of Meaning: An Introduction to a Philosophy of Language*. London: Routledge, 1979.

MODERN PHILOSOPHY
OF LANGUAGE

I

GOTTLOB FREGE
(1848–1925)

The German philosopher Gottlob Frege was born in Wismar in Pomerania. He completed his doctorate at the University of Göttingen and subsequently spent his entire teaching career at the University of Jena, where he had also been a student. Frege's output in philosophy and logic went largely unnoticed in his lifetime; Bertrand Russell and Ludwig Wittgenstein were among the few to realize the significance of his contribution to these fields. However, in the past few decades Frege's reputation, both as a founder of the analytic movement in philosophy and as one of the greatest logicians of all time, has been secured.

Frege's interest in philosophy and logic was derived from his concern with questions about the foundations of mathematics. He advocated the thesis known as logicism – the view that arithmetic could be formalized in terms of, and hence reduced to, the laws of logic which would then provide it with secure and self-evident foundations. His interest in philosophical issues relating to mathematics also led to the investigation of more general questions about meaning and language. Michael Dummett believes that Frege has revolutionized philosophy by identifying philosophy of language as fundamental to philosophy as a whole (see Dummett, *Frege: Philosophy of Mathematics*, 1991, and *Origins of Analytical Philosophy*, 1993).

Although Frege is seen by many as the first major philosopher of language, he. had no interest in language in its particularity; rather, he was of the view that we are not capable of having or entertaining abstract thoughts without the medium of language. Conceptual thinking is possible only through a medium of signs. In order to examine thought, philosophers have to analyse and understand language. One of Frege's philosophical aspirations was to construct a perfect or ideal language, by means of his logical notation, which would be capable of expressing thoughts in an accurate and exact manner.

The main driving force behind Frege's philosophical outlook was his

anti-psychologism and the view that the psychological should be sharply separated from the logical. The psychological concerns the subjective or private aspects of human thought. The logical is objective, it is independent of individual human thinking and is exactly the same for all rational beings. Logic deals with questions of truth and falsity. Truth and falsehood are independent of human mental processes. Psychology on the other hand deals with individual mental processes, or the inner, subjective states of mind, which Frege thinks cannot be characterized as true or false. Hence psychology cannot be identified with logic.

The cornerstone of Frege's discussion of meaning is his famous distinction between the sense and the reference of a given significant expression (*Sinn* and *Bedeutung*). Frege introduced the distinction as a solution to puzzles about identity statements and empty names. The statement (a) 'The morning star is (identical with) the morning star' is uninformative, while the identity statement (b) 'The morning star is (identical with) the evening star' is informative. The terms 'morning star' and 'evening star' have the same reference, hence we cannot account for the differences between (a) and (b) by an appeal to the references of those names. The reference of a term is whatever the term stands for; consequently, to know the reference of a name is to know what that name stands for. For instance, if you know that the planet Venus is the reference of the term 'morning star' then you know that the term 'morning star' stands for Venus. But, as the above example shows, knowing the reference of a name is not sufficient to gain an understanding of the meaning of that name. Further puzzles arise in the case of sentences containing reports of propositional attitudes such as 'x believes that p', 'x hopes that p'. If Bob does not know that the evening star is the morning star, the sentence 'Bob believes that the morning star is Venus' will not retain its truth value and meaning if we substitute 'morning star' with its co-referential term 'evening star'. In other words, while 'Bob believes that the morning star is Venus' may be true, it does not follow that 'Bob believes that the evening star is Venus' is also true, even though the morning star is identical with the evening star.

In order to understand the meaning of a name, Frege argued, we need to grasp its sense. The sense of a name is the mode of presentation of its reference and it channels us into thinking of the reference in a certain way. However, the sense of a term should not be confused with the idea or the mental image associated with that term. Senses are mind-independent and intersubjectively accessible to all thinkers, while ideas are private and subjective. The sense of a name or a term also fixes the reference for us. Thus two names with the same sense will always have the same reference (they are called synonyms), but two names with the

same reference need not always have the same sense, as in the case of 'morning star' and 'evening star'.

Frege's theory of sense and reference, discussed in the following paper, set the agenda for philosophy of language in the twentieth century in so far as the 'the theoretical development and explication of the notions of reference and sense became fundamental problems for the philosophy of language' (Burge, 'Philosophy of Language and Mind', 1992, p. 16). The distinction has fathered all the major approaches to theories of meaning in this century, some as a continuation of Frege's approach and others in opposition to it. Alternatives to his theory will be explored in chapters 2, 10, 11, 12, 13 and 17.

Works by Frege

1950; 2nd rev. edn, 1986 *The Foundations of Arithmetic. A Logico-mathematical Enquiry into the Concept of Number*, trans. J. L. Austin. Oxford: Blackwell.

1952; 2nd rev. edn, 1960 *Translations from the Philosophical Writings*, ed. Peter Geach and Max Black, trans. Max Black. Oxford: Blackwell.

1979 *Posthumous Writings*, trans. P. Long and R. White. Oxford: Blackwell.

1984 *Collected Papers on Mathematics, Logic and Philosophy*, ed. Brian McGuinness. Oxford: Blackwell.

Works on Frege

Beaney, Michael, *Frege: Making Sense*. London: Duckworth, 1996.

Burge, Tyler, 'The Philosophy of Language and Mind: 1950–1990', *Philosophical Review*, 101 (1992), pp. 3–47.

Carl, Wolfgang, *Frege's Theory of Sense and Reference*. Cambridge: Cambridge University Press, 1994.

Dummett, Michael, *Frege: Philosophy of Language*. London: Duckworth, 1981 (2nd edn); Cambridge, MA: Harvard University Press, 1973.

Dummett, Michael, *The Interpretation of Frege's Philosophy*. London: Duckworth; Cambridge, MA: Harvard University Press, 1981.

Dummett, Michael, *Origins of Analytical Philosophy*. London: Duckworth, 1993; Cambridge, MA: Harvard University Press, 1994.

Kenny, Anthony, *Frege*. London: Penguin, 1995.

Salmon, Nathan, *Frege's Puzzle*. Cambridge, MA: MIT Press, 1986.

On Sense and Reference

Equality[1] gives rise to challenging questions which are not altogether easy to answer. Is it a relation? A relation between objects, or between names or signs of objects? In my *Begriffsschrift*[2] I assumed the latter. The reasons which seem to favour this are the following: $a = a$ and $a = b$ are obviously statements of differing cognitive value; $a = a$ holds a priori and, according to Kant, is to be labelled analytic, while statements of the form $a = b$ often contain very valuable extensions of our knowledge and cannot always be established a priori. The discovery that the rising sun is not new every morning, but always the same, was one of the most fertile astronomical discoveries. Even today the identification of a small planet or a comet is not always a matter of course. Now if we were to regard equality as a relation between that which the names 'a' and 'b' designate, it would seem that $a = b$ could not differ from $a = a$ (i.e., provided $a = b$ is true). A relation would thereby be expressed of a thing to itself, and indeed one in which each thing stands to itself but to no other thing. What is intended to be said by $a = b$ seems to be that the signs or names 'a' and 'b' designate the same thing, so that those signs themselves would be under discussion; a relation between them would be asserted. But this relation would hold between the names or signs only in so far as they named or designated something. It would be mediated by the connexion of each of the two signs with the same designated thing. But this is arbitrary. Nobody can be forbidden to use any arbitrarily producible event or object as a sign for something. In that case the sentence $a = b$ would no longer refer to the subject matter, but only to its mode of designation; we would express no proper knowledge by its means. But in many cases this is just what we want to do. If the sign 'a' is distinguished from the sign 'b' only as object (here, by means of its shape), not as sign (i.e. not by the manner in which it designates something), the cognitive value of $a = a$ becomes essentially equal to that of $a = b$, provided $a = b$ is true. A difference can arise only if the difference

between the signs corresponds to a difference in the mode of presentation of that which is designated. Let a, b, c be the lines connecting the vertices of a triangle with the midpoints of the opposite sides. The point of intersection of a and b is then the same as the point of intersection of b and c. So we have different designations for the same point, and these names ('point of intersection of a and b', 'point of intersection of b and c') likewise indicate the mode of presentation; and hence the statement contains actual knowledge.

It is natural, now, to think of there being connected with a sign (name, combination of words, letter), besides that to which the sign refers, which may be called the reference of the sign, also what I should like to call the *sense* of the sign, wherein the mode of presentation is contained. In our example, accordingly, the reference of the expressions 'the point of intersection of a and b' and 'the point of intersection of b and c' would be the same, but not their senses. The reference of 'evening star' would be the same as that of 'morning star', but not the sense.

It is clear from the context that by 'sign' and 'name' I have here understood any designation representing a proper name, which thus has as its reference a definite object (this word taken in the widest range), but not a concept or a relation, which shall be discussed further in another article.[3] The designation of a single object can also consist of several words or other signs. For brevity, let every such designation be called a proper name.

The sense of a proper name is grasped by everybody who is sufficiently familiar with the language or totality of designations to which it belongs;[4] but this serves to illuminate only a single aspect of the reference, supposing it to have one. Comprehensive knowledge of the reference would require us to be able to say immediately whether any given sense belongs to it. To such knowledge we never attain.

The regular connexion between a sign, its sense, and its reference is of such a kind that to the sign there corresponds a definite sense and to that in turn a definite reference, while to a given reference (an object) there does not belong only a single sign. The same sense has different expressions in different languages or even in the same language. To be sure, exceptions to this regular behaviour occur. To every expression belonging to a complete totality of signs, there should certainly correspond a definite sense; but natural languages often do not satisfy this condition, and one must be content if the same word has the same sense in the same context. It may perhaps be granted that every grammatically well-formed expression representing a proper name always has a sense. But this is not to say that to the sense there also corresponds a reference. The words 'the celestial body most distant from the Earth' have a sense,

but it is very doubtful if they also have a reference. The expression 'the least rapidly convergent series' has a sense; but it is known to have no reference, since for every given convergent series, another convergent, but less rapidly convergent, series can be found. In grasping a sense, one is not certainly assured of a reference.

If words are used in the ordinary way, what one intends to speak of is their reference. It can also happen, however, that one wishes to talk about the words themselves or their sense. This happens, for instance, when the words of another are quoted. One's own words then first designate words of the other speaker, and only the latter have their usual reference. We then have signs of signs. In writing, the words are in this case enclosed in quotation marks. Accordingly, a word standing between quotation marks must not be taken as having its ordinary reference.

In order to speak of the sense of an expression 'A' one may simply use the phrase 'the sense of the expression "A"'. In reported speech one talks about the sense, e.g., of another person's remarks. It is quite clear that in this way of speaking words do not have their customary reference but designate what is usually their sense. In order to have a short expression, we will say: In reported speech, words are used *indirectly* or have their *indirect* reference. We distinguish accordingly the *customary* from the *indirect* reference of a word; and its *customary* sense from its *indirect* sense. The indirect reference of a word is accordingly its customary sense. Such exceptions must always be borne in mind if the mode of connexion between sign, sense, and reference in particular cases is to be correctly understood.

The reference and sense of a sign are to be distinguished from the associated idea. If the reference of a sign is an object perceivable by the senses, my idea of it is an internal image,[5] arising from memories of sense impressions which I have had and acts, both internal and external, which I have performed. Such an idea is often saturated with feeling; the clarity of its separate parts varies and oscillates. The same sense is not always connected, even in the same man, with the same idea. The idea is subjective: one man's idea is not that of another. There result, as a matter of course, a variety of differences in the ideas associated with the same sense. A painter, a horseman, and a zoologist will probably connect different ideas with the name 'Bucephalus'. This constitutes an essential distinction between the idea and the sign's sense, which may be the common property of many and therefore is not a part of a mode of the individual mind. For one can hardly deny that mankind has a common store of thoughts which is transmitted from one generation to another.[6]

In the light of this, one need have no scruples in speaking simply of *the* sense, whereas in the case of an idea one must, strictly speaking, add

to whom it belongs and at what time. It might perhaps be said: Just as one man connects this idea, and another that idea, with the same word, so also one man can associate this sense and another that sense. But there still remains a difference in the mode of connexion. They are not prevented from grasping the same sense; but they cannot have the same idea. *Si duo idem faciunt, non est idem.* If two persons picture the same thing, each still has his own idea. It is indeed sometimes possible to establish differences in the ideas, or even in the sensations, of different men; but an exact comparison is not possible, because we cannot have both ideas together in the same consciousness.

The reference of a proper name is the object itself which we designate by its means; the idea, which we have in that case, is wholly subjective; in between lies the sense, which is indeed no longer subjective like the idea, but is yet not the object itself. The following analogy will perhaps clarify these relationships. Somebody observes the Moon through a telescope. I compare the Moon itself to the reference; it is the object of the observation, mediated by the real image projected by the object glass in the interior of the telescope, and by the retinal image of the observer. The former I compare to the sense, the latter is like the idea or experience. The optical image in the telescope is indeed one-sided and dependent upon the standpoint of observation; but it is still objective, inasmuch as it can be used by several observers. At any rate it could be arranged for several to use it simultaneously. But each one would have his own retinal image. On account of the diverse shapes of the observers' eyes, even a geometrical congruence could hardly be achieved, and an actual coincidence would be out of the question. This analogy might be developed still further, by assuming A's retinal image made visible to B; or A might also see his own retinal image in a mirror. In this way we might perhaps show how an idea can itself be taken as an object, but as such is not for the observer what it directly is for the person having the idea. But to pursue this would take us too far afield.

We can now recognize three levels of difference between words, expressions, or whole sentences. The difference may concern at most the ideas, or the sense but not the reference, or, finally, the reference as well. With respect to the first level, it is to be noted that, on account of the uncertain connexion of ideas with words, a difference may hold for one person, which another does not find. The difference between a translation and the original text should properly not overstep the first level. To the possible differences here belong also the colouring and shading which poetic eloquence seeks to give to the sense. Such colouring and shading are not objective, and must be evoked by each hearer or reader according to the hints of the poet or the speaker. Without some affinity in human

ideas art would certainly be impossible; but it can never be exactly determined how far the intentions of the poet are realized.

In what follows there will be no further discussion of ideas and experiences; they have been mentioned here only to ensure that the idea aroused in the hearer by a word shall not be confused with its sense or its reference.

To make short and exact expressions possible, let the following phraseology be established:

A proper name (word, sign, sign combination, expression) *expresses* its sense, *stands for* or *designates* its reference. By means of a sign we express its sense and designate its reference.

Idealists or sceptics will perhaps long since have objected: 'You talk, without further ado, of the Moon as an object; but how do you know that the name "the Moon" has any reference? How do you know that anything whatsoever has a reference?' I reply that when we say 'the Moon', we do not intend to speak of our idea of the Moon, nor are we satisfied with the sense alone, but we presuppose a reference. To assume that in the sentence 'The Moon is smaller than the Earth' the idea of the Moon is in question, would be flatly to misunderstand the sense. If this is what the speaker wanted, he would use the phrase 'my idea of the Moon'. Now we can of course be mistaken in the presupposition, and such mistakes have indeed occurred. But the question whether the presupposition is perhaps always mistaken need not be answered here; in order to justify mention of the reference of a sign it is enough, at first, to point out our intention in speaking or thinking. (We must then add the reservation: provided such reference exists.)

So far we have considered the sense and reference only of such expressions, words, or signs as we have called proper names. We now inquire concerning the sense and reference for an entire declarative sentence. Such a sentence contains a thought.[7] Is this thought, now, to be regarded as its sense or its reference? Let us assume for the time being that the sentence has reference. If we now replace one word of the sentence by another having the same reference, but a different sense, this can have no bearing upon the reference of the sentence. Yet we can see that in such a case the thought changes; since, e.g., the thought in the sentence 'The morning star is a body illuminated by the Sun' differs from that in the sentence 'The evening star is a body illuminated by the Sun'. Anybody who did not know that the evening star is the morning star might hold the one thought to be true, the other false. The thought, accordingly, cannot be the reference of the sentence, but must rather be considered as the sense. What is the position now with regard to the reference? Have we a right even to inquire about it? Is it possible that a

sentence as a whole has only a sense, but no reference? At any rate, one might expect that such sentences occur, just as there are parts of sentences having sense but no reference. And sentences which contain proper names without reference will be of this kind. The sentence 'Odysseus was set ashore at Ithaca while sound asleep' obviously has a sense. But since it is doubtful whether the name 'Odysseus', occurring therein, has reference, it is also doubtful whether the whole sentence has one. Yet it is certain, nevertheless, that anyone who seriously took the sentence to be true or false would ascribe to the name 'Odysseus' a reference, not merely a sense; for it is of the reference of the name that the predicate is affirmed or denied. Whoever does not admit the name has reference can neither apply nor withhold the predicate. But in that case it would be superfluous to advance to the reference of the name; one could be satisfied with the sense, if one wanted to go no further than the thought. If it were a question only of the sense of the sentence, the thought, it would be unnecessary to bother with the reference of a part of the sentence; only the sense, not the reference, of the part is relevant to the sense of the whole sentence. The thought remains the same whether 'Odysseus' has reference or not. The fact that we concern ourselves at all about the reference of a part of the sentence indicates that we generally recognize and expect a reference for the sentence itself. The thought loses value for us as soon as we recognize that the reference of one of its parts is missing. We are therefore justified in not being satisfied with the sense of a sentence, and in inquiring also as to its reference. But now why do we want every proper name to have not only a sense, but also a reference? Why is the thought not enough for us? Because, and to the extent that, we are concerned with its truth value. This is not always the case. In hearing an epic poem, for instance, apart from the euphony of the language we are interested only in the sense of the sentences and the images and feelings thereby aroused. The question of truth would cause us to abandon aesthetic delight for an attitude of scientific investigation. Hence it is a matter of no concern to us whether the name 'Odysseus', for instance, has reference, so long as we accept the poem as a work of art.[8] It is the striving for truth that drives us always to advance from the sense to the reference.

We have seen that the reference of a sentence may always be sought, whenever the reference of its components is involved; and that this is the case when and only when we are inquiring after the truth value.

We are therefore driven into accepting the *truth value* of a sentence as constituting its reference. By the truth value of a sentence I understand the circumstance that it is true or false. There are no further truth values. For brevity I call the one the True, the other the False. Every declarative

sentence concerned with the reference of its words is therefore to be regarded as a proper name, and its reference, if it has one, is either the True or the False. These two objects are recognized, if only implicitly, by everybody who judges something to be true – and so even by a sceptic. The designation of the truth values as objects may appear to be an arbitrary fancy or perhaps a mere play upon words, from which no profound consequences could be drawn. What I mean by an object can be more exactly discussed only in connexion with concept and relation. I will reserve this for another article.[9] But so much should already be clear, that in every judgement,[10] no matter how trivial, the step from the level of thoughts to the level of reference (the objective) has already been taken.

One might be tempted to regard the relation of the thought to the True not as that of sense to reference, but rather as that of subject to predicate. One can, indeed, say: 'The thought, that 5 is a prime number, is true.' But closer examination shows that nothing more has been said than in the simple sentence '5 is a prime number'. The truth claim arises in each case from the form of the declarative sentence, and when the latter lacks its usual force, e.g., in the mouth of an actor upon the stage, even the sentence 'The thought that 5 is a prime number is true' contains only a thought, and indeed the same thought as the simple '5 is a prime number'. It follows that the relation of the thought to the True may not be compared with that of subject to predicate. Subject and predicate (understood in the logical sense) are indeed elements of thought; they stand on the same level for knowledge. By combining subject and predicate, one reaches only a thought, never passes from sense to reference, never from a thought to its truth value. One moves at the same level but never advances from one level to the next. A truth value cannot be a part of a thought, any more than, say, the Sun can, for it is not a sense but an object.

If our supposition that the reference of a sentence is its truth value is correct, the latter must remain unchanged when a part of the sentence is replaced by an expression having the same reference. And this is in fact the case. Leibniz gives the definition: '*Eadem sunt, quae sibi mutuo substitui possunt, salva veritate.*' What else but the truth value could be found, that belongs quite generally to every sentence if the reference of its components is relevant, and remains unchanged by substitutions of the kind in question?

If now the truth value of a sentence is its reference, then on the one hand all true sentences have the same reference and so, on the other hand, do all false sentences. From this we see that in the reference of the sentence all that is specific is obliterated. We can never be concerned

only with the reference of a sentence; but again the mere thought alone yields no knowledge, but only the thought together with its reference, i.e., its truth value. Judgements can be regarded as advances from a thought to a truth value. Naturally this cannot be a definition. Judgement is something quite peculiar and incomparable. One might also say that judgements are distinctions of parts within truth values. Such distinction occurs by a return to the thought. To every sense belonging to a truth value there would correspond its own manner of analysis. However, I have here used the word 'part' in a special sense. I have in fact transferred the relation between the parts and the whole of the sentence to its reference, by calling the reference of a word part of the reference of the sentence, if the word itself is a part of the sentence. This way of speaking can certainly be attacked, because the whole reference and one part of it do not suffice to determine the remainder, and because the word 'part' is already used in another sense of bodies. A special term would need to be invented.

The supposition that the truth value of a sentence is its reference shall now be put to further test. We have found that the truth value of a sentence remains unchanged when an expression is replaced by another having the same reference: but we have not yet considered the case in which the expression to be replaced is itself a sentence. Now if our view is correct, the truth value of a sentence containing another as part must remain unchanged when the part is replaced by another sentence having the same truth value. Exceptions are to be expected when the whole sentence or its part is direct or indirect quotation; for in such cases, as we have seen, the words do not have their customary reference. In direct quotation, a sentence designates another sentence, and in indirect quotation a thought.

We are thus led to consider subordinate sentences or clauses. These occur as parts of a sentence complex, which is, from the logical standpoint, likewise a sentence – a main sentence. But here we meet the question whether it is also true of the subordinate sentence that its reference is a truth value. Of indirect quotation we already know the opposite. Grammarians view subordinate clauses as representatives of parts of sentences and divide them accordingly into noun clauses, adjective clauses, adverbial clauses. This might generate the supposition that the reference of a subordinate clause was not a truth value but rather of the same kind as the reference of a noun or adjective or adverb – in short, of a part of a sentence, whose sense was not a thought but only a part of a thought. Only a more thorough investigation can clarify the issue. In so doing, we shall not follow the grammatical categories strictly, but rather group together what is logically of the same kind. Let us first

search for cases in which the sense of the subordinate clause, as we have just supposed, is not an independent thought.

The case of an abstract[11] noun clause, introduced by 'that', includes the case of indirect quotation, in which we have seen the words to have their indirect reference coinciding with what is customarily their sense. In this case, then, the subordinate clause has for its reference a thought, not a truth value; as sense not a thought, but the sense of the words 'the thought, that ...', which is only a part of the thought in the entire complex sentence. This happens after 'say', 'hear', 'be of the opinion', 'be convinced', 'conclude', and similar words.[12] There is a different, and indeed somewhat complicated, situation after words like 'perceive', 'know', 'fancy', which are to be considered later.

That in the cases of the first kind the reference of the subordinate clause is in fact the thought can also be recognized by seeing that it is indifferent to the truth of the whole whether the subordinate clause is true or false. Let us compare, for instance, the two sentences 'Copernicus believed that the planetary orbits are circles' and 'Copernicus believed that the apparent motion of the Sun is produced by the real motion of the Earth'. One subordinate clause can be substituted for the other without harm to the truth. The main clause and the subordinate clause together have as their sense only a single thought, and the truth of the whole includes neither the truth nor the untruth of the subordinate clause. In such cases it is not permissible to replace one expression in the subordinate clause by another having the same customary reference, but only by one having the same indirect reference, i.e., the same customary sense. If somebody were to conclude: The reference of a sentence is not its truth value, for in that case it could always be replaced by another sentence of the same truth value; he would prove too much; one might just as well claim that the reference of 'morning star' is not Venus, since one may not always say 'Venus' in place of 'morning star'. One has the right to conclude only that the reference of a sentence is not *always* its truth value, and that 'morning star' does not always stand for the planet Venus, viz. when the word has its indirect reference. An exception of such a kind occurs in the subordinate clause just considered which has a thought as its reference.

If one says 'It seems that ...' one means 'It seems to me that ...' or 'I think that ...' We therefore have the same case again. The situation is similar in the case of expressions such as 'to be pleased', 'to regret', 'to approve', 'to blame', 'to hope', 'to fear'. If, toward the end of the battle of Waterloo,[13] Wellington was glad that the Prussians were coming, the basis for his joy was a conviction. Had he been deceived, he would have been no less pleased so long as his illusion lasted; and before he became

so convinced he could not have been pleased that the Prussians were coming – even though in fact they might have been already approaching.

Just as a conviction or a belief is the ground of a feeling, it can, as in inference, also be the ground of a conviction. In the sentence: 'Columbus inferred from the roundness of the Earth that he could reach India by travelling towards the west', we have as the reference of the parts two thoughts, that the Earth is round, and that Columbus by travelling to the west could reach India. All that is relevant here is that Columbus was convinced of both, and that the one conviction was a ground for the other. Whether the Earth is really round, and whether Columbus could really reach India by travelling to the west, are immaterial to the truth of our sentence; but it is not immaterial whether we replace 'the Earth' by 'the planet which is accompanied by a moon whose diameter is greater than the fourth part of its own'. Here also we have the indirect reference of the words.

Adverbial final clauses beginning 'in order that' also belong here; for obviously the purpose is a thought; therefore: indirect reference for the words, subjunctive mood.

A subordinate clause with 'that' after 'command', 'ask', 'forbid' would appear in direct speech as an imperative. Such a clause has no reference but only a sense. A command, a request, are indeed not thoughts, yet they stand on the same level as thoughts. Hence in subordinate clauses depending upon 'command', 'ask', etc., words have their indirect reference. The reference of such a clause is therefore not a truth value but a command, a request, and so forth.

The case is similar for the dependent question in phrases such as 'doubt whether', 'not to know what'. It is easy to see that here also the words are to be taken to have their indirect reference. Dependent clauses expressing questions and beginning with 'who', 'what', 'where', 'when', 'how', 'by what means', etc., seem at times to approximate very closely to adverbial clauses in which words have their customary references. These cases are distinguished linguistically [in German] by the mood of the verb. With the subjunctive, we have a dependent question and indirect reference of the words, so that a proper name cannot in general be replaced by another name of the same object.

In the cases so far considered the words of the subordinate clauses had their indirect reference, and this made it clear that the reference of the subordinate clause itself was indirect, i.e., not a truth value but a thought, a command, a request, a question. The subordinate clause could be regarded as a noun, indeed one could say: as a proper name of that thought, that command, etc., which it represented in the context of the sentence structure.

We now come to other subordinate clauses, in which the words do have their customary reference without however a thought occurring as sense and a truth value as reference. How this is possible is best made clear by examples.

Whoever discovered the elliptic form of the planetary orbits died in misery.

If the sense of the subordinate clause were here a thought, it would have to be possible to express it also in a separate sentence. But this does not work, because the grammatical subject 'whoever' has no independent sense and only mediates the relation with the consequent clause 'died in misery'. For this reason the sense of the subordinate clause is not a complete thought, and its reference is Kepler, not a truth value. One might object that the sense of the whole does contain a thought as part, viz., that there was somebody who first discovered the elliptic form of the planetary orbits; for whoever takes the whole to be true cannot deny this part. This is undoubtedly so; but only because otherwise the dependent clause 'whoever discovered the elliptic form of the planetary orbits' would have no reference. If anything is asserted there is always an obvious presupposition that the simple or compound proper names used have reference. If one therefore asserts 'Kepler died in misery', there is a presupposition that the name 'Kepler' designates something; but it does not follow that the sense of the sentence 'Kepler died in misery' contains the thought that the name 'Kepler' designates something. If this were the case the negation would have to run not

Kepler did not die in misery

but

Kepler did not die in misery, or the name 'Kepler' has no reference.

That the name 'Kepler' designates something is just as much a pre-supposition for the assertion

Kepler died in misery

as for the contrary assertion. Now languages have the fault of containing expressions which fail to designate an object (although their grammatical form seems to qualify them for that purpose) because the truth of some sentences is a prerequisite. Thus it depends on the truth of the sentence:

There was someone who discovered the elliptic form of the planetary orbits

whether the subordinate clause

Whoever discovered the elliptic form of the planetary orbits

really designates an object or only seems to do so while having in fact no reference. And thus it may appear as if our subordinate clause contained as a part of its sense the thought that there was somebody who discovered the elliptic form of the planetary orbits. If this were right the negation would run:

> Either whoever discovered the elliptic form of the planetary orbits did not die in misery or there was nobody who discovered the elliptic form of the planetary orbits.

This arises from an imperfection of language, from which even the symbolic language of mathematical analysis is not altogether free; even there combinations of symbols can occur that seem to stand for something but have (at least so far) no reference, e.g. divergent infinite series. This can be avoided, e.g., by means of the special stipulation that divergent infinite series shall stand for the number o. A logically perfect language (*Begriffsschrift*) should satisfy the conditions, that every expression grammatically well constructed as a proper name out of signs already introduced shall in fact designate an object, and that no new sign shall be introduced as a proper name without being secured a reference. The logic books contain warnings against logical mistakes arising from the ambiguity of expressions. I regard as no less pertinent a warning against apparent proper names having no reference. The history of mathematics supplies errors which have arisen in this way. This lends itself to demagogic abuse as easily as ambiguity – perhaps more easily. 'The will of the people' can serve as an example; for it is easy to establish that there is at any rate no generally accepted reference for this expression. It is therefore by no means unimportant to eliminate the source of these mistakes, at least in science, once and for all. Then such objections as the one discussed above would become impossible, because it could never depend upon the truth of a thought whether a proper name had a reference.

With the consideration of these noun clauses may be coupled that of types of adjective and adverbial clauses which are logically in close relation to them.

Adjective clauses also serve to construct compound proper names though, unlike noun clauses, they are not sufficient by themselves for this purpose. These adjective clauses are to be regarded as equivalent to adjectives. Instead of 'the square root of 4 which is smaller than o', one can also say 'the negative square root of 4'. We have here the case of a compound proper name constructed from the expression for a concept with the help of the singular definite article. This is at any rate permissible if the concept applies to one and only one single object.[14]

Expressions for concepts can be so constructed that marks of a concept are given by adjective clauses as, in our example, by the clause 'which is smaller than 0'. It is evident that such an adjective clause cannot have a thought as sense or a truth value as reference, any more than the noun clause could. Its sense, which can also be expressed in many cases by a single adjective, is only a part of a thought. Here, as in the case of the noun clause, there is no independent subject and therefore no possibility of reproducing the sense of the subordinate clause in an independent sentence.

Places, instants, stretches of time, are, logically considered, objects; hence the linguistic designation of a definite place, a definite instant, or a stretch of time is to be regarded as a proper name. Now adverbial clauses of place and time can be used for the construction of such a proper name in a manner similar to that which we have seen in the case of noun and adjective clauses. In the same way, expressions for concepts bringing in places, etc., can be constructed. It is to be noted here also that the sense of these subordinate clauses cannot be reproduced in an independent sentence, since an essential component, viz. the determination of place or time, is missing and is only indicated by a relative pronoun or a conjunction.[15]

In conditional clauses, also, there may usually be recognized to occur an indefinite indicator, having a similar correlate in the dependent clause. (We have already seen this occur in noun, adjective, and adverbial clauses.) In so far as each indicator refers to the other, both clauses together form a connected whole, which as a rule expresses only a single thought. In the sentence

> If a number is less than 1 and greater than 0, its square is less than 1 and greater than 0

the component in question is 'a number' in the conditional clause and 'its' in the dependent clause. It is by means of this very indefiniteness that the sense acquires the generality expected of a law. It is this which is responsible for the fact that the antecedent clause alone has no complete thought as its sense and in combination with the consequent clause expresses one and only one thought, whose parts are no longer thoughts. It is, in general, incorrect to say that in the hypothetical judgement two judgements are put in reciprocal relationship. If this or something similar is said, the word 'judgement' is used in the same sense as I have connected with the word 'thought', so that I would use the formulation: 'A hypothetical thought establishes a reciprocal relationship between two thoughts.' This could be true only if an indefinite indicator is absent;[16] but in such a case there would also be no generality.

If an instant of time is to be indefinitely indicated in both conditional and dependent clauses, this is often achieved merely by using the present tense of the verb, which in such a case however does not indicate the temporal present. This grammatical form is then the indefinite indicator in the main and subordinate clauses. An example of this is: 'When the Sun is in the tropic of Cancer, the longest day in the northern hemisphere occurs.' Here, also, it is impossible to express the sense of the subordinate clause in a full sentence, because this sense is not a complete thought. If we say: 'The Sun is in the tropic of Cancer', this would refer to our present time and thereby change the sense. Just as little is the sense of the main clause a thought; only the whole, composed of main and subordinate clauses, has such a sense. It may be added that several common components in the antecedent and consequent clauses may be indefinitely indicated.

It is clear that noun clauses with 'who' or 'what' and adverbial clauses with 'where', 'when', 'wherever', 'whenever' are often to be interpreted as having the sense of conditional clauses, e.g., 'who touches pitch, defiles himself'.

Adjective clauses can also take the place of conditional clauses. Thus the sense of the sentence previously used can be given in the form 'The square of a number which is less than 1 and greater than 0 is less than 1 and greater than 0.'

The situation is quite different if the common component of the two clauses is designated by a proper name. In the sentence:

Napoleon, who recognized the danger to his right flank, himself led his guards against the enemy position

two thoughts are expressed:

(1) Napoleon recognized the danger to his right flank;
(2) Napoleon himself led his guards against the enemy position.

When and where this happened is to be fixed only by the context, but is nevertheless to be taken as definitely determined thereby. If the entire sentence is uttered as an assertion, we thereby simultaneously assert both component sentences. If one of the parts is false, the whole is false. Here we have the case that the subordinate clause by itself has a complete thought as sense (if we complete it by indication of place and time). The reference of the subordinate clause is accordingly a truth value. We can therefore expect that it may be replaced, without harm to the truth value of the whole, by a sentence having the same truth value. This is indeed the case; but it is to be noticed that for purely grammatical reasons, its subject must be 'Napoleon', for only then can it be brought into the

form of an adjective clause belonging to 'Napoleon'. But if the demand that it be expressed in this form be waived, and the connexion be shown by 'and', this restriction disappears.

Subsidiary clauses beginning with 'although' also express complete thoughts. This conjunction actually has no sense and does not change the sense of the clause but only illuminates it in a peculiar fashion.[17] We could indeed replace the conditional clause without harm to the truth of the whole by another of the same truth value; but the light in which the clause is placed by the conjunction might then easily appear unsuitable, as if a song with a sad subject were to be sung in a lively fashion.

In the last cases the truth of the whole included the truth of the component clauses. The case is different if a conditional clause expresses a complete thought by containing, in place of an indefinite indicator, a proper name or something which is to be regarded as equivalent. In the sentence

If the Sun has already risen, the sky is very cloudy

the time is the present, that is to say, definite. And the place is also to be thought of as definite. Here it can be said that a relation between the truth values of conditional and dependent clauses has been asserted, viz. such that the case does not occur in which the antecedent stands for the True and the Consequent for the False. Accordingly, our sentence is true if the Sun has not yet risen, whether the sky is very cloudy or not, and also if the Sun has risen and the sky is very cloudy. Since only truth values are here in question, each component clause can be replaced by another of the same truth value without changing the truth value of the whole. To be sure, the light in which the subject then appears would usually be unsuitable; the thought might easily seem distorted; but this has nothing to do with its truth value. One must always take care not to clash with the subsidiary thoughts, which are however not explicitly expressed and therefore should not be reckoned in the sense. Hence, also, no account need be taken of their truth values.[18]

The simple cases have now been discussed. Let us review what we have learned.

The subordinate clause usually has for its sense not a thought, but only a part of one, and consequently no truth value as reference. The reason for this is either that the words in the subordinate clause have indirect reference, so that the reference, not the sense, of the subordinate clause is a thought; or else that, on account of the presence of an indefinite indicator, the subordinate clause is incomplete and expresses a thought only when combined with the main clause. It may happen, however, that the sense of the subsidiary clause is a complete thought, in which case it

can be replaced by another of the same truth value without harm to the truth of the whole – provided there are no grammatical obstacles.

An examination of all the subordinate clauses which one may encounter will soon provide some which do not fit well into these categories. The reason, so far as I can see, is that these subordinate clauses have no such simple sense. Almost always, it seems, we connect with the main thoughts expressed by us subsidiary thoughts which, although not expressed, are associated with our words, in accordance with psychological laws, by the hearer. And since the subsidiary thought appears to be connected with our words of its own accord, almost like the main thought itself, we want it also to be expressed. The sense of the sentence is thereby enriched, and it may well happen that we have more simple thoughts than clauses. In many cases the sentence must be understood in this way, in others it may be doubtful whether the subsidiary thought belongs to the sense of the sentence or only accompanies it.[19] One might perhaps find that the sentence

Napoleon, who recognized the danger to his right flank, himself led his guards against the enemy position

expresses not only the two thoughts shown above, but also the thought that the knowledge of the danger was the reason why he led the guards against the enemy position. One may in fact doubt whether this thought is merely slightly suggested or really expressed. Let the question be considered whether our sentence be false if Napoleon's decision had already been made before he recognized the danger. If our sentence could be true in spite of this, the subsidiary thought should not be understood as part of the sense. One would probably decide in favour of this. The alternative would make for a quite complicated situation: We would have more simple thoughts than clauses. If the sentence

Napoleon recognized the danger to his right flank

were now to be replaced by another having the same truth value, e.g.,

Napoleon was already more than 45 years old

not only would our first thought be changed, but also our third one. Hence the truth value of the latter might change – viz. if his age was not the reason for the decision to lead the guards against the enemy. This shows why clauses of equal truth value cannot always be substituted for one another in such cases. The clause expresses more through its connexion with another than it does in isolation.

Let us now consider cases where this regularly happens. In the sentence:

Bebel mistakenly supposes that the return of Alsace-Lorraine would appease France's desire for revenge

two thoughts are expressed, which are not however shown by means of antecedent and consequent clauses, viz.:

(1) Bebel believes that the return of Alsace-Lorraine would appease France's desire for revenge;
(2) The return of Alsace-Lorraine would not appease France's desire for revenge.

In the expression of the first thought, the words of the subordinate clause have their indirect reference, while the same words have their customary reference in the expression of the second thought. This shows that the subordinate clause in our original complex sentence is to be taken twice over, with different reference, standing once for a thought, once for a truth value. Since the truth value is not the whole reference of the subordinate clause, we cannot simply replace the latter by another of equal truth value. Similar considerations apply to expressions such as 'know', 'discover', 'it is known that'.

By means of a subordinate causal clause and the associated main clause we express several thoughts, which however do not correspond separately to the original clauses. In the sentence: 'Because ice is less dense than water, it floats on water' we have

(1) Ice is less dense than water;
(2) If anything is less dense than water, it floats on water;
(3) Ice floats on water.

The third thought, however, need not be explicitly introduced, since it is contained in the remaining two. On the other hand, neither the first and third nor the second and third combined would furnish the sense of our sentence. It can now be seen that our subordinate clause

because ice is less dense than water

expresses our first thought, as well as a part of our second. This is how it comes to pass that our subsidiary clause cannot be simply replaced by another of equal truth value; for this would alter our second thought and thereby might well alter its truth value.

The situation is similar in the sentence

If iron were less dense than water, it would float on water.

Here we have the two thoughts that iron is not less dense than water, and that something floats on water if it is less dense than water. The subsidiary clause again expresses one thought and a part of the other.

If we interpret the sentence already considered

After Schleswig-Holstein was separated from Denmark, Prussia and Austria quarrelled

in such a way that it expresses the thought that Schleswig-Holstein was once separated from Denmark, we have first this thought, and secondly the thought that at a time, more closely determined by the subordinate clause, Prussia and Austria quarrelled. Here also the subordinate clause expresses not only one thought but also a part of another. Therefore it may not in general be replaced by another of the same truth value.

It is hard to exhaust all the possibilities given by language; but I hope to have brought to light at least the essential reasons why a subordinate clause may not always be replaced by another of equal truth value without harm to the truth of the whole sentence structure. These reasons arise:

(1) when the subordinate clause does not stand for a truth value, inasmuch as it expresses only a part of a thought;
(2) when the subordinate clause does stand for a truth value but is not restricted to so doing, inasmuch as its sense includes one thought and part of another

The first case arises:

(a) in indirect reference of words
(b) if a part of the sentence is only an indefinite indicator instead of a proper name.

In the second case, the subsidiary clause may have to be taken twice over, viz., once in its customary reference, and the other time in indirect reference; or the sense of a part of the subordinate clause may likewise be a component of another thought, which, taken together with the thought directly expressed by the subordinate clause, makes up the sense of the whole sentence.

It follows with sufficient probability from the foregoing that the cases where a subordinate clause is not replaceable by another of the same value cannot be brought in disproof of our view that a truth value is the reference of a sentence having a thought as its sense.

Let us return to our starting point.

When we found '$a = a$' and '$a = b$' to have different cognitive values, the explanation is that for the purpose of knowledge, the sense of the sentence, viz., the thought expressed by it, is no less relevant than its reference, i.e. its truth value. If now $a = b$, then indeed the reference of 'b' is the same as that of 'a', and hence the truth value of '$a = b$' is the

same as that of '$a = a$'. In spite of this, the sense of 'b' may differ from that of 'a', and thereby the sense expressed in '$a = b$' differs from that of '$a = a$'. In that case the two sentences do not have the same cognitive value. If we understand by 'judgement' the advance from the thought to its truth value, as in the above paper, we can also say that the judgements are different.

Notes and References

1. I use this word strictly and understand '$a = b$' to have the sense of 'a is the same as b' or 'a and b coincide'.

2. Translator's note: The reference is to Frege's *Begriffsschrift*, ein der arithmetischen nachgebildete Formelsprache des reinen Denkens (Halle, 1879).

3. Translator's note: See Frege's 'Ueber Begriff und Gegenstand', *Vierteljahrsschrift für wissenschaftliche Philosophie*, 16 (1892), pp. 192–205.

4. In the case of an actual proper name such as 'Aristotle' opinions as to the sense may differ. It might, for instance, be taken to be the following: the pupil of Plato and teacher of Alexander the Great. Anybody who does this will attach another sense to the sentence 'Aristotle was born in Stagira' than will a man who takes as the sense of the name: the teacher of Alexander the Great who was born in Stagira. So long as the reference remains the same, such variations of sense may be tolerated, although they are to be avoided in the theoretical structure of a demonstrative science and ought not to occur in a perfect language.

5. We can include with ideas the direct experiences in which sense-impressions and acts themselves take the place of the traces which they have left in the mind. The distinction is unimportant for our purpose, especially since memories of sense-impressions and acts always help to complete the perceptual image. One can also understand direct experience as including any object, in so far as it is sensibly perceptible or spatial.

6. Hence it is inadvisable to use the word 'idea' to designate something so basically different.

7. By a thought I understand not the subjective performance of thinking but its objective content, which is capable of being the common property of several thinkers.

8. It would be desirable to have a special term for signs having only sense. If we name them, say, representations, the words of the actors on the stage would be representations; indeed the actor himself would be a representation.

9. Translator's note: See his 'Ueber Begriff und Gegenstand', *Vierteljahrsschrift für wissenschaftliche Philosophie*, 16 (1892), pp. 192–205.

10. A judgement, for me, is not the mere comprehension of a thought, but the admission of its truth.

11. Translator's note: A literal translation of Frege's 'abstracten Nennsätzen' whose meaning eludes me.

12. In 'A lied in saying he had seen B', the subordinate clause designates a thought which is said (1) to have been asserted by A (2) while A was convinced of its falsity.

13. Translator's note: Frege uses the Prussian name for the battle – 'Belle Alliance'.

14. In accordance with what was said above an expression of the kind in question must actually always be assured of reference, by means of a special stipulation, e.g. by the convention that o shall count as its reference, when the concept applies to no object or to more than one.

15. In the case of these sentences, various interpretations are easily possible. The sense of the sentence: 'After Schleswig-Holstein was separated from Denmark, Prussia and Austria quarrelled' can also be rendered in the form 'After the separation of Schleswig-Holstein from Denmark, Prussia and Austria quarrelled'. In this version, it is surely sufficiently clear that the sense is not to be taken as having as a part the thought that Schleswig-Holstein was once separated from Denmark, but that this is the necessary presupposition in order for the expression 'after the separation of Schleswig-Holstein from Denmark' to have any reference at all. To be sure, our sentence can also be interpreted as saying that Schleswig-Holstein was once separated from Denmark. We then have a case which is to be considered later. In order to understand the difference more clearly, let us project ourselves into the mind of a Chinese who, having little knowledge of European history, believes it to be false that Schleswig-Holstein was ever separated from Denmark. He will take our sentence, in the first version, to be neither true nor false but will deny it to have any reference, on the ground of absence of reference for its subordinate clause. This clause would only apparently determine a time. If he interpreted our sentence in the second way, however, he would find a thought expressed in it which he would take to be false, beside a part which would be without reference for him.

16. At times an explicit linguistic indication is missing and must be read off from the entire context.

17. Similarly in the case of 'but', 'yet'.

18. The thought of our sentence might also be expressed thus: 'Either the Sun has not risen yet or the sky is very cloudy' – which shows how this kind of sentence connexion is to be understood.

19. This may be important for the question whether an assertion is a lie, or an oath a perjury.

2

BERTRAND RUSSELL
(1872–1970)

Bertrand Arthur William Russell, philosopher, social commentator and essayist, was born into a distinguished British aristocratic family. Along with G. E. Moore, Frege, and Wittgenstein, Russell is one of the founders of analytic philosophy and, like Frege, he is also one of the most important logicians of all time. His philosophical interests ranged over the areas of logic, philosophy of mathematics, epistemology and metaphysics. In addition, throughout his long life Russell remained a tireless social and political commentator and campaigner whose pacifism and progressive political positions earned him prison sentences in 1918 and 1961 and deprived him of a steady academic job in both Britain and America.

Russell's main philosophical concerns can be summarized as:

(1) The denial of idealism and the attempt to replace it with a realist metaphysics.

(2) A preoccupation with the challenge of scepticism and the search for secure foundations for knowledge. This included his defence of logicism – and his monumental attempt, together with Alfred North Whitehead, to establish the foundations of mathematics by reducing it to logic.

(3) The employment of formal logic as a tool for analysing philosophical problems. This was an aspect of his rigorous and scientific approach to philosophy which became a hallmark of analytic philosophy.

Russell's concern with questions of logic and mathematics was inseparable from his interest in metaphysics. These, in turn, gave rise to a preoccupation with problems of meaning and language. However, it should be noted that Russell never saw himself as a philosopher of language and deplored what he saw as the inordinate attention paid to ordinary language in twentieth-century philosophy.

Russell's most famous example of the analytic method is his discussion of denoting phrases, such as descriptions and proper names. Starting with his landmark article 'On Denoting' in 1905, Russell set up his theory of descriptions, his aim being to solve a number of philosophical

difficulties by uncovering the correct logical form of various types of sentences. According to the law of excluded middle, given a sentence or proposition such as 'the present king of France is bald', either it or its negation must be true. But each of these options seems to commit us to the existence of a present king of France, which is obviously an undesirable conclusion. Russell's analysis of the logical form of such sentences helps us to avoid this ontological commitment. Second, the theory of descriptions attempts to solve the type of difficulties about identity statements that also preoccupied Frege (see chapter 1 and Introduction) without resorting to abstract entities such as senses. The third problem concerns negative existential statements such as 'The golden mountain does not exist': a correct understanding of the underlying logical form of such a sentence should enable us to make a true negative judgement without committing us to the existence, or subsistence, of entities whose existence we are denying. The theory of descriptions enables us to maintain that the sentence 'The golden mountain does not exist' is both meaningful and false without committing us to the existence of golden mountains. Russell demonstrates these points through the analysis of the following logical puzzle.

Take the sentence:

(a) The present king of France is bald.

This is a grammatical, assertoric sentence which, on the face of it, has to be either true or false. But which one is it? According to Russell, the correct analysis of (a) will give us the following reading:

(1) There is at least one king of France.
(2) There is at most one king of France.
(3) That thing (king of France) is bald.

According to this analysis, then, the correct answer to the above question is that (a) is false because condition (1) fails.

The theory of descriptions, Russell argued, shows that the apparent grammatical form of a sentence can mislead us about the hidden logical form of the proposition the sentence expresses. In order to demonstrate this he distinguishes, firstly, between logically proper names, or names for short, and descriptions and, secondly, between definite and indefinite descriptions. Definite descriptions have the form 'the so and so', while indefinite descriptions have the form 'a so and so'. To know the meaning of a name is to know to whom or what it is applied. Names, in order to be meaningful, have to have bearers. Descriptions, however, do not need to have bearers. You can understand a description even if you do not know its reference, but you cannot understand the meaning of a name if

you do not know whether it has a reference or not. According to Russell, ordinary names are abbreviated definite descriptions and hence the meaning of a name is the description associated with it. Genuine names, on the other hand, have a reference only and are not associated with a set of descriptions; possible examples of such genuine names are 'this', 'I' and 'now'. Thus, while for Frege all names have both sense and reference, Russell allows for a class of names (genuine names) which have a reference only and which can be grasped by us in an unmediated way. The theory of descriptions acts as a theory of reference since, according to Russell, a definite description denotes something if, and only if, it applies to that particular thing and to nothing else. For instance, we understand what is meant by the proper name 'Ludwig Wittgenstein' in so far as we know that the name is associated with the definite description 'the author of the *Tractatus Logico-Philosophicus*'. And we know that the name 'Ludwig Wittgenstein' does refer, if we know that there exists, or existed, a unique person that satisfies that description.

The most accessible statement of some of the key elements of the 'theory of descriptions' can be found in Russell's lectures on *The Philosophy of Logical Atomism*, an extract of which is reproduced here.

Works by Russell

1903 *The Principles of Mathematics*. Cambridge: Cambridge University Press.
1910, 1912, 1913 (with Alfred North Whitehead) *Principia Mathematica* (3 vols). Cambridge: Cambridge University Press.
1912 *The Problems of Philosophy*. London: Williams & Norgate.
1914 *Our Knowledge of the External World*. Chicago/London: Open Court.
1918 *Mysticism and Logic and Other Essays*. London: Longmans, Green.
1921 *The Analysis of Mind*. London: Longmans, Green.
1928 *Sceptical Essays*. London: Allen & Unwin; New York: Norton.
1945 *A History of Western Philosophy*. London: Allen & Unwin, 1946.
1949 *The Philosophy of Logical Atomism*. Minneapolis, MN: Department of Philosophy, University of Minnesota. Reprinted as *Russell's Logical Atomism*. London: Fontana, 1972.
1956 *Logic and Knowledge: Essays, 1901–1950*. London: Allen & Unwin.
1959 *My Philosophical Development*. London: Allen & Unwin.

Works on Russell

Ayer, A. J., *Bertrand Russell*. Oxford: Oxford University Press; Chicago: University of Chicago Press, 1972.

Grayling, A. C. *Bertrand Russell* (Past Masters). Oxford: Oxford University Press, 1996.
Monk, Ray, *Bertrand Russell: The Spirit of Solitude*. London: Jonathan Cape, 1996.
Sainsbury, Mark, *Russell*. London: Routledge, 1979.

From 'Descriptions and Incomplete Symbols'

I am proposing to deal this time with the subject of descriptions, and what I call 'incomplete symbols', and the existence of described individuals. You will remember that last time I dealt with the existence of *kinds* of things, what you mean by saying 'There are men' or 'There are Greeks' or phrases of that sort, where you have an existence which may be plural. I am going to deal today with an existence which is asserted to be singular, such as 'The man with the iron mask existed' or some phrase of that sort, where you have some object described by the phrase 'The so-and-so' in the singular, and I want to discuss the analysis of propositions in which phrases of that kind occur.

There are, of course, a great many propositions very familiar in metaphysics which are of that sort: 'I exist' or 'God exists' or 'Homer existed', and other such statements are always occurring in metaphysical discussions, and are, I think, treated in ordinary metaphysics in a way which embodies a simple logical mistake that we shall be concerned with today, the same sort of mistake that I spoke of last week in connexion with the existence of kinds of things. One way of examining a proposition of that sort is to ask yourself what would happen if it were false. If you take such a proposition as 'Romulus existed', probably most of us think that Romulus did not exist. It is obviously a perfectly significant statement, whether true or false, to say that Romulus existed. If Romulus himself entered into our statement, it would be plain that the statement that he did not exist would be nonsense, because you cannot have a constituent of a proposition which is nothing at all. Every constituent has got to be there as one of the things in the world, and therefore if Romulus himself entered into the propositions that he existed or that he did not exist, both these propositions could not only not be true, but could not be even significant, unless he existed. That is obviously not the case, and the first conclusion one draws is that, although it *looks* as if Romulus were a constituent of that proposition, that is really a mistake.

Romulus does not occur in the proposition 'Romulus did not exist'.

Suppose you try to make out what you do mean by that proposition. You can take, say, all the things that Livy has to say about Romulus, all the properties he ascribes to him, including the only one probably that most of us remember, namely, the fact that he was called 'Romulus'. You can put all this together, and make a propositional function saying 'x has such-and-such properties', the properties being those you find enumerated in Livy. There you have a propositional function, and when you say that Romulus did not exist you are simply saying that that propositional function is never true, that it is impossible in the sense I was explaining last time, i.e., that there is no value of x that makes it true. That reduces the non-existence of Romulus to the sort of non-existence I spoke of last time, where we had the non-existence of unicorns. But it is not a *complete* account of this kind of existence or non-existence, because there is one other way in which a described individual can fail to exist, and that is where the description applies to more than one person. You cannot, e.g., speak of '*the* inhabitant of London', not because there are none, but because there are so many.

You see, therefore, that this proposition 'Romulus existed' or 'Romulus did not exist' does introduce a propositional function, because the name 'Romulus' is not really a name but a sort of truncated description. It stands for a person who did such-and-such things, who killed Remus, and founded Rome, and so on. It is short for that description; if you like, it is short for 'the person who was called "Romulus"'. If it were really a name, the question of existence could not arise, because a name has got to name something or it is not a name, and if there is no such person as Romulus there cannot be a name for that person who is not there, so that this single word 'Romulus' is really a sort of truncated or telescoped description, and if you think of it as a name you will get into logical errors. When you realize that it is a description, you realize therefore that any proposition about Romulus really introduces the propositional function embodying the description, as (say) 'x was called "Romulus"'. That introduces you at once to a propositional function, and when you say 'Romulus did not exist', you mean that this propositional function is not true for one value of x.

There are two sorts of descriptions, what one may call 'ambiguous descriptions', when we speak of '*a* so-and-so', and what one may call 'definite descriptions', when we speak of '*the* so-and-so' (in the singular). Instances are:

Ambiguous: A man, a dog, a pig, a Cabinet Minister.
Definite: The man with the iron mask.
 The last person who came into this room.

The only Englishman who ever occupied the Papal See.
The number of the inhabitants of London.
The sum of 43 and 34.

(It is not necessary for a description that it should describe an individual: it may describe a predicate or a relation or anything else.)

It is phrases of that sort, definite descriptions, that I want to talk about today. I do not want to talk about ambiguous descriptions, as what there was to say about them was said last time.

I want you to realize that the question whether a phrase is a definite description turns only upon its form, not upon the question whether there is a definite individual so described. For instance, I should call 'the inhabitant of London' a definite description, although it does not in fact describe any definite individual.

The first thing to realize about a definite description is that it is not a name. We will take 'the author of *Waverley*'. That is a definite description, and it is easy to see that it is not a name. A name is a simple symbol (i.e., a symbol which does not have any parts that are symbols), a simple symbol used to designate a certain particular or by extension an object which is not a particular but is treated for the moment as if it were, or is falsely believed to be a particular, such as a person. This sort of phrase, 'the author of *Waverley*', is not a name because it is a complex symbol. It contains parts which *are* symbols. It contains four words, and the meanings of those four words are already fixed and they have fixed the meaning of 'the author of *Waverley*' in the only sense in which that phrase does have any meaning. In that sense, its meaning is already determinate, i.e., there is nothing arbitrary or conventional about the meaning of that whole phrase, when the meanings of 'the', 'author', 'of', and '*Waverley*' have already been fixed. In that respect, it differs from 'Scott', because when you have fixed the meaning of all the other words in the language, you have done nothing toward fixing the meaning of the name 'Scott'. That is to say, if you understand the English language, you would understand the meaning of the phrase 'the author of *Waverley*' if you had never heard it before, whereas you would not understand the meaning of 'Scott' if you had never heard the word before because to know the meaning of a name is to know who it is applied to.

You sometimes find people speaking as if descriptive phrases were names, and you will find it suggested, e.g., that such a proposition as 'Scott is the author of *Waverley*' really asserts that 'Scott' and 'the author of *Waverley*' are two names for the same person. That is an entire delusion; first of all, because 'the author of *Waverley*' is not a name, and, secondly, because, as you can perfectly well see, if that were what is

meant, the proposition would be one like 'Scott is Sir Walter', and would not depend upon any fact except that the person in question was so called, because a name is what a man is called. As a matter of fact, Scott was the author of *Waverley* at a time when no one called him so, when no one knew whether he was or not, and the fact that he was the author was a physical fact, the fact that he sat down and wrote it with his own hand, which does not have anything to do with what he was called. It is in no way arbitrary. You cannot settle by any choice of nomenclature whether he is or is not to be the author of *Waverley*, because in actual fact he chose to write it and you cannot help yourself. That illustrates how 'the author of *Waverley*' is quite a different thing from a name. You can prove this point very clearly by formal arguments. In 'Scott is the author of *Waverley*' the 'is', of course, expresses identity, i.e., the entity whose name is Scott is identical with the author of *Waverley*. But, when I say 'Scott is mortal,' this 'is' is the 'is' of predication, which is quite different from the 'is' of identity. It is a mistake to interpret 'Scott is mortal' as meaning 'Scott is identical with one among mortals', because (among other reasons) you will not be able to say what 'mortals' are except by means of the propositional function '*x* is mortal', which brings back the 'is' of predication. You cannot reduce the 'is' of predication to the other 'is'. But the 'is' in 'Scott is the author of *Waverley*' is the 'is' of identity and not of predication.*

If you were to try to substitute for 'the author of *Waverley*' in that proposition any name whatever, say '*c*', so that the proposition becomes 'Scott is *c*', then if '*c*' is a name for anybody who is not Scott, that proposition would become false, while if, on the other hand, '*c*' is a name for Scott, then the proposition will become simply a tautology. It is at once obvious that if '*c*' were 'Scott' itself, 'Scott is Scott' is just a tautology. But if you take any other name which is just a name for Scott, then if the name is being used *as* a name and not as a description, the proposition will still be a tautology. For the name itself is merely a means of pointing to the thing, and does not occur in what you are asserting, so that if one thing has two names, you make exactly the same assertion whichever of the two names you use, provided they are really names and not truncated descriptions.

So there are only two alternatives. If '*c*' is a name, the proposition 'Scott is *c*' is either false or tautologous. But the proposition 'Scott is the author of *Waverley*' is neither, and therefore is not the same as any proposition of the form 'Scott is *c*', where '*c*' is a name. That is another

* The confusion of these two meanings of 'is' is essential to the Hegelian conception of identity-in-difference.

way of illustrating the fact that a description is quite a different thing from a name.

I should like to make clear what I was saying just now, that if you substitute another name in place of 'Scott' which is also a name of the same individual, say, 'Scott is Sir Walter', then 'Scott' and 'Sir Walter' are being used as names and not as descriptions, your proposition is strictly a tautology. If one asserts 'Scott is Sir Walter', the way one would mean it would be that one was using the names as descriptions. One would mean that the person called 'Scott' is the person called 'Sir Walter', and 'the person called "Scott" ' is a description, and so is 'the person called "Sir Walter" '. So that would not be a tautology. It would mean that the person called 'Scott' is identical with the person called 'Sir Walter'. But if you are using both as names, the matter is quite different. You must observe that the name does not occur in that which you assert when you use the name. The name is merely that which is a means of expressing what it is you are trying to assert, and when I say 'Scott wrote *Waverley*', the name 'Scott' does not occur in the thing I am asserting. The thing I am asserting is about the person, not about the name. So if I say 'Scott is Sir Walter', using these two names *as* names, neither 'Scott' nor 'Sir Walter' occurs in what I am asserting, but only the person who has these names, and thus what I am asserting is a pure tautology.

It is rather important to realize this about the two different uses of names or of any other symbols: the one when you are talking about the symbol and the other when you are using it *as* a symbol, as a means of talking about something else. Normally, if you talk about your dinner, you are not talking about the word 'dinner' but about what you are going to eat, and that is a different thing altogether. The ordinary use of words is as a means of getting through to things, and when you are using words in that way the statement 'Scott is Sir Walter' is a pure tautology, exactly on the same level as 'Scott is Scott'.

That brings me back to the point that when you take 'Scott is the author of *Waverley*' and you substitute for 'the author of *Waverley*' a name in the place of a description, you get necessarily either a tautology or a falsehood – a tautology if you substitute 'Scott' or some other name for the same person, and a falsehood if you substitute anything else. But the proposition itself is neither a tautology nor a falsehood, and that shows you that the proposition 'Scott is the author of *Waverley*' is a different proposition from any that can be obtained if you substitute a name in the place of 'the author of *Waverley*'. That conclusion is equally true of any other proposition in which the phrase 'the author of *Waverley*' occurs. If you take any proposition in which that phrase occurs and

substitute for that phrase a proper name, whether that name be 'Scott' or any other, you will get a different proposition. Generally speaking, if the name that you substitute is 'Scott', your proposition, if it was true before, will remain true, and if it was false before will remain false. But it is a *different* proposition. It is not *always* true that it will remain true or false, as may be seen by the example: 'George IV wished to know if Scott was the author of *Waverley*'. It is not true that George IV wished to know if Scott was Scott. So it is even the case that the truth or the falsehood of a proposition is sometimes changed when you substitute a name of an object for a description of the same object. But in any case it is always a different proposition when you substitute a name for a description.

Identity is a rather puzzling thing at first sight. When you say 'Scott is the author of *Waverley*', you are half-tempted to think there are two people, one of whom is Scott and the other the author of *Waverley*, and they happen to be the same. That is obviously absurd, but that is the sort of way one is always tempted to deal with identity.

When I say 'Scott is the author of *Waverley*' and that 'is' expresses identity, the reason that identity can be asserted there truly and without tautology is just the fact that the one is a name and the other a description. Or they might both be descriptions. If I say 'The author of *Waverley* is the author of *Marmion*', that, of course, asserts identity between two descriptions.

Now the next point that I want to make clear is that when a description (when I say 'description' I mean, for the future, a *definite* description) occurs in a proposition, there is no constituent of that proposition corresponding to that description as a whole. In the true analysis of the proposition, the description is broken up and disappears. That is to say, when I say 'Scott is the author of *Waverley*' it is a wrong analysis of that to suppose that you have there three constituents, 'Scott', 'is', and 'the author of *Waverley*'. That, of course, is the sort of way you might think of analysing. You might admit that 'the author of *Waverley*' was complex and could be further cut up, but you might think the proposition could be split into those three bits to begin with. That is an entire mistake. 'The author of *Waverley*' is not a constituent of the proposition at all. There is no constituent really there corresponding to the descriptive phrase. I will try to prove that to you now.

The first and most obvious reason is that you can have significant propositions denying the existence of 'the so-and-so'. 'The unicorn does not exist.' 'The greatest finite number does not exist.' Propositions of that sort are perfectly significant, are perfectly sober, true, decent propositions, and that could not possibly be the case if the unicorn were

a constituent of the proposition, because plainly it could not be a constituent as long as there were not any unicorns. Because the constituents of propositions, of course, are the same as the constituents of the corresponding facts, and since it is a fact that the unicorn does not exist, it is perfectly clear that the unicorn is not a constituent of that fact, because if there were any fact of which the unicorn was a constituent, there would be a unicorn, and it would not be true that it did not exist. That applies in this case of descriptions particularly. Now since it is possible for 'the so-and-so' not to exist and yet for propositions in which 'the so-and-so' occurs to be significant and even true, we must try to see what is meant by saying that the so-and-so does exist.

The occurrence of tense in verbs is an exceedingly annoying vulgarity due to our preoccupation with practical affairs. It would be much more agreeable if they had no tense, as I believe is the case in Chinese, but I do not know Chinese. You ought to be able to say 'Socrates exists in the past', 'Socrates exists in the present' or 'Socrates exists in the future', or simply 'Socrates exists', without any implication of tense, but language does not allow that, unfortunately. Nevertheless, I am going to use language in this tenseless way: when I say 'The so-and-so exists', I am not going to mean that it exists in the present or in the past or in the future, but simply that it exists, without implying anything involving tense.

'The author of *Waverley* exists': there are two things required for that. First of all, what is 'the author of *Waverley*'? It is the person who wrote *Waverley*, i.e., we are coming now to this, that you have a propositional function involved, viz., 'x writes *Waverley*', and the author of *Waverley* is the person who writes *Waverley*, and in order that the person who writes *Waverley* may exist, it is necessary that this propositional function should have two properties:

(1) It must be true for *at least* one x.
(2) It must be true for *at most* one x.

If nobody had ever written *Waverley* the author could not exist, and if two people had written it, *the* author could not exist. So that you want these two properties, the one that it is true for at least one x, and the other that it is true for at most one x, both of which are required for existence.

The property of being true for at least one x is the one we dealt with last time: what I expressed by saying that the propositional function is *possible*. Then we come on to the second condition, that it is true for at most one x, and that you can express in this way: 'If x and y wrote *Waverley*, then x is identical with y, whatever x and y may be'. That says

that at most one wrote it. It does not say that anybody wrote *Waverley* at all, because if nobody had written it, that statement would still be true. It only says that at most one person wrote it.

The first of these conditions for existence fails in the case of the unicorn, and the second in the case of the inhabitant of London.

We can put these two conditions together and get a portmanteau expression including the meaning of both. You can reduce them both down to this, that: '("*x* wrote *Waverley*" is equivalent to "*x* is *c*" whatever *x* may be) is possible in respect of *c*'. That is as simple, I think, as you can make the statement.

You see that means to say that there is some entity *c*, we may not know what it is, which is such that when *x* is *c*, it is true that *x* wrote *Waverley*, and when *x* is not *c*, it is not true that *x* wrote *Waverley*, which amounts to saying that *c* is the only person who wrote *Waverley*; and I say there is a value of *c* which makes that true. So that this whole expression, which is a propositional function about *c*, is *possible* in respect of *c* (in the sense explained last time).

That is what I mean when I say that the author of *Waverley* exists. When I say 'The author of *Waverley* exists', I mean that there is an entity *c* such that '*x* wrote *Waverley*' is true when *x* is *c*, and is false when *x* is not *c*. 'The author of *Waverley*' as a constituent has quite disappeared there, so that when I say 'The author of *Waverley* exists' I am not saying anything about the author of *Waverley*. You have instead this elaborate to-do with propositional functions, and 'the author of *Waverley*' has disappeared. That is why it is possible to say significantly 'The author of *Waverley* did not exist'. It would not be possible if 'the author of *Waverley*' were a constituent of propositions in whose verbal expression this descriptive phrase occurs.

The fact that you can discuss the proposition 'God exists' is a proof that 'God', as used in that proposition, is a description and not a name. If 'God' were a name, no question as to existence could arise.

I have now defined what I mean by saying that a thing described exists. I have still to explain what I mean by saying that a thing described has a certain property. Supposing you want to say 'The author of *Waverley* was human', that will be represented thus: '("*x* wrote *Waverley*" is equivalent to "*x* is *c*" whatever *x* may be, and *c* is human) is possible with respect to *c*'.

You will observe that what we gave before as the meaning of 'The author of *Waverley* exists' is part of this proposition. It is part of any proposition in which 'the author of *Waverley*' has what I call a 'primary occurrence'. When I speak of a 'primary occurrence' I mean that you are not having a proposition about the author of *Waverley* occurring as a

part of some larger proposition, such as 'I believe that the author of *Waverley*' was human' or 'I believe that the author of *Waverley* exists'. When it is a primary occurrence, i.e., when the proposition concerning it is not just part of a larger proposition, the phrase which we defined as the meaning of 'The author of *Waverley* exists' will be part of that proposition. If I say the author of *Waverley* was human, or a poet, or a Scotsman, or whatever I say about the author of *Waverley* in the way of a primary occurrence, always this statement of his existence is part of the proposition. In that sense all these propositions that I make about the author of *Waverley* imply that the author of *Waverley* exists. So that any statement in which a description has a primary occurrence implies that the object described exists. If I say 'The present King of France is bald', that implies that the present King of France exists. If I say, 'The present King of France has a fine head of hair', that also implies that the present King of France exists. Therefore unless you understand how a proposition containing a description is to be denied, you will come to the conclusion that it is not true either that the present King of France is bald or that he is not bald, because if you were to enumerate all the things that are bald you would not find him there, and if you were to enumerate all the things that are not bald, you would not find him there either. The only suggestion I have found for dealing with that on conventional lines is to suppose that he wears a wig. You can only avoid the hypothesis that he wears a wig by observing that the denial of the proposition 'The present King of France is bald' will not be 'The present King of France is not bald', if you mean by that 'There is such a person as the King of France and that person is not bald'. The reason of this is that when you state that the present King of France is bald you say 'There is a c such that c is now King of France and c is bald' and the denial is not 'There is a c such that c is now King of France and c is not bald'. It is more complicated. It is: 'Either there is not a c such that c is now King of France, or, if there is such a c, then c is not bald.' Therefore you see that, if you want to deny the proposition 'The present King of France is bald', you can do it by denying that he exists, instead of by denying that he is bald. In order to deny this statement that the present King of France is bald, which is a statement consisting of two parts, you can proceed by denying either part. You can deny the one part, which would lead you to suppose that the present King of France exists but is not bald, or the other part, which will lead you to the denial that the present King of France exists; and either of those two denials will lead you to the falsehood of the proposition 'The present King of France is bald'. When you say 'Scott is human' there is no possibility of a double denial. The only way you can deny 'Scott is human' is by saying 'Scott

is not human'. But where a descriptive phrase occurs, you do have the double possibility of denial.

It is of the utmost importance to realize that 'the so-and-so' does not occur in the analysis of propositions in whose verbal expression it occurs, that when I say 'The author of *Waverley* is human', 'the author of *Waverley*' is not the subject of that proposition, in the sort of way that Scott would be if I said 'Scott is human', using 'Scott' as a name. I cannot emphasize sufficiently how important this point is, and how much error you get into metaphysics if you do not realize that when I say 'The author of *Waverley* is human' that is not a proposition of the same form as 'Scott is human'. It does not contain a constituent 'the author of *Waverley*'. The importance of that is very great for many reasons, and one of them is this question of existence. As I pointed out to you last time, there is a vast amount of philosophy that rests upon the notion that existence is, so to speak, a property that you can attribute to things, and that the things that exist have the property of existence and the things that do not exist do not. That is rubbish, whether you take kinds of things, or individual things described. When I say, e.g., 'Homer existed', I am meaning by 'Homer' some description, say 'the author of the Homeric poems', and I am asserting that those poems were written by one man, which is a very doubtful proposition; but if you could get hold of the actual person who did actually write those poems (supposing there was such a person), to say of him that he existed would be uttering nonsense, not a falsehood but nonsense, because it is only of persons described that it can be significantly said that they exist. Last time I pointed out the fallacy in saying 'Men exist, Socrates is a man, therefore Socrates exists'. When I say 'Homer exists, this is Homer, therefore this exists', that is a fallacy of the same sort. It is an entire mistake to argue: 'This is the author of the Homeric poems and the author of the Homeric poems exists, therefore this exists'. It is only where a propositional function comes in that existence may be significantly asserted. You can assert 'The so-and-so exists', meaning that there is just one c which has those properties, but when you get hold of a c that has them, you cannot say of this c that it exists, because that is nonsense: it is not false, but it has no meaning at all.

So the individuals that there are in the world do not exist, or rather it is nonsense to say that they exist and nonsense to say that they do not exist. It is not a thing you can say when you have named them, but only when you have described them. When you say 'Homer exists', you mean 'Homer' is a description which applies to something. A description when it is fully stated is always of the form 'the so-and-so'.

The sort of things that are like these descriptions in that they occur in

words in a proposition, but are not in actual fact constituents of the
proposition rightly analysed, things of that sort I call 'incomplete sym-
bols'. There are a great many sorts of incomplete symbols in logic, and
they are sources of a great deal of confusion and false philosophy, because
people get misled by grammar. You think that the proposition 'Scott is
mortal' and the proposition 'The author of *Waverley* is mortal' are of the
same form. You think that they are both simple propositions attributing a
predicate to a subject. That is an entire delusion: one of them is (or
rather might be) and one of them is not. These things, like 'the author
of *Waverley*', which I call incomplete symbols, are things that have
absolutely no meaning whatsoever in isolation but merely acquire a
meaning in a context. 'Scott' taken as a name has a meaning all by itself.
It stands for a certain person, and there it is. But 'the author of *Waverley*'
is not a name, and does not all by itself mean anything at all, because
when it is rightly used in propositions, those propositions do not contain
any constituent corresponding to it.

There are a great many other sorts of incomplete symbols besides
descriptions. These are classes, which I shall speak of next time, and
relations taken in extension, and so on. Such aggregations of symbols
are really the same thing as what I call 'logical fictions', and they embrace
practically all the familiar objects of daily life: tables, chairs, Piccadilly,
Socrates, and so on. Most of them are either classes, or series, or series
of classes. In any case they are all incomplete symbols, i.e., they are
aggregations that only have a meaning in use and do not have any
meaning in themselves.

It is important, if you want to understand the analysis of the world,
or the analysis of facts, or if you want to have any idea what there really
is in the world, to realize how much of what there is in phraseology is
of the nature of incomplete symbols. You can see that very easily in the
case of 'the author of *Waverley*' because 'the author of *Waverley*' does
not stand simply for Scott, nor for anything else. If it stood for Scott,
'Scott is the author of *Waverley*' would be the same proposition as 'Scott
is Scott', which it is not, since George IV wished to know the truth of
the one and did not wish to know the truth of the other. If 'the author
of *Waverley*' stood for anything other than Scott, 'Scott is the author of
Waverley' would be false, which it is not. Hence you have to conclude
that 'the author of *Waverley*' does not, in isolation, really stand for
anything at all; and that is the characteristic of incomplete symbols.

3

ALFRED TARSKI

(1902–80)

Polish mathematician, logician and philosopher Alfred Tarski was born in Warsaw and educated at the University of Warsaw where, in 1924, he received a doctoral degree in mathematics. He belonged to a group of Polish logicians and philosophers who were engaged in what they called 'scientific philosophy', and had contacts with the logical positivists in Austria and Germany in the 1920s and 1930s. Like many other Central European philosophers of his generation, Tarski was forced to flee from the advancing German forces. He lived and taught in the United States from 1939, where he was appointed Professor of Mathematics at the University of California in Berkeley, in 1946. He is best known for his contribution to modern formal logic, but his influence on the development of philosophy of language in the second half of the twentieth century has been monumental.

The paper 'The Concept of Truth in Formalized Languages', the first part of which is reproduced here, first appeared in Polish in 1931, but it made its impact on philosophy outside Poland when it was presented, in 1935, to a congress organized by the logical positivists in Paris. The paper provides a formal definition of truth that has been set out in such a way as to avoid the semantic paradoxes, such as the paradox of the liar.

The semantic paradoxes arise with the construction of sentences which say of themselves that they are not true, or negate their own truth value. The simplest instance is 'This sentence is not true': the sentence is paradoxical because it is false, if it is true, and it is true, if it is false. The most celebrated example is the original liar paradox devised by Eubulides of Miletus: 'The Cretan said: All Cretans are liars'. Bertrand Russell's discovery of a set theoretical paradox in Frege's logicist programme (known as 'Russell's paradox') in 1902 heightened the awareness of the pitfalls of self-referentiality.

The starting point of Tarski's theory of truth, also known as the

semantic theory of truth, is the claim that universal and general defin-
itions of truth applicable to all languages, e.g., the traditional cor-
respondence and coherence theories of truth, will encounter semantic
paradoxes such as the paradox of the liar. The paradox, Tarski argued,
arises from the attempt to formulate the truth conditions of all the
sentences of a given language within that same language.

Tarski's solution was to distinguish, in the first place, between an
object language and a metalanguage. We speak in the metalanguage
about the object language. We can use a metalanguage in order to
interpret and analyse the properties of an object language – the language
under discussion. In order to avoid the problem of self-referentiality,
Tarski suggests, the terms 'true' and 'false' should be seen as predicates
in the metalanguage and not the object language.

Tarski then defines the concept of truth for a formalized language.
Any satisfactory theory of truth should meet the conditions of being (a)
materially adequate, and (b) formally correct. There are two conditions
of 'material adequacy': the first states that truth is predicated of sentences
of a particular language L. Thus, Tarski's approach gives the traditional
concept of truth a new semantic and linguistic twist. The second con-
dition of material adequacy, and the main component of Tarski's semantic
theory of truth, is Convention T, which states that 'For a definition of
truth in the metalanguage of a language L to be adequate it must have
for its consequences all sentences of L which are obtained from the
expression "x is true if and only if p" by substituting for "x" a name or
structural description of any sentence of L and for "p" the expression
which is the translation of that sentence into the metalanguage'. Con-
vention T provides the truth conditions of sentences of English in the
following way:

> 'It is snowing' is true iff (if and only if) it is snowing.
> 'Grass is green' is true iff grass is green.
> 'Man is mortal' is true iff man is mortal.

On the left-hand side of the biconditional, in quotation marks we place
the name of the sentence and on the right-hand side the translation or
the expression of that sentence in the metalanguage; such equivalences
are called T-sentences and can be schematized as: x is true iff p (where x
is the name of a sentence and p stands for the translation of that sentence
into the metalanguage). The schema can generate a T-sentence for every
indicative sentence of any given language, and this ensures the material
adequacy of Tarski's definition of truth.

The semantic theory of truth is also known as a disquotational theory
of truth since in effect it establishes logical equivalences between, for

instance, ' "grass is green" is true' and 'grass is green'. It also generated various versions of the redundancy theory of truth, according to which the sentence '*p* is true' is equivalent to the sentence *p*; this 'equivalence thesis' is the basis for Tarski's semantic definition of truth, hence the connection between the semantic theories and the redundancy theories of truth.

Tarski's theory has had a great impact on the development of both logic and philosophy of language in this century. Many contemporary philosophers of language subscribe to some version of the semantic theory of truth. However, there is no universal agreement on the import or the correct interpretation of the theory. Karl Popper, for instance, saw in Tarski's theory the best hope for the expression of an adequate correspondence theory of truth, while Richard Rorty, at the other extreme, cites Tarski's theory in defence of his relativistic views. The semantic theory has been adopted by Donald Davidson in developing his influential theory of meaning and interpretation. Davidson's work will be discussed in the introduction to chapter 9.

Works by Tarski

1956 *Logic, Semantics, Metamathematics*. Oxford: Clarendon Press.
1969 'Truth and Proof', *Scientific American*, 194, pp. 63–77.

Works on Tarski

Davidson, Donald, *Inquiries into Truth and Interpretation*. Oxford: Clarendon Press, 1984.
Field, H., 'Tarski's Theory of Truth', *Journal of Philosophy*, 69 (1972), pp. 347–75.
Haack, Susan, *Philosophy of Logics*, chapter 7. Cambridge: Cambridge University Press, 1978.
Kirkham, R., *Theories of Truth*, Cambridge, MA: MIT Press, 1992.
Popper, Karl, *Conjectures and Refutations* (particularly pp. 223–4). London: Routledge, 1963.

The Semantic Conception of Truth and the Foundations of Semantics

This paper consists of two parts; the first has an expository character, and the second is rather polemical.

In the first part I want to summarize in an informal way the main results of my investigations concerning the definition of truth and the more general problem of the foundations of semantics. These results have been embodied in a work which appeared in print several years ago.[1] Although my investigations concern concepts dealt with in classical philosophy, they happen to be comparatively little known in philosophical circles, perhaps because of their strictly technical character. For this reason I hope I shall be excused for taking up the matter once again.[2]

I am especially indebted and grateful to Professors Ernest Nagel (Columbia University) and David Rynin (University of California, Berkeley) for their help in preparing the final text and for various critical remarks.

I. Exposition

1. The Main Problem – A Satisfactory Definition of Truth

Our discussion will be centered around the notion[3] of *truth*. The main problem is that of giving a *satisfactory definition* of this notion, i.e., a definition which is _materially adequate_ and _formally correct_. But such a formulation of the problem, because of its generality, cannot be considered unequivocal, and requires some further comments.

In order to avoid any ambiguity, we must first specify the conditions under which the definition of truth will be considered adequate from the material point of view. The desired definition does not aim to specify the meaning of a familiar word used to denote a novel notion; on the contrary, it aims to catch hold of the actual meaning of an old notion. We must then characterize this notion precisely enough to enable anyone to determine whether the definition actually fulfills its task.

our task?

Secondly, we must determine on what the formal correctness of the definition depends. Thus, we must specify the words or concepts which we wish to use in defining the notion of truth; and we must also give the formal rules to which the definition should conform. Speaking more generally, we must describe the formal structure of the language in which the definition will be given.

The discussion of these points will occupy a considerable portion of the first part of the paper.

2. The Extension of the Term 'True'

We begin with some remarks regarding the extension of the concept of truth which we have in mind here.

The predicate 'true' is sometimes used to refer to psychological phenomena such as judgements or beliefs, sometimes to certain physical objects, namely, linguistic expressions and specifically sentences, and sometimes to certain ideal entities called 'propositions'. By 'sentence' we understand here what is usually meant in grammar by 'declarative sentence'; as regards the term 'proposition', its meaning is notoriously a subject of lengthy disputations by various philosophers and logicians, and it seems never to have been made quite clear and unambiguous. For several reasons it appears most convenient to *apply the term 'true' to sentences*, and we shall follow this course.[4]

Consequently, we must always relate the notion of truth, like that of a sentence, to a specific language; for it is obvious that the same expression which is a true sentence in one language can be false or meaningless in another.

Of course, the fact that we are interested here primarily in the notion of truth for sentences does not exclude the possibility of a subsequent extension of this notion to other kinds of objects.

3. The Meaning of the Term 'True'

Much more serious difficulties are connected with the problem of the meaning (or the intension) of the concept of truth.

The word 'true', like other words from our everyday language, is certainly not unambiguous. And it does not seem to me that the philosophers who have discussed this concept have helped to diminish its ambiguity. In works and discussions of philosophers we meet many different conceptions of truth and falsity, and we must indicate which conception will be the basis of our discussion.

We should like our definition to do justice to the intuitions which adhere to the *classical Aristotelian conception of truth* – intuitions which find their expression in the well-known words of Aristotle's *Metaphysics*:

> To say of what is that it is not, or of what is not that it is, is false, while to say of what is that it is, or of what is not that it is not, is true.

If we wished to adapt ourselves to modern philosophical terminology, we could perhaps express this conception by means of the familiar formula:

> The truth of a sentence consists in its agreement with (or correspondence to) reality. *What is correspondance w/ reality?*

(For a theory of truth which is to be based upon the latter formulation the term 'correspondence theory' has been suggested.)

If, on the other hand, we should decide to extend the popular usage of the term 'designate' by applying it not only to names, but also to sentences, and if we agreed to speak of the designata of sentences as 'states of affairs', we could possibly use for the same purpose the following phrase:

> A sentence is true if it designates an existing state of affairs.[5]

However, all these formulations can lead to various mis-understandings, for none of them is sufficiently precise and clear (though this applies much less to the original Aristotelian formulation than to either of the others); at any rate, none of them can be considered a satisfactory definition of truth. It is up to us to look for a more precise expression of our intuitions.

4. A Criterion for the Material Adequacy of the Definition[6]
Let us start with a concrete example. Consider the sentence 'snow is white'. We ask the question under what conditions this sentence is true or false. It seems clear that if we base ourselves on the classical conception of truth, we shall say that the sentence is true if snow is white, and that it is false if snow is not white. Thus, if the definition of truth is to conform to our conception, it must imply the following equivalence:

> The sentence 'snow is white' is true if, and only if, snow is white.

Let me point out that the phrase 'snow is white' occurs on the left side of this equivalence in quotation marks, and on the right without quotation marks. On the right side we have the sentence itself, and on the left the name of the sentence. Employing the medieval logical terminology we could say that on the right side the words 'snow is white' occur in *suppositio formalis*, and on the left in *suppositio materialis*. It is hardly necessary to explain why we must have the name of the sentence, and not the sentence itself, on the left side of the equivalence. For, in the first place, from the point of view of the grammar of our language, an

expression of the form 'X is true' will not become a meaningful sentence if we replace in it 'X' by a sentence or by anything other than a name – since the subject of a sentence may be only a noun or an expression functioning like a noun. And, in the second place. the fundamental conventions regarding the use of any language require that in any utterance we make about an object it is the name of the object which must be employed, and not the object itself. In consequence, if we wish to say something about a sentence, for example that it is true, we must use the name of this sentence, and not the sentence itself.[7]

It may be added that enclosing a sentence in quotation marks is by no means the only way of forming its name. For instance, by assuming the usual order of letters in our alphabet, we can use the following expression as the name (the description) of the sentence 'snow is white':

> the sentence constituted by three words, the first of which consists of the 19th, 14th, 15th, and 23rd letters, the second of the 9th and 19th letters, and the third of the 23rd, 8th, 9th, 20th, and 5th letters of the English alphabet.

We shall now generalize the procedure which we have applied above. Let us consider an arbitrary sentence; we shall replace it by the letter 'p'. We form the name of this sentence and we replace it by another letter, say 'X'. We ask now what is the logical relation between the two sentences 'X is true' and 'p'. It is clear that from the point of view of our basic conception of truth these sentences are equivalent. In other words, the following equivalence holds:

> (T) X is true if, and only if, p.

We shall call any such equivalence (with 'p' replaced by any sentence of the language to which the word 'true' refers, and 'X' replaced by a name of this sentence) an '*equivalence of the form* (T)'.

Now at last we are able to put into a precise form the conditions under which we will consider the usage and the definition of the term 'true' as adequate from the material point of view: we wish to use the term 'true' in such a way that all equivalences of the form (T) can be asserted, and *we shall call a definition of truth 'adequate' if all these equivalences follow from it.*

It should be emphasized that neither the expression (T) itself (which is not a sentence, but only a schema of a sentence) nor any particular instance of the form (T) can be regarded as a definition of truth. We can only say that every equivalence of the form (T) obtained by replacing 'p' by a particular sentence, and 'X' by a name of this sentence, may be considered a partial definition of truth, which explains wherein the truth

of this one individual sentence consists. The general definition has to be, in a certain sense, a logical conjunction of all these partial definitions.

(The last remark calls for some comments. A language may admit the construction of infinitely many sentences; and thus the number of partial definitions of truth referring to sentences of such a language will also be infinite. Hence to give our remark a precise sense we should have to explain what is meant by a 'logical conjunction of infinitely many sentences'; but this would lead us too far into technical problems of modern logic.)

5. Truth as a Semantic Concept

I should like to propose the name *'the semantic conception of truth'* for the conception of truth which has just been discussed.

Semantics is a discipline which, speaking loosely, *deals with certain relations between expressions of a language and the objects* (or 'states of affairs') *'referred to'* by *those expressions*. As typical examples of semantic concepts we may mention the concepts of *designation, satisfaction*, and *definition* as these occur in the following examples:

> the expression 'the father of his country' designates (denotes) George Washington;
> snow satisfies the sentential function (the condition) 'x is white';
> the equation '$2 \cdot x = 1$' defines (uniquely determines) the number $\frac{1}{2}$.

While the words 'designates', 'satisfies' and 'defines' express relations (between certain expressions and the objects 'referred to' by these expressions), the word 'true' is of a different logical nature: it expresses a property (or denotes a class) of certain expressions, viz., of sentences. However, it is easily seen that all the formulations which were given earlier and which aimed to explain the meaning of this word (cf. sections 3 and 4) referred not only to sentences themselves, but also to objects 'talked about' by these sentences, or possibly to 'states of affairs' described by them. And, moreover, it turns out that the simplest and the most natural way of obtaining an exact definition of truth is one which involves the use of other semantic notions, e.g., the notion of satisfaction. It is for these reasons that we count the concept of truth which is discussed here among the concepts of semantics, and the problem of defining truth proves to be closely related to the more general problem of setting up the foundations of theoretical semantics.

It is perhaps worth while saying that semantics as it is conceived in this paper (and in former papers of the author) is a sober and modest discipline which has no pretensions of being a universal patent medicine for all the ills and diseases of mankind, whether imaginary or real. You

will not find in semantics any remedy for decayed teeth or illusions of grandeur or class conflicts. Nor is semantics a device for establishing that everyone except the speaker and his friends is speaking nonsense.

From antiquity to the present day the concepts of semantics have played an important role in the discussions of philosophers, logicians, and philologists. Nevertheless, these concepts have been treated for a long time with a certain amount of suspicion. From a historical stand-point, this suspicion is to be regarded as completely justified. For although the meaning of semantic concepts as they are used in everyday language seems to be rather clear and understandable, still all attempts to characterize this meaning in a general and exact way miscarried. And what is worse, various arguments in which these concepts were involved, and which seemed otherwise quite correct and based upon apparently obvious premises, led frequently to paradoxes and antinomies. It is sufficient to mention here the *antinomy of the liar*, Richard's *antinomy of definability* (by means of a finite number of words), and Grelling-Nelson's *antinomy of heterological terms*.[8]

I believe that the method which is outlined in this paper helps to overcome these difficulties and assures the possibility of a consistent use of semantic concepts.

6. Languages with a Specified Structure

Because of the possible occurrence of antinomies, the problem of speci-fying the formal structure and the vocabulary of a language in which definitions of semantic concepts are to be given becomes especially acute; and we turn now to this problem.

There are certain general conditions under which the structure of a language is regarded as *exactly specified*. Thus, to specify the structure of a language, we must characterize unambiguously the class of those words and expressions which are to be considered *meaningful*. In par-ticular, we must indicate all words which we decide to use without defining them, and which are called '*undefined* (or *primitive*) *terms*'; and we must give the so-called *rules of definition* for introducing new or *defined terms*. Furthermore, we must set up criteria for distinguishing within the class of expressions those which we call '*sentences*'. Finally, we must formulate the conditions under which a sentence of the language can be *asserted*. In particular, we must indicate all *axioms* (or *primitive sentences*), i.e., those sentences which we decide to assert without proof; and we must give the so-called *rules of inference* (or *rules of proof*) by means of which we can deduce new asserted sentences from other sentences which have been previously asserted. Axioms, as well as

sentences deduced from them by means of rules of inference, are referred
to as 'theorems' or 'provable sentences'.

If in specifying the structure of a language we refer exclusively to the
form of the expressions involved, the language is said to be *formalized*.
In such a language theorems are the only sentences which can be asserted.

At the present time the only languages with a specified structure are
the formalized languages of various systems of deductive logic, possibly
enriched by the introduction of certain nonlogical terms. However, the
field of application of these languages is rather comprehensive; we are
able, theoretically, to develop in them various branches of science, for
instance, mathematics and theoretical physics.

(On the other hand, we can imagine the construction of languages
which have an exactly specified structure without being formalized. In
such a language the assertability of sentences, for instance, may depend
not always on their form, but sometimes on other, nonlinguistic factors.
It would be interesting and important actually to construct a language
of this type, and specifically one which would prove to be sufficient for
the development of a comprehensive branch of empirical science; for this
would justify the hope that languages with specified structure could
finally replace everyday language in scientific discourse.)

*The problem of the definition of truth obtains a precise meaning and
can be solved in a rigorous way only for those languages whose structure
has been exactly specified.* For other languages – thus, for all natural,
'spoken' languages – the meaning of the problem is more or less vague,
and its solution can have only an approximate character. Roughly speak-
ing, the approximation consists in replacing a natural language (or a
portion of it in which we are interested) by one whose structure is
exactly specified, and which diverges from the given language 'as little
as possible'.

7. The Antinomy of the Liar

In order to discover some of the more specific conditions which must be
satisfied by languages in which (or for which) the definition of truth is
to be given, it will be advisable to begin with a discussion of that antinomy
which directly involves the notion of truth, namely, the antinomy of
the liar.

To obtain this antinomy in a perspicuous form,[9] consider the following
sentence:

The sentence printed in this book on p. 50, line 38 is not true.

For brevity we shall replace the sentence just stated by the letter 's'.
According to our convention concerning the adequate usage of the
- peculiarity of the example, its not really a lie

term 'true', we assert the following equivalence of the form (T):

(1) 's' is true if, and only if, the sentence printed in this paper on p. 50, line 30 is not true.

On the other hand, keeping in mind the meaning of the symbol 's', we establish empirically the following fact:

(2) 's' is identical with the sentence printed in this paper on p. 50, line 38.

Now, by a familiar law from the theory of identity (Leibniz's law), it follows from (2) that we may replace in (1) the expression 'the sentence printed in this paper on p. 50, line 38' by the symbol 's'. We thus obtain what follows:

(3) 's' is true if, and only if, 's' is not true.

In this way we have arrived at an obvious contradiction.

In my judgement, it would be quite wrong and dangerous from the standpoint of scientific progress to depreciate the importance of this and other antinomies, and to treat them as jokes or sophistries. It is a fact that we are here in the presence of an absurdity, that we have been compelled to assert a false sentence (since (3), as an equivalence between two contradictory sentences, is necessarily false). If we take our work seriously, we cannot be reconciled with this fact. We must discover its cause, that is to say, we must analyze premisses upon which the antinomy is based; we must then reject at least one of these premisses, and we must investigate the consequences which this has for the whole domain of our research.

It should be emphasized that antinomies have played a pre-eminent role in establishing the foundations of modern deductive sciences. And just as class-theoretical antinomies, and in particular Russell's antinomy (of the class of all classes that are not members of themselves), were the starting point for the successful attempts at a consistent formalization of logic and mathematics, so the antinomy of the liar and other semantic antinomies give rise to the construction of theoretical semantics.

8. The Inconsistency of Semantically Closed Languages[10]

If we now analyze the assumptions which lead to the antinomy of the liar we notice the following:

(1) We have implicitly assumed that the language in which the antinomy is constructed contains, in addition to its expressions, also the names of these expressions, as well as semantic terms such as the term 'true' referring to sentences of this language; we have also assumed that all

sentences which determine the adequate usage of this term can be asserted in the language. A language with these properties will be called '*semantically closed*'.

(II) We have assumed that in this language the ordinary laws of logic hold.

(III) We have assumed that we can formulate and assert in our language an empirical premisse such as the statement (2) which has occurred in our argument.

It turns out that the assumption (III) is not essential, for it is possible to reconstruct the antinomy of the liar without its help.[11] But the assumptions (I) and (II) prove essential. Since every language which satisfies both of these assumptions is inconsistent, we must reject at least one of them.

It would be superfluous to stress here the consequences of rejecting the assumption (II), that is, of changing our logic (supposing this were possible) even in its more elementary and fundamental parts. We thus consider only the possibility of rejecting the assumption (I). Accordingly, we decide *not to use any language which is semantically closed* in the sense given.

This restriction would of course be unacceptable for those who, for reasons which are not clear to me, believe that there is only one 'genuine' language (or, at least, that all 'genuine' languages are mutually translatable). However, this restriction does not affect the needs or interests of science in any essential way. The languages (either the formalized languages or – what is more frequently the case – the portions of everyday language) which are used in scientific discourse do not have to be semantically closed. This is obvious in case linguistic phenomena and, in particular, semantic notions do not enter in any way into the subject matter of a science; for in such a case the language of this science does not have to be provided with any semantic terms at all. However, we shall see in the next section how semantically closed languages can be dispensed with even in those scientific discussions in which semantic notions are essentially involved.

The problem arises as to the position of everyday language with regard to this point. At first blush it would seem that this language satisfies both assumptions (I) and (II), and that therefore it must be inconsistent. But actually the case is not so simple. Our everyday language is certainly not one with an exactly specified structure. We do not know precisely which expressions are sentences, and we know even to a smaller degree which sentences are to be taken as assertible. Thus the problem of consistency has no exact meaning with respect to this language. We may at best only risk the guess that a language whose structure has been exactly specified

and which resembles our everyday language as closely as possible would be inconsistent.

9. Object Language and Metalanguage

Since we have agreed not to employ semantically closed languages, we have to use two different languages in discussing the problem of the definition of truth and, more generally, any problems in the field of semantics. The first of these languages is the language which is 'talked about' and which is the subject matter of the whole discussion; the definition of truth which we are seeking applies to the sentences of this language. The second is the language in which we 'talk about' the first language, and in terms of which we wish, in particular, to construct the definition of truth for the first language. We shall refer to the first language as 'the object language', and to the second as 'the meta-language'.

It should be noticed that these terms 'object language' and 'meta-language' have only a relative sense. If, for instance, we become interested in the notion of truth applying to sentences, not of our original object language, but of its metalanguage, the latter becomes automatically the object language of our discussion; and in order to define truth for this language, we have to go to a new metalanguage – so to speak, to a metalanguage of a higher level. In this way we arrive at a whole hierarchy of languages.

The vocabulary of the metalanguage is to a large extent determined by previously stated conditions under which a definition of truth will be considered materially adequate. This definition, as we recall, has to imply all equivalences of the form (T):

(T) X is true if, and only if, p.

The definition itself and all the equivalences implied by it are to be formulated in the metalanguage. On the other hand, the symbol 'p' in (T) stands for an arbitrary sentence of our object language. Hence it follows that every sentence which occurs in the object language must also occur in the metalanguage; in other words, the metalanguage must contain the object language as a part. This is at any rate necessary for the proof of the adequacy of the definition – even though the definition itself can sometimes be formulated in a less comprehensive metalanguage which does not satisfy this requirement.

(The requirement in question can be somewhat modified, for it suffices to assume that the object language can be translated into the meta-language; this necessitates a certain change in the interpretation of the

symbol 'p' in (T). In all that follows we shall ignore the possibility of this modification.)

Furthermore, the symbol 'X' in (T) represents the name of the sentence which 'p' stands for. We see therefore that the metalanguage must be rich enough to provide possibilities of constructing a name for every sentence of the object language.

In addition, the metalanguage must obviously contain terms of a general logical character, such as the expression 'if, and only if'.[12]

It is desirable for the metalanguage not to contain any undefined terms except such as are involved explicitly or implicitly in the remarks above, i.e.: terms of the object language; terms referring to the form of the expressions of the object language, and used in building names for these expressions; and terms of logic. In particular, we desire *semantic terms* (referring to the object language) *to be introduced into the metalanguage only by definition*. For, if this postulate is satisfied, the definition of truth, or of any other semantic concept, will fulfill what we intuitively expect from every definition; that is, it will explain the meaning of the term being defined in terms whose meaning appears to be completely clear and unequivocal. And, moreover, we have then a kind of guarantee that the use of semantic concepts will not involve us in any contradictions.

We have no further requirements as to the formal structure of the object language and the metalanguage; we assume that it is similar to that of other formalized languages known at the present time. In particular, we assume that the usual formal rules of definition are observed in the metalanguage.

10. Conditions for a Positive Solution of the Main Problem

Now, we have already a clear idea both of the conditions of material adequacy to which the definition of truth is subjected, and of the formal structure of the language in which this definition is to be constructed. Under these circumstances the problem of the definition of truth acquires the character of a definite problem of a purely deductive nature.

The solution of the problem, however, is by no means obvious, and I would not attempt to give it in detail without using the whole machinery of contemporary logic. Here I shall confine myself to a rough outline of the solution and to the discussion of certain points of a more general interest which are involved in it.

The solution turns out to be sometimes positive, sometimes negative. This depends upon some formal relations between the object language and its metalanguage; or, more specifically, upon the fact whether the metalanguage in its logical part is '*essentially richer*' than the object language or not. It is not easy to give a general and precise definition of

this notion of 'essential richness'. If we restrict ourselves to languages based on the logical theory of types, the condition for the metalanguage to be 'essentially richer' than the object language is that it contain variables of a higher logical type than those of the object language.

If the condition of 'essential richness' is not satisfied, it can usually be shown that an interpretation of the metalanguage in the object language is possible; that is to say, with any given term of the metalanguage a well-determined term of the object language can be correlated in such a way that the assertible sentences of the one language turn out to be correlated with assertible sentences of the other. As a result of this interpretation, the hypothesis that a satisfactory definition of truth has been formulated in the metalanguage turns out to imply the possibility of reconstructing in that language the antinomy of the liar; and this in turn forces us to reject the hypothesis in question.

(The fact that the metalanguage, in its nonlogical part, is ordinarily more comprehensive than the object language does not affect the possibility of interpreting the former in the latter. For example, the names of expressions of the object language occur in the metalanguage, though for the most part they do not occur in the object language itself; but, nevertheless, it may be possible to interpret these names in terms of the object language.)

Thus we see that the condition of 'essential richness' is necessary for the possibility of a satisfactory definition of truth in the metalanguage. If we want to develop the theory of truth in a metalanguage which does not satisfy this condition, we must give up the idea of defining truth with the exclusive help of those terms which were indicated above (in section 8). We have then to include the term 'true', or some other semantic term, in the list of undefined terms of the metalanguage, and to express fundamental properties of the notion of truth in a series of axioms. There is nothing essentially wrong in such an axiomatic procedure, and it may prove useful for various purposes.[13]

It turns out, however, that this procedure can be avoided. For *the condition of the 'essential richness' of the metalanguage proves to be, not only necessary, but also sufficient for the construction of a satisfactory definition of truth*; i.e., if the metalanguage satisfies this condition, the notion of truth can be defined in it. We shall now indicate in general terms how this construction can be carried through.

11. *The Construction (in Outline) of the Definition*[14]

A definition of truth can be obtained in a very simple way from that of another semantic notion, namely, of the notion of *satisfaction*.

Satisfaction is a relation between arbitrary objects and certain

expressions called 'sentential functions'. These are expressions like 'x is white', 'x is greater than y', etc. Their formal structure is analogous to that of sentences; however, they *may* contain the so-called free variables (like 'x' and 'y' in 'x is greater than y'), which cannot occur in sentences.

In defining the notion of a sentential function in formalized languages, we usually apply what is called a 'recursive procedure'; i.e., we first describe sentential functions of the simplest structure (which ordinarily presents no difficulty), and then we indicate the operations by means of which compound functions can be constructed from simpler ones. Such an operation may consist, for instance, in forming the logical disjunction or conjunction of two given functions, i.e., by combining them by the word 'or' or 'and'. A sentence can now be defined simply as a sentential function which contains no free variables.

As regards the notion of satisfaction, we might try to define it by saying that given objects satisfy a given function if the latter becomes a true sentence when we replace in it free variables by names of given objects. In this sense, for example, snow satisfies the sentential function 'x is white' since the sentence 'snow is white' is true. However, apart from other difficulties, this method is not available to us, for we want to use the notion of satisfaction in defining truth.

To obtain a definition of satisfaction we have rather to apply again a recursive procedure. We indicate which objects satisfy the simplest sentential functions; and then we state the conditions under which given objects satisfy a compound function – assuming that we know which objects satisfy the simpler functions from which the compound one has been constructed. Thus, for instance, we say that given numbers satisfy the logical disjunction 'x is greater than y or x is equal to y' if they satisfy at least one of the functions 'x is greater than y' or 'x is equal to y'.

Once the general definition of satisfaction is obtained, we notice that it applies automatically also to those special sentential functions which contain no free variables, i.e., to sentences. It turns out that for a sentence only two cases are possible: a sentence is either satisfied by all objects, or by no objects. Hence we arrive at a definition of truth and falsehood simply by saying that *a sentence is true if it is satisfied by all objects, and false otherwise.*[15]

(It may seem strange that we have chosen a roundabout way of defining the truth of a sentence, instead of trying to apply, for instance, a direct recursive procedure. The reason is that compound sentences are constructed from simpler sentential functions, but not always from simpler sentences; hence no general recursive method is known which applies specifically to sentences.)

From this rough outline it is not clear where and how the assumption

of the 'essential richness' of the metalanguage is involved in the discussion; this becomes clear only when the construction is carried through in a detailed and formal way.[16]

12. Consequences of the Definition

The definition of truth which was outlined above has many interesting consequences.

In the first place, the definition proves to be not only formally correct, but also materially adequate (in the sense established in section 4); in other words, it implies all equivalences of the form (T). In this connection it is important to notice that the conditions for the material adequacy of the definition determine uniquely the extension of the term 'true'. Therefore, every definition of truth which is materially adequate would necessarily be equivalent to that actually constructed. The semantic conception of truth gives us, so to speak, no possibility of choice between various nonequivalent definitions of this notion.

Moreover, we can deduce from our definition various laws of a general nature. In particular, we can prove with its help the *laws of contradiction and of excluded middle*, which are so characteristic of the Aristotelian conception of truth; i.e., we can show that one and only one of any two contradictory sentences is true. These semantic laws should not be identified with the related logical laws of contradiction and excluded middle; the latter belong to the sentential calculus, i.e., to the most elementary part of logic, and do not involve the term 'true' at all.

Further important results can be obtained by applying the theory of truth to formalized languages of a certain very comprehensive class of mathematical disciplines; only disciplines of an elementary character and a very elementary logical structure are excluded from this class. It turns out that for a discipline of this class *the notion of truth never coincides with that of provability*; for all provable sentences are true, but there are true sentences which are not provable.[17] Hence it follows further that every such discipline is consistent, but incomplete; that is to say, of any two contradictory sentences at most one is provable, and – what is more – there exists a pair of contradictory sentences neither of which is provable.[18]

13. Extensions of the Results to Other Semantic Notions

Most of the results at which we arrived in the preceding sections in discussing the notion of truth can be extended with appropriate changes to other semantic notions, for instance, to the notion of satisfaction (involved in our previous discussion), and to those of *designation* and *definition*.

Each of these notions can be analyzed along the lines followed in the analysis of truth. Thus, criteria for an adequate usage of these notions can be established; it can be shown that each of these notions, when used in a semantically closed language according to those criteria, leads necessarily to a contradiction;[19] a distinction between the object language and the metalanguage becomes again indispensable; and the 'essential richness' of the metalanguage proves in each case to be a necessary and sufficient condition for a satisfactory definition of the notion involved. Hence the results obtained in discussing one particular semantic notion apply to the general problem of the foundations of theoretical semantics.

Within theoretical semantics we can define and study some further notions, whose intuitive content is more involved and whose semantic origin is less obvious; we have in mind, for instance, the important notions of *consequence, synonymity,* and *meaning.*[20]

We have concerned ourselves here with the theory of semantic notions related to an individual object language (although no specific properties of this language have been involved in our arguments). However, we could also consider the problem of developing *general semantics* which applies to a comprehensive class of object languages. A considerable part of our previous remarks can be extended to this general problem; however, certain new difficulties arise in this connection, which will not be discussed here. I shall merely observe that the axiomatic method (mentioned in section 10) may prove the most appropriate for the treatment of the problem.[21]

Notes and References

1. Compare Tarski [2] (see bibliography). This work may be consulted for a more detailed and formal presentation of the subject of the paper, especially of the material included in sections 6 and 9–13. It contains also references to my earlier publications on the problems of semantics (a communication in Polish, 1930; the article Tarski [1] in French, 1931; a communication in German, 1932; and a book in Polish, 1933). The expository part of the present paper is related in its character to Tarski [3]. My investigations on the notion of truth and on theoretical semantics have been reviewed or discussed in A. Hofstadter [1], B. Juhos [1], M. Kokoszyńska [1] and [2], T. Kotarbiński [2], H. Scholz [1], J. Weinberg [1], et al.

2. It may be hoped that the interest in theoretical semantics will now increase, as a result of the recent publication of the important work Carnap [2].

3. The words 'notion' and 'concept' are used in this paper with all of the vagueness and ambiguity with which they occur in philosophical literature. Thus, sometimes they refer simply to a term, sometimes to what is meant by a term, and in other cases to what is denoted by a term. Sometimes it is

irrelevant which of these interpretations is meant; and in certain cases perhaps none of them applies adequately. While on principle I share the tendency to avoid these words in any exact discussion, I did not consider it necessary to do so in this informal presentation.

4. For our present purposes it is somewhat more convenient to understand by 'expressions', 'sentences', etc., not individual inscriptions, but classes of inscriptions of similar form (thus, not individual physical things, but classes of such things).

5. For the Aristotelian formulation see Aristotle [1], 1', 7, 27. The other two formulations are very common in the literature, but I do not know with whom they originate. A critical discussion of various conceptions of truth can be found, e.g., in Kotarbiński [1] (so far available only in Polish), pp. 123 ff., and Russell [1], pp. 362 ff.

6. For most of the remarks contained in sections 4 and 8, I am indebted to the late S. Leśniewski who developed them in his unpublished lectures at the University of Warsaw (in 1919 and later). However, Leśniewski did not anticipate the possibility of a rigorous development of the theory of truth, and still less of a definition of this notion; hence, while indicating equivalences of the form (T) as premisses in the antinomy of the liar, he did not conceive them as any sufficient conditions for an adequate usage (or definition) of the notion of truth. Also the remarks in section 8 regarding the occurrence of an empirical premiss in the antinomy of the liar, and the possibility of eliminating this premiss, do not originate with him.

7. In connection with various logical and methodological problems involved in this paper the reader may consult Tarski [6].

8. The antinomy of the liar (ascribed to Eubulides or Epimenides) is discussed here in sections 7 and 8. For the antinomy of definability (due to J. Richard), see e.g., D. Hilbert and P. Bernays [1], vol. 2, pp. 263 ff.; for the antinomy of heterological terms, see K. Grelling and L. Nelson [1], p. 307.

9. Due to Professor J. Lukasiewicz (University of Warsaw).

10. See note 6.

11. This can roughly be done in the following way. Let S be any sentence beginning with the words '*Every sentence*'. We correlate with S a new sentence S^* by subjecting S to the following two modifications: we replace in S the first word, '*Every*', by '*The*'; and we insert after the second word, '*sentence*', the whole sentence S enclosed in quotation marks. Let us agree to call the sentence S '(self-)applicable' or 'non-(self-)applicable' dependent on whether the correlated sentence S^* is true or false. Now consider the following sentence:

Every sentence is non-applicable.

It can easily be shown that the sentence just stated must be both applicable and non-applicable; hence a contradiction. It may not be quite clear in what sense this formulation of the antinomy does not involve an empirical premiss; however, I shall not elaborate on this point.

12. The terms 'logic' and 'logical' are used in this paper in a broad sense, which

has become almost traditional in the last decades; logic is assumed here to comprehend the whole theory of classes and relations (i.e., the mathematical theory of sets). For many different reasons I am personally inclined to use the term 'logic' in a much narrower sense, so as to apply it only to what is sometimes called 'elementary logic', i.e., to the sentential calculus and the (restricted) predicate calculus.

13. Cf. here, however, Tarski [3], pp. 5 f.

14. The method of construction we are going to outline can be applied – with appropriate changes – to all formalized languages that are known at the present time; although it does not follow that a language could not be constructed to which this method would not apply.

15. In carrying through this idea a certain technical difficulty arises. A sentential function may contain an arbitrary number of free variables; and the logical nature of the notion of satisfaction varies with this number. Thus, the notion in question when applied to functions with one variable is a binary relation between these functions and single objects; when applied to functions with two variables it becomes a ternary relation between functions and couples of objects; and so on. Hence, strictly speaking, we are confronted, not with one notion of satisfaction, but with infinitely many notions; and it turns out that these notions cannot be defined independently of each other, but must all be introduced simultaneously.

To overcome this difficulty, we employ the mathematical notion of an infinite sequence (or, possibly, of a finite sequence with an arbitrary number of terms). We agree to regard satisfaction, not as a many-termed relation between sentential functions and an indefinite number of objects, but as a binary relation between functions and sequences of objects. Under this assumption the formulation of a general and precise definition of satisfaction no longer presents any difficulty; and a true sentence can now be defined as one which is satisfied by every sequence.

16. To define recursively the notion of satisfaction, we have to apply a certain form of recursive definition which is not admitted in the object language. Hence the 'essential richness' of the metalanguage may simply consist in admitting this type of definition. On the other hand, a general method is known which makes it possible to eliminate all recursive definitions and to replace them by normal, explicit ones. If we try to apply this method to the definition of satisfaction, we see that we have either to introduce into the metalanguage variables of a higher logical type than those which occur in the object language; or else to assume axiomatically in the metalanguage the existence of classes that are more comprehensive than all those whose existence can be established in the object language. See here Tarski [2], pp. 393 ff. and Tarski [5], p. 7.

17. Due to the development of modern logic, the notion of mathematical proof has undergone a far-reaching simplification. A sentence of a given formalized discipline is provable if it can be obtained from the axioms of this discipline by applying certain simple and purely formal rules of

inference, such as those of detachment and substitution. Hence to show that all provable sentences are true, it suffices to prove that all the sentences accepted as axioms are true, and that the rules of inference when applied to true sentences yield new true sentences; and this usually presents no difficulty.

On the other hand, in view of the elementary nature of the notion of provability, a precise definition of this notion requires only rather simple logical devices. In most cases, those logical devices which are available in the formalized discipline itself (to which the notion of provability is related) are more than sufficient for this purpose. We know, however, that as regards the definition of truth just the opposite holds. Hence, as a rule, the notions of truth and provability cannot coincide; and since every provable sentence is true, there must be true sentences which are not provable.

18. Thus the theory of truth provides us with a general method for consistency proofs for formalized mathematical disciplines. It can be easily realized, however, that a consistency proof obtained by this method may possess some intuitive value – i.e., may convince us, or strengthen our belief, that the discipline under consideration is actually consistent – only in case we succeed in defining truth in terms of a metalanguage which does not contain the object language as a part (cf. here a remark in section 9). For only in this case the deductive assumptions of the metalanguage may be intuitively simpler and more obvious than those of the object language – even though the condition of 'essential richness' will be formally satisfied. Cf. here also Tarski [3], p. 7.

The incompleteness of a comprehensive class of formalized disciplines constitutes the essential content of a fundamental theorem of K. Gödel; cf. Gödel [1], pp. 187 ff. The explanation of the fact that the theory of truth leads so directly to Gödel's theorem is rather simple. In deriving Gödel's result from the theory of truth we make an essential use of the fact that the definition of truth cannot be given in a metalanguage which is only as 'rich' as the object language (cf. note 17); however, in establishing this fact, a method of reasoning has been applied which is very closely related to that used (for the first time) by Gödel. It may be added that Gödel was clearly guided in his proof by certain intuitive considerations regarding the notion of truth, although this notion does not occur in the proof explicitly; cf. Gödel [1], pp. 174 f.

19. The notions of designation and definition lead respectively to the antinomies of Grelling and Nelson and Richard (cf. note 8). To obtain an antinomy for the notion of satisfaction, we construct the following expression:

The sentential function X does not satisfy X.

A contradiction arises when we consider the question whether this expression, which is clearly a sentential function, satisfies itself or not.

20. All notions mentioned in this section can be defined in terms of satisfaction. We can say, e.g., that a given term designates a given object if this object satisfies the sentential function 'x is *identical with* T' where 'T' stands for

the given term. Similarly, a sentential function is said to define a given object if the latter is the only object which satisfies this function. For a definition of consequence see Tarski [4], and for that of synonymity – Carnap [2].

21. General semantics is the subject of Carnap [2]. Cf. here also remarks in Tarski [2], pp. 388 f.

Bibliography

Only the books and articles referred to in the paper will be listed here.

Aristotle [1] *Metaphysica* (*Works*, vol. VIII). English translation by W. D. Ross, Oxford, 1908.

Carnap, R. [2] *Introduction to Semantics*, Cambridge, MA: Harvard University Press, 1942.

Gödel, K. [1] 'Über formal unentscheidbare Sätze der *Principia Mathematica* und verwandter Systeme, I', *Monatshefte für Mathematik und Physik*, 38 (1931), pp. 173–98.

Gonseth, F. [1] 'Le Congrès Descartes Questions de Philosophie scientifique', *Revue thomiste*, 44 (1938), pp. 183–93.

Grelling, K. and Nelson, L. [1] 'Bemerkungen zu den Paradoxien von Russell und Burali-Forti', *Abhandlungen der Fries'schen Schule*, 2 (new series) (1908), pp. 301–34.

Hilbert, D. and Bernays, P. [1]) *Grundlagen der Mathematik*, 2 vols, Berlin, pp. 1934–9.

Hofstadter, A. [1] 'On Semantic Problems', *Journal of Philosophy*, 35 (1938), pp. 225–32.

Juhos, B. von. [1] 'The Truth of Empirical Statements', *Analysis*, 4 (1937), pp. 65–70.

Kokoszyńska, M. [1] 'Über den absoluten Wahrheitsbegriff und einige andere semantische Begriffe', *Erkenntnis*, 6 (1936), pp. 143–65.

Kokoszyńska, M. [2] 'Syntax, Semantik und Wissenschaftslogik', *Actes du Congrès International de Philosophie Scientifique*, 3, Paris, 1936, pp. 9–14.

Kotarbiński, T. [1] *Elementy teorji poznania, logiki formalnej i metodologji nauk* (*Elements of Epistemology, Formal Logic, and the Methodology of Sciences*, in Polish), Lwów, 1929.

Kotarbiński, T. [2] 'W sprawie pojęcia prawdy' ('Concerning the Concept of Truth', in Polish), *Przegląd filozoficzny*, 37, pp. 85–91.

Neurath, O. [1] 'Erster Internationaler Kongress für Einheit der Wissenschaft in Paris 1935', *Erkenntnis*, 5 (1935), pp. 377–406.

Russell, B. [1] *An Inquiry Into Meaning and Truth*, London: Allen & Unwin, 1940.

Scholz, H. [1] review of *Studia philosophica*, 1, *Deutsche literaturzeitung*, 58 (1937), pp. 1914–17.

Tarski, A. [1] 'Sur les ensembles définissables de nombres réels. 1', *Fundamenta mathematicae*, 17 (1931), pp. 210–39.

Tarski, A. [2] 'Der Wahrheitsbegriff in den formalisierten Sprachen.' (German

translation of a book in Polish, 1933), *Studia philosophica*, 1 (1935), pp. 261–405.

Tarski, A. [3] 'Grundlegung der wissenschaftlichen Semantik', *Actes du Congrès International de Philosophie Scientifique*, 3, Paris, 1936, pp. 1–8.

Tarski, A. [4] 'Über den Begriff der logischen Folgerung', *Actes du Congrès International de Philosophie Scientifique*, 7, Paris, 1937, pp. 1–11.

Tarski, A. [5] 'On Undecidable Statements in Enlarged Systems of Logic and the Concept of Truth', *Journal of Symbolic Logic*, 4 (1939), pp. 105–12.

Tarski, A. [6] *Introduction to Logic*. New York: Oxford University Press, 1941.

Weinberg, J. [1] review of *Studia philosophica*, vol. 1, *Philosophical Review*, 47, pp. 70–7.

4

RUDOLF CARNAP

(1891–1970)

The German philosopher and logician Rudolf Carnap was born in Ronsdorf in Germany and studied at the universities of Freiburg and Jena where he was taught by Frege. In 1926 he took a teaching post at the University of Vienna and soon became one of the most important figures of the Vienna Circle. In 1929 Carnap, together with Otto Neurath and Hans Hahn, produced the Circle's manifesto: *The scientific conception of the world: the Vienna Circle*. He also co-founded, with Hans Reichenbach, the journal *Erkenntnis* – the organ of the Circle. With the deterioration of the political climate in Austria and Germany, Carnap fled to the United States in 1935 and took up a Chair at the University of Chicago in 1936, where he became not only a direct link between the European analytic revolution and its American incarnation, but also one of the most influential figures in the development of philosophy in America in the second half of the twentieth century.

The Vienna Circle was a group of like-minded philosophers, mathematicians and scientists, including Freidrich Waismann, Herbert Feigl, Otto Neurath, Hans Hahn and Rudolf Carnap, who, under the leadership of Moritz Schlick, attempted to effect a revolution in philosophy by freeing it from all vestiges of metaphysical thinking and establishing it on a rigorously scientific basis. They were greatly influenced by empiricism as well as more recent developments in philosophy and logic, by Russell and Whitehead's *Principia Mathematica* and Wittgenstein's *Tractatus* in particular. The main tenets of the Vienna Circle thinking were:

(a) A theory of meaning or cognitive significance to the effect that sentences are meaningful only if they are either analytic, and hence true by definition, or verifiable by sense data. The principle of verification, that the meaning of a sentence is the method of its verification, was to provide a clear distinguishing line between sense and non-sense, or science and pseudo-science (and metaphysics).

(b) A complete rejection of metaphysics and speculative philosophy. According to the logical positivists metaphysical speculations should be rejected not because they are false but because they are non-sensical.

(c) The thesis that all sciences can be unified under a single discipline, physics, and that there is no important distinction between the natural and human sciences.

(d) The view that truths of logic and mathematics are analytic and hence tautologous and can therefore be established a priori (without any empirical tests). This view was based on wholesale acceptance by the logical positivists of the analytic–synthetic distinction.

In his first major work, *Der Logische Aufbau der Welt* (1928), Carnap developed the view common to other members of the Vienna Circle of the time, that all meaningful synthetic statements can be reduced to, or translated into, statements about our immediate sense experiences. In his later writings, however, he modified this original position and accepted that the language of empirical sciences is not fully reducible to the language of sense experience. None the less, he maintained that statements of physics can be partly defined by means of 'reduction sentences', or 'operational definitions', and 'observation sentences', whose truth can be ascertained by direct observation.

Carnap, in a Wittgensteinian spirit, also believed that philosophical perplexities can arise out of a misuse of language and that the correct logical analysis of language can help philosophers to overcome philosophical misunderstandings. To this end he attempted to construct artificial languages that are formulated in logical symbolism and have rigorously defined syntactic and semantic rules. (See Carnap, *The Logical Syntax of Language*, 1937, and *Meaning and Necessity*, 1947.) Carnap's later work shows a shift of focus from a preoccupation with syntactical questions to a concern with semantics; a transition that came about under the influence of the work of Alfred Tarski (see chapter 3).

The following paper, which was included in the enlarged edition of *Meaning and Necessity*, presents Carnap's most mature thinking on the issues that had preoccupied the logical positivists for over forty years. The paper initially addresses the difficult question of the existence of abstract entities such as numbers, properties, propositions. Carnap argues that the way to avoid philosophical pseudo-problems is to distinguish between internal and external questions about the existence of such entities. Seemingly deep philosophical questions about the properties, and the existence, of individual entities can be answered only internally to a given form of language. For instance, our common-sense framework allows us to answer questions about chairs, tables, and suchlike; the framework of theoretical physics is the suitable forum for

deciding on questions about subatomic particles; a system of numbers, on the other hand, allows us to talk about the properties of natural numbers. We adopt one or other of these frameworks based on pragmatic considerations, such as their usefulness, fruitfulness, simplicity, etc., in relation to the aims of our enquiry. Questions about the ontological status or the very existence of the totality of things or numbers are external ones. They concern the framework of a discourse or conceptual scheme; thus they are not factual questions and do not have an empirical content. According to Carnap, once the criterion of what is acceptable to a framework or conceptual system has been settled, then whether that criterion has been satisfied or not is decided internally, within the parameters set by that particular discourse.

Carnap's distinction between external and internal questions stems from his conventionalism about logic or the 'linguistic framework'. Our choice of logical principles is to be justified on pragmatic grounds only and should be based on what he calls 'the principle of tolerance', according to which all theoretical positions may be considered and then accepted or rejected on the basis of their ability to resolve intellectual conflicts and their usefulness for the purpose of enquiry at hand.

The development of philosophy of language in America in the past fifty years has been shaped by both positive and critical reactions to Carnap's work. This is particularly true of the writings of W. V. O. Quine, the most influential American philosopher of the twentieth century and the subject of chapter 8.

Works by Carnap

1931 'The Logicist Foundations of Mathematics', *Erkenntnis*, 2, pp. 91–105.
1936 and 1937 'Testability and Meaning', *Philosophy of Science*, vols 3 and 4.
1937 *The Logical Syntax of Language*. London: Kegan Paul; New York: Harcourt Brace Jovanovich.
1947; 2nd enl. edn, 1956 *Meaning and Necessity*. Chicago: University of Chicago Press.
1967 *The Logical Structure of the World: Pseudoproblems in Philosophy*. London: Kegan Paul; Berkeley: University of California Press.

Works on Carnap

Ayer, A. J. (ed.), *Logical Positivism*. London: Allen & Unwin; New York: Free Press, 1959.
Buck, Roger C. and Cohen, Robert S. (eds), *In Memory of Rudolf Carnap*. Dordrecht: Reidel, 1971.

Schilpp, P. A. (ed.), *The Philosophy of Rudolf Carnap*. La Salle, IL: Open Court, 1963.

Coffa, Alberto J., *The Semantic Tradition from Kant to Carnap: To the Vienna Station*. Cambridge: Cambridge University Press, 1991.

Greath, R. (ed.), *Dear Carnap, Dear Van: The Quine–Carnap Correspondence and Related Work*. Berkeley: University of California Press, 1990.

Hanfling, Oswald, *Logical Positivism*. Oxford: Blackwell; New York: Columbia University Press, 1981.

Empiricism, Semantics, and Ontology

1. The Problem of Abstract Entities

Empiricists are in general rather suspicious with respect to any kind of abstract entities like properties, classes, relations, numbers, propositions, etc. They usually feel much more in sympathy with nominalists than with realists (in the medieval sense). As far as possible they try to avoid any reference to abstract entities and to restrict themselves to what is sometimes called a nominalistic language, i.e., one not containing such references. However, within certain scientific contexts it seems hardly possible to avoid them. In the case of mathematics, some empiricists try to find a way out by treating the whole of mathematics as a mere calculus, a formal system for which no interpretation is given or can be given. Accordingly, the mathematician is said to speak not about numbers, functions, and infinite classes, but merely about meaningless symbols and formulas manipulated according to given formal rules. In physics it is more difficult to shun the suspected entities, because the language of physics serves for the communication of reports and predictions and hence cannot be taken as a mere calculus. A physicist who is suspicious of abstract entities may perhaps try to declare a certain part of the language of physics as uninterpreted and uninterpretable, that part which refers to real numbers as space-time coordinates or as values of physical magnitudes, to functions, limits, etc. More probably he will just speak about all these things like anybody else but with an uneasy conscience, like a man who in his everyday life does with qualms many things which are not in accord with the high moral principles he professes on Sundays. Recently the problem of abstract entities has arisen again in connection with semantics, the theory of meaning and truth. Some semanticists say that certain expressions designate certain entities, and among these designated entities they include not only concrete material things but also abstract entities, e.g., properties as designated by predicates and

propositions as designated by sentences.[1] Others object strongly to this procedure as violating the basic principles of empiricism and leading back to a metaphysical ontology of the Platonic kind.

It is the purpose of this article to clarify this controversial issue. The nature and implications of the acceptance of a language referring to abstract entities will first be discussed in general; it will be shown that using such a language does not imply embracing a Platonic ontology but is perfectly compatible with empiricism and strictly scientific thinking. Then the special question of the role of abstract entities in semantics will be discussed. It is hoped that the clarification of the issue will be useful to those who would like to accept abstract entities in their work in mathematics, physics, semantics, or any other field; it may help them to overcome nominalistic scruples.

2. Linguistic Frameworks

Are there properties, classes, numbers, propositions? In order to understand more clearly the nature of these and related problems, it is above all necessary to recognize a fundamental distinction between two kinds of questions concerning the existence or reality of entities. If someone wishes to speak in his language about a new kind of entities, he has to introduce a system of new ways of speaking, subject to new rules; we shall call this procedure the construction of a linguistic *framework* for the new entities in question. And now we must distinguish two kinds of questions of existence: first, questions of the existence of certain entities of the new kind *within the framework*; we call them *internal questions*; and second, questions concerning the existence or reality *of the system of entities as a whole*, called *external questions*. Internal questions and possible answers to them are formulated with the help of the new forms of expressions. The answers may be found either by purely logical methods or by empirical methods, depending upon whether the framework is a logical or a factual one. An external question is of a problematic character which is in need of closer examination.

The World of Things

Let us consider as an example the simplest kind of entities dealt with in the everyday language: the spatio-temporally ordered system of observable things and events. Once we have accepted the *thing* language with its framework for things, we can raise and answer internal questions, e.g., 'Is there a white piece of paper on my desk?', 'Did King Arthur actually live?', 'Are unicorns and centaurs real or merely imaginary?', and the like. These questions are to be answered by empirical investigations.

Results of observations are evaluated according to certain rules as con-
firming or disconfirming evidence for possible answers. (This evaluation
is usually carried out, of course, as a matter of habit rather than a
deliberate, rational procedure. But it is possible, in a rational recon-
struction, to lay down explicit rules for the evaluation. This is one of the
main tasks of a pure, as distinguished from a psychological,
epistemology.) The concept of reality occurring in these internal questions
is an empirical, scientific, nonmetaphysical concept. To recognize some-
thing as a real thing or event means to succeed in incorporating it into
the system of things at a particular space–time position so that it fits
together with the other things recognized as real, according to the rules
of the framework.

From these questions we must distinguish the external question of the
reality of the thing world itself. In contrast to the former questions, this
question is raised neither by the man in the street nor by scientists, but
only by philosophers. Realists give an affirmative answer, subjective
idealists a negative one, and the controversy goes on for centuries without
ever being solved. And it cannot be solved because it is framed in a
wrong way. To be real in the scientific sense means to be an element of
the system; hence this concept cannot be meaningfully applied to the
system itself. Those who raise the question of the reality of the thing
world itself have perhaps in mind not a theoretical question, as their
formulation seems to suggest, but rather a *practical* question, a matter
of a practical decision concerning the structure of our language. We have
to make the choice whether or not to accept and use the forms of
expression in the framework in question.

In the case of this particular example, there is usually no deliberate
choice because we all have accepted the thing language early in our lives
as a matter of course. Nevertheless, we may regard it as a matter of
decision in this sense: we are free to choose to continue using the thing
language or not; in the latter case we could restrict ourselves to a language
of sense data and other 'phenomenal' entities, or construct an alternative
to the customary thing language with another structure, or, finally, we
could refrain from speaking. If someone decides to accept the thing
language there is no objection against saying that he has accepted the
world of things. But this must not be interpreted as if it meant his
acceptance of a *belief* in the reality of the thing world: there is no such
belief or assertion or assumption, because it is not a theoretical question.
To accept the thing world means nothing more than to accept a certain
form of language, in other words, to accept rules for forming statements
and for testing, accepting, or rejecting them. The acceptance of the thing
language leads, on the basis of observations made, also to the acceptance,

belief, and assertion of certain statements. But the thesis of the reality of the thing world cannot be among these statements, because it cannot be formulated in the thing language or, it seems, in any other theoretical language.

The decision of accepting the thing language, although itself not of a cognitive nature, will nevertheless usually be influenced by theoretical knowledge, just like any other deliberate decision concerning the acceptance of linguistic or other rules. The purposes for which the language is intended to be used, for instance, the purpose of communicating factual knowledge, will determine which factors are relevant for the decision. The efficiency, fruitfulness, and simplicity of the use of the thing language may be among the decisive factors. And the questions concerning these qualities are indeed of a theoretical nature. But these questions cannot be identified with the question of realism. They are not yes–no questions but questions of degree. The thing language in the customary form works indeed with a high degree of efficiency for most purposes of everyday life. This is a matter of fact, based upon the content of our experiences. However, it would be wrong to describe this situation by saying: 'The fact of the efficiency of the thing language is confirming evidence for the reality of the thing world'; we should rather say instead: 'This fact makes it advisable to accept the thing language.'

The System of Numbers

As an example of a system which is of a logical rather than a factual nature let us take the system of natural numbers. The framework for this system is constructed by introducing into the language new expressions with suitable rules; (1) numerals like 'five' and sentence forms like 'There are five books on the table'; (2) the general term 'number' for the new entities, and sentence forms like 'Five is a number'; (3) expressions for properties of numbers (e.g., 'odd', 'prime'), relations (e.g., 'greater than'), and functions (e.g., 'plus'), and sentence forms like 'Two plus three is five'; (4) numerical variables ('m,' 'n,' etc.) and quantifiers for universal sentences ('for every n, ...') and existential sentences ('There is an n such that ...') with the customary deductive rules.

Here again there are internal questions, e.g., 'Is there a prime number greater than a hundred?' Here, however, the answers are found, not by empirical investigation based on observations, but by logical analysis based on the rules for the new expressions. Therefore the answers are here analytic, i.e., logically true.

What is now the nature of the philosophical question concerning the existence or reality of numbers? To begin with, there is the internal

question which, together with the affirmative answer, can be formulated in the new terms, say, by 'There are numbers' or, more explicitly, 'There is an n such that n is a number'. This statement follows from the analytic statement 'Five is a number' and is therefore itself analytic. Moreover, it is rather trivial (in contradistinction to a statement like 'There is a prime number greater than a million', which is likewise analytic but far from trivial), because it does not say more than that the new system is not empty; but this is immediately seen from the rule which states that words like 'five' are substitutable for the new variables. Therefore nobody who meant the question 'Are there numbers?' in the internal sense would either assert or even seriously consider a negative answer. This makes it plausible to assume that those philosophers who treat the question of the existence of numbers as a serious philosophical problem and offer lengthy arguments on either side do not have in mind the internal question. And, indeed, if we were to ask them: 'Do you mean the question as to whether the framework of numbers, *if* we were to accept it, would be found to be empty or not?', they would probably reply: 'Not at all; we mean a question *prior* to the acceptance of the new framework'. They might try to explain what they mean by saying that it is a question of the ontological status of numbers; the question whether or not numbers have a certain metaphysical characteristic called reality (but a kind of ideal reality, different from the material reality of the thing world) or subsistence or status of 'independent entities'. Unfortunately, these philosophers have so far not given a formulation of their question in terms of the common scientific language. Therefore our judgement must be that they have not succeeded in giving to the external question and to the possible answers any cognitive content. Unless and until they supply a clear cognitive interpretation, we are justified in our suspicion that their question is a pseudo-question, that is, one disguised in the form of a theoretical question while in fact it is nontheoretical; in the present case it is the practical problem whether or not to incorporate into the language the new linguistic forms which constitute the framework of numbers.

The System of Propositions

New variables, 'p', 'q', etc., are introduced with a rule to the effect that any (declarative) sentence may be substituted for a variable of this kind; this includes, in addition to the sentences of the original thing language, also all general sentences with variables of any kind which may have been introduced into the language. Further, the general term 'proposition', is introduced. 'p is a proposition' may be defined by 'p or not p' (or by any other sentence form yielding only analytic sentences). Therefore, every

sentence of the form '. . . is a proposition' (where any sentence may stand in the place of the dots) is analytic. This holds, for example, for the sentence:

(a) 'Chicago is large is a proposition'.

(We disregard here the fact that the rules of English grammar require not a sentence but a that-clause as the subject of another sentence; accordingly, instead of (a) we should have to say 'That Chicago is large is a proposition'.) Predicates may be admitted whose argument expressions are sentences; these predicates may be either extensional (e.g., the customary truth-functional connectives) or not (e.g., modal predicates like 'possible', 'necessary', etc.). With the help of the new variables, general sentences may be formed, e.g.,

(b) 'For every p, either p or not-p.'
(c) 'There is a p such that p is not necessary and not-p is not necessary.'
(d) 'There is a p such that p is a proposition.'

(c) and (d) are internal assertions of existence. The statement 'There are propositions' may be meant in the sense of (d); in this case it is analytic (since it follows from (a)) and even trivial. If, however, the statement is meant in an external sense, then it is noncognitive. It is important to notice that the system of rules for the linguistic expressions of the propositional framework (of which only a few rules have here been briefly indicated) is sufficient for the introduction of the framework. Any further explanations as to the nature of the propositions (i.e., the elements of the system indicated, the values of the variables 'p', 'q', etc.) are theoretically unnecessary because, if correct, they follow from the rules. For example, are propositions mental events (as in Russell's theory)? A look at the rules shows us that they are not, because otherwise existential statements would be of the form: 'If the mental state of the person in question fulfills such and such conditions, then there is a p such that . . .' The fact that no references to mental conditions occur in existential statements (like (c), (d), etc.) shows that propositions are not mental entities. Further, a statement of the existence of linguistic entities (e.g., expressions, classes of expressions, etc.) must contain a reference to a language. The fact that no such reference occurs in the existential statements here, shows that propositions are not linguistic entities. The fact that in these statements no reference to a subject (an observer or knower) occurs (nothing like: 'There is a p which is necessary for Mr X') shows that the propositions (and their properties, like necessity, etc.) are not subjective. Although characterizations of these or similar kinds are, strictly speaking, unnecessary, they may nevertheless be

practically useful. If they are given, they should be understood, not as ingredient parts of the system, but merely as marginal notes with the purpose of supplying to the reader helpful hints or convenient pictorial associations which may make his learning of the use of the expressions easier than the bare system of the rules would do. Such a characterization is analogous to an extrasystematic explanation which a physicist sometimes gives to the beginner. He might, for example, tell him to imagine the atoms of a gas as small balls rushing around with great speed, or the electromagnetic field and its oscillations as quasi-elastic tensions and vibrations in an ether. In fact, however, all that can accurately be said about atoms or the field is implicitly contained in the physical laws of the theories in question.[2]

The System of Thing Properties
The thing language contains words like 'red', 'hard', 'stone', 'house', etc., which are used for describing what things are like. Now we may introduce new variables, say 'f' 'g', etc., for which those words are substitutable and furthermore the general term 'property'. New rules are laid down which admit sentences like 'Red is a property', 'Red is a color', 'These two pieces of paper have at least one color in common' (i.e., 'There is an f such that f is a color, and ...'). The last sentence is an internal assertion. It is of an empirical, factual nature. However, the external statement, the philosophical statement of the reality of properties – a special case of the thesis of the reality of universals – is devoid of cognitive content.

The Systems of Integers and Rational Numbers
Into a language containing the framework of natural numbers we may introduce first the (positive and negative) integers as relations among natural numbers and then the rational numbers as relations among integers. This involves introducing new types of variables, expressions substitutable for them, and the general terms 'integer' and 'rational number'.

The System of Real Numbers
On the basis of the rational numbers, the real numbers may be introduced as classes of a special kind (segments) of rational numbers (according to the method developed by Dedekind and Frege). Here again a new type of variables is introduced, expressions substitutable for them (e.g., '$\sqrt{2}$') and the general term 'real number'.

The Spatio-Temporal Coordinate System for Physics

The new entities are the space–time points. Each is an ordered quadruple of four real numbers, called its coordinates, consisting of three spatial and one temporal coordinates. The physical state of a spatio-temporal point or region is described either with the help of qualitative predicates (e.g., 'hot') or by ascribing numbers as values of a physical magnitude (e.g., mass, temperature, and the like). The step from the system of things (which does not contain space–time points but only extended objects with spatial and temporal relations between them) to the physical coordinate system is again a matter of decision. Our choice of certain features, although itself not theoretical, is suggested by theoretical knowledge, either logical or factual. For example, the choice of real numbers rather than rational numbers or integers as coordinates is not much influenced by the facts of experience but mainly due to considerations of mathematical simplicity. The restriction to rational coordinates would not be in conflict with any experimental knowledge we have, because the result of any measurement is a rational number. However, it would prevent the use of ordinary geometry (which says, e.g., that the diagonal of a square with the side 1 has the irrational value $\sqrt{2}$) and thus lead to great complications. On the other hand, the decision to use three rather than two or four spatial coordinates is strongly suggested, but still not forced upon us, by the result of common observations. If certain events allegedly observed in spiritualistic séances, e.g., a ball moving out of a sealed box, were confirmed beyond any reasonable doubt, it might seem advisable to use four spatial coordinates. Internal questions are here, in general, empirical questions to be answered by empirical investigations. On the other hand, the external questions of the reality of physical space and physical time are pseudo-questions. A question like 'Are there (really) space–time points?' is ambiguous. It may be meant as an internal question; then the affirmative answer is, of course, analytic and trivial. Or it may be meant in the external sense: 'Shall we introduce such and such forms into our language?'; in this case it is not a theoretical but a practical question, a matter of decision rather than assertion, and hence the proposed formulation would be misleading. Or finally, it may be meant in the following sense: 'Are our experiences such that the use of the linguistic forms in question will be expedient and fruitful?' This is a theoretical question of a factual, empirical nature. But it concerns a matter of degree; therefore a formulation in the form 'real or not?' would be inadequate.

3. What Does Acceptance of a Kind of Entities Mean?

Let us now summarize the essential characteristics of situations involving the introduction of a new kind of entities, characteristics which are common to the various examples outlined above.

The acceptance of a new kind of entities is represented in the language by the introduction of a framework of new forms of expressions to be used according to a new set of rules. There may be new names for particular entities of the kind in question; but some such names may already occur in the language before the introduction of the new framework. (Thus, for example, the thing language contains certainly words of the type of 'blue' and 'house' before the framework of properties is introduced; and it may contain words like 'ten' in sentences of the form 'I have ten fingers' before the framework of numbers is introduced.) The latter fact shows that the occurrence of constants of the type in question – regarded as names of entities of the new kind after the new framework is introduced – is not a sure sign of the acceptance of the new kind of entities. Therefore the introduction of such constants is not to be regarded as an essential step in the introduction of the framework. The two essential steps are rather the following. First, the introduction of a general term, a predicate of higher level, for the new kind of entities, permitting us to say of any particular entity that it belongs to this kind (e.g., 'Red is a *property*', 'Five is a *number*'). Second, the introduction of variables of the new type. The new entities are values of these variables; the constants (and the closed compound expressions, if any) are substitutable for the variables.[3] With the help of the variables, general sentences concerning the new entities can be formulated.

After the new forms are introduced into the language, it is possible to formulate with their help internal questions and possible answers to them. A question of this kind may be either empirical or logical; accordingly a true answer is either factually true or analytic.

From the internal questions we must clearly distinguish external questions, i.e., philosophical questions concerning the existence or reality of the total system of the new entities. Many philosophers regard a question of this kind as an ontological question which must be raised and answered *before* the introduction of the new language forms. The latter introduction, they believe, is legitimate only if it can be justified by an ontological insight supplying an affirmative answer to the question of reality. In contrast to this view, we take the position that the introduction of the new ways of speaking does not need any theoretical justification because it does not imply any assertion of reality. We may still speak (and have done so) of 'the acceptance of the new entities' since this form

of speech is customary; but one must keep in mind that this phrase does not mean for us anything more than acceptance of the new framework, i.e., of the new linguistic forms. Above all, it must not be interpreted as referring to an assumption, belief, or assertion of 'the reality of the entities'. There is no such assertion. An alleged statement of the reality of the system of entities is a pseudo-statement without cognitive content. To be sure, we have to face at this point an important question; but it is a practical, not a theoretical question; it is the question of whether or not to accept the new linguistic forms. The acceptance cannot be judged as being either true or false because it is not an assertion. It can only be judged as being more or less expedient, fruitful, conducive to the aim for which the language is intended. Judgements of this kind supply the motivation for the decision of accepting or rejecting the kind of entities.[4]

Thus it is clear that the acceptance of a linguistic framework must not be regarded as implying a metaphysical doctrine concerning the reality of the entities in question. It seems to me due to neglect of this important distinction that some contemporary nominalists label the admission of variables of abstract types as 'Platonism.'[5] This is, to say the least, an extremely misleading terminology. It leads to the absurd consequence that the position of everybody who accepts the language of physics with its real number variables (as a language of communication, not merely as a calculus) would be called Platonistic, even if he is a strict empiricist who rejects Platonic metaphysics.

A brief historical remark may here be inserted. The non-cognitive character of the questions which we have called here external questions was recognized and emphasized already by the Vienna Circle under the leadership of Moritz Schlick, the group from which the movement of logical empiricism originated. Influenced by ideas of Ludwig Wittgenstein, the Circle rejected both the thesis of the reality of the external world and the thesis of its irreality as pseudo-statements,[6] the same was the case for both the thesis of the reality of universals (abstract entities, in our present terminology) and the nominalistic thesis that they are not real and that their alleged names are not names of anything but merely *flatus vocis*. (It is obvious that the apparent negation of a pseudo-statement must also be a pseudo-statement.) It is therefore not correct to classify the members of the Vienna Circle as nominalists, as is sometimes done. However, if we look at the basic anti-metaphysical and pro-scientific attitude of most nominalists (and the same holds for many materialists and realists in the modern sense), disregarding their occasional pseudo-theoretical formulations, then it is, of course, true to say that the Vienna Circle was much closer to those philosophers than to their opponents.

4. Abstract Entities in Semantics

The problem of the legitimacy and the status of abstract entities has recently again led to controversial discussions in connection with semantics. In a semantical meaning analysis certain expressions in a language are often said to designate (or name or denote or signify or refer to) certain extralinguistic entities.[7] As long as physical things or events (e.g., Chicago or Caesar's death) are taken as designata (entities designated), no serious doubts arise. But strong objections have been raised, especially by some empiricists, against abstract entities as designata, e.g., against semantical statements of the following kind:

(1) 'The word "red" designates a property of things';
(2) 'The word "color" designates a property of properties of things';
(3) 'The word "five" designates a number';
(4) 'The word "odd" designates a property of numbers';
(5) 'The sentence "Chicago is large" designates a proposition'.

Those who criticize these statements do not, of course, reject the use of the expressions in question, like 'red' or 'five'; nor would they deny that these expressions are meaningful. But to be meaningful, they would say, is not the same as having a meaning in the sense of an entity designated. They reject the belief, which they regard as implicitly presupposed by those semantical statements, that to each expression of the types in question (adjectives like 'red', numerals like 'five', etc.) there is a particular real entity to which the expression stands in the relation of designation. This belief is rejected as incompatible with the basic principles of empiricism or of scientific thinking. Derogatory labels like 'Platonic realism', 'hypostatization', or ' "Fido"-Fido principle' are attached to it. The latter is the name given by Gilbert Ryle (in his review of my *Meaning and Necessity* [*Philosophy*, 24 (1949), pp. 69–76]) to the criticized belief, which, in his view, arises by a naïve inference of analogy: just as there is an entity well known to me, viz., my dog Fido, which is designated by the name 'Fido', thus there must be for every meaningful expression a particular entity to which it stands in the relation of designation or naming, i.e., the relation exemplified by 'Fido'-Fido. The belief criticized is thus a case of hypostatization, i.e., of treating as names expressions which are not names. While 'Fido' is a name, expressions like 'red', 'five', etc., are said not to be names, not to designate anything.

Our previous discussion concerning the acceptance of frameworks enables us now to clarify the situation with respect to abstract entities as designata. Let us take as an example the statement:

(a) ' "Five" designates a number.'

The formulation of this statement presupposes that our language L contains the forms of expressions which we have called the framework of numbers, in particular, numerical variables and the general term 'number'. If L contains these forms, the following is an analytic statement in L:

(b) 'Five is a number.'

Further, to make the statement (a) possible, L must contain an expression like 'designates' or 'is a name of' for the semantical relation of designation. If suitable rules for this term are laid down, the following is likewise analytic:

(c) ' "Five" designates five.'

(Generally speaking, any expression of the form ' "..." designates ...' is an analytic statement provided the term '...' is a constant in an accepted framework. If the latter condition is not fulfilled, the expression is not a statement.) Since (a) follows from (c) and (b), (a) is likewise analytic.

Thus it is clear that *if* someone accepts the framework of numbers, then he must acknowledge (c) and (b) and hence (a) as true statements. Generally speaking, if someone accepts a framework for a certain kind of entities, then he is bound to admit the entities as possible designata. Thus the question of the admissibility of entities of a certain type or of abstract entities in general as designata is reduced to the question of the acceptability of the linguistic framework for those entities. Both the nominalistic critics, who refuse the status of designators or names to expressions like 'red', 'five', etc., because they deny the existence of abstract entities and the skeptics, who express doubts concerning the existence and demand evidence for it, treat the question of existence as a theoretical question. They do not, of course, mean the internal question; the affirmative answer to *this* question is analytic and trivial and too obvious for doubt or denial, as we have seen. Their doubts refer rather to the system of entities itself; hence they mean the external question. They believe that only after making sure that there really is a system of entities of the kind in question are we justified in accepting the framework by incorporating the linguistic forms into our language. However, we have seen that the external question is not a theoretical question but rather the practical question whether or not to accept those linguistic forms. This acceptance is not in need of a theoretical justification (except with respect to expediency and fruitfulness), because it does not imply a belief or assertion. Ryle says that the 'Fido'-Fido principle is 'a grotesque theory'. Grotesque or not, Ryle is wrong in calling it a theory. It is rather the practical decision to accept certain frameworks. Maybe Ryle is

historically right with respect to those whom he mentions as previous representatives of the principle, viz., John Stuart Mill, Frege, and Russell. If these philosophers regarded the acceptance of a system of entities as a theory, an assertion, they were victims of the same old, metaphysical confusion. But it is certainly wrong to regard *my* semantical method as involving a belief in the reality of abstract entities, since I reject a thesis of this kind as a metaphysical pseudo-statement.

The critics of the use of abstract entities in semantics overlook the fundamental difference between the acceptance of a system of entities and an internal assertion, e.g., an assertion that there are elephants or electrons or prime numbers greater than a million. Whoever makes an internal assertion is certainly obliged to justify it by providing evidence, empirical evidence in the case of electrons, logical proof in the case of the prime numbers. The demand for a theoretical justification, correct in the case of internal assertions, is sometimes wrongly applied to the acceptance of a system of entities. Thus, for example, Ernest Nagel (in his review of my *Meaning and Necessity* [*Journal of Philosophy*, 45 (1948), pp. 467–72]) asks for 'evidence relevant for affirming with warrant that there are such entities as infinitesimals or propositions'. He characterizes the evidence required in these cases – in distinction to the empirical evidence in the case of electrons – as 'in the broad sense logical and dialectical'. Beyond this no hint is given as to what might be regarded as relevant evidence. Some nominalists regard the acceptance of abstract entities as a kind of superstition or myth, populating the world with fictitious or at least dubious entities, analogous to the belief in centaurs or demons. This shows again the confusion mentioned, because a superstition or myth is a false (or dubious) internal statement.

Let us take as example the natural numbers as cardinal numbers, i.e., in contexts like 'Here are three books'. The linguistic forms of the framework of numbers, including variables and the general term 'number', are generally used in our common language of communication; and it is easy to formulate explicit rules for their use. Thus the logical characteristics of this framework are sufficiently clear (while many internal questions, i.e., arithmetical questions, are, of course, still open). In spite of this, the controversy concerning the external question of the ontological reality of the system of numbers continues. Suppose that one philosopher says: 'I believe that there are numbers as real entities. This gives me the right to use the linguistic forms of the numerical framework and to make semantical statements about numbers as designata of numerals.' His nominalistic opponent replies: 'You are wrong: there are no numbers. The numerals may still be used as meaningful expressions. But they are not names, there are no entities designated by them. There-

fore the word "number" and numerical variables must not be used (unless a way were found to introduce them as merely abbreviating devices, a way of translating them into the nominalistic thing language).' I cannot think of any possible evidence that would be regarded as relevant by both philosophers, and therefore, if actually found, would decide the controversy or at least make one of the opposite theses more probable than the other. (To construe the numbers as classes or properties of the second level, according to the Frege–Russell method, does not, of course, solve the controversy, because the first philosopher would affirm and the second deny the existence of the system of classes or properties of the second level.) Therefore I feel compelled to regard the external question as a pseudo-question, until both parties to the controversy offer a common interpretation of the question as a cognitive question; this would involve an indication of possible evidence regarded as relevant by both sides.

There is a particular kind of misinterpretation of the acceptance of abstract entities in various fields of science and in semantics, that needs to be cleared up. Certain early British empiricists (e.g., Berkeley and Hume) denied the existence of abstract entities on the ground that immediate experience presents us only with particulars, not with universals, e.g., with this red patch, but not with Redness or Color-in-General; with this scalene triangle, but not with Scalene Triangularity or Triangularity-in-General. Only entities belonging to a type of which examples were to be found within immediate experience could be accepted as ultimate constituents of reality. Thus, according to this way of thinking, the existence of abstract entities could be asserted only if one could show either that some abstract entities fall within the given, or that abstract entities can be defined in terms of the types of entity which are given. Since these empiricists found no abstract entities within the realm of sense data, they either denied their existence, or else made a futile attempt to define universals in terms of particulars. Some contemporary philosophers, especially English philosophers following Bertrand Russell, think in basically similar terms. They emphasize a distinction between the data (that which is immediately given in consciousness, e.g., sense data, immediately past experiences, etc.) and the constructs based on the data. Existence or reality is ascribed only to the data; the constructs are not real entities; the corresponding linguistic expressions are merely ways of speech not actually designating anything (reminiscent of the nominalists' *flatus vocis*). We shall not criticize here this general conception. (As far as it is a principle of accepting certain entities and not accepting others, leaving aside any ontological, phenomenalistic, and nominalistic pseudo-statements, there cannot be any

theoretical objection to it.) But if this conception leads to the view that other philosophers or scientists who accept abstract entities thereby assert or imply their occurrence as immediate data, then such a view must be rejected as a misinterpretation. References to space–time points, the electromagnetic field, or electrons in physics, to real or complex numbers and their functions in mathematics, to the excitatory potential or unconscious complexes in psychology, to an inflationary trend in economics, and the like, do not imply the assertion that entities of these kinds occur as immediate data. And the same holds for references to abstract entities as designata in semantics. Some of the criticisms by English philosophers against such references give the impression that, probably due to the misinterpretation just indicated, they accuse the semanticist not so much of bad metaphysics (as some nominalists would do) but of bad psychology. The fact that they regard a semantical method involving abstract entities not merely as doubtful and perhaps wrong, but as manifestly absurd, preposterous, and grotesque, and that they show a deep horror and indignation against this method, is perhaps to be explained by a misinterpretation of the kind described. In fact, of course, the semanticist does not in the least assert or imply that the abstract entities to which he refers can be experienced as immediately given either by sensation or by a kind of rational intuition. An assertion of this kind would indeed be very dubious psychology. The psychological question as to which kind of entities do and which do not occur as immediate data is entirely irrelevant for semantics, just as it is for physics, mathematics, economics, etc., with respect to the examples mentioned above.[8]

5. Conclusion

For those who want to develop or use semantical methods, the decisive question is not the alleged ontological question of the existence of abstract entities but rather the question whether the use of abstract linguistic forms or, in technical terms, the use of variables beyond those for things (or phenomenal data), is expedient and fruitful for the purposes for which semantical analyses are made, viz., the analysis, interpretation, clarification, or construction of languages of communication, especially languages of science. This question is here neither decided nor even discussed. It is not a question simply of yes or no, but a matter of degree. Among those philosophers who have carried out semantical analyses and thought about suitable tools for this work, beginning with Plato and Aristotle and, in a more technical way on the basis of modern logic, with C. S. Peirce and Frege, a great majority accepted abstract entities. This

does not, of course, prove the case. After all, semantics in the technical sense is still in the initial phases of its development, and we must be prepared for possible fundamental changes in methods. Let us therefore admit that the nominalistic critics may possibly be right. But if so, they will have to offer better arguments than they have so far. Appeal to ontological insight will not carry much weight. The critics will have to show that it is possible to construct a semantical method which avoids all references to abstract entities and achieves by simpler means essentially the same results as the other methods.

The acceptance or rejection of abstract linguistic forms, just as the acceptance or rejection of any other linguistic forms in any branch of science, will finally be decided by their efficiency as instruments, the ratio of the results achieved to the amount and complexity of the efforts required. To decree dogmatic prohibitions of certain linguistic forms instead of testing them by their success or failure in practical use, is worse than futile; it is positively harmful because it may obstruct scientific progress. The history of science shows examples of such prohibitions based on prejudices deriving from religious, mythological, metaphysical, or other irrational sources, which slowed up the developments for shorter or longer periods of time. Let us learn from the lessons of history. Let us grant to those who work in any special field of investigation the freedom to use any form of expression which seems useful to them; the work in the field will sooner or later lead to the elimination of those forms which have no useful function. *Let us be cautious in making assertions and critical in examining them, but tolerant in permitting linguistic forms.*

Notes and References

1. The terms 'sentence' and 'statement' are here used synonymously for declarative (indicative, propositional) sentences.
2. In my book *Meaning and Necessity*, I have developed a semantical method which takes propositions as entities designated by sentences (more specifically, as intension of sentences). In order to facilitate the understanding of the systematic development, I added some informal, extrasystematic explanations concerning the nature of propositions. I said that the term 'proposition' 'is used neither for a linguistic expression nor for a subjective, mental occurrence, but rather for something objective that may or may not be exemplified in nature.... We apply the term "proposition" to any entities of a certain logical type, namely, those that may be expressed by (declarative) sentences in a language' (p. 27). After some more detailed discussions concerning the relation between propositions and facts, and the nature of false propositions, I added: 'It has been the purpose of the preceding remarks to facilitate the understanding of our conception of propositions. If, however, a reader should

find these explanations more puzzling than clarifying, or even unacceptable, he may disregard them' (p. 31) (that is, disregard these extrasystematic explanations, not the whole theory of the propositions as intensions of sentences, as one reviewer understood). In spite of this warning, it seems that some of those readers who were puzzled by the explanations, did not disregard them but thought that by raising objections against them they could refute the theory. This is analogous to the procedure of some laymen who by (correctly) criticizing the ether picture or other visualizations of physical theories, thought they had refuted those theories. Perhaps the discussions in the present paper will help in clarifying the role of the system of linguistic rules for the introduction of a framework for entities on the one hand, and that of extrasystematic explanations concerning the nature of the entities on the other.

3. W. V. O. Quine was the first to recognize the importance of the introduction of variables as indicating the acceptance of entities. 'The ontology to which one's use of language commits him comprises simply the objects that he treats as falling ... within the range of values of his variables': 'Notes on Existence and Necessity', *Journal of Philosophy*, 40 (1943), p. 118. Compare Quine, 'Designation and Existence', *Journal of Philosophy*, 36 (1939), pp. 701–9, and 'On Universals', *Journal of Symbolic Logic*, 12 (1947), pp. 74–84.

4. For a closely related point of view on these questions, see the detailed discussions in Herbert Feigl, 'Existential Hypotheses', *Philosophy of Science*, 17 (1950), pp. 35–62.

5. Paul Bernays, 'Sur le platonisme dans les mathématiques', *L'Enseignement math.*, 34 (1935), pp. 52–69. W. V. O. Quine, see previous footnote and a recent paper 'On What There Is', *Review of the Metaphysics*, 2 (1948), pp. 21–38. Quine does not acknowledge the distinction which I emphasize above, because according to his general conception there are no sharp boundary lines between logical and factual truth, between questions of meaning and questions of fact, between the acceptance of a language structure and the acceptance of an assertion formulated in the language. This conception, which seems to deviate considerably from customary ways of thinking, is explained in his article 'Semantics and Abstract Objects', *Proceedings of the American Academy of Art and Sciences*, 80 (1951), pp. 90–96. When Quine in his article 'On What There Is' classifies my logicistic conception of mathematics (derived from Frege and Russell) as 'platonic realism' (p. 33), this is meant (according to a personal communication from him) not as ascribing to me agreement with Plato's metaphysical doctrine of universals, but merely as referring to the fact that I accept a language of mathematics containing variables of higher levels. With respect to the basic attitude to take in choosing a language form (an 'ontology' in Quine's terminology, which seems to me misleading), there appears now to be agreement between us: 'the obvious counsel is tolerance and an experimental spirit' ('On What There Is', p. 38).

6. See Carnap, *Scheinprobleme in der Philosophie; das Fremdpsychische und der Realismusstreit*, Berlin, 1928. Moritz Schlick, *Positivismus and Realismus*, reprinted in *Gesammelte Aufsätze*, Wien, 1938.

7. See *Meaning and Necessity*. The distinction I have drawn in the latter book between the method of the name-relation and the method of intension and extension is not essential for our present discussion. The term 'designation' is used in the present article in a neutral way: it may be understood as referring to the name-relation or to the intension-relation or to the extension-relation or to any similar relations used in other semantical methods.

8. Wilfrid Sellars ('Acquaintance and Description Again', in *Journal of Philosophy*, 46 [1949], pp. 496–504; see pp. 502) analyzes clearly the roots of the mistake 'of taking the designation relation of semantic theory to be a reconstruction of *being present to an experience*'.

5

LUDWIG WITTGENSTEIN
(1889–1951)

Ludwig Wittgenstein was born into an extremely wealthy and talented Austrian-Jewish family in Vienna. He became interested in philosophy of mathematics as a student of aeronautical engineering in Manchester. He visited Frege in Jena (1911) and, on his advice, began to study philosophy with Bertrand Russell in Cambridge. Wittgenstein's philosophical output falls into two distinct periods. The first phase (1912–22) culminated in the publication of a seventy-page book, the *Tractatus Logico-Philosophicus*. The main aim of the *Tractatus* was to draw the limits of language, and hence the limits of thought, and thus to demarcate sense from non-sense. In the process Wittgenstein was also attempting to solve, or dissolve, some of the most enduring philosophical questions on matters of logic, ethics, aesthetics, the meaning of life, God, the human subject, the soul and the nature of philosophy.

The *Tractatus* explains the relationship between language, thought and the world through the 'picture theory of meaning'. According to this theory, a proposition is meaningful if it pictures or represents a fact or a possible state of affairs. Both language and reality are composed of simple elements and they share a common form which can be discovered through logical analysis. According to Wittgenstein's austere conception of meaning in this period, only factual discourse has sense. All non-factual, and non-analytic uses of language, including ethics, aesthetics and philosophy are, strictly speaking, non-sense. The *Tractatus* proved to be highly influential among the logical positivists of the Vienna Circle who interpreted Wittgenstein's work in the light of their own aims of demarcating science from non-science (see chapter 4). Bertrand Russell's doctrine of logical atomism was also influenced by Wittgenstein.

Gradually Wittgenstein came to doubt the views expressed in the *Tractatus*. In 1929 be returned to Cambridge and started to lecture. The transcripts of these lectures are published in *The Blue and Brown Books* where he rejects his earlier view that language has a unitary essence and

emphasizes the multifarious uses of language in the context of the social lives of flesh-and-blood human beings.

The extract presented here is the opening section of the *Philosophical Investigations* where Wittgenstein criticizes his earlier views of language, as well as to those of Russell and Frege, and introduces various elements of his new approach, including his view on meaning as use and language-games. *Philosophical Investigations* is a multi-layered, complex work, ranging mainly, but not exclusively, over philosophy of language and philosophy of mind. One core element of the book is Wittgenstein's emphasis on language as a rule-governed, public activity. Since Plato, Wittgenstein contends, philosophers have made the mistake of thinking that there is an essential meaning unifying all the various uses of a given term. Wittgenstein uses the example of games to argue against the assumption that there is a common nature to meaning and language. Some, but not all, games are amusing or involve competition or winning and losing; some games require team effort, others are played by solitary individuals; there is only a range of similarities and dissimilarities between games, not some common feature or essence of 'gamehood' running through them all. Just as the word 'game' is applied to a range of cases that have only a family resemblance, Wittgenstein maintained, so it is with philosophically favoured terms such as 'knowledge', 'truth', 'virtue', etc. Family resemblances are networks of similarities, criss-crossing and overlapping each other, and it is in part through these networks that we can identify specific language-games. Language-games are played or enacted within a form of life – the social context in which a language-game can be played (and interpreted). For instance, the language-game of prayer can be understood only within the context of a religious form of life. To expect that a prayer should have the same conditions of meaningfulness as a scientific theory is to confuse two very different types of language-game.

In spite of the many changes of position, there are several points of contact between the early and the later Wittgenstein. Firstly, in both periods Wittgenstein's interests remained focused on questions dealing with language and meaning. Secondly, a concern with the question of demarcation between sense and non-sense remains constant throughout his work, even though the way in which the lines of demarcation are drawn changes. In his earlier work Wittgenstein draws a single boundary line between sense and non-sense. In his later work a multitude of boundary lines separate different areas of discourse or language-games. Thus, in this period, the boundaries of meaningfulness become internal to language itself. Thirdly, in both periods Wittgenstein assigned a thera-peutic role to philosophy. The task of philosophy is to enable us to

overcome the (philosophical) obfuscation and confusions that an in-correct understanding of language and its logical grammar can impose. Philosophical problems arise, he maintained, when 'language goes on holiday' (*The Blue and Brown Books*, 1958, § 38). Wittgenstein's work throughout his life was an attempt to overcome such confusions.

Wittgenstein's later philosophy is often seen as the harbinger of the ordinary-language philosophy that was popular in Britain in the late 1940s and throughout the 1950s (see chapters 6 and 7). His views have also had a great impact on the work of the British philosopher of language Michael Dummett (see chapter 15), who has emphasized the connection between meaning and use. In addition, Wittgenstein's argu-ments against the possibility of a private language, based on the neces-sarily public nature of rule-following requirements, has received a great deal of attention from philosophers such as Saul Kripke (see chapter 11).

Works by Wittgenstein

1921 *Tractatus Logico-Philosophicus*, trans. David F. Pears and Bernard F. McGuinness. London: Routledge, 1961.
1953 *Philosophical Investigations*, trans. G. E. M. Anscombe. Oxford: Blackwell, 1958.
1956 *Remarks on the Foundations of Mathematics*. Oxford: Blackwell.
1958 *The Blue and Brown Books*, ed. R. Rhees. Oxford: Blackwell.
1969 *On Certainty*, ed. G. E. M. Anscombe and G. H. von Wright. Oxford: Blackwell.

Works on Wittgenstein:

Baker, G. P. and Hacker, P. M. S., *An Analytical Commentary on the 'Philosophical Investigations'* (vols i–v). Oxford: Blackwell, 1980–96.
Glock, H. J., *A Wittgenstein Dictionary*. Oxford: Blackwell, 1996.
Grayling, A. C., *Wittgenstein*. Oxford: Oxford University Press, 1988.
Kenny, Anthony, *Wittgenstein*. Harmondsworth: Penguin, 1973.
McGinn, Colin, *Wittgenstein on Meaning*. Oxford: Blackwell, 1984.
Malcolm, Norman, *Ludwig Wittgenstein: A Memoir*. Oxford: Oxford University Press, 1984 (2nd edn).
Monk, Ray, *Wittgenstein: the Duty of Genius*. London: Vintage, 1990.
Sluga, Hans and Stern, David G. (eds), *The Cambridge Companion to Wittgenstein*. Cambridge: Cambridge University Press, 1996.

Philosophical Investigations (§1–44)

(1) 'Cum ipsi (majores hornines) appellabant rem aliquam, et cum secundum eam vocem corpus ad aliquid movebant, videbam, et tenebam hoc ab eis vocari rem illam, quod sonabant, cum eam vellent ostendere. Hoc autem eos velle ex motu corporis aperiebatur: tamquam verbis naturalibus omnium gentium, quae fiunt vultu et nutu oculorum, ceterorumque membrorum actu, et sonitu vocis indicante affectionem animi in petendis, habendis, rejiciendis, fugiendisve rebus. Ita verba in variis sententiis locis suis posita, et crebro audita, quarum rerum signa essent, paulatim colligebam, measque jam voluntates, edomito in eis signis ore, per haec enuntiabam.' (Augustine, *Confessions*, I, 8.)*

These words, it seems to me, give us a particular picture of the essence of human language. It is this: the individual words in language name objects – sentences are combinations of such names. – In this picture of language we find the roots of the following idea: Every word has a meaning. This meaning is correlated with the word. It is the object for which the word stands.

Augustine does not speak of there being any difference between kinds of word. If you describe the learning of language in this way you are, I believe, thinking primarily of nouns like 'table', 'chair', 'bread', and of people's names, and only secondarily of the names of certain actions and properties; and of the remaining kinds of word as something that will take care of itself.

Now think of the following use of language: I send someone shopping.

* 'When they (my elders) named some object, and accordingly moved towards something, I saw this and I grasped that the thing was called by the sound they uttered when they meant to point it out. Their intention was shewn by their bodily movements, as it were the natural language of all peoples: the expression of the face, the play of the eyes, the movement of other parts of the body, and the tone of voice which expresses our state of mind in seeking, having, rejecting, or avoiding something. Thus, as I heard words repeatedly used in their proper places in various sentences, I gradually learnt to understand what objects they signified; and after I had trained my mouth to form these signs, I used them to express my own desires.'

I give him a slip marked 'five red apples'. He takes the slip to the shopkeeper, who opens the drawer marked 'apples'; then he looks up the word 'red' in a table and finds a colour sample opposite it; then he says the series of cardinal numbers – I assume that he knows them by heart – up to the word 'five' and for each number he takes an apple of the same colour as the sample out of the drawer. – It is in this and similar ways that one operates with words. – 'But how does he know where and how he is to look up the word "red" and what he is to do with the word "five"?' – Well, I assume that he *acts* as I have described. Explanations come to an end somewhere. – But what is the meaning of the word 'five'? – No such thing was in question here, only how the word 'five' is used.

(2) That philosophical concept of meaning has its place in a primitive idea of the way language functions. But one can also say that it is the idea of a language more primitive than ours.

Let us imagine a language for which the description given by Augustine is right. The language is meant to serve for communication between a builder A and an assistant B. A is building with building stones: there are blocks, pillars, slabs and beams. B has to pass the stones, and that in the order in which A needs them. For this purpose they use a language consisting of the words 'block', 'pillar', 'slab', 'beam'. A calls them out; – B brings the stone which he has learnt to bring at such-and-such a call. – Conceive this as a complete primitive language.

(3) Augustine, we might say, does describe a system of communication; only not everything that we call language is this system. And one has to say this in many cases where the question arises: 'Is this an appropriate description or not?' The answer is: 'Yes, it is appropriate, but only for this narrowly circumscribed region, not for the whole of what you were claiming to describe.'

It is as if someone were to say: 'A game consists in moving objects about on a surface according to certain rules ...' – and we replied: 'You seem to be thinking of board games, but there are others. You can make your definition correct by expressly restricting it to those games.'

(4) Imagine a script in which the letters were used to stand for sounds, and also as signs of emphasis and punctuation. (A script can be conceived as a language for describing sound-patterns.) Now imagine someone interpreting that script as if there were simply a correspondence of letters to sounds and as if the letters had not also completely different functions. Augustine's conception of language is like such an over-simple conception of the script.

(5) If we look at the example in §1, we may perhaps get an inkling how much this general notion of the meaning of a word surrounds the working of language with a haze which makes clear vision impossible. It disperses the fog to study the phenomena of language in primitive kinds of application in which one can command a clear view of the aim and functioning of the words.

A child uses such primitive forms of language when it learns to talk. Here the teaching of language is not explanation, but training.

(6) We could imagine that the language of §2 was the *whole* language of A and B; even the whole language of a tribe. The children are brought up to perform *these* actions, to use *these* words as they do so, and to react in *this* way to the words of others.

An important part of the training will consist in the teacher's pointing to the objects, directing the child's attention to them, and at the same time uttering a word; for instance, the word 'slab' as he points to that shape. (I do not want to call this 'ostensive definition', because the child cannot as yet *ask* what the name is. I will call it 'ostensive teaching of words'. – I say that it will form an important part of the training, because it is so with human beings; not because it could not be imagined otherwise.) This ostensive teaching of words can be said to establish an association between the word and the thing. But what does this mean? Well, it may mean various things; but one very likely thinks first of all that a picture of the object comes before the child's mind when it hears the word. But now, if this does happen – is it the purpose of the word? – Yes, it *may* be the purpose. – I can imagine such a use of words (or series of sounds). (Uttering a word is like striking a note on the keyboard of the imagination.) But in the language of §2 it is *not* the purpose of the words to evoke images. (It may, of course, be discovered that that helps to attain the actual purpose.)

But if the ostensive teaching has this effect, – am I to say that it effects an understanding of the word? Don't you understand the call 'Slab!' if you act upon it in such-and-such a way? – Doubtless the ostensive teaching helped to bring this about; but only together with a particular training. With different training the same ostensive teaching of these words would have effected a quite different understanding.

'I set the brake up by connecting up rod and lever.' – Yes, given the whole of the rest of the mechanism. Only in conjunction with that is it a brake-lever, and separated from its support it is not even a lever; it may be anything, or nothing.

(7) In the practice of the use of language (2) one party calls out the

words, the other acts on them. In instruction in the language the following process will occur: the learner *names* the objects; that is, he utters the word when the teacher points to the stone. – And there will be this still simpler exercise: the pupil repeats the words after the teacher – both of these being processes resembling language.

We can also think of the whole process of using words in (2) as one of those games by means of which children learn their native language. I will call these games 'language-games' and will sometimes speak of a primitive language as a language-game.

And the processes of naming the stones and of repeating words after someone might also be called language-games. Think of much of the use of words in games like ring-a-ring-a-roses.

I shall also call the whole, consisting of language and the actions into which it is woven, the 'language-game'.

(8) Let us now look at an expansion of language (2). Besides the four words 'block', 'pillar', etc., let it contain a series of words used as the shopkeeper in (1) used the numerals (it can be the series of letters of the alphabet); further, let there be two words, which may as well be 'there' and 'this' (because this roughly indicates their purpose), that are used in connexion with a pointing gesture; and finally a number of colour samples. A gives an order like: 'd—slab—there'. At the same time he shews the assistant a colour sample, and when he says 'there' he points to a place on the building site. From the stock of slabs B takes one for each letter of the alphabet up to 'd', of the same colour as the sample, and brings them to the place indicated by A. – On other occasions A gives the order 'this—there'. At 'this' he points to a building stone. And so on.

(9) When a child learns this language, it has to learn the series of 'numerals' a, b, c ... by heart. And it has to learn their use. – Will this training include ostensive teaching of the words? – Well, people will, for example, point to slabs and count: 'a, b, c slabs'. – Something more like the ostensive teaching of the words 'block', 'pillar', etc., would be the ostensive teaching of numerals that serve not to count but to refer to groups of objects that can be taken in at a glance. Children do learn the use of the first five or six cardinal numerals in this way.

Are 'there' and 'this' also taught ostensively? – Imagine how one might perhaps teach their use. One will point to places and things – but in this case the pointing occurs in the *use* of the words too and not merely in learning the use.

(10) Now what do the words of this language *signify*? – What is sup-

posed to shew what they signify, if not the kind of use they have? And we have already described that. So we are asking for the expression 'This word signifies *this*' to be made a part of the description. In other words, the description ought to take the form: 'The word ... signifies...'

Of course, one can reduce the description of the use of the word 'slab' to the statement that this word signifies this object. This will be done when, for example, it is merely a matter of removing the mistaken idea that the word 'slab' refers to the shape of building stone that we in fact call a 'block' – but the kind of *'referring'* this is, that is to say the use of these words for the rest, is already known.

Equally one can say that the signs 'a', 'b', etc., signify numbers; when for example this removes the mistaken idea that 'a', 'b', 'c', play the part actually played in language by 'block', 'slab', 'pillar'. And one can also say that 'c' means this number and not that one; when for example this serves to explain that the letters are to be used in the order a, b, c, d, etc. and not in the order a, b, d, c.

But assimilating the descriptions of the uses of words in this way cannot make the uses themselves any more like one another. For, as we see, they are absolutely unlike.

(11) Think of the tools in a tool-box: there is a hammer, pliers, a saw, a screwdriver, a rule, a glue-pot, glue, nails and screws. – The functions of words are as diverse as the functions of these objects. (And in both cases there are similarities.)

Of course, what confuses us is the uniform appearance of words when we hear them spoken or meet them in script and print. For their *application* is not presented to us so clearly. Especially when we are doing philosophy!

(12) It is like looking into the cabin of a locomotive. We see handles all looking more or less alike. (Naturally, since they are all supposed to be handled.) But one is the handle of a crank which can be moved continuously (it regulates the opening of a valve); another is the handle of a switch, which has only two effective positions: it is either off or on; a third is the handle of a brake-lever: the harder one pulls on it, the harder it brakes; a fourth, the handle of a pump: it has an effect only so long as it is moved to and fro.

(13) When we say: 'Every word in language signifies something' we have so far said *nothing whatever*; unless we have explained exactly *what* distinction we wish to make. (It might be, of course, that we wanted to distinguish the words of language (8) from words 'without meaning'

such as occur in Lewis Carroll's poems, or words like 'Lilliburlero' in songs.)

(14) Imagine someone's saying: '*All* tools serve to modify something. Thus the hammer modifies the position of the nail, the saw the shape of the board, and so on.' – And what is modified by the rule, the glue-pot, the nails? – 'Our knowledge of a thing's length, the temperature of the glue, and the solidity of the box.' – Would anything be gained by this assimilation of expressions? –

(15) The word 'to signify' is perhaps used in the most straightforward way when the object signified is marked with the sign. Suppose that the tools A uses in building bear certain marks. When A shews his assistant such a mark, he brings the tool that has that mark on it.

It is in this and more or less similar ways that a name means and is given to a thing. – It will often prove useful in philosophy to say to ourselves: naming something is like attaching a label to a thing.

(16) What about the colour samples that A shews to B: are they part of the *language*? Well, it is as you please. They do not belong among the words; yet when I say to someone: 'Pronounce the word "the" ', you will count the second 'the' as part of the sentence. Yet it has a role just like that of a colour sample in language-game (8); that is, it is a sample of what the other is meant to say.

It is most natural, and causes least confusion, to reckon the samples among the instruments of the language.

((Remark on the reflexive pronoun '*this* sentence'.))

(17) It will be possible to say: in language (8) we have different *kinds of word*. For the functions of the word 'slab' and the word 'block' are more alike than those of 'slab' and 'd'. But how we group words into kinds will depend on the aim of the classification – and on our own inclination.

Think of the different points of view from which one can classify tools or chess-men.

(18) Do not be troubled by the fact that languages (2) and (8) consist only of orders. If you want to say that this shews them to be incomplete, ask yourself whether our language is complete; – whether it was so before the symbolism of chemistry and the notation of the infinitesimal calculus were incorporated in it; for these are, so to speak, suburbs of our language. (And how many houses or streets does it take before a town begins to be a town?) Our language can be seen as an ancient city: a maze of little streets and squares, of old and new houses, and of houses with additions from various periods; and this surrounded by a multitude

of new boroughs with straight regular streets and uniform houses.

(19) It is easy to imagine a language consisting only of orders and reports in battle. – Or a language consisting only of questions and expressions for answering yes and no. And innumerable others. – And to imagine a language means to imagine a form of life.

But what about this: is the call 'Slab!' in example (2) a sentence or a word? – If a word, surely it has not the same meaning as the like-sounding word of our ordinary language, for in §2 it is a call. But if a sentence, it is surely not the elliptical sentence: 'Slab!' of our language. – As far as the first question goes you can call 'Slab!' a word and also a sentence; perhaps it could be appropriately called a 'degenerate sentence' (as one speaks of a degenerate hyperbola); in fact it *is* our 'elliptical' sentence. – But that is surely only a shortened form of the sentence 'Bring me a slab', and there is no such sentence in example (2). – But why should I not on the contrary have called the sentence 'Bring me a slab' a *lengthening* of the sentence 'Slab!'? – Because if you shout 'Slab!' you really mean: 'Bring me a slab' – But how do you do this: how do you *mean* that while you *say* 'Slab!'? do you say the unshortened sentence to yourself? And why should I translate the call 'Slab!' into a different expression in order to say what someone means by it? And if they mean the same thing – why should I not say: 'When he says "Slab!" he means "Slab!" '? Again, if you can mean 'Bring me the slab', why should you not be able to mean 'Slab!'? – But when I call 'Slab!', then what I want is, *that he should bring me a slab*! – Certainly, but does 'wanting this' consist in thinking in some form or other a different sentence from the one you utter? –

(20) But now it looks as if when someone says 'Bring me a slab' he could mean this expression as *one* long word corresponding to the single word 'Slab!' – Then can one mean it sometimes as one word and sometimes as four? And how does one usually mean it? – I think we shall be inclined to say: we mean the sentence as *four* words when we use it in contrast with other sentences such as '*Hand* me a slab', 'Bring *him* a slab', 'Bring *two* slabs', etc.; that is, in contrast with sentences containing the separate words of our command in other combinations. – But what does using one sentence in contrast with others consist in? Do the others, perhaps, hover before one's mind? *All* of them? And *while* one is saying the one sentence, or before, or afterwards? – No. Even if such an explanation rather tempts us, we need only think for a moment of what actually happens in order to see that we are going astray here. We say that we use the command in contrast with other sentences because *our language*

contains the possibility of those other sentences. Someone who did not understand our language, a foreigner, who had fairly often heard someone giving the order: 'Bring me a slab!', might believe that this whole series of sounds was one word corresponding perhaps to the word for 'building stone' in his language. If he himself had then given this order perhaps he would have pronounced it differently, and we should say: he pronounces it so oddly because he takes it for a *single* word. – But then, is there not also something different going on in him when he pronounces it – something corresponding to the fact that he conceives the sentence as a *single* word? – Either the same thing may go on in him, or something different. For what goes on in you when you give such an order? Are you conscious of its consisting of four words *while* you are uttering it? Of course you have a *mastery* of this language – which contains those other sentences as well – but is this having a mastery, something that *happens* while you are uttering the sentence? – And I have admitted that the foreigner will probably pronounce a sentence differently if he conceives it differently; but what we call his wrong conception *need* not lie in anything that accompanies the utterance of the command.

The sentence is 'elliptical', not because it leaves out something that we think when we utter it, but because it is shortened – in comparison with a particular paradigm of our grammar. – Of course one might object here: 'You grant that the shortened and the unshortened sentence have the same sense. – What is this sense, then? Isn't there a verbal expression for this sense?' – But doesn't the fact that sentences have the same sense consist in their having the same *use*? – (In Russian one says 'stone red' instead of 'the stone is red'; do they feel the copula to be missing in the sense, or attach it in *thought*?)

(21) Imagine a language-game in which A asks and B reports the number of slabs or blocks in a pile, or the colours and shapes of the building stones that are stacked in such-and-such a place. – Such a report might run: 'Five slabs'. Now what is the difference between the report or statement 'Five slabs' and the order 'Five slabs!'? – Well, it is the part which uttering these words plays in the language-game. No doubt the tone of voice and the look with which they are uttered, and much else besides, will also be different. But we could also imagine the tone's being the same – for an order and a report can be spoken in a *variety* of tones of voice and with various expressions of face – the difference being only in the application. (Of course, we might use the words 'statement' and 'command' to stand for grammatical forms of sentence and intonations; we do in fact call 'Isn't the weather glorious today?' a question, although

it is used as a statement.) We could imagine a language in which *all* statements had the form and tone of rhetorical questions; or every command the form of the question 'Would you like to ...?' Perhaps it will then be said: 'What he says has the form of a question but is really a command' – that is, has the function of a command in the technique of using the language. (Similarly one says 'You will do this' not as a prophecy but as a command. What makes it the one or the other?)

(22) Frege's idea that every assertion contains an assumption, which is the thing that is asserted, really rests on the possibility found in our language of writing every statement in the form: 'It is asserted that such-and-such is the case.' – But 'that such-and-such is the case' is *not* a sentence in our language – so far it is not a *move* in the language-game. And if I write, not 'It is asserted that ...', but 'it is asserted: such-and-such is the case', the words 'It is asserted' simply become superfluous.

We might very well also write every statement in the form of a question followed by a 'Yes'; for instance: 'Is it raining? Yes!' would this shew that every statement contained a question?

Of course we have the right to use an assertion sign in contrast with a question mark, for example, or if we want to distinguish an assertion from a fiction or a supposition. It is only a mistake if one thinks that the assertion consists of two actions, entertaining and asserting (assigning the truth value, or something of the kind), and that in performing these actions we follow the propositional sign roughly as we sing from the musical score. Reading the written sentence loud or soft is indeed comparable with singing from a musical score, but *'meaning'* (thinking) the sentence that is read is not.

Frege's assertion sign marks the *beginning of the sentence*. Thus its function is like that of the full stop. It distinguishes the whole period from a clause *within* the period. If I hear someone say 'It's raining' but do not know whether I have heard the beginning and end of the period, so far this sentence does not serve to tell me anything.

(23) But how many kinds of sentence are there? Say assertion, question, and command? – There are *countless* kinds: countless different kinds of use of what we call 'symbols', 'words, 'sentences'. And this multiplicity is not something fixed, given once for all; but new types of language, new language-games, as we may say, come into existence, and others become obsolete and get forgotten. (We can get a *rough picture* of this from the changes in mathematics.)

Here the term 'language *game*' is meant to bring into prominence the

fact that the *speaking* of language is part of an activity, or of a form of life.

Review the multiplicity of language-games in the following examples, and in others:

Giving orders and obeying them –
Describing the appearance of an object, or giving its measurements –
Constructing an object from a description (a drawing) –
Reporting an event –
Speculating about an event –
Forming and testing a hypothesis –
Presenting the results of an experiment in tables and diagrams –
Making up a story; and reading it –
Play-acting –
Singing catches –
Guessing riddles –
Making a joke; telling it –
Solving a problem in practical arithmetic –
Translating from one language into another –
Asking, thanking, cursing, greeting, praying.

– It is interesting to compare the multiplicity of the tools in language and of the ways they are used, the multiplicity of kinds of word and sentence, with what logicians have said about the structure of language. (Including the author of the *Tractatus Logico-Philosophicus*.)

(24) If you do not keep the multiplicity of language-games in view you will perhaps be inclined to ask questions like: 'What is a question?' – Is it the statement that I do not know such-and-such, or the statement that I wish the other person would tell me ...? Or is it the description of my mental state of uncertainty? – And is the cry 'Help!' such a description?

Think how many different kinds of thing are called 'description': description of a body's position by means of its coordinates; description of a facial expression; description of a sensation of touch; of a mood.

Of course it is possible to substitute the form of statement or description for the usual form of question: 'I want to know whether ...' or 'I

Imagine a picture representing a boxer in a particular stance. Now, this picture can be used to tell someone how he should stand, should hold himself; or how he should not hold himself; or how a particular man did stand in such-and-such a place; and so on. One might (using the language of chemistry) call this picture a proposition-radical. This will be how Frege thought of the 'assumption'.

am in doubt whether . . .' – but this does not bring the different language-games any closer together.

The significance of such possibilities of transformation, for example of turning all statements into sentences beginning 'I think' or 'I believe' (and thus, as it were, into descriptions of *my* inner life) will become clearer in another place. (Solipsism.)

(25) It is sometimes said that animals do not talk because they lack the mental capacity. And this means: 'They do not think, and that is why they do not talk.' But – they simply do not talk. Or to put it better: they do not use language – if we except the most primitive forms of language. – Commanding, questioning, recounting, chatting, are as much a part of our natural history as walking, eating, drinking, playing.

(26) One thinks that learning language consists in giving names to objects. Viz. to human beings, to shapes, to colours, to pains, to moods, to numbers, etc. To repeat – naming is something like attaching a label to a thing. One can say that this is preparatory to the use of a word. But *what* is it a preparation *for*?

(27) 'We name things and then we can talk about them: can refer to them in talk.' – As if what we did next were given with the mere act of naming. As if there were only one thing called 'talking about a thing'. Whereas in fact we do the most various things with our sentences. Think of exclamations alone, with their completely different functions.

Water!
Away!
Ow!
Help!
Fine!
No!

Are you inclined still to call these words 'names of objects'?

In languages (2) and (8) there was no such thing as asking something's name. This, with its correlate, ostensive definition, is, we might say, a language-game on its own. That is really to say: we are brought up, trained, to ask: 'What is that called?' – upon which the name is given. And there is also a language-game of inventing a name for something, and hence of saying, 'This is . . .' and then using the new name. (Thus, for example, children give names to their dolls and then talk about them and to them. Think in this connexion how singular is the use of a person's name to *call* him!)

(28) Now one can ostensively define a proper name, the name of a

colour, the name of a material, a numeral, the name of a point of the compass and so on. The definition of the number two, 'That is called "two" ' – pointing to two nuts – is perfectly exact. – But how can two be defined like that? The person one gives the definition to doesn't know what one wants to call 'two'; he will suppose that 'two' is the name given to *this* group of nuts! – He *may* suppose this; but perhaps he does not. He might make the opposite mistake; when I want to assign a name to this group of nuts, he might understand it as a numeral. And he might equally well take the name of a person, of which I give an ostensive definition, as that of a colour, of a race, or even of a point of the compass. That is to say: an ostensive definition can be variously interpreted in *every* case.

(29) Perhaps you say: two can only be ostensively defined in *this* way: 'This *number* is called "two" '. For the word 'number' here shews what place in language, in grammar, we assign to the word. But this means that the word 'number' must be explained before the ostensive definition can be understood. – The word 'number' in the definition does indeed shew this place; does shew the post at which we station the word. And we can prevent misunderstandings by saying: 'This *colour* is called so-and-so', 'This *length* is called so-and-so', and so on. That is to say: misunderstandings are sometimes averted in this way. But is there only *one* way of taking the word 'colour' or 'length'? – Well, they just need defining. – Defining, then, by means of other words! And what about the last definition in this chain? (Do not say: 'There isn't a "last" definition'. That is just as if you chose to say: 'There isn't a last house in this road; one can always build an additional one'.)

Whether the word 'number' is necessary in the ostensive definition depends on whether without it the other person takes the definition otherwise than I wish. And that will depend on the circumstances under which it is given, and on the person I give it to.

Could one define the word 'red' by pointing to something that was *not* red? That would be as if one were supposed to explain the word 'modest' to someone whose English was weak, and one pointed to an arrogant man and said, 'That man is *not* modest.' That it is ambiguous is no argument against such a method of definition. Any definition can be misunderstood.

But it might well be asked: are we still to call this 'definition'? – For, of course, even if it has the same practical consequences, the same *effect* on the learner, it plays a different part in the calculus from what we ordinarily call 'ostensive definition' of the word 'red'.

And how he 'takes' the definition is seen in the use that he makes of the word defined.

(30) So one might say: the ostensive definition explains the use – the meaning – of the word when the overall role of the word in language is clear. Thus if I know that someone means to explain a colour-word to me the ostensive definition 'That is called "sepia"' will help me to understand the word. – And you can say this, so long as you do not forget that all sorts of problems attach to the words 'to know' or 'to be clear'.

One has already to know (or be able to do) something in order to be capable of asking a thing's name. But what does one have to know?

(31) When one shews someone the king in chess and says: 'This is the king', this does not tell him the use of this piece – unless he already knows the rules of the game up to this last point: the shape of the king. You could imagine his having learnt the rules of the game without ever having been shewn an actual piece. The shape of the chess-man corresponds here to the sound or shape of a word.

One can also imagine someone's having learnt the game without ever learning or formulating rules. He might have learnt quite simple board-games first, by watching, and have progressed to more and more complicated ones. He too might be given the explanation 'This is the king' – if, for instance, he were being shewn chess-men of a shape he was not used to. This explanation again only tells him the use of the piece because, as we might say, the place for it was already prepared. Or even: we shall only say that it tells him the use, if the place is already prepared. And in this case it is so, not because the person to whom we give the explanation already knows rules, but because in another sense he is already master of a game.

Consider this further case: I am explaining chess to someone; and I begin by pointing to a chess-man and saying: 'This is the king; it can move like this ... and so on.' – In this case we shall say: the words 'This is the king' (or 'This is called the "king"') are a definition only if the learner already 'knows what a piece in a game is'. That is, if he has already played other games, or has watched other people playing 'and understood' – *and similar things*. Further, only under these conditions will he be able to ask relevantly in the course of learning the game: 'What do you call this?' – that is, this piece in a game.

We may say: only someone who already knows how to do something with it can significantly ask a name.

And we can imagine the person who is asked replying: 'Settle the name

yourself' – and now the one who asked would have to manage everything for himself.

(32) Someone coming into a strange country will sometimes learn the language of the inhabitants from ostensive definitions that they give him; and he will often have to *guess* the meaning of these definitions; and will guess sometimes right, sometimes wrong.

And now, I think, we can say: Augustine describes the learning of human language as if the child came into a strange country and did not understand the language of the country; that is, as if it already had a language, only not this one. Or again: as if the child could already *think*, only not yet speak. And 'think' would here mean something like 'talk to itself'.

(33) Suppose, however, someone were to object: 'It is not true that you must already be master of a language in order to understand an ostensive definition: all you need – of course – is to know or guess what the person giving the explanation is pointing to. That is, whether for example to the shape of the object, or to its colour, or to its number, and so on.' – And what does 'pointing to the shape', 'pointing to the colour' consist in? Point to a piece of paper. – And now point to its shape – now to its colour – now to its number (that sounds queer). – How did you do it? – You will say that you 'meant' a different thing each time you pointed. And if I ask how that is done, you will say you concentrated your attention on the colour, the shape, etc. But I ask again: how is *that* done?

Suppose someone points to a vase and says, 'Look at that marvellous blue – the shape isn't the point.' – Or: 'Look at the marvellous shape – the colour doesn't matter.' Without doubt you will do something *different* when you act upon these two invitations. But do you always do the *same* thing when you direct your attention to the colour? Imagine various different cases. To indicate a few:

'Is this blue the same as the blue over there? Do you see any difference?' – You are mixing paint and you say, 'It's hard to get the blue of this sky.'
'It's turning fine, you can already see blue sky again.'
'Look what different effects these two blues have.'
'Do you see the blue book over there? Bring it here.'
'This blue signal-light means . . .'
'What's this blue called? – Is it "indigo"?'

You sometimes attend to the colour by putting your hand up to keep the outline from view; or by not looking at the outline of the thing; sometimes

by staring at the object and trying to remember where you saw that colour before.

You attend to the shape, sometimes by tracing it, sometimes by screwing up your eyes so as not to see the colour clearly, and in many other ways. I want to say: This is the sort of thing that happens *while* one 'directs one's attention to this or that'. But it isn't these things by themselves that make us say someone is attending to the shape, the colour, and so on. Just as a move in chess doesn't consist simply in moving a piece in such-and-such a way on the board – nor yet in one's thoughts and feelings as one makes the move: but in the circumstances that we call 'playing a game of chess', 'solving a chess problem', and so on.

(34) But suppose someone said: 'I always do the same thing when I attend to the shape: my eye follows the outline and I feel . . .' And suppose this person to give someone else the ostensive definition 'That is called a "circle" ', pointing to a circular object and having all these experiences – cannot his hearer still interpret the definition differently, even though he sees the other's eyes following the outline, and even though he feels what the other feels? That is to say: this 'interpretation' may also consist in how he now makes use of the word; in what he points to, for example, when told: 'Point to a circle'. – For neither the expression 'to intend the definition in such-and-such a way' nor the expression 'to interpret the definition in such-and-such a way' stands for a process which accompanies the giving and hearing of the definition.

(35) There are, of course, what can be called 'characteristic experiences' of pointing to (e.g.) the shape. For example, following the outline with one's finger or with one's eyes as one points. – But *this* does not happen in all cases in which I 'mean the shape', and no more does any other one characteristic process occur in all these cases. – Besides, even if something of the sort did recur in all cases, it would still depend on the circumstances – that is, on what happened before and after the pointing – whether we should say, 'He pointed to the shape and not to the colour'.

For the words 'to point to the shape', 'to mean the shape', and so on, are not used in the same way as *these*: 'to point to this book (not to that one)', 'to point to the chair, not the table', and so on. – Only think how differently we *learn* the use of the words 'to point to this thing', 'to point to that thing', and on the other hand 'to point to the colour, not the shape', 'to mean the colour', and so on.

To repeat: in certain cases, especially when one points 'to the shape' or 'to the number' there are characteristic experiences and ways of

pointing – 'characteristic' because they recur often (not always) when shape or number are 'meant'. But do you also know of an experience characteristic of pointing to a piece in a game *as a piece in a game*? All the same one can say: 'I mean that this *piece* is called the "king", not this particular bit of wood I am pointing to'. (Recognizing, wishing, remembering, etc.)

(36) And we do here what we do in a host of similar cases: because we cannot specify any *one* bodily action which we call pointing to the shape (as opposed, for example, to the colour), we say that a *spiritual* (mental, intellectual) activity corresponds to these words.

Where our language suggests a body and there is none: there, we should like to say, is a *spirit*.

(37) What is the relation between name and thing named? – Well, what *is* it? Look at language-game (2) or at another one: there you can see the sort of thing this relation consists in. This relation may also consist, among many other things, in the fact that hearing the name calls before our mind the picture of what is named; and it also consists, among other things, in the name's being written on the thing named or being pronounced when that thing is pointed at.

(38) But what, for example, is the word 'this' the name of in language-game (8) or the word 'that' in the ostensive definition 'that is called …'? – If you do not want to produce confusion you will do best not to call these words names at all. – Yet, strange to say, the word 'this' has been called the only *genuine* name; so that anything else we call a name was one only in an inexact, approximate sense.

This queer conception springs from a tendency to sublime the logic of our language – as one might put it. The proper answer to it is: we call

What is it to *mean* the words '*That* is blue' at one time as a statement about the object one is point to – at another as an explanation of the word 'blue'? Well, in the second case one really means 'That is called "blue" ' – Then can one at one time mean the word 'is' as 'is called' and the word 'blue' as ' "blue" ', and another time mean 'is' really as 'is'?

Is is also possible for someone to get an explanation of the words out of what was intended as a piece of information. [Marginal note: Here lurks a crucial superstition.]

Can I say 'bububu' and mean 'If it doesn't rain I shall go for a walk'? – It is only in a language that I can mean something by something. This shews clearly that the grammar of 'to mean' is not like that of the expression 'to imagine' and the like.

very different things 'names'; the word 'name' is used to characterize many different kinds of use of a word, related to one another in many different ways; – but the kind of use that 'this' has is not among them.

It is quite true that, in giving an ostensive definition for instance, we often point to the object named and say the name. And similarly, in giving an ostensive definition for instance, we say the word 'this' while pointing to a thing. And also the word 'this' and a name often occupy the same position in a sentence. But it is precisely characteristic of a name that it is defined by means of the demonstrative expression 'That is N' (or 'That is called "N" '). But do we also give the definitions: 'That is called "this" ', or 'This is called "this" '?

This is connected with the conception of naming as, so to speak, an occult process. Naming appears as a *queer* connexion of a word with an object. – And you really get such a queer connexion when the philosopher tries to bring out *the* relation between name and thing by staring at an object in front of him and repeating a name or even the word 'this' innumerable times. For philosophical problems arise when language *goes on holiday*. And *here* we may indeed fancy naming to be some remarkable act of mind, as it were a baptism of an object. And we can also say the word 'this' *to* the object, as it were *address* the object as 'this' – a queer use of this word, which doubtless only occurs in doing philosophy.

(39) But why does it occur to one to want to make precisely this word into a name, when it evidently is *not* a name? – That is just the reason. For one is tempted to make an objection against what is ordinarily called a name. It can be put like this: *a name ought really to signify a simple*. And for this one might perhaps give the following reasons: The word 'Excalibur', say, is a proper name in the ordinary sense. The sword Excalibur consists of parts combined in a particular way. If they are combined differently Excalibur does not exist. But it is clear that the sentence 'Excalibur has a sharp blade' makes *sense* whether Excalibur is still whole or is broken up. But if 'Excalibur' is the name of an object, this object no longer exists when Excalibur is broken in pieces, and as no object would then correspond to the name it would have no meaning. But then the sentence 'Excalibur has a sharp blade' would contain a word that had no meaning, and hence the sentence would be nonsense. But it does make sense; so there must always be something corresponding to the words of which it consists. So the word 'Excalibur,' must disappear when the sense is analysed and its place be taken by words which name simples. It will be reasonable to call these words the real names.

(40) Let us first discuss *this* point of the argument: that a word has no

meaning if nothing corresponds to it. – It is important to note that the word 'meaning' is being used illicitly if it is used to signify the thing that 'corresponds' to the word. That is to confound the meaning of a name with the *bearer* of the name. When Mr N. N. dies one says that the bearer of the name dies, not that the meaning dies. And it would he nonsensical to say that, for if the name ceased to have meaning it would make no sense to say 'Mr N. N. is dead.'

(41) In §15 we introduced proper names into language (8). Now suppose that the tool with the name 'N' is broken. Not knowing this, A gives B the sign 'N'. Has this sign meaning now or not? – What is B to do when he is given it? – We have not settled anything about this. One might ask: what *will* he do? Well, perhaps he will stand there at a loss, or shew A the pieces. Here one *might* say: 'N' has become meaningless; and this expression would mean that the sign 'N' no longer had a use in our language-game (unless we gave it a new one). 'N' might also become meaningless because, for whatever reason, the tool was given another name and the sign 'N' no longer used in the language-game. – But we could also imagine a convention whereby B has to shake his head in reply if A gives him the sign belonging to a tool that is broken. – In this way the command 'N' might be said to be given a place in the language-game even when the tool no longer exists, and the sign 'N' to have meaning even when its bearer ceases to exist.

(42) But has for instance a name which has *never* been used for a tool also got a meaning in that game? – Let us assume that 'X' is such a sign and that A gives this sign to B – well, even such signs could be given a place in the language-game, and B might have, say, to answer them too with a shake of the head. (One could imagine this as a sort of joke between them.)

(43) For a *large* class of cases – though not for all – in which we employ the word 'meaning' it can be defined thus: the meaning of a word is its use in the language.

And the *meaning* of a name is sometimes explained by pointing to its *bearer*.

(44) We said that the sentence 'Excalibur has a sharp blade' made sense even when Excalibur was broken in pieces. Now this is so because in this language-game a name is also used in the absence of its bearer. But we can imagine a language-game with names (that is, with signs which we should certainly include among names) in which they are used only in the presence of the bearer; and so could *always* be replaced by a demonstrative pronoun and the gesture of pointing.

6

J. L. AUSTIN
(1911–60)

John Langshaw Austin was born in Lancaster, England, and educated at Oxford where he also held the White's Chair of Moral Philosophy from 1952 until his death in 1960. Austin and Gilbert Ryle were the main proponents of what has been variously called 'linguistic philosophy' and 'ordinary-language philosophy'. Austin's approach to philosophy can be seen, in large part, as a reaction to the writings of the early Wittgenstein and the logical positivists. He rejected all attempts to theorize about language at a level of complete generalities and advocated the detailed study of ordinary language for gaining an insight into philosophical problems. His method of philosophizing involved the construction of taxonomies and the analysis of the minutiae of linguistic usage in group discussions.

Austin attacked the tendency of philosophers to create philosophical 'pseudo-problems' and advocated a common-sense, almost anti-philo-sophical realism. Unlike Wittgenstein, however, he was not aiming at the mere dissolution of philosophical problems. Linguistic analysis, he argued, can free us from philosophical 'pseudo-problems', and it can also show the way to pose and answer some genuine philosophical questions. Many of the traditional philosophical questions and argu-ments, for instance the problem of free will and determinism or the argument from illusion, are caused by sloppy thinking of the philo-sophers.

An original feature of Austin's work was his attack on some of the age-old dichotomies in philosophy, in particular what he called the truth and falsehood, the fact and value, and the appearance and reality fetishisms. These dichotomies were set up, and subsequently reified, by philosophers, including the logical positivists, Austin argued, partly because of their inattention to the more subtle nuances and distinctions in the workings of ordinary language. It is Austin's view that the common stock of knowledge that has been handed down from generation to

generation, through established linguistic usage, is a reliable but under-used source of philosophical illumination. The study of ordinary language, Austin thought, is worth more than any attempt by philosophers to dream up new distinctions and alternatives.

Austin's most important contribution to philosophy of language is his theory of speech acts, according to which the use of language on different occasions and in different contexts amounts to doing things (with words) or the performance of specific linguistic actions. Speech, Austin holds, should be seen as a type of action; confusions often arise when philosophers insist on a separation between talking and acting and fail to pay attention to the uses of language in performing a large number of actions.

Although Austin had discussed his views with friends and colleagues in Oxford during the 1930s, it was not until the 1950s, and particularly 1955 when he gave the William James Lectures at Harvard University, that his views became better known to a wider public. These lectures were published posthumously as *How to do things with Words* (1962), the first two chapters of which appear here. Austin begins his discussion by drawing an important distinction between performative and constative utterances. Performative utterances – e.g., 'I promise to be there on time', 'I baptize this child in the name of the Father' – do not describe a state of affairs; rather, in appropriate circumstances, they constitute specific actions, in this instance the actions of promising and baptizing. Constative utterances, on the other hand, state how things are in the world. They are true or false depending on whether or not they correspond to the way things are. Performatives are not true or false in the same sense; rather, they can be felicitous or infelicitous, sincere or insincere, depending on the circumstances in which they have been uttered and the intentions of the speakers. The early Wittgenstein, and the logical positivists, had concentrated on the constative uses of language only and the conditions where such sentences can be meaningful. They had failed to give an account of the ways in which a performative (non-descriptive) sentence such as 'I bequeath you my book collection' can be meaningful.

Upon subsequent examination, Austin argues, the distinction between performative and constative utterances breaks down because the utterance of a constative statement itself amounts to performing a speech act: the speech act of stating or describing how things stand. Consequently Austin broadens his initial dual distinction into a threefold classification of the performative utterances: (a) locutionary, (b) illocutionary, and (c) perlocutionary speech acts. Locutionary acts are the speech act of saying something; illocutionary acts concern what is done in saying something or performing a locutionary act. Informing, ordering, warning, under-

taking, etc., are examples of illocutionary acts; they are utterances, according to Austin, which have a certain (conventional) force. Perlocutionary acts have to do with the effects of a speech act on an audience. Convincing, persuading, deterring, surprising or misleading are examples of perlocutionary acts; they concern the effect a speaker brings about or achieves by saying something (see *How to do things with Words* p. 108).

A speaker performs an illocutionary act only if she has had the intention of doing so, even though she may not succeed in her objective. What I say may count as a warning only if I intend to warn my interlocutors. However, I may be singularly unsuccessful in achieving my aim because no one takes me seriously. Perlocutionary acts may or may not be intended and may or may not have the intended effects. For instance, a speaker may mislead a hearer without intending to do so and, by the same token, she may fail to persuade someone despite every intention to do so.

Austin's influence on current analytic philosophy of language is negligible. One notable exception is John Searle who is the main proponent of Austin's speech act theory in the analytic tradition and who has retained some of Austin's insights in his development of speech act theory. Austin's work has had considerable impact on French philosophers such as Jacques Derrida and Paul Ricoeur, however, as well as on English-speaking philosophers with continental leanings such as Richard Rorty and Stanley Cavell.

Works by Austin

1961; 2nd edn 1970 *Philosophical Papers*. Oxford: Clarendon Press.
1962 *Sense and Sensibilia*. Oxford: Oxford University Press.
1962 *How to do things with Words*. Oxford: Clarendon Press.

Works on Austin

Cavell, Stanley, *Must We Mean What We Say?: A Book of Essays*. Cambridge University Press, 1976; New York: Scribner, 1969.
Cavell, Stanley, *Philosophical Passages: Wittgenstein, Emerson, Austin, Derrida*. Oxford: Blackwell, 1995.
Fann, K. T. (ed.), *A Symposium on J. L. Austin*. London: Routledge, 1969.
Searle, John R., *Speech Acts: An Essay on the Philosophy of Language*. Cambridge: Cambridge University Press, 1969.
Warnock, Geoffrey, *J. L. Austin*. London: Routledge, 1989.

Performatives and Constatives

What I shall have to say here is neither difficult nor contentious; the only merit I should like to claim for it is that of being true, at least in parts. The phenomenon to be discussed is very widespread and obvious, and it cannot fail to have been already noticed, at least here and there, by others. Yet I have not found attention paid to it specifically.

It was for too long the assumption of philosophers that the business of a 'statement' can only be to 'describe' some state of affairs, or to 'state some fact', which it must do either truly or falsely. Grammarians, indeed, have regularly pointed out that not all 'sentences' are (used in making) statements:[1] there are, traditionally, besides (grammarians') statements, also questions and exclamations, and sentences expressing commands or wishes or concessions. And doubtless philosophers have not intended to deny this, despite some loose use of 'sentence' for 'statement'. Doubtless, too, both grammarians and philosophers have been aware that it is by no means easy to distinguish even questions, commands, and so on from statements by means of the few and jejune grammatical marks available, such as word order, mood, and the like: though perhaps it has not been usual to dwell on the difficulties which this fact obviously raises. For how do we decide which is which? What are the limits and definitions of each?

But now in recent years, many things which would once have been accepted without question as 'statements' by both philosophers and grammarians have been scrutinized with new care. This scrutiny arose somewhat indirectly – at least in philosophy. First came the view, not always formulated without unfortunate dogmatism, that a statement (of fact) ought to be 'verifiable', and this led to the view that many 'statements' are only what may be called pseudo-statements. First and most obviously, many 'statements' were shown to be, as Kant perhaps first argued systematically, strictly nonsense, despite an unexceptionable grammatical form: and the continual discovery of fresh types of nonsense,

unsystematic though their classification and mysterious though their explanation is too often allowed to remain, has done on the whole nothing but good. Yet we, that is, even philosophers, set some limits to the amount of nonsense that we are prepared to admit we talk: so that it was natural to go on to ask, as a second stage, whether many apparent pseudo-statements really set out to be 'statements' at all. It has come to be commonly held that many utterances which look like statements are either not intended at all, or only intended in part, to record or impart straightforward information about the facts: for example, 'ethical propositions' are perhaps intended, solely or partly, to evince emotion or to prescribe conduct or to influence it in special ways. Here too Kant was among the pioneers. We very often also use utterances in ways beyond the scope at least of traditional grammar. It has come to be seen that many specially perplexing words embedded in apparently descriptive statements do not serve to indicate some specially odd additional feature in the reality reported, but to indicate (not to report) the circumstances in which the statement is made or reservations to which it is subject or the way in which it is to be taken and the like. To overlook these possibilities in the way once common is called the 'descriptive' fallacy; but perhaps this is not a good name, as 'descriptive' itself is special. Not all true or false statements are descriptions, and for this reason I prefer to use the word 'constative'. Along these lines it has by now been shown piecemeal, or at least made to look likely, that many traditional philosophical perplexities have arisen through a mistake – the mistake of taking as straightforward statements of fact utterances which are *either* (in interesting non-grammatical ways) nonsensical *or else* intended as something quite different.

Whatever we may think of any particular one of these views and suggestions, and however much we may deplore the initial confusion into which philosophical doctrine and method have been plunged, it cannot be doubted that they are producing a revolution in philosophy. If anyone wishes to call it the greatest and most salutary in its history, this is not, if you come to think of it, a large claim. It is not surprising that beginnings have been piecemeal, with *parti pris*, and for extraneous aims; this is common with revolutions.

Preliminary Isolation of the Performative[2]

The type of utterance we are to consider here is not, of course, in general a type of nonsense; though misuse of it can, as we shall see, engender rather special varieties of 'nonsense'. Rather, it is one of our second class – the masqueraders. But it does not by any means necessarily

masquerade as a statement of fact, descriptive or constative. Yet it does quite commonly do so, and that, oddly enough, when it assumes its most explicit form. Grammarians have not, I believe, seen through this 'disguise', and philosophers only at best incidentally.[3] It will be convenient, therefore, to study it first in this misleading form, in order to bring out its characteristics by contrasting them with those of the statement of fact which it apes.

We shall take, then, for our first examples some utterances which can fall into no hitherto recognized *grammatical* category save that of 'statement', which are not nonsense, and which contain none of those verbal danger signals which philosopher have by now detected or think they have detected (curious words like 'good' or 'all', suspect auxiliaries like 'ought' or 'can', and dubious constructions like the hypothetical): all will have, as it happens, humdrum verbs in the first person singular present indicative active.[4] Utterances can be found, satisfying these conditions, yet such that

(A) they do not 'describe' or 'report' or constate anything at all, are not 'true or false'; and
(B) the uttering of the sentence is, or is a part of, the doing of an action, which again would not *normally* be described as, or as 'just', saying something.

This is far from being as paradoxical as it may sound or as I have meanly been trying to make it sound: indeed, the examples now to be given will be disappointing.

(E.*a*) 'I do (sc. take this woman to be my lawful wedded wife)' – as uttered in the course of the marriage ceremony.[5]
(E.*b*) 'I name this ship the *Queen Elizabeth*' – as uttered when smashing the bottle against the stem.
(E.*c*) 'I give and bequeath my watch to my brother' – as occurring in a will.
(E.*d*) 'I bet you sixpence it will rain tomorrow.'

In these examples it seems clear that to utter the sentence (in, of course, the appropriate circumstances) is not to *describe* my doing of what I should be said in so uttering to be doing[6] or to state that I am doing it: it is to do it. None of the utterances cited is either true or false: I assert this as obvious and do not argue it. It needs argument no more than that 'damn' is not true or false: it may be that the utterance 'serves to inform you' – but that is quite different. To name the ship *is* to say (in the appropriate circumstances) the words 'I name, etc.' When I say, before the registrar or altar, etc., 'I do', I am not reporting on a marriage: I am indulging in it.

What are we to call a sentence or an utterance of this type?[7] I propose to call it a *performative sentence* or a performative utterance, or, for short, 'a performative'. The term 'performative' will be used in a variety of cognate ways and constructions, much as the term 'imperative' is.[8] The name is derived, of course, from 'perform', the usual verb with the noun 'action': it indicates that the issuing of the utterance is the performing of an action – it is not normally thought of as just saying something.

A number of other terms may suggest themselves, each of which would suitably cover this or that wider or narrower class of performatives: for example, many performatives are *contractual* ('I bet') or *declaratory* ('I declare war') utterances. But no term in current use that I know of is nearly wide enough to cover them all. One technical term that comes nearest to what we need is perhaps 'operative', as it is used strictly by lawyers in referring to that part, i.e., those clauses, of an instrument which serves to effect the transaction (conveyance or whatnot) which is its main object, whereas the rest of the document merely 'recites' the circumstances in which the transaction is to be effected.[9] But 'operative' has other meanings, and indeed is often used nowadays to mean little more than 'important'. I have preferred a new word, to which, though its etymology is not irrelevant, we shall perhaps not be so ready to attach some pre-conceived meaning.

Can Saying Make It So?

Are we then to say things like this:

'To marry is to say a few words', or
'Betting is simply saying something'?

Such a doctrine sounds odd or even flippant at first, but with sufficient safeguards it may become not odd at all.

A sound initial objection to them may be this; and it is not without some importance. In very many cases it is possible to perform an act of exactly the same kind *not* by uttering words, whether written or spoken, but in some other way. For example, I may in some places effect marriage by cohabiting, or I may bet with a totalisator machine by putting a coin in a slot. We should then, perhaps, convert the propositions above, and put it that 'to say a few certain words is to marry' or 'to marry is, in some cases, simply to say a few words' or 'simply to say a certain something is to bet'.

But probably the real reason why such remarks sound dangerous lies in another obvious fact, to which we shall have to revert in detail later,

which is this. The uttering of the words is, indeed, usually a, or even *the*, leading incident in the performance of the act (of betting or whatnot), the performance of which is also the object of the utterance, but it is far from being usually, even if it is ever, the *sole* thing necessary if the act is to be deemed to have been performed. Speaking generally, it is always necessary that the *circumstances* in which the words are uttered should be in some way, or ways, *appropriate*, and it is very commonly necessary that either the speaker himself or other persons should *also* perform certain *other* actions, whether 'physical' or 'mental' actions or even acts of uttering further words. Thus, for naming the ship, it is essential that I should be the person appointed to name her, for (Christian) marrying, it is essential that I should not be already married with a wife living, sane and undivorced, and so on: for a bet to have been made, it is generally necessary for the offer of the bet to have been accepted by a taker (who must have done something, such as to say 'Done'), and it is hardly a gift if I *say* 'I give it you' but never hand it over.

So far, well and good. The action may be performed in ways other than by a performative utterance, and in any case the circumstances, including other actions, must be appropriate. But we may, in objecting, have something totally different, and this time quite mistaken, in mind, especially when we think of some of the more awe-inspiring performatives such as 'I promise to ...' Surely the words must be spoken 'seriously' and so as to be taken 'seriously'? This is, though vague, true enough in general – it is an important commonplace in discussing the purport of any utterance whatsoever. I must not be joking, for example, nor writing a poem. But we are apt to have a feeling that their being serious consists in their being uttered as (merely) the outward and visible sign, for convenience or other record or for information, of an inward and spiritual act: from which it is but a short step to go on to believe or to assume without realizing that for many purposes the outward utterance is a description, *true* or *false*, of the occurrence of the inward performance. The classic expression of this idea is to be found in the *Hippolytus* (l. 612), where Hippolytus says

ἡ γλῶσσ᾽ ὀμώμοχ᾽, ἡ δὲ φρὴν ἀνώμοτος,

i.e., 'my tongue swore to, but my heart (or mind or other backstage artiste) did not'.[10] Thus 'I promise to ...' obliges me – puts on record my spiritual assumption of a spiritual shackle.

It is gratifying to observe in this very example how excess of profundity, or rather solemnity, at once paves the way for immorality. For one who says 'Promising is not merely a matter of uttering words! It is an inward and spiritual act!' is apt to appear as a solid moralist standing out against

a generation of superficial theorizers: we see him as he sees himself, surveying the invisible depths of ethical space, with all the distinction of a specialist in the *sui generis*. Yet he provides Hippolytus with a let-out, the bigamist with an excuse for his 'I do' and the welsher with a defence for his 'I bet'. Accuracy and morality alike are on the side of the plain saying that *our word is our bond*.

If we exclude such fictitious inward acts as this, can we suppose that any of the other things which certainly are normally required to accompany an utterance such as 'I promise that ...' or 'I do (take this woman ...)' are in fact described by it, and consequently do by their presence make it true or by their absence make it false? Well, taking the latter first, we shall next consider what we actually do say about the utterance concerned when one or another of its normal concomitants is *absent*. In no case do we say that the utterance was false but rather that the utterance – or rather the *act*,[11] e.g., the promise – was void, or given in bad faith, or not implemented, or the like. In the particular case of promising, as with many other performatives, it is appropriate that the person uttering the promise should have a certain intention, viz., here to keep his word: and perhaps of all concomitants this looks the most suitable to be that which 'I promise' does describe or record. Do we not actually, when such intention is absent, speak of a 'false' promise? Yet so to speak is *not* to say that the utterance 'I promise that ...' is false, in the sense that though he states that he does, he doesn't, or that though he describes he misdescribes – misreports. For he *does* promise: the promise here is not even *void*, though it is given *in bad faith*. His utterance is perhaps misleading, probably deceitful and doubtless wrong, but it is not a lie or a misstatement. At most we might make out a case for saying that it implies or insinuates a falsehood or a misstatement (to the effect that he does intend to do something): but that is a very different matter. Moreover, we do not speak of a false bet or a false christening; and that we *do* speak of a false promise need commit us no more than the fact that we speak of a false move. 'False' is not necessarily used of statements only.

Conditions for Happy Performatives

We were to consider, you will remember, some cases and senses (only some, Heaven help us!) in which to *say* something is to *do* something; or in which *by* saying or *in* saying something we are doing something. This topic is one development – there are many others – in the recent

movement towards questioning in age-old assumption in philosophy –
the assumption that to say something, at least in all cases worth con-
sidering, i.e., all cases considered, is always and simply to *state* some-
thing. This assumption is no doubt unconscious, no doubt is precipitate,
but it is wholly natural in philosophy apparently. We must learn to run
before we can walk. If we never made mistakes how should we correct
them?

I began by drawing your attention, by way of example, to a few simple
utterances of the kind known as performatories or performatives. These
have on the face of them the look – or at least the grammatical make-
up – of 'statements'; but nevertheless they are seen, when more closely
inspected, to be, quite plainly, *not* utterances which could be 'true' or
'false'. Yet to be 'true' or 'false' is traditionally the characteristic mark
of a statement. One of our examples was, for instance, the utterance 'I
do' (take this woman to be my lawful wedded wife), as uttered in the
course of a marriage ceremony. Here we should say that in saying these
words we are *doing* something – namely, marrying, rather than *reporting*
something, namely *that* we are marrying. And the act of marrying, like,
say, the act of betting, is at least *preferably* (though still not *accurately*)
to be described as *saying certain words*, rather than as performing a
different, inward and spiritual, action of which these words are merely
the outward and audible sign. That this is so can perhaps hardly be
proved, but it is, I should claim, a fact.

It is worthy of note that, as I am told, in the American law of evidence,
a report of what someone else said is admitted as evidence if what he
said is an utterance of our performative kind: because this is regarded as
a report not so much of something he *said*, as which it would be hearsay
and not admissible as evidence, but rather as something he *did*, an
action of his. This coincides very well with our initial feelings about
performatives.

So far then we have merely felt the firm ground of prejudice slide away
beneath our feet. But now how, as philosophers, are we to proceed? One
thing we might go on to do, of course, is to take it all back: another
would be to bog, by logical stages, down. But all this must take time.
Let us first at least concentration attention on the little matter already
mentioned in passing – this matter of 'the appropriate circumstances'.
To bet is not, as I pointed out in passing, merely to utter the words 'I
bet, etc.': someone might do that all right, and yet we might still not
agree that he had in fact, or at least entirely, succeeded in betting. To
satisfy ourselves of this, we have only, for example, to announce our bet
after the race is over. Besides the uttering of the words of the so-called
performative, a good many other things have as a general rule to be right

and to go right if we are to be said to have happily brought off our action. What these are we may hope to discover by looking at and classifying types of case in which something *goes wrong* and the act – marrying, betting, bequeathing, christening, or whatnot – is therefore at least to some extent a failure: the utterance is then, we may say, not indeed false but in general *unhappy*. And for this reason we call the doctrine of *the things that can be and go wrong* on the occasion of such utterances, the doctrine of the *Infelicities*.

Suppose we try first to state schematically – and I do not wish to claim any sort of finality for this scheme – some at least of the things which are necessary for the smooth or 'happy' functioning of a performative (or at least of a highly developed explicit performative, such as we have hitherto been alone concerned with), and then give examples of infelicities and their effects. I fear, but at the same time of course hope, that these necessary conditions to be satisfied will strike you as obvious.

(A.1) There must exist an accepted conventional procedure having a certain conventional effect, that procedure to include the uttering of certain words by certain persons in certain circumstances, and further,

(A.2) the particular persons and circumstances in a given case must be appropriate for the invocation of the particular procedure invoked.

(B.1) The procedure must be executed by all participants both correctly and

(B.2) completely.

(Γ.1) Where, as often, the procedure is designed for use by persons having certain thoughts or feelings, or for the inauguration of certain consequential conduct on the part of any participant, then a person participating in and so invoking the procedure must in fact have those thoughts or feelings, and the participants must intend so to conduct themselves,[12] and further

(Γ.2) must actually so conduct themselves subsequently.

Now if we sin against any one (or more) of these six rules, our performative utterance will be (in one way or another) unhappy. But, of course, there are considerable differences between these 'ways' of being unhappy – ways which are intended to be brought out by the letter-numerals selected for each heading.

The first big distinction is between all the four rules A and B taken together, as opposed to the two rules Γ (hence the use of Roman as opposed to Greek letters). If we offend against any of the former rules (A's or B's) – that is if we, say, utter the formula incorrectly, or if, say, we are not in a position to do the act because we are, say, married already, or it is the purser and not the captain who is conducting the ceremony, then the act in question, e.g., marrying, is not successfully performed at

all, does not come off, is not achieved. Whereas in the two Γ cases the act *is* achieved, although to achieve it in such circumstances, as when we are, say, insincere, is an abuse of the procedure. Thus, when I say 'I promise' and have no intention of keeping it, I have promised but ... We need names for referring to this general distinction, so we shall call in general those infelicities A.1–B.2 which are such that the act for the performing of which, and in the performing of which, the verbal formula in question is designed, is not achieved, by the name *Misfires*: and on the other hand we may christen those infelicities where the act *is* achieved *Abuses* (do not stress the normal connotations of these names!). When the utterance is a misfire, the procedure which we purport to invoke is disallowed or is botched: and our act (marrying, etc.) is void or without effect, etc. We speak of our act as a purported act, or perhaps an attempt – or we use such an expression as 'went through a form of marriage' by contrast with 'married'. On the other hand, in the Γ cases, we speak of our infelicitous act as 'professed' or 'hollow' rather than 'purported' or 'empty', and as not implemented, or not consummated, rather than as void or without effect. But let me hasten to add that these distinctions are not hard and fast, and more especially that such words as 'purported' and 'professed' will not bear very much stressing. Two final words about being void or without effect. This does not mean, of course, to say that we won't have done anything: lots of things will have been done – we shall most interestingly have committed the act of bigamy – but we shall *not* have done the purported act, viz., marrying. Because despite the name, you do not when bigamous marry twice. (In short, the algebra of marriage is BOOLEAN.) Further, 'without effect' does not here mean 'without consequences, results, effects'.

Next, we must try to make clear the general distinction between the A cases and the B cases, among the misfires. In both of the cases labelled A there is *misinvocation* of a procedure – either because there *is*, speaking vaguely, no such procedure, or because the procedure in question cannot be made to apply in the way attempted. Hence infelicities of this kind A may be called *Misinvocations*. Among them, we may reasonably christen the second sort – where the procedure does exist all right but can't be applied as purported – *Misapplications*. But I have not succeeded in finding a good name for the other, former, class. By contrast with the A cases, the notion of the B cases is rather that the procedure is all right, and it does apply all right, but we muff the execution of the ritual with more or less dire consequences: so B cases as opposed to A cases will be called *Misexecutions* as opposed to Misinvocations: the purported act is *vitiated* by a flaw or hitch in the conduct of the ceremony. The Class B.1 is that of Flaws, the Class B.2 that of Hitches.

We get then the following scheme:[13]

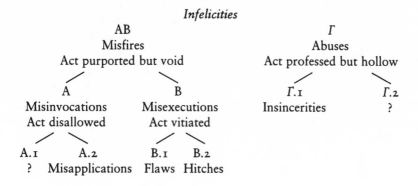

Infelicities

AB — Misfires — Act purported but void
→ A — Misinvocations — Act disallowed
→→ A.1 — ?
→→ A.2 — Misapplications
→ B — Misexecutions — Act vitiated
→→ B.1 — Flaws
→→ B.2 — Hitches

Γ — Abuses — Act professed but hollow
→ Γ.1 — Insincerities
→ Γ.2 — ?

I expect some doubts will be entertained about A.1 and Γ.2; but we will postpone them for detailed consideration shortly.

But before going on to details, let me make some general remarks about these infelicities. We may ask:

(1) To what variety of 'act' does the notion of infelicity apply?

(2) How complete is this classification of infelicity?

(3) Are these classes of infelicity mutually exclusive?

Let us take these questions in (that) order.

(1) How widespread is infelicity?

Well, it seems clear in the first place that, although it has excited us (or failed to excite us) in connexion with certain acts which are or are in part acts of *uttering words*, infelicity is an ill to which *all* acts are heir which have the general character of ritual or ceremonial, all *conventional* acts: not indeed that *every* ritual is liable to every form of infelicity (but then nor is every performative utterance). This is clear if only from the mere fact that many conventional acts, such as betting or conveyance of property, can be performed in non-verbal ways. The same sorts of rule must be observed in all such conventional procedures – we have only to omit the special reference to verbal utterance in our A. This much is obvious.

But, furthermore, it is worth pointing out – reminding you – how many of the 'acts' which concern the jurist are or include the utterance of performatives, or at any rate are or include the performance of some conventional procedures. And of course you will appreciate that in this way and that writers on jurisprudence have constantly shown themselves aware of the varieties of infelicity and even at times of the peculiarities of the performative utterance. Only the still widespread obsession that

the utterances of the law, and utterances used in, say, 'acts in the law', *must* somehow be statements true or false, has prevented many lawyers from getting this whole matter much straighter than we are likely to – and I would not even claim to know whether some of them have not already done so. Of more direct concern to us, however, is to realize that, by the same token, a great many of the acts which fall within the province of ethics are *not*, as philosophers are too prone to assume, simply in the last resort *physical movements*: very many of them have the general character, in whole or part, of conventional or ritual acts, and are therefore, among other things, exposed to infelicity.

Lastly we may ask – and here I must let some of my cats on the table – does the notion of infelicity apply to utterances *which are statements*? So far we have produced the infelicity as characteristic of the *performative* utterance, which was 'defined' (if we can call it so much) mainly by contrast with the supposedly familiar 'statement'. Yet I will content myself here with pointing out that one of the things that has been happening lately in philosophy is that close attention has been given even to 'statements' which, though not false exactly nor yet 'contradictory', are yet outrageous. For instance, statements which refer to something which does not exist as, for example, 'The present King of France is bald'. There might be a temptation to assimilate this to purporting to bequeath something which you do not own. Is there not a presupposition of existence in each? Is not a statement which refers to something which does not exist not so much false as void? And the more we consider a statement not as a sentence (or proposition) but as an act of speech (out of which the others are logical constructions) the more we are studying the whole thing as an act. Or again, there are obvious similarities between a lie and a false promise. We shall have to return to this matter later.[14]

(2) Our second question was: How complete is this classification?
 (i) Well, the first thing to remember is that, since in uttering our performatives we are undoubtedly in a sound enough sense 'performing actions', then, as actions, these will be subject to certain whole dimensions of unsatisfactoriness to which all actions are subject but which are distinct – or distinguishable – from what we have chosen to discuss as infelicities. I mean that actions in general (not all) are liable, for example, to be done under duress, or by accident, or owing to this or that variety of mistake, say, or otherwise unintentionally. In many such cases we are certainly unwilling to say of some such act simply that it was done or that he did it. I am not going into the general doctrine here: in many such cases we may even say the act was 'void' (or voidable for duress or undue influence)

and so forth. Now I suppose some very general high-level doctrine might embrace both what we have called infelicities *and* these other 'unhappy' features of the doing of actions – in our case actions containing a performative utterance – in a single doctrine: but we are not including this kind of unhappiness – we must just remember, though, that features of this sort can and do constantly obtrude into any particular case we are discussing. Features of this sort would normally come under the heading of 'extenuating circumstances' or of 'factors reducing or abrogating the agent's responsibility', and so on.

(ii) Secondly, as *utterances* our performatives are *also* heir to certain other kinds of ill which infect *all* utterances. And these likewise, though again they might be brought into a more general account, we are deliberately at present excluding. I mean, for example, the following: a performative utterance will, for example, be *in a peculiar way* hollow or void if said by an actor on the stage, or if introduced in a poem, or spoken in soliloquy. This applies in a similar manner to any and every utterance – a sea-change in special circumstances. Language in such circumstances is in special ways – intelligibly – used not seriously, but in ways *parasitic* upon its normal use – ways which fall under the doctrine of the *etiolations* of language. All this we are *excluding* from consideration. Our performative utterances, felicitous or not, are to be understood as issued in ordinary circumstances.

(iii) It is partly in order to keep this sort of consideration at least for the present out of it, that I have not here introduced a sort of 'infelicity' – it might really be called such – arising out of 'mis-understanding'. It is obviously necessary that to have promised I must normally

(A) have been *heard* by someone, perhaps the promisee;
(B) have been understood by him as promising.

If one or another of these conditions is not satisfied, doubts arise as to whether I have really promised, and it might be held that my act was only attempted or was void. Special precautions are taken in law to avoid this and other infelicities, e.g., in the serving of writs or summonses. This particular very important consideration we shall have to return to later in another connexion.

(3) Are these cases of infelicity mutually exclusive? The answer to this is obvious.

(*a*) No, in the sense that we can go wrong in two ways at once (we can insincerely promise a donkey to give it a carrot).

(*b*) No, more importantly, in the sense that the ways of going wrong 'shade into one another' and 'overlap', and the decision between them is 'arbitrary' in various ways.

Suppose, for example, I see a vessel on the stocks, walk up and smash the bottle hung at the stem, proclaim 'I name this ship the *Mr Stalin*' and for good measure kick away the chocks: but the trouble is, I was not the person chosen to name it (whether or not – an additional complication – *Mr Stalin* was the destined name; perhaps in a way it is even more of a shame if it was). We can all agree

(1) that the ship was not thereby named;[15]
(2) that it is an infernal shame.

One could say that I 'went through a form of' naming the vessel but that my 'action' was 'void' or 'without effect', because I was not a proper person, had not the 'capacity' to perform it: but one might also and alternatively say that, where there is not even a pretence of capacity or a colourable claim to it, then there is no accepted conventional procedure; it is a mockery, like a marriage with a monkey. Or again one could say that part of the procedure is getting oneself appointed. When the saint baptized the penguins, was this void because the procedure of baptizing is inappropriate to be applied to penguins, or because there is no accepted procedure of baptizing anything except humans? I do not think that these uncertainties matter in theory, though it is pleasant to investigate them and in practice convenient to be ready, as jurists are, with a terminology to cope with them.

Notes and References

1. It is, of course, not really correct that a sentence ever *is* a statement: rather, it is *used* in *making a statement*, and the statement itself is a 'logical construction' out of the makings of statements.
2. Everything said in these sections is provisional, and subject to revision in the light of later sections.
3. Of all people, jurists should be best aware of the true state of affairs. Perhaps some now are. Yet they will succumb to their own timorous fiction, that a statement of 'the law' is a statement of fact.
4. Not without design: they are all 'explicit' performatives, and of that pre-potent class later called 'exercitives'.
5. [Austin realized that the expression 'I do' is not used in the marriage ceremony too late to correct his mistake. We have let it remain in the text as it is philosophically unimportant that it is a mistake. James O. Urmson (ed.).]
6. Still less anything that I have already done or have yet to do.

7. 'Sentences' form a class of 'utterances', which class is to be defined, so far as I am concerned, grammatically, though I doubt if the definition has yet been given satisfactorily. With performative utterances are contrasted, for example and essentially, 'constative' utterances: to issue a constative utterance (i.e., to utter it with a historical reference) is to make a statement. To issue a performative utterance is, for example, to make a bet. See further below on 'illocutions'.

8. Formerly I used 'performatory': but 'performative' is to be preferred as shorter, less ugly, more tractable, and more traditional in formation.

9. I owe this observation to Professor H. L. A. Hart.

10. But I do not mean to rule out all the offstage performers – the lights men, the stage manager, even the prompter; I am objecting only to certain officious understudies, who would duplicate the play.

11. We deliberately avoid distinguishing these, precisely because the distinction is not in point.

12. It will be explained later why the having of these thoughts, feelings, and intentions is not included as just one among the other 'circumstances' already dealt with in (A).

13. [Austin from time to time used other names for the different infelicities. For interest some are here given: A.1, Non-plays; A.2, Misplays; B, Miscarriages; B.1, Misexecutions; B.2, Non-executions; Γ, Disrespects; Γ.1, Dissimulations; Γ.2, Non-fulfilments, Disloyalties, Infractions, Indisciplines, Breaches. J. O. U.]

14. [See *How to do things with Words*, pp. 47 ff. J. O. U.]

15. Naming babies is even more difficult; we might have the wrong name and the wrong cleric – that is, someone entitled to name babies but not intended to name *this* one.

7

H. P. GRICE
(1913–88)

Herbert Paul Grice, born in Birmingham, was educated at Oxford where he also taught until 1967. He subsequently emigrated to the United States where he held a Chair at the University of California at Berkeley from 1967–80. Despite the fact that Grice published only a few articles in his lifetime, he is widely recognized as one of the most insightful philosophers of language of the second half of the twentieth century.

Grice's approach is similar to that of the ordinary-language philosophers in that he was interested in the study of language as a medium of communication. However, he also advanced a theory of meaning which went beyond mere linguistic analysis. The article reproduced in this collection sets out Grice's theory of meaning. He begins by distinguishing between natural and non-natural meaning. 'Dark clouds means rain', according to Grice, gives an example of natural meaning, here not a question of man-made conventions but a set of relationships between different natural events. Natural meanings are discovered and not made: we discover that dark clouds are a strong indicator of rain, so we are inclined to say, 'Dark clouds mean rain'. Non-natural meaning is broader in scope insofar as it encompasses all systems of sign, including linguistic ones, which human conventions have endowed with meaning. Some examples of non-natural meaning Grice gives are:

> The ringing of the bell means that the bus is full.
> By raising her hand, Mary means that she knows the answer.
> That remark, 'The coast is clear', means that the rebels have left.

In all these instances meaningfulness is the outcome of pre-established human conventions. Non-natural meaning is artificially constructed rather than discerned or discovered from existing natural patterns. Linguistic meaning is one sub-category of non-natural meaning, but as the above examples show, there are instances of non-natural meaning that have nothing to do with language.

Within the category of linguistic meaning, Grice draws a further distinction between (i) a speaker's or utterer's meaning, and (ii) sentence meaning. The first concerns the meaning conveyed by a speaker; the second concerns the literal meaning of sentences, and this can be subdivided further into the general meaning of a sentence and what that sentence means on a particular occasion of use. According to Grice, in constructing a theory of meaning the speaker's meaning, on particular occasions, and her communicative intentions, should be seen as more basic and prior to the abstract level of sentence meaning. In taking this position Grice was distancing himself from earlier analytic philosophers of language who had concentrated on sentences as the primary unit of meaning. He also emphasized a broader understanding of what speakers mean by drawing attention to what he called the 'utterer's meaning', by which he means whatever one person tries to communicate to another by linguistic or non-linguistic means, including gestures, facial expressions, drawing and so on.

After this initial stage-setting, Grice defines meaning through the following analysis: an utterer (U) means (non-naturally) something through an action or utterance (X) if and only if U intends to produce some effect on an audience (A) by getting A to recognize through X that she intends that effect. There are basically two kinds of effects that a person can induce in an audience:

(a) A speaker can get a hearer(s) to believe something.
(b) A speaker can get a hearer(s) to do something.

(a) is ordinarily performed through indicative utterances while (b) is performed through imperative utterances. Thus, for Grice, meaning is the product of an interaction between a speaker and a hearer and cannot be analysed in isolation from the communicative intentions of thinking human beings.

A further important aspect of Grice's theory of meaning is his explanation of how the mutual interaction between what a speaker says in a specific context, together with certain conversational maxims that have been implicitly or explicitly adopted by a linguistic community, give rise to what he calls 'conversational implicatures'. Grice argues that often in conversation what is implied or suggested is quite distinct from what is actually said. Some implications of what is being said are closely related to the words used, as in the case of 'He is an Englishman; he is therefore brave'. These types of implication are 'conventional'; they have to do with the meaning and the conventional uses of words and expressions.

There is a second type of implication which is non-conventional, a subclass of which Grice calls 'conversational implicatures'.

Conversational implicatures are connected with certain general features of discourse, rather than the specific meaning of what has been said. The general principle governing all conversation is the 'cooperative principle', which, roughly, enjoins the participants in a conversation to make their conversational contribution 'such as is required at the stage at which it occurs, by the accepted purpose or direction of the talk exchange in which they are engaged'. For example, a referee who recommends a student for a job by praising his punctuality and good manners only implies that she does not have a high opinion of the student's abilities. Grice uses his theory of the conversational implicature to elucidate the connection between the logical connectives used in ordinary language, e.g., *or, and, if . . . then*, and their formal counterparts. His main thesis is that the logical particles used in ordinary language have a truth-functional sense but they can conversationally implicate more than just their strict meaning. He argues that it would be a mistake to think that formal logic does not capture the meaning of these connectives. What is absent from formal languages is the conversational implicatures of their use. Thus Grice establishes a common ground between ordinary-language philosophy and the concerns of the earlier analytic philosophers, such as Russell, with formal languages of logic by showing that the correct understanding of how ordinary language works sheds a new light on the old problem of the meaning of logical connectives.

Works by Grice

1989 *Studies in the Ways of Words*. Cambridge, MA: Harvard University Press.
1991 *The Conception of Value*. Oxford: Clarendon Press.

Works on Grice

Avramides, A., *Meaning and Mind*. Cambridge, MA: MIT Press, 1989.
Grandy, Richard E. and Warner, Richard (eds), *Philosophical Grounds of Rationality*, 6. Oxford: Clarendon Press, 1986.
Neale, S., 'Paul Grice and the Philosophy of Language' in *Linguistics and Philosophy*, 15 (1992).
Schiffer, Stephen R., *Meaning*. Oxford: Clarendon Press, 1972.
Strawson, Peter F., *Logico-Linguistic Papers*. London: Methuen, 1971.

Meaning

Consider the following sentences:

'Those spots mean (meant) measles.'
'Those spots didn't mean anything to me, but to the doctor they meant measles.'
'The recent budget means that we shall have a hard year.'

(1) I cannot say, 'Those spots meant measles, but he hadn't got measles,' and I cannot say, 'The recent budget means that we shall have a hard year, but we shan't have.' That is to say, in cases like the above, *x meant that p* and *x means that p* entail *p*.

(2) I cannot argue from 'Those spots mean (meant) measles' to any conclusion about 'what is (was) meant by those spots'; for example, I am not entitled to say, 'What was meant by those spots was that he had measles.' Equally I cannot draw from the statement about the recent budget the conclusion 'What is meant by the recent budget is that we shall have a hard year.'

(3) I cannot argue from 'Those spots meant measles' to any conclusion to the effect that somebody or other meant by those spots so-and-so. *Mutatis mutandis*, the same is true of the sentence about the recent budget.

(4) For none of the above examples can a restatement be found in which the verb 'mean' is followed by a sentence or phrase in quotation marks. Thus 'Those spots meant measles' cannot be reformulated as 'Those spots mean "measles" ' or as 'Those spots meant "he has measles." '

(5) On the other hand, for all these examples an approximate restatement can be found beginning with the phrase 'The fact that . . .'; for example, 'The fact that he had those spots meant that he had measles' and 'The fact that the recent budget was as it was means that we shall have a hard year.'

Now contrast the specimen sentences with the following:

'Those three rings on the bell (of the bus) mean that the bus is full.'
'That remark, "Smith couldn't get on without his trouble and strife", meant that Smith found his wife indispensable.'

(1) I can use the first of these and go on to say, 'But it isn't in fact full – the conductor has made a mistake'; and I can use the second and go on, 'But in fact Smith deserted her seven years ago.' That is to say, here *x means that p* and *x meant that p* do not entail *p*.

(2) I can argue from the first to some statement about 'what is (was) meant' by the rings on the bell and from the second to some statement about 'what is (was) meant' by the quoted remark.

(3) I can argue from the first sentence to the conclusion that somebody (namely the conductor) meant, or at any rate should have meant, by the rings that the bus is full, and I can argue analogously for the second sentence.

(4) The first sentence can be restated in a form in which the verb 'mean' is followed by a phrase in quotation marks, that is, 'Those three rings on the bell mean "the bus is full".' So also can the second sentence.

(5) Such a sentence as 'The fact that the bell has been rung three times means that the bus is full' is not a restatement of the meaning of the first sentence. Both may be true, but they do not have, even approximately, the same meaning.

When the expressions 'means', 'means something', 'means that' are used in the kind of way in which they are used in the first set of sentences, I shall speak of the sense, or senses, in which they are used, as the *natural* sense, or senses, of the expressions in question. When the expressions are used in the kind of way in which they are used in the second set of sentences, I shall speak of the sense, or senses, in which they are used, as the *nonnatural* sense, or senses, of the expressions in question. I shall use the abbreviation 'means$_{NN}$' to distinguish the nonnatural sense or senses.

I propose, for convenience, also to include under the head of natural senses of 'mean' such senses of 'mean' as may be exemplified in sentences of the pattern 'A means (meant) *to do* so-and-so (by *x*)', where *A* is a human agent. By contrast, as the previous examples show, I include under the head of nonnatural senses of 'mean' any senses of 'mean' found in sentences of the patterns 'A means (meant) something by *x*' or 'A means (meant) by *x* that ...' (This is over-rigid; but it will serve as an indication.)

I do not want to maintain that *all* our uses of 'mean' fall easily, obviously, and tidily into one of the two groups I have distinguished; but

I think that in most cases we should be at least fairly strongly inclined to assimilate a use of 'mean' to one group rather than to the other. The question which now arises is this: 'What more can be said about the distinction between the cases where we should say that the word is applied in a natural sense and the cases where we should say that the word is applied in a nonnatural sense?' Asking this question will not of course prohibit us from trying to give an explanation of 'meaning$_{NN}$' in terms of one or another natural sense of 'mean.'

This question about the distinction between natural and nonnatural meaning is, I think, what people are getting at when they display an interest in a distinction between 'natural' and 'conventional' signs. But I think my formulation is better. For some things which can mean$_{NN}$ something are not signs (e.g., words are not), and some are not conventional in any ordinary sense (e.g., certain gestures); while some things which mean naturally are not signs of what they mean (cf. the recent budget example).

I want first to consider briefly, and reject, what I might term a causal type of answer to the question, 'What is meaning$_{NN}$?' We might try to say, for instance, more or less with C. L. Stevenson,[1] that for x to mean$_{NN}$ something, x must have (roughly) a tendency to produce in an audience some attitude (cognitive or otherwise) and a tendency, in the case of a speaker, to *be* produced by that attitude, these tendencies being dependent on 'an elaborate process of conditioning attending the use of the sign in communication'.[2] This clearly will not do.

(1) Let us consider a case where an utterance, if it qualifies at all as meaning$_{NN}$ something, will be of a descriptive or informative kind and the relevant attitude, therefore, will be a cognitive one, for example, a belief. (I use 'utterance' as a neutral word to apply to any candidate for meaning$_{NN}$; it has a convenient act–object ambiguity.) It is no doubt the case that many people have a tendency to put on a tailcoat when they think they are about to go to a dance, and it is no doubt also the case that many people, on seeing someone put on a tailcoat, would conclude that the person in question was about to go to a dance. Does this satisfy us that putting on a tailcoat means$_{NN}$ that one is about to go to a dance (or indeed means$_{NN}$ anything at all)? Obviously not. It is no help to refer to the qualifying phrase 'dependent on an elaborate process of conditioning'. For if all this means is that the response to the sight of a tailcoat being put on is in some way learned or acquired, it will not exclude the present case from being one of meaning$_{NN}$. But if we have to take seriously the second part of the qualifying phrase ('attending the use of the sign in communication'), then the account of meaning$_{NN}$ is obviously circular. We might just as well say, 'X has meaning$_{NN}$ if it is

used in communication', which, though true, is not helpful.

(2) If this is not enough, there is a difficulty – really the same difficulty, I think – which Stevenson recognizes: how we are to avoid saying, for example, that 'Jones is tall' is part of what is meant by 'Jones is an athlete', since to tell someone that Jones is an athlete would tend to make him believe that Jones is tall. Stevenson here resorts to invoking linguistic rules, namely, a permissive rule of language that 'athletes may be non-tall'. This amounts to saying that we are not prohibited by rule from speaking of 'non-tall athletes'. But why are we not prohibited? Not because it is not bad grammar, or is not impolite, and so on, but presumably because it is not meaningless (or, if this is too strong, does not in any way violate the rules of meaning for the expressions concerned). But this seems to involve us in another circle. Moreover, one wants to ask why, if it is legitimate to appeal here to rules to distinguish what is meant from what is suggested, this appeal was not made earlier, in the case of groans, for example, to deal with which Stevenson originally introduced the qualifying phrase about dependence on conditioning.

A further deficiency in a causal theory of the type just expounded seems to be that, even if we accept it as it stands, we are furnished with an analysis only of statements about the *standard* meaning, or the meaning in general, of a 'sign'. No provision is made for dealing with statements about what a particular speaker or writer means by a sign on a particular occasion (which may well diverge from the standard meaning of the sign); nor is it obvious how the theory could be adapted to make such provision. One might even go further in criticism and maintain that the causal theory ignores the fact that the meaning (in general) of a sign needs to be explained in terms of what users of the sign do (or should) mean by it on particular occasions; and so the latter notion, which is unexplained by the causal theory, is in fact the fundamental one. I am sympathetic to this more radical criticism, though I am aware that the point is controversial.

I do not propose to consider any further theories of the 'causal-tendency' type. I suspect no such theory could avoid difficulties analogous to those I have outlined without utterly losing its claim to rank as a theory of this type.

I will now try a different and, I hope, more promising line. If we can elucidate the meaning of

'x meant$_{NN}$ something (on a particular occasion)' and
'x meant$_{NN}$ that so-and-so (on a particular occasion)'

and of

'A meant$_{NN}$ something by x (on a particular occasion)' and

'*A* meant$_{NN}$ by *x* that so-and-so (on a particular occasion)',

this might reasonably be expected to help us with

'*x* means$_{NN}$ (timeless) something (that so-and-so)'
'*A* means$_{NN}$ (timeless) by *x* something (that so-and-so)'.

and with the explication of 'means the same as', 'understands', 'entails', and so on. Let us for the moment pretend that we have to deal only with utterances which might be informative or descriptive.

A first shot would be to suggest that '*x* meant$_{NN}$ something' would be true if *x* was intended by its utterer to induce a belief in some 'audience' and that to say what the belief was would be to say what *x* meant$_{NN}$. This will not do. I might leave *B*'s handkerchief near the scene of a murder in order to induce the detective to believe that *B* was the murderer; but we should not want to say that the handkerchief (or my leaving it there) meant$_{NN}$ anything or that I had meant$_{NN}$ by leaving it that *B* was the murderer. Clearly we must at least add that, for *x* to have meant$_{NN}$ anything, not merely must it have been 'uttered' with the intention of inducing a certain belief but also the utterer must have intended an 'audience' to recognize the intention behind the utterance.

This, though perhaps better, is not good enough. Consider the following cases:

(1) Herod presents Salome with the head of St John the Baptist on a charger.
(2) Feeling faint, a child lets its mother see how pale it is (hoping that she may draw her own conclusions and help).
(3) I leave the china my daughter has broken lying around for my wife to see.

Here we seem to have cases which satisfy the conditions so far given for meaning$_{NN}$. For example, Herod intended to make Salome believe that St John the Baptist was dead and no doubt also intended Salome to recognize that he intended her to believe that St John the Baptist was dead. Similarly for the other cases. Yet I certainly do not think that we should want to say that we have here cases of meaning$_{NN}$.

What we want to find is the difference between, for example, 'deliberately and openly letting someone know' and 'telling' and between 'getting someone to think' and 'telling'.

The way out is perhaps as follows. Compare the following two cases:

(1) I show Mr *X* a photograph of Mr *Y* displaying undue familiarity to Mrs *X*.
(2) I draw a picture of Mr *Y* behaving in this manner and show it to Mr *X*.

I find that I want to deny that in (1) the photograph (or my showing it to Mr X) meant$_{NN}$ anything at all; while I want to assert that in (2) the picture (or my drawing and showing it) meant$_{NN}$ something (that Mr Y had been unduly familiar), or at least that I had meant$_{NN}$ by it that Mr Y had been unduly familiar. What is the difference between the two cases? Surely that in case (1) Mr X's recognition of my intention to make him believe that there is something between Mr Y and Mrs X is (more or less) irrelevant to the production of this effect by the photograph. Mr X would be led by the photograph at least to suspect Mrs X even if, instead of showing it to him, I had left it in his room by accident; and I (the photograph-shower) would not be unaware of this. But it will make a difference to the effect of my picture on Mr X whether or not he takes me to be intending to inform him (make him believe something) about Mrs X, and not to be just doodling or trying to produce a work of art.

But now we seem to be landed in a further difficulty if we accept this account. For consider now, say, frowning. If I frown spontaneously, in the ordinary course of events, someone looking at me may well treat the frown as a natural sign of displeasure. But if I frown deliberately (to convey my displeasure), an onlooker may be expected, provided he recognizes my intention, *still* to conclude that I am displeased. Ought we not then to say, since it could not be expected to make any difference to the onlooker's reaction whether he regards my frown as spontaneous or as intended to be informative, that my frown (deliberate) does *not* mean$_{NN}$ anything? I think this difficulty can be met; for though in general a deliberate frown may have the same effect (with respect to inducing belief in my displeasure) as a spontaneous frown, it can be expected to have the same effect only *provided* the audience takes it as intended to convey displeasure. That is, if we take away the recognition of intention, leaving the other circumstances (including the recognition of the frown as deliberate), the belief-producing tendency of the frown must be regarded as being impaired or destroyed.

Perhaps we may sum up what is necessary for A to mean something by x as follows. A must intend to induce by x a belief in an audience, and he must also intend his utterance to be recognized as so intended. But these intentions are not independent; the recognition is intended by A to play its part in inducing the belief, and if it does not do so something will have gone wrong with the fulfillment of A's intentions. Moreover, A's intending that the recognition should play this part implies, I think, that he assumes that there is some chance that it will in fact play this part, that he does not regard it as a foregone conclusion that the belief will be induced in the audience whether or not the intention behind the utterance is recognized. Shortly, perhaps, we may say that 'A meant$_{NN}$

something by x' is roughly equivalent to 'A uttered x with the intention of inducing a belief by means of the recognition of this intention'. (This seems to involve a reflexive paradox, but it does not really do so.)

Now perhaps it is time to drop the pretense that we have to deal only with 'informative' cases. Let us start with some examples of imperatives or quasi-imperatives. I have a very avaricious man in my room, and I want him to go; so I throw a pound note out of the window. Is there here any utterance with a meaning$_{NN}$? No, because in behaving as I did, I did not intend his recognition of my purpose to be in any way effective in getting him to go. This is parallel to the photograph case. If, on the other hand, I had pointed to the door or given him a little push, then my behavior might well be held to constitute a meaningful$_{NN}$ utterance, just because the recognition of my intention would be intended by me to be effective in speeding his departure. Another pair of cases would be (1) a policeman who stops a car by standing in its way and (2) a policeman who stops a car by waving.

Or, to turn briefly to another type of case, if, as an examiner, I fail a man, I may well cause him distress or indignation or humiliation; and if I am vindictive, I may intend this effect and even intend him to recognize my intention. But I should not be inclined to say that my failing him meant$_{NN}$ anything. On the other hand, if I cut someone in the street, I do feel inclined to assimilate this to the cases of meaning$_{NN}$, and this inclination seems to me dependent on the fact that I could not reasonably expect him to be distressed (indignant, humiliated) unless he recognized my intention to affect him in this way. If my college stopped my salary altogether, I should accuse them of ruining me; if they cut it by one pound, I might accuse them of insulting me; with some larger cuts I might not know quite what to say.

Perhaps then we may make the following generalizations.

(1) 'A meant$_{NN}$ something by x' is (roughly) equivalent to 'A intended the utterance of x to produce some effect in an audience by means of the recognition of this intention'; and we may add that to ask what A meant is to ask for a specification of the intended effect (though, of course, it may not always be possible to get a straight answer involving a 'that' clause, for example, 'a belief that . . .').

(2) 'x meant something' is (roughly) equivalent to 'Somebody meant$_{NN}$ something by x'. Here again there will be cases where this will not quite work. I feel inclined to say that (as regards traffic lights) the change to red meant$_{NN}$ that the traffic was to stop; but it would be very unnatural to say, 'Somebody (e.g., the Corporation) meant$_{NN}$ by the red-light change that the traffic was to stop'. Nevertheless, there seems to be *some* sort of reference to somebody's intentions.

(3) 'x means$_{NN}$ (timeless) that so-and-so' might as a first shot be equated with some statement or disjunction of statements about what 'people' (vague) intend (with qualifications about 'recognition') to effect by x. I shall have a word to say about this.

Will any kind of intended effect do, or may there be cases where an effect is intended (with the required qualifications) and yet we should not want to talk of meaning$_{NN}$? Suppose I discovered some person so constituted that, when I told him that whenever I grunted in a special way I wanted him to blush or to incur some physical malady, thereafter whenever he recognized the grunt (and with it my intention), he did blush or incur the malady. Should we then want to say that the grunt meant$_{NN}$ something? I do not think so. This points to the fact that for x to have meaning$_{NN}$, the intended effect must be something which in some sense is within the control of the audience, or that in some sense of 'reason' the recognition of the intention behind x is for the audience a reason and not merely a cause. It might look as if there is a sort of pun here ('reason for believing' and 'reason for doing'), but I do not think this is serious. For though no doubt from one point of view questions about reasons for believing are questions about evidence and so quite different from questions about reasons for doing, nevertheless to recognize an utterer's intention in uttering x (descriptive utterance), to have a reason for believing that so-and-so, is at least quite like 'having a motive for' accepting so-and-so. Decisions 'that' seem to involve decisions 'to' (and this is why we can 'refuse to believe' and also be 'compelled to believe'). (The 'cutting' case needs slightly different treatment, for one cannot in any straightforward sense 'decide' to be offended; but one can refuse to be offended.) It looks, then, as if the intended effect must be something within the control of the audience, or at least the *sort* of thing which is within its control.

One point before passing to an objection or two. I think it follows from what I have said about the connection between meaning$_{NN}$ and recognition of intention that (insofar as I am right) only what I may call the primary intention of an utterer is relevant to the meaning$_{NN}$ of an utterance. For if I utter x, intending (with the aid of the recognition of this intention) to induce an effect E, and intend this effect E to lead to a further effect F, then insofar as the occurrence of F is thought to be dependent solely on E, I cannot regard F as in the least dependent on recognition of my intention to induce E. That is, if (say) I intend to get a man to do something by giving him some information, it cannot be regarded as relevant to the meaning$_{NN}$ of my utterance to describe what I intend him to do.

Now some questions may be raised about my use, fairly free, of such

words as 'intention' and 'recognition'. I must disclaim any intention of peopling all our talking life with armies of complicated psychological occurrences. I do not hope to solve any philosophical puzzles about intending, but I do want briefly to argue that no special difficulties are raised by my use of the word 'intention' in connection with meaning. First, there will be cases where an utterance is accompanied or preceded by a conscious 'plan', or explicit formulation of intention (e.g., I declare how I am going to use x, or ask myself how to 'get something across'). The presence of such an explicit 'plan' obviously counts fairly heavily in favor of the utterer's intention (meaning) being as 'planned'; though it is not, I think, conclusive; for example, a speaker who has declared an intention to use a familiar expression in an unfamiliar way may slip into the familiar use. Similarly in nonlinguistic cases: if we are asking about an agent's intention, a previous expression counts heavily; nevertheless, a man might plan to throw a letter in the dustbin and yet take it to the post; when lifting his hand, he might 'come to' and say *either* 'I didn't intend to do this at all' *or* 'I suppose I must have been intending to put it in.'

Explicitly formulated linguistic (or quasilinguistic) intentions are no doubt comparatively rare. In their absence we would seem to rely on very much the same kinds of criteria as we do in the case of non-linguistic intentions where there is a general usage. An utterer is held to intend to convey what is normally conveyed (or normally intended to be conveyed), and we require a good reason for accepting that a particular use diverges from the general usage (e.g., he never knew or had forgotten the general usage). Similarly in non-linguistic cases: we are presumed to intend the normal consequences of our actions.

Again, in cases where there is doubt, say, about which of two or more things an utterer intends to convey, we tend to refer to the context (linguistic or otherwise) of the utterance and ask which of the alternatives would be relevant to other things he is saying or doing, or which intention in a particular situation would fit in with some purpose he obviously has (e.g., a man who calls for a 'pump' at a fire would not want a bicycle pump). Non-linguistic parallels are obvious: context is a criterion in settling the question of why a man who has just put a cigarette in his mouth has put his hand in his pocket; relevance to an obvious end is a criterion in settling why a man is running away from a bull.

In certain linguistic cases we ask the utterer afterward about his intention, and in a few of these cases (the very difficult ones, such as a philosopher being asked to explain the meaning of an unclear passage in one of his works), the answer is not based on what he remembers but is more like a decision, a decision about how what he said is to be taken.

I cannot find a nonlinguistic parallel here; but the case is so special as not to seem to contribute a vital difference.

All this is very obvious; but surely to show that the criteria for judging linguistic intentions are very like the criteria for judging nonlinguistic intentions is to show that linguistic intentions are very like nonlinguistic intentions.

Notes and References

1. *Ethics and Language* (New Haven, CT: Yale University Press, 1944), chapter 3.
2. Ibid., p. 57.

8

W. V. O. QUINE

(1908–)

Willard Van Orman Quine, the most influential English-language philosopher of the second half of the twentieth century, was born in Akron, Ohio. He spent his entire academic career at Harvard, where he obtained his doctoral degree under the supervision of A. N. Whitehead, and where he is currently an emeritus professor. He came into contact with the logical positivists during a visit to Europe in the 1930s when he attended some of the meetings of the Vienna Circle and met Rudolf Carnap in Prague and Alfred Tarski and Jan Lukasiewicz in Warsaw. Although Quine's work contains some of the most searching criticisms of logical positivism, he never abandoned his adherence to a number of its main tenets. In particular, he has remained wholly committed to naturalism and empiricism. He has also stressed that the task of philosophy should be continuous with that of the natural sciences; but he has added a new dimension to Anglo-Austrian logical empiricism by making use of elements drawn from American Pragmatism to develop a more sophisticated and rigorous version of empiricism.

Quine's ground-breaking article 'Two Dogmas of Empiricism' (1951), reproduced in this collection, is a direct attack on logical positivism, as well as a more general criticism of some of the main tenets of empiricism. As we saw, in chapter 4 and in the Introduction, the main theses of logical positivism are:

(I) The distinction between analytic and synthetic sentences or truths of reason and truths of facts.

(II) The principle of verification. The view that sentences or propositions are meaningful only if they are either analytic or verifiable by empirical means.

(III) The thesis that each meaningful empirical sentence is associated with specific sensory experiences which can confirm or disconfirm it, or what Quine calls 'reductionism'.

Quine argues against all three theses, but the bulk of his paper is devoted to an attack on the analytic–synthetic distinction. His critique proceeds through a series of masterly arguments against the very possibility of defining the notion of analyticity. He targets various formulations of analyticity and shows that no non-circular definition is available. Analytic sentences, traditionally, have been seen as true in virtue of the meaning of the terms contained in them. They are also a priori, in that knowledge of them does not necessarily depend on having any information about states of affairs that obtain in the empirical world. Quine shows, in some detail, that this definition of analyticity makes use of the notion of synonymy, or sameness of meaning, which in turn presupposes an understanding of analyticity.

Quine then proceeds to attack what he calls 'the second dogma of empiricism', thesis III of logical positivism, which he believes to be in essence one with the first dogma of empiricism (thesis I). The logical positivists held that meaningful empirical sentences can each be reduced to, be confirmed or disconfirmed by sense experiences. Quine, on the other hand, argues that there is no correlation between single sentences and the external-world experiences which confirm or disconfirm them; rather, 'statements about the external world face the tribunal of sense experience not individually but only as a corporate body' (*From a Logical Point of View*, 1953, p. 41). This view has become known as 'holism' and has many adherents in contemporary philosophy.

According to Quinean holism, each belief is part of a network of other beliefs which, overall, form 'the web of belief'. The web has a centre and a periphery; there are various connections between all these beliefs – some of them direct and some of them indirect. The beliefs in the centre, such as beliefs in logical and simple arithmetical truths, are protected from falsification more rigorously than those on the periphery, but no belief is immune to revision. Thus Quine is also repudiating the view that some branches of knowledge, whether logic, mathematics or philosophy, can have a privileged or foundational position distinct from that of the natural sciences. Any belief is open to revision, given our willingness to revise other beliefs connected with it. In the same way, any belief can be held to be true come what may, if we make drastic enough adjustments to our web of belief. Hence the prospect of being able to distinguish between analytic 'first principles' or Carnapian frameworks and factual statements is just a philosophical chimera.

With the rejection of the analytic–synthetic distinction, Quine is not only undermining thesis II – the verificationist theory of meaning – but also the whole idea that there could be such a thing as a theory of meaning. In line with his physicalism or naturalism, he believes that the

only way we can study the phenomenon of human language is by looking at the behaviour of those involved in linguistic interactions. The doctrine, known as 'behaviourism', has played a vital role in the overall development of Quine's work. The linguistic behaviourism of Quine, together with his rejection of analyticity, has given rise to one of the most controversial aspects of his philosophical outlook: the doctrine of indeterminacy of translation, or the view that there are no objective facts of the matter to enable us to distinguish between various alternative ways of translating a given language and hence there is bound to be a radical indeterminacy or inconclusiveness in any translation from one language to another or from one sentence to another in the same language. According to Quine, we can set up or construct different manuals of translations which will all be compatible with the available evidence (i.e., the behaviour of the speakers and the data we have about the environment in which their speech takes place) but which will remain incompatible with each other.

Quine's work has set the agenda for much of the philosophy of language and logic of the past forty years. With more than twenty-four books and countless articles he has shaped English-language philosophy in ways no other living philosopher has succeeded in doing.

Works by Quine

1953 *From a Logical Point of View.* Cambridge, MA: Harvard University Press.
1960 *Word and Object.* Cambridge, MA: MIT Press.
1966 *The Ways of Paradox and Other Essays.* New York: Random House.
1969 *Ontological Relativity and Other Essays.* New York: Columbia University Press.
1973 *The Roots of Reference.* La Salle, IL: Open Court.
1981 *Theories and Things.* Cambridge, MA: Harvard University Press.
1992 (rev. edn) *Pursuit of Truth.* Cambridge, MA: Harvard University Press.

Works on Quine

Barrett, R. B. and Gibson, R. F. (eds), *Perspectives on Quine.* Oxford: Blackwell, 1993.
Davidson, D. and Hintikka, Jaako (eds), *Words and Objections: Essays on the Work of W. V. Quine.* Dordrecht: Reidel, 1969.
Hahn, Lewis and Schilpp, Paul Arthur (eds), *The Philosophy of W. V. Quine.* La Salle, IL, Open Court, 1987.
Hookway, Christopher, *Quine.* Oxford: Polity Press, 1988.
Romanos, George D., *Quine and Analytic Philosophy.* Cambridge, MA: MIT Press, 1983.

Two Dogmas of Empiricism

Modern empiricism has been conditioned in large part by two dogmas. One is a belief in some fundamental cleavage between truths which are *analytic*, or grounded in meanings independently of matters of fact, and truths which are *synthetic*, or grounded in fact. The other dogma is *reductionism*: the belief that each meaningful statement is equivalent to some logical construct upon terms which refer to immediate experience. Both dogmas, I shall argue, are ill-founded. One effect of abandoning them is, as we shall see, a blurring of the supposed boundary between speculative metaphysics and natural science. Another effect is a shift toward pragmatism.

1. Background for Analyticity

Kant's cleavage between analytic and synthetic truths was foreshadowed in Hume's distinction between relations of ideas and matters of fact, and in Leibniz's distinction between truths of reason and truths of fact. Leibniz spoke of the truths of reason as true in all possible worlds. Picturesqueness aside, this is to say that the truths of reason are those which could not possibly be false. In the same vein we hear analytic statements defined as statements whose denials are self-contradictory. But this definition has small explanatory value; for the notion of self-contradictoriness, in the quite broad sense needed for this definition of analyticity, stands in exactly the same need of clarification as does the notion of analyticity itself. The two notions are the two sides of a single dubious coin.

Kant conceived of an analytic statement as one that attributes to its subject no more than is already conceptually contained in the subject. This formulation has two shortcomings: it limits itself to statements of subject-predicate form, and it appeals to a notion of containment which is left at a metaphorical level. But Kant's intent, evident more from the

use he makes of the notion of analyticity than from his definition of it, can be restated thus: a statement is analytic when it is true by virtue of meanings and independently of fact. Pursuing this line, let us examine the concept of *meaning* which is presupposed.

Meaning, let us remember, is not to be identified with naming.[1] Frege's example of 'Evening Star' and 'Morning Star', and Russell's of 'Scott' and 'the author of *Waverley*', illustrate that terms can name the same thing but differ in meaning. The distinction between meaning and naming is no less important at the level of abstract terms. The terms '9' and 'the number of the planets' name one and the same abstract entity but presumably must be regarded as unlike in meaning; for astronomical observation was needed, and not mere reflection on meanings, to determine the sameness of the entity in question.

The above examples consist of singular terms, concrete and abstract. With general terms, or predicates, the situation is somewhat different but parallel. Whereas a singular term purports to name an entity, abstract or concrete, a general term does not; but a general term is *true of* an entity, or of each of many, or of none.[2] The class of all entities of which a general term is true is called the *extension* of the term. Now paralleling the contrast between the meaning of a singular term and the entity named, we must distinguish equally between the meaning of a singular term and its extension. The general terms 'creature with a heart' and 'creature with kidneys', for example, are perhaps alike in extension but unlike in meaning.

Confusion of meaning with extension, in the case of general terms, is less common than confusion of meaning with naming in the case of singular terms. It is indeed a commonplace in philosophy to oppose intension (or meaning) to extension, or, in a variant vocabulary, connotation to denotation.

The Aristotelian notion of essence was the forerunner, no doubt, of the modern notion of intension or meaning. For Aristotle it was essential in men to be rational, accidental to be two-legged. But there is an important difference between this attitude and the doctrine of meaning. From the latter point of view it may indeed be conceded (if only for the sake of argument) that rationality is involved in the meaning of the word 'man' while two-leggedness is not; but two-leggedness may at the same time be viewed as involved in the meaning of 'biped' while rationality is not. Thus from the point of view of the doctrine of meaning it makes no sense to say of the actual individual, who is at once a man and a biped, that his rationality is essential and his two-leggedness accidental or vice versa. Things had essences, for Aristotle, but only linguistic forms have meanings. Meaning is what essence becomes when

it is divorced from the object of reference and wedded to the word.

For the theory of meaning a conspicuous question is the nature of its objects: what sort of things are meanings? A felt need for meant entities may derive from an earlier failure to appreciate that meaning and reference are distinct. Once the theory of meaning is sharply separated from the theory of reference, it is a short step to recognizing as the primary business of the theory of meaning simply the synonymy of linguistic forms and the analyticity of statements; meanings themselves, as obscure intermediary entities, may well be abandoned.[3]

The problem of analyticity then confronts us anew. Statements which are analytic by general philosophical acclaim are not, indeed, far to seek. They fall into two classes. Those of the first class, which may be called *logically true*, are typified by:

(1) No unmarried man is married.

The relevant feature of this example is that it not merely is true as it stands, but remains true under any and all reinterpretations of 'man' and 'married'. If we suppose a prior inventory of *logical* particles, comprising 'no', 'un-', 'not', 'if', 'then', 'and', etc., then in general a logical truth is a statement which is true and remains true under all reinterpretations of its components other than the logical particles.

But there is also a second class of analytic statements, typified by:

(2) No bachelor is married.

The characteristic of such a statement is that it can be turned into a logical truth by putting synonyms for synonyms; thus (2) can be turned into (1) by putting 'unmarried man' for its synonym 'bachelor'. We still lack a proper characterization of this second class of analytic statements, and therewith of analyticity generally, inasmuch as we have had in the above description to lean on a notion of 'synonymy' which is no less in need of clarification than analyticity itself.

In recent years Carnap has tended to explain analyticity by appeal to what he calls state-descriptions.[4] A state-description is any exhaustive assignment of truth values to the atomic, or noncompound, statements of the language. All other statements of the language are, Carnap assumes, built up of their component clauses by means of the familiar logical devices, in such a way that the truth value of any complex statement is fixed for each state-description by specifiable logical laws. A statement is then explained as analytic when it comes out true under every state-description. This account is an adaptation of Leibniz's 'true in all possible worlds'. But note that this version of analyticity serves its purpose only if the atomic statements of the language are, unlike 'John

is a bachelor' and 'John is married', mutually independent. Otherwise there would be a state-description which assigned truth to 'John is a bachelor' and to 'John is married', and consequently 'No bachelors are married' would turn out synthetic rather than analytic under the proposed criterion. Thus the criterion of analyticity in terms of state-descriptions serves only for languages devoid of extra-logical synonym-pairs, such as 'bachelor' and 'unmarried man' – synonym-pairs of the type which give rise to the 'second class' of analytic statements. The criterion in terms of state-descriptions is a reconstruction at best of logical truth, not of analyticity.

I do not mean to suggest that Carnap is under any illusions on this point. His simplified model language with its state-descriptions is aimed primarily not at the general problem of analyticity but at another purpose, the clarification of probability and induction. Our problem, however, is analyticity; and here the major difficulty lies not in the first class of analytic statements, the logical truths, but rather in the second class, which depends on the notion of synonymy.

2. Definition

There are those who find it soothing to say that the analytic statements of the second class reduce to those of the first class, the logical truths, by *definition*; 'bachelor', for example, is *defined* as 'unmarried man'. But how do we find that 'bachelor' is defined as 'unmarried man'? Who defined it thus, and when? Are we to appeal to the nearest dictionary, and accept the lexicographer's formulation as law? Clearly this would be to put the cart before the horse. The lexicographer is an empirical scientist, whose business is the recording of antecedent facts; and if he glosses 'bachelor' as 'unmarried man' it is because of his belief that there is a relation of synonymy between those forms, implicit in general or preferred usage prior to his own work. The notion of synonymy presupposed here has still to be clarified, presumably in terms relating to linguistic behavior. Certainly the 'definition' which is the lexicographer's report of an observed synonymy cannot be taken as the ground of the synonymy.

Definition is not, indeed, an activity exclusively of philologists. Philosophers and scientists frequently have occasion to 'define' a recondite term by paraphrasing it into terms of a more familiar vocabulary. But ordinarily such a definition, like the philologist's, is pure lexicography, affirming a relation of synonymy antecedent to the exposition in hand.

Just what it means to affirm synonymy, just what the interconnections

may be which are necessary and sufficient in order that two linguistic forms be properly describable as synonymous, is far from clear; but, whatever these interconnections may be, ordinarily they are grounded in usage. Definitions reporting selected instances of synonymy come then as reports upon usage.

There is also, however, a variant type of definitional activity which does not limit itself to the reporting of pre-existing synonymies. I have in mind what Carnap calls *explication* – an activity to which philosophers are given, and scientists also in their more philosophical moments. In explication the purpose is not merely to paraphrase the definiendum into an outright synonym, but actually to improve upon the definiendum by refining or supplementing its meaning. But even explication, though not merely reporting a pre-existing synonymy between definiendum and definiens, does rest nevertheless on *other* pre-existing synonymies. The matter may be viewed as follows. Any word worth explicating has some contexts which, as wholes, are clear and precise enough to be useful; and the purpose of explication is to preserve the usage of these favored contexts while sharpening the usage of other contexts. In order that a given definition be suitable for purposes of explication, therefore, what is required is not that the definiendum in its antecedent usage be synonymous with the definiens, but just that each of these favored contexts of the definiendum, taken as a whole in its antecedent usage, be synonymous with the corresponding context of the definiens.

Two alternative definientia may be equally appropriate for the purposes of a given task of explication and yet not be synonymous with each other; for they may serve interchangeably within the favored contexts but diverge elsewhere. By cleaving to one of these definientia rather than the other, a definition of explicative kind generates, by fiat, a relation of synonymy between definiendum and definiens which did not hold before. But such a definition still owes its explicative function, as seen, to pre-existing synonymies.

There does, however, remain still an extreme sort of definition which does not hark back to prior synonymies at all: namely, the explicitly conventional introduction of novel notations for purposes of sheer abbreviation. Here the definiendum becomes synonymous with the definiens simply because it has been created expressly for the purpose of being synonymous with the definiens. Here we have a really transparent case of synonymy created by definition; would that all species of synonymy were as intelligible. For the rest, definition rests on synonymy rather than explaining it.

The word 'definition' has come to have a dangerously reassuring sound, owing no doubt to its frequent occurrence in logical and math-

ematical writings. We shall do well to digress now into a brief appraisal of the role of definition in formal work.

In logical and mathematical systems either of two mutually antagonistic types of economy may be striven for, and each has its peculiar practical utility. On the one hand we may seek economy of practical expression – ease and brevity in the statement of multifarious relations. This sort of economy calls usually for distinctive concise notations for a wealth of concepts. Second, however, and oppositely, we may seek economy in grammar and vocabulary; we may try to find a minimum of basic concepts such that, once a distinctive notation has been appropriated to each of them, it becomes possible to express any desired further concept by mere combination and iteration of our basic notations. This second sort of economy is impractical in one way, since a poverty in basic idioms tends to a necessary lengthening of discourse. But it is practical in another way: it greatly simplifies theoretical discourse *about* the language, through minimizing the terms and the forms of construction wherein the language consists.

Both sorts of economy, though prima facie incompatible, are valuable in their separate ways. The custom has consequently arisen of combining both sorts of economy by forging in effect two languages, the one a part of the other. The inclusive language, though redundant in grammar and vocabulary, is economical in message lengths, while the part, called primitive notation, is economical in grammar and vocabulary. Whole and part are correlated by rules of translation whereby each idiom not in primitive notation is equated to some complex built up of primitive notation. These rules of translation are the so-called *definitions* which appear in formalized systems. They are best viewed not as adjuncts to one language but as correlations between two languages, the one a part of the other.

But these correlations are not arbitrary. They are supposed to show how the primitive notations can accomplish all purposes, save brevity and convenience, of the redundant language. Hence the definiendum and its definiens may be expected, in each case, to be related in one or another of the three ways lately noted. The definiens may be a faithful paraphrase of the definiendum into the narrower notation, preserving a direct synonymy[5] as of antecedent usage; or the definiens may, in the spirit of explication, improve upon the antecedent usage of the definiendum; or finally, the definiendum may be a newly created notation, newly endowed with meaning here and now.

In formal and informal work alike, thus, we find that definition – except in the extreme case of the explicitly conventional introduction of new notations – hinges on prior relations of synonymy. Recognizing then

that the notion of definition does not hold the key to synonymy and analyticity, let us look further into synonymy and say no more of definition.

3. Interchangeability

A natural suggestion, deserving close examination, is that the synonymy of two linguistic forms consists simply in their interchangeability in all contexts without change of truth value – interchangeability, in Leibniz's phrase, *salva veritate*.[6] Note that synonyms so conceived need not even be free from vagueness, as long as the vaguenesses match.

But it is not quite true that the synonyms 'bachelor' and 'unmarried man' are everywhere interchangeable *salva veritate*. Truths which become false under substitution of 'unmarried man' for 'bachelor' are easily constructed with the help of 'bachelor of arts' or 'bachelor's buttons'; also with the help of quotation, thus:

'Bachelor' has less than ten letters.

Such counter-instances can, however, perhaps be set aside by treating the phrases 'bachelor of arts' and 'bachelor's buttons' and the quotation 'bachelor' each as a single indivisible word and then stipulating that the interchangeability *salva veritate* which is to be the touchstone of synonymy is not supposed to apply to fragmentary occurrences inside of a word. This account of synonymy, supposing it acceptable on other counts, has indeed the drawback of appealing to a prior conception of 'word' which can be counted on to present difficulties of formulation in its turn. Nevertheless some progress might be claimed in having reduced the problem of synonymy to a problem of wordhood. Let us pursue this line a bit, taking 'word' for granted.

The question remains whether interchangeability *salva veritate* (apart from occurrences within words) is a strong enough condition for synonymy, or whether, on the contrary, some heteronymous expressions might be thus interchangeable. Now let us be clear that we are not concerned here with synonymy in the sense of complete identity in psychological associations or poetic quality; indeed, no two expressions are synonymous in such a sense. We are concerned only with what may be called *cognitive* synonymy. Just what this is cannot be said without successfully finishing the present study; but we know something about it from the need which arose for it in connection with analyticity in §1. The sort of synonymy needed there was merely such that any analytic statement could be turned into a logical truth by putting synonyms for synonyms. Turning the tables and assuming analyticity, indeed, we could

explain cognitive synonymy of terms as follows (keeping to the familiar example): to say that 'bachelor' and 'unmarried man' are cognitively synonymous is to say no more nor less than that the statement:

(3) All and only bachelors are unmarried men

is analytic.[7]

What we need is an account of cognitive synonymy not presupposing analyticity – if we are to explain analyticity conversely with help of cognitive synonymy as undertaken in §1. And indeed such an independent account of cognitive synonymy is at present up for consideration, namely, interchangeability *salva veritate* everywhere except within words. The question before us, to resume the thread at last, is whether such interchangeability is a sufficient condition for cognitive synonymy. We can quickly assure ourselves that it is, by examples of the following sort. The statement:

(4) Necessarily all and only bachelors are bachelors

is evidently true, even supposing 'necessarily' so narrowly construed as to be truly applicable only to analytic statements. Then, if 'bachelor' and 'unmarried man' are interchangeable *salva veritate*, the result

(5) Necessarily all and only bachelors are unmarried men

of putting 'unmarried man' for an occurrence of 'bachelor' in (4) must, like (4), be true. But to say that (5) is true is to say that (3) is analytic, and hence that 'bachelor' and 'unmarried man' are cognitively synonymous.

Let us see what there is about the above argument that gives it its air of hocus-pocus. The condition of interchangeability *salva veritate* varies in its force with variations in the richness of the language at hand. The above argument supposes we are working with a language rich enough to contain the adverb 'necessarily', this adverb being so construed as to yield truth when and only when applied to an analytic statement. But can we condone a language which contains such an adverb? Does the adverb really make sense? To suppose that it does is to suppose that we have already made satisfactory sense of 'analytic'. Then what are we so hard at work on right now?

Our argument is not flatly circular, but something like it. It has the form, figuratively speaking, of a closed curve in space.

Interchangeability *salva veritate* is meaningless until relativized to a language whose extent is specified in relevant respects. Suppose now we consider a language containing just the following materials. There is an indefinitely large stock of one-place predicates (for example, 'F' where 'Fx' means that x is a man) and many-place predicates (for example, 'G'

where 'Gxy' means that x loves y), mostly having to do with extralogical subject matter. The rest of the language is logical. The atomic sentences consist each of a predicate followed by one or more variables 'x', 'y', etc.; and the complex sentences are built up of the atomic ones by truth functions ('not', 'and', 'or', etc.) and quantification.[8] In effect such a language enjoys the benefits also of descriptions and indeed singular terms generally, these being contextually definable in known ways.[9] Even abstract singular terms naming classes, classes of classes, etc., are contextually definable in case the assumed stock of predicates includes the two-place predicate of class membership.[10] Such a language can be adequate to classical mathematics and indeed to scientific discourse generally, except in so far as the latter involves debatable devices such as contrary-to-fact conditionals or modal adverbs like 'necessarily'.[11] Now a language of this type is extensional, in this sense: any two predicates which agree extensionally (that is, are true of the same objects) are interchangeable *salva veritate*.[12]

In an extensional language, therefore, interchangeability *salva veritate* is no assurance of cognitive synonymy of the desired type. That 'bachelor' and 'unmarried man' are interchangeable *salva veritate* in an extensional language assures us of no more than that (3) is true. There is no assurance here that the extensional agreement of 'bachelor' and 'unmarried man' rests on meaning rather than merely on accidental matters of fact, as does the extensional agreement of 'creature with a heart' and 'creature with kidneys'.

For most purposes extensional agreement is the nearest approximation to synonymy we need care about. But the fact remains that extensional agreement falls far short of cognitive synonymy of the type required for explaining analyticity in the manner of §1. The type of cognitive synonymy required there is such as to equate the synonymy of 'bachelor' and 'unmarried man' with the analyticity of (3), not merely with the truth of (3).

So we must recognize that interchangeability *salva veritate*, if construed in relation to an extensional language, is not a sufficient condition of cognitive synonymy in the sense needed for deriving analyticity in the manner of §1. If a language contains an intensional adverb 'necessarily' in the sense lately noted, or other particles to the same effect, then interchangeability *salva veritate* in such a language does afford a sufficient condition of cognitive synonymy; but such a language is intelligible only in so far as the notion of analyticity is already understood in advance.

The effort to explain cognitive synonymy first, for the sake of deriving analyticity from it afterward as in §1, is perhaps the wrong approach.

Instead we might try explaining analyticity somehow without appeal to cognitive synonymy. Afterward we could doubtless derive cognitive synonymy from analyticity satisfactorily enough if desired. We have seen that cognitive synonymy of 'bachelor' and 'unmarried man' can be explained as analyticity of (3). The same explanation works for any pair of one-place predicates, of course, and it can be extended in obvious fashion to many-place predicates. Other syntactical categories can also be accommodated in fairly parallel fashion. Singular terms may be said to be cognitively synonymous when the statement of identity formed by putting '=' between them is analytic. Statements may be said simply to be cognitively synonymous when their biconditional (the result of joining them by 'if and only if') is analytic.[13] If we care to lump all categories into a single formulation, at the expense of assuming again the notion of 'word' which was appealed to early in this section, we can describe any two linguistic forms as cognitively synonymous when the two forms are interchangeable (apart from occurrences within 'words') *salva* (no longer *veritate* but) *analyticitate*. Certain technical questions arise, indeed, over cases of ambiguity or homonymy; let us not pause for them, however, for we are already digressing. Let us rather turn our backs on the problem of synonymy and address ourselves anew to that of analyticity.

4. Semantical Rules

Analyticity at first seemed most naturally definable by appeal to a realm of meanings. On refinement, the appeal to meanings gave way to an appeal to synonymy or definition. But definition turned out to be a will-o'-the wisp, and synonymy turned out to be best understood only by dint of a prior appeal to analyticity itself. So we are back at the problem of analyticity.

I do not know whether the statement 'Everything green is extended' is analytic. Now does my indecision over this example really betray an incomplete understanding, an incomplete grasp of the 'meanings', of 'green' and 'extended'? I think not. The trouble is not with 'green' or 'extended', but with 'analytic'.

It is often hinted that the difficulty in separating analytic statements from synthetic ones in ordinary language is due to the vagueness of ordinary language and that the distinction is clear when we have a precise artificial language with explicit 'semantical rules'. This, however, as I shall now attempt to show, is a confusion.

The notion of analyticity about which we are worrying is a purported relation between statements and languages: a statement S is said to be

analytic for a language *L*, and the problem is to make sense of this relation generally, that is, for variable '*S*' and '*L*'. The gravity of this problem is not perceptibly less for artificial languages than for natural ones. The problem of making sense of the idiom '*S* is analytic for *L*', with variable '*S*' and '*L*', retains its stubbornness even if we limit the range of the variable '*L*' to artificial languages. Let me now try to make this point evident.

For artificial languages and semantical rules we look naturally to the writings of Carnap. His semantical rules take various forms, and to make my point I shall have to distinguish certain of the forms. Let us suppose, to begin with, an artificial language L_o whose semantical rules have the form explicitly of a specification, by recursion or otherwise, of all the analytic statements of L_o. The rules tell us that such and such statements, and only those, are the analytic statements of L_o. Now here the difficulty is simply that the rules contain the word 'analytic', which we do not understand! We understand what expressions the rules attribute analyticity to, but we do not understand what the rules attribute to those expressions. In short, before we can understand a rule which begins 'A statement *S* is analytic for language L_o if and only if ...', we must understand the general relative term 'analytic for'; we must understand '*S* is analytic for *L*' where '*S*' and '*L*' are variables.

Alternatively we may, indeed, view the so-called rule as a conventional definition of a new simple symbol 'analytic-for-L_o', which might better be written untendentiously as '*K*' so as not to seem to throw light on the interesting word 'analytic'. Obviously any number of classes *K*, *M*, *N*, etc. of statements of L_o can be specified for various purposes or for no purpose; what does it mean to say that *K*, as against *M*, *N*, etc., is the class of the 'analytic' statements of L_o?

By saying what statements are analytic for L_o we explain 'analytic-for-L_o' but not 'analytic', not 'analytic for'. We do not begin to explain the idiom '*S* is analytic for *L*' with variable '*S*' and '*L*', even if we are content to limit the range of '*L*' to the realm of artificial languages.

Actually we do know enough about the intended significance of 'analytic' to know that analytic statements are supposed to be true. Let us then turn to a second form of semantical rule, which says not that such-and-such statements are analytic but simply that such-and-such statements are included among the truths. Such a rule is not subject to the criticism of containing the un-understood wood 'analytic'; and we may grant for the sake of argument that there is no difficulty over the broader term 'true'. A semantical rule of this second type, a rule of truth, is not supposed to specify all the truths of the language; it merely stipulates, recursively or otherwise, a certain multitude of statements

which, along with others unspecified, are to count as true. Such a rule may be conceded to be quite clear. Derivatively, afterward, analyticity can be demarcated thus: a statement is analytic if it is (not merely true but) true according to the semantical rule.

Still there is really no progress. Instead of appealing to an unexplained word 'analytic', we are now appealing to an unexplained phrase 'semantical rule'. Not every true statement which says that the statements of some class are true can count as a semantical rule – otherwise *all* truths would be 'analytic' in the sense of being true according to sem- antical rules. Semantical rules are distinguishable, apparently, only by the fact of appearing on a page under the heading 'Semantical Rules'; and this heading is itself then meaningless.

We can say indeed that a statement is *analytic-for-L_0* if and only if it is true according to such-and-such specifically appended 'semantical rules', but then we find ourselves back at essentially the same case which was originally discussed: 'S is analytic-for-L_0 if and only if ...' Once we seek to explain 'S is analytic for L' generally for variable 'L' (even allowing limitation of 'L' to artificial languages), the explanation 'true according to the semantical rules of L' is unavailing; for the relative term 'semantical rule of' is as much in need of clarification, at least, as 'analytic for'.

It may be instructive to compare the notion of semantical rule with that of postulate. Relative to a given set of postulates, it is easy to say what a postulate is: it is a member of the set. Relative to a given set of semantical rules, it is equally easy to say what a semantical rule is. But given simply a notation, mathematical or otherwise, and indeed as thoroughly understood a notation as you please in point of the trans- lations or truth conditions of its statements, who can say which of its true statements rank as postulates? Obviously the question is meaningless – as meaningless as asking which points in Ohio are starting points. Any finite (or effectively specifiable infinite) selection of statements (preferably true ones, perhaps) is as much *a* set of postulates as any other. The word 'postulate' is significant only relative to an act of inquiry; we apply the word to a set of statements just in so far as we happen, for the year or the moment, to be thinking of those statements in relation to the state- ments which can be reached from them by some set of transformations to which we have seen fit to direct our attention. Now the notion of semantical rule is as sensible and meaningful as that of postulate, if conceived in a similarly relative spirit – relative, this time, to one or another particular enterprise of schooling unconversant persons in suf- ficient conditions for truth of statements of some natural or artificial language L. But from this point of view no one signalization of a subclass

of the truths of L is intrinsically more a semantical rule than another; and, if 'analytic' means 'true by semantical rules', no one truth of L is analytic to the exclusion of another.[14]

It might conceivably be protested that an artificial language L (unlike a natural one) is a language in the ordinary sense *plus* a set of explicit semantical rules – the whole constituting, let us say, an ordered pair; and that the semantical rules of L then are specifiable simply as the second component of the pair L. But, by the same token and more simply, we might construe an artificial language L outright as an ordered pair whose second component is the class of its analytic statements; and then the analytic statements of L become specifiable simply as the statements in the second component of L. Or better still, we might just stop tugging at our bootstraps altogether.

Not all the explanations of analyticity known to Carnap and his readers have been covered explicitly in the above considerations, but the extension to other forms is not hard to see. Just one additional factor should be mentioned which sometimes enters: sometimes the semantical rules are in effect rules of translation into ordinary language, in which case the analytic statements of the artificial language are in effect recognized as such from the analyticity of their specified translations in ordinary language. Here certainly there can be no thought of an illumination of the problem of analyticity from the side of the artificial language.

From the point of view of the problem of analyticity the notion of an artificial language with semantical rules is a *feu follet par excellence*. Semantical rules determining the analytic statements of an artificial language are of interest only in so far as we already understand the notion of analyticity; they are of no help in gaining this understanding.

Appeal to hypothetical languages of an artificially simple kind could conceivably be useful in clarifying analyticity, if the mental or behavioral or cultural factors relevant to analyticity – whatever they may be – were somehow sketched into the simplified model. But a model which takes analyticity merely as an irreducible character is unlikely to throw light on the problem of explicating analyticity.

It is obvious that truth in general depends on both language and extralinguistic fact. The statement 'Brutus killed Caesar' would be false if the world had been different in certain ways, but it would also be false if the word 'killed' happened rather to have the sense of 'begat'. Thus one is tempted to suppose in general that the truth of a statement is somehow analyzable into a linguistic component and a factual component. Given this supposition, it next seems reasonable that in some statements the factual component should be null; and these are the

analytic statements. But, for all its a priori reasonableness, a boundary between analytic and synthetic statements simply has not been drawn. That there is such a distinction to be drawn at all is an unempirical dogma of empiricists, a metaphysical article of faith.

5. The Verification Theory and Reductionism

In the course of these somber reflections we have taken a dim view first of the notion of meaning, then of the notion of cognitive synonymy, and finally of the notion of analyticity. But what, it may be asked, of the verification theory of meaning? This phrase has established itself so firmly as a catchword of empiricism that we should be very unscientific indeed not to look beneath it for a possible key to the problem of meaning and the associated problems.

The verification theory of meaning, which has been conspicuous in the literature from Peirce onward, is that the meaning of a statement is the method of empirically confirming or infirming it. An analytic statement is that limiting case which is confirmed no matter what.

As urged in §1, we can as well pass over the question of meanings as entities and move straight to sameness of meaning, or synonymy. Then what the verification theory says is that statements are synonymous if and only if they are alike in point of method of empirical confirmation or infirmation.

This is an account of cognitive synonymy not of linguistic forms generally, but of statements.[15] However, from the concept of synonymy of statements we could derive the concept of synonymy for other linguistic forms, by considerations somewhat similar to those at the end of §3. Assuming the notion of 'word', indeed, we could explain any two forms as synonymous when the putting of the one form for an occurrence of the other in any statement (apart from occurrences within 'words') yields a synonymous statement. Finally, given the concept of synonymy thus for linguistic forms generally, we could define analyticity in terms of synonymy and logical truth as in §1. For that matter, we could define analyticity more simply in terms of just synonymy of statements together with logical truth; it is not necessary to appeal to synonymy of linguistic forms other than statements. For a statement may be described as analytic simply when it is synonymous with a logically true statement.

So, if the verification theory can be accepted as an adequate account of statement synonymy, the notion of analyticity is saved after all. However, let us reflect. Statement synonymy is said to be likeness of method of empirical confirmation or infirmation. Just what are these methods which are to be compared for likeness? What, in other words,

is the nature of the relation between a statement and the experiences which contribute to or detract from its confirmation?

The most naïve view of the relation is that it is one of direct report. This is *radical reductionism*. Every meaningful statement is held to be translatable into a statement (true or false) about immediate experience. Radical reductionism, in one form or another, well antedates the verification theory of meaning explicitly so called. Thus Locke and Hume held that every idea must either originate directly in sense experience or else be compounded of ideas thus originating; and taking a hint from Tooke we might rephrase this doctrine in semantical jargon by saying that a term, to be significant at all, must be either a name of a sense datum or a compound of such names or an abbreviation of such a compound. So stated, the doctrine remains ambiguous as between sense data as sensory events and sense data as sensory qualities; and it remains vague as to the admissible ways of compounding. Moreover, the doctrine is unnecessarily and intolerably restrictive in the term-by-term critique which it imposes. More reasonably, and without yet exceeding the limits of what I have called radical reductionism, we may take full statements as our significant units – thus demanding that our statements as wholes be translatable into sense-datum language, but not that they be translatable term by term.

This emendation would unquestionably have been welcome to Locke and Hume and Tooke, but historically it had to await an important reorientation in semantics – the reorientation whereby the primary vehicle of meaning came to be seen no longer in the term but in the statement. This reorientation, seen in Bentham and Frege, underlies Russell's concept of incomplete symbols defined in use;[16] also it is implicit in the verification theory of meaning, since the objects of verification are statements.

Radical reductionism, conceived now with statements as units, set itself the task of specifying a sense-datum language and showing how to translate the rest of significant discourse, statement by statement, into it. Carnap embarked on this project in the *Aufbau*.

The language which Carnap adopted as his starting point was not a sense-datum language in the narrowest conceivable sense, for it included also the notations of logic, up through higher set theory. In effect it included the whole language of pure mathematics. The ontology implicit in it (that is, the range of values of its variables) embraced not only sensory events but classes, classes of classes, and so on. Empiricists there are who would boggle at such prodigality. Carnap's starting point is very parsimonious, however, in its extralogical or sensory part. In a series of constructions in which he exploits the resources of modern logic with

much ingenuity, Carnap succeeds in defining a wide array of important additional sensory concepts which, but for his constructions, one would not have dreamed were definable on so slender a basis. He was the first empiricist who, not content with asserting the reducibility of science to terms of immediate experience, took serious steps toward carrying out the reduction.

If Carnap's starting point is satisfactory, still his constructions were, as he himself stressed, only a fragment of the full program. The construction of even the simplest statements about the physical world was left in a sketchy state. Carnap's suggestions on this subject were, despite their sketchiness, very suggestive. He explained spatio-temporal point-instants as quadruples of real numbers and envisaged assignment of sense qualities to point-instants according to certain canons. Roughly summarized, the plan was that qualities should be assigned to point-instants in such a way as to achieve the laziest world compatible with our experience. The principle of least action was to be our guide in constructing a world from experience.

Carnap did not seem to recognize, however, that his treatment of physical objects fell short of reduction not merely through sketchiness, but in principle. Statements of the form 'Quality q is at point-instant $x;y;z;t$' were, according to his canons, to be apportioned truth values in such a way as to maximize and minimize certain overall features, and with growth of experience the truth values were to be progressively revised in the same spirit. I think this is a good schematization (deliberately oversimplified, to be sure) of what science really does; but it provides no indication, not even the sketchiest, of how a statement of the form 'Quality q is at $x;y;z;t$' could ever be translated into Carnap's initial language of sense data and logic. The connective 'is at' remains an added undefined connective; the canons counsel us in its use but not in its elimination.

Carnap seems to have appreciated this point afterward; for in his later writings he abandoned all notion of the translatability of statements about the physical world into statements about immediate experience. Reductionism in its radical form has long since ceased to figure in Carnap's philosophy.

But the dogma of reductionism has, in a subtler and more tenuous form, continued to influence the thought of empiricists. The notion lingers that to each statement, or each synthetic statement, there is associated a unique range of possible sensory events such that the occurrence of any of them would add to the likelihood of truth of the statement, and that there is associated also another unique range of possible sensory events whose occurrence would detract from that

likelihood. This notion is of course implicit in the verification theory of meaning.

The dogma of reductionism survives in the supposition that each statement, taken in isolation from its fellows, can admit of confirmation or infirmation at all. My countersuggestion, issuing essentially from Carnap's doctrine of the physical world in the *Aufbau*, is that our statements about the external world face the tribunal of sense experience not individually but only as a corporate body.[17]

The dogma of reductionism, even in its attenuated form, is intimately connected with the other dogma – that there is a cleavage between the analytic and the synthetic. We have found ourselves led, indeed, from the latter problem to the former through the verification theory of meaning. More directly, the one dogma clearly supports the other in this way: as long as it is taken to be significant in general to speak of the confirmation and infirmation of a statement, it seems significant to speak also of a limiting kind of statement which is vacuously confirmed, *ipso facto*, come what may; and such a statement is analytic.

The two dogmas are, indeed, at root identical. We lately reflected that in general the truth of statements does obviously depend both upon language and upon extralinguistic fact; and we noted that this obvious circumstance carries in its train, not logically but all too naturally, a feeling that the truth of a statement is somehow analyzable into a linguistic component and a factual component. The factual component must, if we are empiricists, boil down to a range of confirmatory experiences. In the extreme case where the linguistic component is all that matters, a true statement is analytic. But I hope we are now impressed with how stubbornly the distinction between analytic and synthetic has resisted any straightforward drawing. I am impressed also, apart from prefabricated examples of black and white balls in an urn, with how baffling the problem has always been of arriving at any explicit theory of the empirical confirmation of a synthetic statement. My present suggestion is that it is nonsense, and the root of much nonsense, to speak of a linguistic component and a factual component in the truth of any individual statement. Taken collectively, science has its double dependence upon language and experience; but this duality is not significantly traceable into the statements of science taken one by one.

The idea of defining a symbol in use was, as remarked, an advance over the impossible term-by-term empiricism of Locke and Hume. The statement, rather than the term, came with Bentham to be recognized as the unit accountable to an empiricist critique. But what I am now urging is that even in taking the statement as unit we have drawn our grid too finely. The unit of empirical significance is the whole of science.

6. Empiricism without the Dogmas

The totality of our so-called knowledge or beliefs, from the most casual matters of geography and history to the profoundest laws of atomic physics or even of pure mathematics and logic, is a man-made fabric which impinges on experience only along the edges. Or, to change the figure, total science is like a field of force whose boundary conditions are experience. A conflict with experience at the periphery occasions readjustments in the interior of the field. Truth values have to be redistributed over some of our statements. Re-evaluation of some statements entails re-evaluation of others, because of their logical interconnections – the logical laws being in turn simply certain further statements of the system, certain further elements of the field. Having re-evaluated one statement we must re-evaluate some others, which may be statements logically connected with the first or may be the statements of logical connections themselves. But the total field is so underdetermined by its boundary conditions, experience, that there is much latitude of choice as to what statements to re-evaluate in the light of any single contrary experience. No particular experiences are linked with any particular statements in the interior of the field, except indirectly through considerations of equilibrium affecting the field as a whole.

If this view is right, it is misleading to speak of the empirical content of an individual statement – especially if it is a statement at all remote from the experiential periphery of the field. Furthermore it becomes folly to seek a boundary between synthetic statements, which hold contingently on experience, and analytic statements, which hold come what may. Any statement can be held true come what may, if we make drastic enough adjustments elsewhere in the system. Even a statement very close to the periphery can be held true in the face of recalcitrant experience by pleading hallucination or by amending certain statements of the kind called logical laws. Conversely, by the same token, no statement is immune to revision. Revision even of the logical law of the excluded middle has been proposed as a means of simplifying quantum mechanics; and what difference is there in principle between such a shift and the shift whereby Kepler superseded Ptolemy, or Einstein Newton, or Darwin Aristotle?

For vividness I have been speaking in terms of varying distances from a sensory periphery. Let me try now to clarify this notion without metaphor. Certain statements, though *about* physical objects and not sense experience, seem peculiarly germane to sense experience – and in a selective way: some statements to some experiences, others to others. Such statements, especially germane to particular experiences, I picture

as near the periphery. But in this relation of 'germaneness' I envisage nothing more than a loose association reflecting the relative likelihood, in practice, of our choosing one statement rather than another for revision in the event of recalcitrant experience. For example, we can imagine recalcitrant experiences to which we would surely be inclined to accommodate our system by re-evaluating just the statement that there are brick houses on Elm Street, together with related statements on the same topic. We can imagine other recalcitrant experiences to which we would be inclined to accommodate our system by re-evaluating just the statement that there are no centaurs, along with kindred statements. A recalcitrant experience can, I have urged, be accommodated by any of various alternative re-evaluations in various alternative quarters of the total system; but, in the cases which we are now imagining, our natural tendency to disturb the total system as little as possible would lead us to focus our revisions upon these specific statements concerning brick houses or centaurs. These statements are felt, therefore, to have a sharper empirical reference than highly theoretical statements of physics or logic or ontology. The latter statements may be thought of as relatively centrally located within the total network, meaning merely that little preferential connection with any particular sense data obtrudes itself.

As an empiricist I continue to think of the conceptual scheme of science as a tool, ultimately, for predicting future experience in the light of past experience. Physical objects are conceptually imported into the situation as convenient intermediaries – not by definition in terms of experience, but simply as irreducible posits[18] comparable, epistemologically, to the gods of Homer. For my part I do, qua lay physicist, believe in physical objects and not in Homer's gods; and I consider it a scientific error to believe otherwise. But in point of epistemological footing the physical objects and the gods differ only in degree and not in kind. Both sorts of entities enter our conception only as cultural posits. The myth of physical objects is epistemologically superior to most in that it has proved more efficacious than other myths as a device for working a manageable structure into the flux of experience.

Positing does not stop with macroscopic physical objects. Objects at the atomic level are posited to make the laws of macroscopic objects, and ultimately the laws of experience, simpler and more manageable; and we need not expect or demand full definition of atomic and sub-atomic entities in terms of macroscopic ones, any more than definition of macroscopic things in terms of sense data. Science is a continuation of common sense, and it continues the common-sense expedient of swelling ontology to simplify theory.

Physical objects, small and large, are not the only posits. Forces are

another example; and indeed we are told nowadays that the boundary between energy and matter is obsolete. Moreover, the abstract entities which are the substance of mathematics – ultimately classes and classes of classes and so on up – are another posit in the same spirit. Epistemologically these are myths on the same footing with physical objects and gods, neither better nor worse except for differences in the degree to which they expedite our dealings with sense experiences.

The overall algebra of rational and irrational numbers is underdetermined by the algebra of rational numbers, but is smoother and more convenient; and it includes the algebra of rational numbers as a jagged or gerrymandered part.[19] Total science, mathematical and natural and human, is similarly but more extremely underdetermined by experience. The edge of the system must be kept squared with experience; the rest, with all its elaborate myths or fictions, has as its objective the simplicity of laws.

Ontological questions, under this view, are on a par with questions of natural science.[20] Consider the question whether to countenance classes as entities. This, as I have argued elsewhere,[21] is the question whether to quantify with respect to variables which take classes as values. Now Carnap[22] has maintained that this is a question not of matters of fact but of choosing a convenient language form, a convenient conceptual scheme or framework for science. With this I agree, but only on the proviso that the same be conceded regarding scientific hypotheses generally. Carnap (p. 32n) has recognized that he is able to preserve a double standard for ontological questions and scientific hypotheses only by assuming an absolute distinction between the analytic and the synthetic; and I need not say again that this is a distinction which I reject.[23]

The issue over there being classes seems more a question of convenient conceptual scheme; the issue over there being centaurs, or brick houses on Elm Street, seems more a question of fact. But I have been urging that this difference is only one of degree, and that it turns upon our vaguely pragmatic inclination to adjust one strand of the fabric of science rather than another in accommodating some particular recalcitrant experience. Conservatism figures in such choices, and so does the quest for simplicity.

Carnap, Lewis, and others take a pragmatic stand on the question of choosing between language forms, scientific frameworks; but their pragmatism leaves off at the imagined boundary between the analytic and the synthetic. In repudiating such a boundary I espouse a more thorough pragmatism. Each man is given a scientific heritage plus a continuing barrage of sensory stimulation; and the considerations which guide him in warping his scientific heritage to fit his continuing sensory promptings are, where rational, pragmatic.

Notes and References

1. W. V. O. Quine, *From a Logical Point of View*, p. 9.
2. See Quine, ibid., p. 10, and pp. 107–15.
3. See Quine, ibid., pp. 11 f, and below, pp. 48 f.
4. Rudolf Carnap, *Meaning and Necessity* (Chicago: University of Chicago Press, 1947), pp. 9 ff; *Logical Foundations of Probability* (Chicago: University of Chicago Press, 1950), pp. 70 ff.
5. According to an important variant sense of 'definition', the relation preserved may be the weaker relation of mere agreement in reference; see Quine, op. cit., p. 132. But definition in this sense is better ignored in the present connection, being irrelevant to the question of synonymy.
6. Cf. C. I. Lewis, *A Survey of Symbolic Logic* (Berkeley, CA: University of California Press, 1918), p. 373.
7. This is cognitive synonymy in a primary, broad sense. Carnap, *Meaning and Necessity*, pp. 56 ff; and C. I. Lewis, *An Analysis of Knowledge and Valuation* (La Salle, IL: Open Court, 1946), pp. 83 ff, have suggested how, once this notion is at hand, a narrower sense of cognitive synonymy which is preferable for some purposes can in turn be derived. But this special ramification of concept-building lies aside from the present purposes and must not be confused with the broad sort of cognitive synonymy here concerned.
8. Quine, op. cit., pp. 81 ff, below, contain a description of just such a language, except that there happens there to be just one predicate, the two-place predicate '∈'.
9. See Quine, op. cit., pp. 5–8; pp. 85 f, 166 f.
10. See Quine, op. cit., p. 87.
11. On such devices, see also Quine, op. cit., Essay VIII.
12. This is the substance of Quine, *Mathematical Logic*, p. 121.
13. The 'if and only if' itself is intended in the truth functional sense. See Carnap, *Meaning and Necessity*, p. 14.
14. The foregoing paragraph was not part of the present essay as originally published. It was prompted by R. M. Martin, 'On "Analytic"', *Philosophical Studies*, 3 (1953), pp. 42–7, as was the end of Essay VII, Quine, op. cit.
15. The doctrine can indeed be formulated with terms rather than statements as the units. Thus Lewis describes the meaning of a term as '*a criterion in mind*, by reference to which one is able to apply or refuse to apply the expression in question in the case of presented, or imagined, things or situations' (*An Analysis of Knowledge and Valuation*, p. 133). – For an instructive account of the vicissitudes of the verification theory of meaning, centered however on the question of meaning*fulness* rather than synonymy and analyticity, see Hempel.
16. See Quine, op. cit., p. 6.
17. This doctrine was well argued by Pierre Duhem, *La Theorie physique: son*

objet et sa structure (Paris, 1906), pp. 303–28. Or see Armand Lowinger, *The Methodology of Pierre Duhem* (New York: Columbia University Press, 1941), pp. 132–40.

18. Cf. Quine, op. cit., pp. 17 f.
19. Cf. Quine, op. cit., p. 18.
20. 'L'ontologie fait corps avec la science elle-même et ne peut en être separée.' Emile Meyerson, *Identite et realite* (Paris, 1908; 4th edn., 1932).
21. Quine, op. cit., pp. 12 f, 102 ff.
22. Carnap, *Meaning and Necessity*.
23. For an effective expression of further misgivings over this distinction, see Morton White, 'The Analytic and the Synthetic: an Untenable Dualism', in Sidney Hook (ed.), *John Dewey: Philosopher of Science and Freedom* (New York: Dial Press, 1950).

9

DONALD DAVIDSON

(1917–)

The American philosopher Donald Davidson was born in Springfield, Massachusetts. He studied at Harvard with Quine before taking up teaching positions at Stanford, Princeton and Chicago universities. He has taught at Berkeley, California, since 1981. Over the past thirty years, through a series of interconnected articles, Davidson has put forward a comprehensive theory of language and mind. His work has continued and enlarged Quine's philosophical approach, but has also added many novel elements to the Quinean programme.

Davidson's theory of meaning is constructed on the basis of Tarski's theory of truth (see chapter 3) which he applies to individual speakers of particular languages. In constructing an adequate theory of meaning, every sentence of an object language L should be matched with a corresponding sentence in the metalanguage that has exactly the same truth conditions. A complete theory of meaning for a language L will provide T-sentences of the form ' "La neige est blanche" is true in French if and only if snow is white', for all the sentences of the object language, and thus will specify the meaning of each sentence of L. When applied to particular languages, Davidson's is an empirical theory of meaning and its results should be empirically testable. For instance, the test should ensure that we do not end up with T-sentences such as ' "La neige est blanche" is true if and only if grass is green'.

According to Davidson, such a test is available through 'radical interpretation' (a modification of Quine's method of 'radical translation'). The term 'radical translation', as originally used by Quine, refers to situations where a translator engages in preparing a manual of translation for the language of a group of linguistically untouched people, without the help of a dictionary or a bilingual speaker. The term 'radical interpretation' introduced by Davidson has a wider scope; it applies to the interpretation of one's own language as well as to the translation of foreign, previously unknown, languages. This approach allows us to

spell out the requirements and the preconditions for learning/ translating/interpreting a language.

The paper 'Belief and the Basis of Meaning' (1974), reproduced here, is one link in the overall Davidsonian project of constructing a comprehensive theory of language and mind. Davidson begins by rejecting the intention-centred theories of meaning of Wittgenstein and Grice (see chapters 5 and 7) because, he argues, we have no non-linguistic evidence to verify what beliefs and intentions speakers have. Any attempt to define meaning in terms of the belief and intentions of the speakers will be circular. 'Belief and the Basis of Meaning' addresses the question 'What do we need to know if we are to interpret the utterances of a speaker?'. Davidson examines the strategies which a radical interpreter must employ in order to interpret the words of others. In general, an interpreter knows what a speaker means by an utterance when she can identify the content of the belief(s) the speaker intends to express, that is, if she knows what beliefs the speaker holds true.

According to Davidson, to be able to identify something as a belief we must be able to interpret it, and in order to be able to interpret it or to assign meaning to it, we have to regard the speaker's beliefs, on the whole, as being true or in agreement with our own. The radical interpreter has to begin constructing her manual of translation by applying what Davidson, and Quine, following Wilson, call the 'principle of charity'. If all we know is what sentences a speaker holds true, and we cannot assume that his language is our own, Davidson argues, we cannot take even a first step towards interpretation. Since knowledge of beliefs comes only with the ability to interpret words, one must assume general agreement at the outset. Thus, the principle of charity is a prerequisite of establishing that a person has any beliefs. The underlying thought is that the understanding of someone's language will depend on sharing a worldview. Of course there will always be important divergences between different belief systems, but Davidson argues that we can make sense of the differences only against the background of shared beliefs, for without the assumption of a 'vast common ground, there is no place for the disputants to have their quarrel' (*Inquiries into Truth and Interpretation*, 1984, p. 200).

Davidson's holistic view of language, his view that the meaning of a sentence depends on the meaning of other sentences in the language, is his chief justification for the adoption of the principle of charity. We must assume that most beliefs are correct, for a belief is identified by its location in a pattern of beliefs, and it is this pattern which determines the subject matter of the belief. Davidson's holism, together with the rules regarding the compositionality of language, also ensure that

T-sentences such as ' "La neige est blanche" in French is true if and only if snow is green' will not be accepted into our final manual of translation or theory of meaning. To take a very simple example, it would be difficult to see how one could assign the value true to 'snow is green' in an object language and the value false to 'the rabbit is green' and retain the conventional meaning of 'rabbit', 'grass', 'white', etc.

According to Davidson, any language, including our own, incorporates or depends upon a largely correct, shared view of how things are. Communication, or interpretation, across various languages proves the existence of a shared and largely true view of the world. In the absence of successful communication or interpretation, however, we would not have any criterion for ascribing beliefs to a biological entity. We can either communicate and translate and thus share a view of the world, or fail to communicate and so fail to identify a linguistic community which is radically different from ours. This failure, Davidson claims, shows that in fact there cannot be such a linguistic community.

Works by Davidson

1980 *Essays on Actions and Events*, Oxford: Clarendon Press.
1984 *Inquiries into Truth and Interpretation*. Oxford: Clarendon Press.
1990 'The Structure and Content of Truth': The Dewey Lectures 1989, *Journal of Philosophy*, 87, pp. 279–328.
1990 'Three Varieties of Knowledge', in A. Phillips Griffiths (ed.), *A. J. Ayer: Memorial Essays*, Royal Institute of Philosophy, Supplement 30. Cambridge: Cambridge University Press, pp. 153–66.

Works on Davidson

Evnine, Simon, *Donald Davidson*. Oxford: Polity Press/Blackwell, 1991.
LePore, E. (ed.), *Truth and Interpretation: Perspective on the Philosophy of Donald Davidson*. Oxford: Blackwell, 1986.
LePore, E. and McLaughlin, B. (eds), *Actions and Events*. Oxford: Blackwell, 1985.
Malpas, Jeff E., *Donald Davidson and the Mirror of Meaning*. Cambridge: Cambridge University Press, 1992.
Ramberg, Bjorn T., *Donald Davidson's Philosophy of Language*. Oxford: Blackwell, 1989.

Belief and the Basis of Meaning

Meaning and belief play interlocking and complementary roles in the interpretation of speech. By emphasizing the connection between our grounds for attributing beliefs to speakers, and our grounds for assigning meanings to their utterances, I hope to explain some problematic features both of belief and of meaning.

We interpret a bit of linguistic behaviour when we say what a speaker's words mean on an occasion of use. The task may be seen as one of redescription. We know that the words 'Es schneit' have been uttered on a particular occasion and we want to redescribe this uttering as an act of saying that it is snowing.[1] What do we need to know if we are to be in a position to redescribe speech in this way, that is, to interpret the utterances of a speaker? Since a competent interpreter can interpret any of a potential infinity of utterances (or so we may as well say), we cannot specify what he knows by listing cases. He knows, for example, that in uttering 'Es schneit' under certain conditions and with a certain intent, Karl has said that it is snowing; but there are endless further cases. What we must do then is state a finite theory from which particular interpretations follow. The theory may be used to describe an aspect of the interpreter's competence at understanding what is said. We may, if we please, also maintain that there is a mechanism in the interpreter that corresponds to the theory. If this means only that there is some mechanism or other that performs that task, it is hard to see how the claim can fail to be true.

Theory of interpretation is the business jointly of the linguist, psychologist and philosopher. Its subject matter is the behaviour of a speaker or speakers, and it tells what certain of their utterances mean. Finally, the theory can be used to describe what every interpreter knows, namely a specifiable infinite subset of the truths of the theory. In what follows, I shall say a little, and assume a lot, about the form a theory of

interpretation can take. But I want to focus on the question how we can tell that any such theory is true.

One answer comes pat. The theory is true if its empirical implications are true; we can test the theory by sampling its implications for truth. In the present case, this means noticing whether or not typical interpretations a theory yields for the utterances of a speaker are correct. We agreed that any competent interpreter knows whether the relevant implications are true; so any competent interpreter can test a theory in this way. This does not mean, of course, that finding a true theory is trivial; it does mean that given a theory, testing it may require nothing arcane.

The original question, however, is how we know that a particular interpretation is correct, and our pat answer is not addressed to this question. An utterance can no doubt be interpreted by a correct theory, but if the problem is to determine when an interpretation is correct, it is no help to support the theory that yields it by giving samples of correct interpretations. There is an apparent impasse; we need the theory before we can recognize evidence on its behalf.

The problem is salient because uninterpreted utterances seem the appropriate evidential base for a theory of meaning. If an acceptable theory could be supported by such evidence, that would constitute conceptual progress, for the theory would be specifically semantical in nature, while the evidence would be described in non-semantical terms. An attempt to build on even more elementary evidence, says behaviouristic evidence, could only make the task of theory construction harder, though it might make it more satisfying. In any case, we can without embarrassment undertake the lesser enterprise.

A central source of trouble is the way beliefs and meanings conspire to account for utterances. A speaker who holds a sentence to be true on an occasion does so in part because of what he means, or would mean, by an utterance of that sentence, and in part because of what he believes. If all we have to go on is the fact of honest utterance, we cannot infer the belief without knowing the meaning, and have no chance of inferring the meaning without the belief.

Various strategies for breaking into this circle suggest themselves. One is to find evidence for what words mean that is independent of belief. It would have to be independent of intentions, desires, regrets, wishes, approvals, and conventions too, for all these have a belief component. Perhaps there are some who think it would be possible to establish the correctness of a theory of interpretation without knowing, or establishing, a great deal about beliefs, but it is not easy to imagine how it could be done.

Far more plausible is the idea of deriving a theory of interpretation

from detailed information about the intentions, desires, and beliefs of speakers (or interpreters, or both). This I take to be the strategy of those who undertake to define or explain linguistic meaning on the basis of non-linguistic intentions, uses, purposes, functions, and the like: the traditions are those of Mead and Dewey, of Wittgenstein and Grice. This strategy will not meet the present need either, I think.

There can be nothing wrong, of course, with the methodological maxim that when baffling problems about meanings, reference, synonymy, and so on arise, we should remember that these concepts, like those of word, sentence, and language themselves, abstract away from the social transactions and setting which give them what content they have. Everyday linguistic and semantic concepts are part of an intuitive theory for organizing more primitive data, so only confusion can result from treating these concepts and their supposed objects as if they had a life of their own. But this observation cannot answer the question how we know when an interpretation of an utterance is correct. If our ordinary concepts suggest a confused theory, we should look for a better theory, not give up theorizing.

There can be no objection either to detailing the complicated and important relations between what a speaker's words mean and his non-linguistic intentions and beliefs. I have my doubts about the possibility of *defining* linguistic meaning in terms of non-linguistic intentions and beliefs, but those doubts, if not the sources of those doubts, are irrelevant to the present theme.

The present theme is the nature of the evidence for the adequacy of a theory of interpretation. The evidence must be describable in non-semantic, non-linguistic terms if it is to respond to the question we have set; it must also be evidence we can imagine the virgin investigator having without his already being in possession of the theory it is supposed to be evidence for. This is where I spy trouble. There is a principled, and not merely a practical, obstacle to verifying the existence of detailed, general and abstract beliefs and intentions, while being unable to tell what a speaker's words mean. We sense well enough the absurdity in trying to learn without asking him whether someone believes there is a largest prime, or whether he intends, by making certain noises, to get someone to stop smoking by that person's recognition that the noises were made with that intention. The absurdity lies not in the fact that it would be very hard to find out these things without language, but in the fact that we have no good idea how to set about authenticating the existence of such attitudes when communication is not possible.

This point is not happily stated by saying that our sophisticated beliefs and intentions and thoughts are like silent utterances. My claim is only

that making detailed sense of a person's intentions and beliefs cannot be independent of making sense of his utterances. If this is so, then an inventory of a speaker's sophisticated beliefs and intentions cannot be the evidence for the truth of a theory for interpreting his speech behaviour.

Since we cannot hope to interpret linguistic activity without knowing what a speaker believes, and cannot found a theory of what he means on a prior discovery of his beliefs and intentions, I conclude that in interpreting utterances from scratch – in *radical* interpretation – we must somehow deliver simultaneously a theory of belief and a theory of meaning. How is this possible?

In order to make the problem sharp and simple enough for a relatively brief discussion, let me make a change in the description of the evidential base for a theory of interpretation. Instead of utterances of expressions, I want to consider a certain attitude towards expressions, an attitude that may or may not be evinced in actual utterances. The attitude is that of holding true, relativized to time. We may as well suppose we have available all that could be known of such attitudes, past, present, and future. Finally, I want to imagine that we can describe the external circumstances under which the attitudes hold or fail to hold. Typical of the sort of evidence available then would be the following: a speaker holds 'Es schneit' true when and only when it is snowing. I hope it will be granted that it is plausible to say we can tell when a speaker holds a sentence to be true without knowing what he means by the sentence, or what beliefs he holds about its unknown subject matter, or what detailed intentions do or might prompt him to utter it. It is often argued that we must assume that most of a speaker's utterances are of sentences he holds true: if this is right, the independent availability of the evidential base is assured. But weaker assumptions will do, since even the compulsive liar and the perennial kidder may be found out.

The problem, then, is this: we suppose we know what sentences a speaker holds true, and when, and we want to know what he means and believes. Perhaps we could crack the case if we knew enough about his beliefs and intentions, but there is no chance of this without prior access to a theory of interpretation. Given the interpretations, we could read off beliefs from the evidential base, but this assumes what we want to know.

I am struck by the analogy with a well-known problem in decision theory. Suppose an agent is indifferent between getting $5.00, and a gamble that offers him $11.00 if a coin comes up heads, and $0.00 if it comes up tails. We might expect (i.e., 'interpret') his indifference by supposing that money has a diminishing marginal utility for him: $5.00 is midway on his subjective value scale between $0.00 and $11.00. We

arrive at this by assuming the gamble is worth the sum of the values of the possible outcomes as tempered by their likelihoods. In this case, we assume that heads and tails are equally likely. Unfortunately there is an equally plausible alternative explanation: since $5.00 obviously isn't midway in utility between $0.00 and $11.00, the agent must believe tails are more likely to come up than heads; if he thought heads and tails equally probable, he would certainly prefer the gamble, which would then be equal to a straight offer of $5.50.

The point is obvious. Choices between gambles are the result of two psychological factors, the relative values the chooser places on the outcomes, and the probability he assigns to those outcomes, conditional on his choice. Given the agent's beliefs (his subjective probabilities) it's easy to compute his relative values from his choices; given his values, we can infer his beliefs. But given only his choices, how can we work out both his beliefs and his values?

The problem is much like the problem of interpretation. The solution in the case of decision theory is neat and satisfying; nothing as good is available in the theory of meaning. Still, one can, I think, see the possibility of applying an analogous strategy. Simplified a bit, Frank Ramsey's proposal for coping with the problem of decision theory is this.[2] Suppose that there are two alternatives, getting $11.00 and getting $0.00, and that there is an event E such that the agent is indifferent between the following two gambles: Gamble One – if E happens the agent receives $11.00; if E fails to happen he gets $0.00. Gamble Two – if E happens he gets $0.00; if E fails to happen he gets $11.00. The agent's indifference between the gambles shows that he must judge that E is as likely to happen as not. For if he thought E more likely to occur than not, he would prefer the first gamble which promises him $11.00 if E occurs, and if he thought E more likely not to occur than to occur he would prefer the second gamble which pairs E's non-occurrence with $11.00. This solves, for decision theory, the problem of how to separate out subjective probability from subjective utility, for once an event like E is discovered, it is possible to scale other values, and then to determine the subjective probabilities of all events.

In this version of decision theory, the evidential base is preferences between alternatives, some of them wagers; preference here corresponds to the attitude of holding true in the case of interpretation, as I put that problem. Actual choices in decision theory correspond to actual utterances in interpretation. The explanation of a particular preference involves the assignment of a comparative ranking of values and an evaluation of probabilities. Support for the explanation doesn't come from a new kind of insight into the attitudes and beliefs of the agent, but

from more observations of preferences of the very sort to be explained. In brief, to explain (i.e., interpret) a particular choice or preference, we observer *other* choices or preferences; these will support a theory on the basis of which the original choice or preference can be explained. Attributions of subjective values and probabilities are part of the theoretical structure, and are convenient ways of summarizing facts about the structure of basic preferences; there is no way to test for them independently. Broadly stated, my theme is that we should think of meanings and beliefs as interrelated constructs of a single theory just as we already view subjective values and probabilities as interrelated constructs of decision theory.

One way of representing some of the explanatory facts about choice behaviour elicited by a theory of decision is to assign numbers to measure, say, the subjective values of outcomes to a particular agent. So we might assign the numbers 0, 1, and 2 as measures of the values to someone of receiving $0.00, $5.00, and $11.00 respectively. To the unwary this could suggest that for that agent $11.00 was worth twice as much as $5.00. Only by studying the underlying theory would the truth emerge that the assignment of numbers to measure utilities was unique up to a linear transformation, but not beyond. The numbers 2, 4, and 6 would have done as well in recording the facts, but 6 is not twice 4. The theory makes sense of comparisons of differences, but not of comparisons of absolute magnitudes. When we represent the facts of preference, utility, and subjective probability by assigning numbers, only some of the properties of numbers are used to capture the empirically justified pattern. Other properties of the numbers used may therefore be chosen arbitrarily, like the zero point and the unit in measuring utility or temperature.

The same facts may be represented by quite different assignments of numbers. In the interpretation of speech, introducing such supposed entities as propositions to be meanings of sentences or objects of belief may mislead us into thinking the evidence justifies, or should justify, a kind of uniqueness that it does not. In the case of decision theory, we can establish exactly which properties of numbers are relevant to the measurement of utility and which to the measurement of probability. Propositions being much vaguer than numbers, it is not clear to what extent they are overdesigned for their job.

There is not just an analogy between decision theory and interpretation theory, there is a connection. Seen from the side of decision theory, there is what Ward Edwards once dubbed the 'presentation problem' for empirical applications of decision theory. To learn the preferences of an agent, particularly among complex gambles, it is obviously necessary to

describe the options in words. But how can the experimenter know what those words mean to the subject? The problem is not merely theoretical: it is well known that two descriptions of what the experimenter takes to be the same option may elicit quite different responses from a subject. We are up against a problem we discussed a moment ago in connection with interpretation: it is not reasonable to suppose we can interpret verbal behaviour without fine-grained information about beliefs and intentions, nor is it reasonable to imagine we can justify the attribution of preferences among complex options unless we can interpret speech behaviour. A radical theory of decision must include a theory of interpretation and cannot presuppose it.

Seen from the side of a theory of interpretation, there is the obvious difficulty in telling when a person accepts a sentence as true. Decision theory, and the common-sense ideas that stand behind it, help make a case for the view that beliefs are best understood in their role of rationalizing choices or preferences. Here we are considering only one special kind of belief, the belief that a sentence is true. Yet even in this case, it would be better if we could go behind the belief to a preference which might show itself in choice. I have no detailed proposal to make at the moment how this might, or should, be done. A first important step has been made by Richard Jeffrey.[3] He eliminates some troublesome confusions in Ramsey's theory by reducing the rather murky ontology of the theory, which dealt with events, options, and propositions to an ontology of propositions only. Preferences between propositions holding true then becomes the evidential base, so that the revised theory allows us to talk of degrees of belief in the truth of propositions, and the relative strength of desires that propositions be true. As Jeffrey points out, for the purposes of his theory, the objects of these various attitudes could as well be taken to be sentences. If this change is made, we can unify the subject matter of decision theory and theory of interpretation. Jeffrey assumes, of course, the sentences are understood by agent and theory builders in the same way. But the two theories may be united by giving up this assumption. The theory for which we should ultimately strive is one that takes as evidential base preferences between sentences – preferences that one sentence rather than another be true. The theory would then explain individual preferences of this sort by attributing beliefs and values to the agent, and meanings to his words.[4]

In this paper I shall not speculate further on the chances for an integrated theory of decision and interpretation; so I return to the problem of interpreting utterances on the basis of information about when, and under what external circumstances, the sentences they exemplify are held true. The central ideas in what I have said so far may be

summarized: behavioural or dispositional facts that can be described in ways that do not assume interpretations, but on which a theory of interpretation can be based, will necessarily be a vector of meaning and belief. One result is that to interpret a particular utterance it is necessary to construct a comprehensive theory for the interpretation of a potential infinity of utterances. The evidence for the interpretation of a particular utterance will therefore have to be evidence for the interpretation of all utterances of a speaker or community. Finally, if entities like meanings, propositions, and objects of belief have a legitimate place in explaining speech behaviour, it is only because they can be shown to play a useful role in the construction of an adequate theory. There is no reason to believe in advance that these entities will be any help, and so it cannot be an independent goal of a theory or analysis to identify the meanings of expressions or the objects of belief.

The appreciation of these ideas, which we owe largely to Quine, represents one of the few real breakthroughs in the study of language. I have put things in my own way, but I think that the differences between us are more matters of emphasis than of substance. Much that Quine has written understandably concentrates on undermining misplaced confidence in the usefulness or intelligibility of concepts like those of analyticity, synonymy, and meaning. I have tried to accentuate the positive. Quine, like the rest of us, wants to provide a theory of interpretation. His animadversions on meanings are designed to discourage false starts; but the arguments in support of the strictures provide foundations for an acceptable theory.

I have accepted what I think is essentially Quine's picture of the problem of interpretation, and the strategy for its solution that I want to propose will obviously owe a great deal to him. There also will be some differences. One difference concerns the form the theory should take. Quine would have us produce a translation manual (a function, recursively given) that yields a sentence in the language of the interpreter for each sentence of the speaker (or more than one sentence in the case of ambiguity). To interpret a particular utterance one would give the translating sentence and specify the translation manual. In addition, it would be necessary to know exactly what information was preserved by a translation manual that met the empirical constraints: what was invariant, so to speak, from one acceptable translation manual to another.

I suggest making the theory explicitly semantical in character, in fact, that the theory should take the form of a theory of truth in Tarski's style.[5] In Tarski's style, but with modifications to meet present problems. For one thing, we are after a *theory* of truth where Tarski is interested

in an explicit definition. This is a modification I will not discuss now: it mainly concerns the question how rich an ontology is available in the language in which the theory is given. Secondly, in order to accommodate the presence of demonstrative elements in natural language it is necessary to relativize the theory of truth to times and speakers (and possibly to some other things). The third modification is more serious and comes to the heart of the business under discussion. Tarski's Convention T demands of a theory of truth that it put conditions on some predicate, say 'is true', such that all sentences of a certain form are entailed by it. These are just those sentences with the familiar form: ' "Snow is white" is true if and only if snow is white'. For the formalized languages that Tarski talks about, T-sentences (as we may call these theorems) are known by their syntax, and this remains true even if the object language and metalanguage are different languages and even if for quotation marks we substitute something more manageable. But in radical interpretation a syntactical test of the truth of T-sentences would be worthless, since such a test would presuppose the understanding of the object language one hopes to gain. The reason is simple: the syntactical test is merely meant to formalize the relation of synonymy or translation, and this relation is taken as unproblematic in Tarski's work on truth. Our outlook inverts Tarski's: we want to achieve an understanding of meaning or translation by assuming a prior grasp of the concept of truth. What we require, therefore, is a way of judging the acceptability of T-sentences that is not syntactical, and makes no use of the concepts of translation, meaning, or synonymy, but is such that acceptable T-sentences will in fact yield interpretations.

A theory of truth will be materially adequate, that is, will correctly determine the extension of the truth predicate, provided it entails, for each sentence s of the object language, a theorem of the form 's is true if and only if p' where 's' is replaced by a description of s and 'p' is replaced by a sentence that is true if and only if s is. For purposes of interpretation, however, truth in a T-sentence is not enough. A theory of truth will yield interpretations only if its T-sentences state truth conditions in terms that may be treated as 'giving the meaning' of object-language sentences. Our problem is to find constraints on a theory strong enough to guarantee that it can be used for interpretation.

There are constraints of a formal nature that flow from the demand that the theory be finitely axiomatized, and that it satisfy Convention T (as appropriately modified).[6] If the metalanguage is taken to contain ordinary quantification theory, it is difficult, if not impossible, to discover anything other than standard quantificational structures in the object language. This does not mean that anything whatever can be read into

the object language simply by assuming it to be in the metalanguage; for example, the presence of modal operators in the metalanguage does not necessarily lead to a theory of truth for a modal object language.

A satisfactory theory cannot depart much, it seems, from standard quantificational structures or their usual semantics. We must expect the theory to rely on something very like Tarski's sort of recursive characterization of satisfaction, and to describe sentences of the object language in terms of familiar patterns created by quantification and cross-reference, predication, truth-functional connections, and so on. The relation between these semantically tractable patterns and the surface grammar of sentences may, of course, be very complicated.

The result of applying the formal constraints is, then, to fit the object language as a whole to the procrustean bed of quantification theory. Although this can no doubt be done in many ways if any, it is unlikely that the differences between acceptable theories will, in matters of logical form, be great. The identification of the semantic features of a sentence will then be essentially invariant: correct theories will agree on the whole about the quantificational structure to be assigned to a given sentence.

Questions of logical form being settled, the logical constants of quantification theory (including identity) will have been perforce discovered in the object language (well concealed, probably, beneath the surface). There remain the further primitive expressions to be interpreted. The main problem is to find a systematic way of matching predicates of the metalanguage to the primitive predicates of the object language so as to produce acceptable T-sentences. If the metalanguage predicates translate the object-language predicates, things will obviously come out right; if they have the same extensions, this might be enough. But it would be foreign to our programme to use these concepts in stating the constraints: the constraints must deal only with sentences and truth. Still, it is easy to see how T-sentences for sentences with indexical features sharply limit the choice of interpreting predicates; for example, the T-sentence for 'Das ist weiss' must have something like this form: 'For all speakers of German x and all times t "Das ist weiss" is true spoken by x at t if and only if the object demonstrated by x at t is white'. There may, as Quine has pointed out in his discussions of ontological relativity, remain room for alternative ontologies, and so for alternative systems for interpreting the predicates of the object language. I believe the range of acceptable theories of truth can be reduced to the point where all acceptable theories will yield T-sentences that we can treat as giving correct interpretations, by application of further reasonable and non-question-begging constraints. But the details must be reserved for another occasion.

Much more, obviously, must be said about the empirical constraints

on the theory – the conditions under which a T-sentence may be accepted as correct. We have agreed that the evidential base for the theory will consist of facts about the circumstances under which speakers hold sentences of their language to be true. Such evidence, I have urged, is neutral as between meaning and belief and assumes neither. It now needs to be shown that such data can provide a test for the acceptability of T-sentences.

I propose that we take the fact that speakers of a language hold a sentence to be true (under observed circumstances) as prima-facie evidence that the sentence is true under those circumstances. For example, positive instances of 'Speakers (of German) hold "Es schneit" true when, and only when, it is snowing' should be taken to confirm not only the generalization, but also the T-sentence, ' "Es schneit" is true (in German) for a speaker x at time t if and only if it is snowing at t (and near x)'.

Not all the evidence can be expected to point the same way. There will be differences from speaker to speaker, and from time to time for the same speaker, with respect to the circumstances under which a sentence is held true. The general policy, however, is to choose truth conditions that do as well as possible in making speakers hold sentences true when (according to the theory and the theory builder's view of the facts) those sentences are true. That is the general policy, to be modified in a host of obvious ways. Speakers can be allowed to differ more often and more radically with respect to some sentences than others, and there is no reason not to take into account the observed or inferred individual differences that may be thought to have caused anomalies (as seen by the theory).[7]

Building the theory cannot be a matter of deciding on an appropriate T-sentence for one sentence of the object language at a time; a pattern must be built up that preserves the formal constraints discussed above while suiting the evidence as well as may be. And of course the fact that a theory does not make speakers universal holders of truths is not an inadequacy of the theory; the aim is not the absurd one of making disagreement and error disappear. The point is rather that widespread agreement is the only possible background against which disputes and mistakes can be interpreted. Making sense of the utterances and behaviour of others, even their most aberrant behaviour, requires us to find a great deal of reason and truth in them. To see too much unreason on the part of others is simply to undermine our ability to understand what it is they are so unreasonable about. If the vast amount of agreement on plain matters that is assumed in communication escapes notice, it's because the shared truths are too many and too dull to bear mentioning. What we want to talk about is what's new, surprising, or disputed.

A theory for interpreting the utterances of a single speaker, based on nothing but his attitudes towards sentences, would, we may be sure, have many equally eligible rivals, for differences in interpretation could be offset by appropriate differences in the beliefs attributed. Given a community of speakers with apparently the same linguistic repertoire, however, the theorist will strive for a single theory of interpretation: this will greatly narrow his practical choice of preliminary theories for each individual speaker. (In a prolonged dialogue, one starts perforce with a socially applicable theory, and refines it as evidence peculiar to the other speaker accumulates.)

What makes a social theory of interpretation possible is that we can construct a plurality of private belief structures: belief is built to take up the slack between sentences held true by individuals and sentences true (or false) by public standards. What is private about belief is not that it is accessible to only one person, but that it may be idiosyncratic. Attributions of belief are as publicly verifiable as interpretations, being based on the same evidence: if we can understand what a person says, we can know what he believes.

If interpretation is approached in the style I have been discussing, it is not likely that only one theory will be found satisfactory. The resulting indeterminacy of interpretation is the semantic counterpart of Quine's indeterminacy of translation. On my approach, the degree of indeterminacy will, I think, be less than Quine contemplates: this is partly because I advocate adoption of the principle of charity on an across-the-board basis, and partly because the uniqueness of quantificational structure is apparently assured if Convention T is satisfied. But in any case the question of indeterminacy is not central to the concerns of this paper. Indeterminacy of meaning or translation does not represent a failure to capture significant distinctions; it marks the fact that certain apparent distinctions are not significant. If there is indeterminacy, it is because when all the evidence is in, alternative ways of stating the facts remain open. An analogy from decision theory has already been noted: if the numbers 1, 2, and 3 capture the meaningful relations in subjective value between three alternatives, then the numbers -17, -2 and +13 do as well. Indeterminacy of this kind cannot be of genuine concern.

What is important is that if meaning and belief are interlocked as I have suggested, then the idea that each belief has a definite object, and the idea that each word and sentence has a definite meaning, cannot be invoked in describing the goal of a successful theory. For even if, contrary to what may reasonably be expected, there were no indeterminacy at all, entities such as meanings and objects of belief would be of no independent interest. We could, of course, invent such entities with a clear conscience

if we were sure there were no permissible variant theories. But if we knew this, we would know how to state our theories without mention of the objects.

Theories of belief and meaning may require no exotic objects, but they do use concepts which set such theories apart from the physical and other non-psychological sciences: concepts like those of meaning and belief are, in a fundamental way, not reducible to physical, neurological, or even behaviouristic concepts. This irreducibility is not due, however, to the indeterminacy of meaning or translation, for if I am right, indeterminacy is important only for calling attention to how the interpretation of speech must go hand in hand with the interpretation of action generally, and so with the attribution of desires and beliefs. It is rather the methods we must invoke in constructing theories of belief and meaning that ensures the irreducibility of the concepts essential to those theories. Each interpretation and attribution of attitude is a move within a holistic theory, a theory necessarily governed by concern for consistency and general coherence with the truth, and it is this that sets these theories forever apart from those that describe mindless objects, or describe objects as mindless.[8]

Notes and References

1. I use the expression 'says that' in the present context in such a way that a speaker says (on a particular occasion) that it is snowing if and only if he utters words that (on that occasion) mean that it is snowing. So a speaker may say that it is snowing without *his* meaning, or asserting, that it is snowing.
2. F. P. Ramsay, 'Truth and Probability', in *The Foundations of Mathematics* (New York: Humanities Press, 1950).
3. R. C. Jeffrey, *The Logic of Decision* (Chicago/London: University of Chicago Press, 1983).
4. For progress in developing such a theory, see my 'Toward a Unified Theory of Meaning and Action', in *Grayer Philosophische Studien*, 2 (1980).
5. A. Tarski, 'The Concept of Truth in Formalized Languages' (1931), in *Logic, Semantics, Metamathematics*. (Oxford: Clarendon Press, 1956).
6. See Essays 5 and 9 of Davidson's *Essays on Actions and Events*.
7. For more on such modifications, see Essay 11 of Davidson's *Essays on Truth and Interpretation*, and particularly D. K. Lewis, 'Radical Interpretation', in *Synthése*, 27 (1974), pp. 331–44.
8. See Essay 11 of Davidson's *Essays on Truth and Interpretation*.

10

KEITH DONNELLAN

(1938–)

The contemporary American philosopher of language Keith Donnellan teaches at the University of California at Los Angeles (UCLA). His work on questions of meaning and reference set off a chain reaction that culminated in the development of the currently dominant externalist causal theories of meaning and reference.

In order to appreciate the import of Donnellan's contribution to the discussions of reference and meaning, we must take a step back and look at the development of theories of reference up to the time of the publication of his article 'Reference and Definite Descriptions' (1966), reprinted here. As we have seen (chapter 2), Bertrand Russell held the view that ordinary names are disguised definite descriptions and do not refer directly to their bearers. According to Russell, only logically proper names, such as 'this' and 'now', used under appropriate circumstances, can refer directly. Frege, on the other hand, argued that both proper names and descriptions refer, or attach themselves to their objects, through what he calls their sense or conceptual content. Peter Strawson, another major player in this debate, in his article 'On Referring' (1950) aligned himself with Frege and argued that Russell was incorrect to think that descriptions are not referring terms. Yet, unlike Russell and Frege, Strawson held a pragmatic view of reference, where it is the speakers, primarily, rather than words or names, who refer.

Donnellan wishes to effect a synthesis of these opposing views. According to him, descriptions fall into two different categories depending on the uses to which they are put and the circumstances in which they are used. He distinguishes between the referential and attributive uses of descriptions. Strawson's focus was on the referential use of descriptions, where a term is used by a speaker in order to enable the hearer to pick out or identify whom or what he or she is talking about. Russell's theory, on the other hand, focused on the attributive use of descriptions, where a speaker says something without having a specific person or object

in mind. Our ability to distinguish between these two ways of using descriptions depends on our tacit and explicit knowledge of the context and the occasions surrounding their use.

Donnellan's views are more closely aligned with Strawson's pragmatic approach in that they emphasize the speaker's use of names to refer to, pick out, or talk about things. To take an example, the sentence 'The murderer of Smith is unbalanced' is used referentially if the speaker knows or thinks that the hearers are going to understand it as meaning that Jones is unbalanced, i.e., if they know which particular individual the speaker has in mind. The same definite description is used in an attributive way if the speaker intends to make a general comment about whoever might have murdered Smith, without having a definite person in mind. Whether a description is used attributively or referentially depends both on the speaker's intentions and the general context in which the description is being used.

Donnellan also discusses the case of proper names. According to him, and contra Russell, ordinary proper names are not disguised definite descriptions. Rather they function the way Russell claimed that logically proper names do, and definite descriptions, when used referentially, can work as Russellian genuine proper names are supposed to function. In other words, there is no significant distinction to be made between ordinary proper names and the Russellian logically proper names. In a subsequent article 'Proper Names and Identifying Descriptions', (1970) Donnellan introduces what he calls 'an historical account of referring' which has many points in common with Kripke's and Putnam's accounts of reference (see chapters 11 and 12). According to the historical account of reference, a proper name refers to a specific object because it is connected to that object through a chain of previous uses of that name or related names.

Saul Kripke, although largely in sympathy with Donnellan's position, has advanced several astute criticisms of his views. He has pointed out that in many instances there is a problem in deciding if it is the intentions of the speakers or the beliefs of the hearers that decide whether a definite description is used attributively or referentially. In his article 'Speaker's Reference and Semantic Reference' (1977), Kripke has drawn attention to the Gricean distinction between what a sentence means and what a speaker means in using that sentence on particular occasions, and he has accused Donnellan of failing to take sufficient notice of this distinction in his criticism of Russell. A speaker's intention to refer to an object by using an expression does not fully determine the success or failure of the speaker to pick out the object. It must be said that, despite these criticisms, Donnellan's work remains the vital first step in the shift of

perspective on questions of reference and meaning that took place in the
1970s.

Works by Donnellan

1968 'Putting Humpty-Dumpty Together Again', *Philosophical Review*, 77, pp.
 203–15.
1970 'Proper Names and Identifying Descriptions', *Synthése*, 21, pp. 335–58.
1974 'Speaking about Nothing', *Philosophical Review*, 83, pp. 3–30.
1983 'Kripke and Putnam on Natural Kind Terms', in Carl Ginet and Sydney
 Shoemaker (eds), *Knowledge and Mind: Philosophical Essays*. New
 York/Oxford: Oxford University Press.

Works on Donnellan

Bertolet, R., 'The Semantic Significance of Donnellan's Distinction',
 Philosophical Studies, 37 (1980), pp. 281–8.
Davies, M., *Meaning, Quantification, Necessity: Themes in Philosophical
 Logic*. London: Routledge, 1981.
French, Peter A., Uehling, T. E. and Wettstein, H. K. (eds), *Contemporary
 Perspectives in the Philosophy of Language*. Minneapolis: University of
 Minnesota Press, 1979.
Kaplan, David, 'Dthat', in Peter Cole (ed.), *Syntax and Semantics*, vol. 9. New
 York: Academic Press, 1978.
Yourgrau, Palle (ed.), *Demonstratives*. Oxford: Clarendon Press, 1990.
See also the suggested further reading in chapter 11.

Reference and Definite Descriptions[1]

I

Definite descriptions I shall argue, have two possible functions. They are used to refer to what a speaker wishes to talk about, but they are also used quite differently. Moreover, a definite description occurring in one and the same sentence may, on different occasions of its use, function in either way. The failure to deal with this duality of function obscures the genuine referring use of definite descriptions. The best-know theories of definite descriptions, those of Russell and Strawson, I shall suggest, are both guilty of this. Before discussing this distinction in use, I will mention some features of these theories to which it is especially relevant.

On Russell's view a definite description may denote an entity: 'if "C" is a denoting phrase [as definite descriptions are by definition], it may happen that there is one entity x (there cannot be more than one) for which the proposition "x is identical with C" is true ... We may then say that the entity x is the denotation of the phrase "C".'[2] In using a definite description, then, a speaker may use an expression which denotes some entity, but this is the only relationship between that entity and the use of the definite description recognized by Russell. I shall argue, however, that there are two uses of definite descriptions. The definition of denotation given by Russell is applicable to both, but in one of these the definite description serves to do something more. I shall say that in this use the speaker uses the definite description to *refer* to something, and call this use the 'referential use' of a definite description. Thus, if I am right, referring is not the same as denoting and the referential use of definite descriptions is not recognized on Russell's view.

Furthermore, on Russell's view the type of expression that comes closest to performing the function of the referential use of definite descriptions turns out, as one might suspect, to be a proper name (in 'the narrow logical sense'). Many of the things said about proper names by Russell can, I think, be said about the referential use of definite descriptions without straining

senses unduly. Thus the gulf Russell thought he saw between names and definite descriptions is narrower than he thought.

Strawson, on the other hand, certainly does recognize a referential use of definite descriptions. But what I think he did not see is that a definite description may have a quite different role – may be used nonreferentially, even as it occurs in one and the same sentence. Strawson, it is true, points out nonreferential uses of definite descriptions,[3] but which a definite description has seems to be for him a function of the kind of sentence in which it occurs; whereas, if I am right, there can be two possible uses of a definite description in the same sentence. Thus, in 'On Referring', he says, speaking of expressions used to refer, 'Any expression of any of these classes [one being that of definite descriptions] can occur as the subject of what would traditionally be regarded as a singular subject-predicate sentence; and would, so occurring, exemplify the use I wish to discuss.'[4] So the definite description in, say, the sentence 'The Republican candidate for president in 1968 will be a conservative' presumably exemplifies the referential use. But if I am right, we could not say this of the sentence in isolation from some particular occasion on which it is used to state something; and then it might or might not turn out that the definite description has a referential use.

Strawson and Russell seem to me to make a common assumption here about the question of how definite descriptions function: that we can ask how a definite description functions in some sentence independently of a particular occasion upon which it is used. This assumption is not really rejected in Strawson's arguments against Russell. Although he can sum up his position by saying, ' "Mentioning" or "referring" is not something an expression does; it is something that someone can use an expression to do,'[5] he means by this to deny the radical view that a 'genuine' referring expression *has* a referent, functions to refer, independent of the context of some use of the expression. The denial of this view, however, does not entail that definite descriptions cannot be identified as referring expressions in a sentence unless the sentence is being used. Just as we can speak of a function of a tool that is not at the moment performing its function, Strawson's view, I believe, allows us to speak of the referential function of a definite description in a sentence even when it is not being used. This, I hope to show, is a mistake.

A second assumption shared by Russell's and Strawson's account of definite descriptions is this. In many cases a person who uses a definite description can be said (in some sense) to presuppose or imply that something fits the description.[6] If I state that the king is on his throne, I presuppose or imply that there is a king. (At any rate, this would be a natural thing to say for anyone who doubted that there is a king.)

Both Russell and Strawson assume that where the presupposition or implication is false, the truth value of what the speaker says is affected. For Russell the statement made is false; for Strawson it has no truth value. Now if there are two uses of definite descriptions, it may be that the truth value is affected differently in each case by the falsity of the presupposition or implication. This is what I shall in fact argue. It will turn out, I believe, that one or the other of the two views, Russell's or Strawson's, may be correct about the nonreferential use of definite descriptions, but neither fits the referential use. This is not so surprising about Russell's view, since he did not recognize this use in any case, but it is surprising about Strawson's since the referential use is what he tries to explain and defend. Furthermore, on Strawson's account, the result of there being nothing which fits the description is a failure of reference.[7] This too, I believe, turns out not to be true about the referential use of definite descriptions.

II

There are some uses of definite descriptions which carry neither any hint of a referential use nor any presupposition or implication that something fits the description. In general, it seems, these are recognizable from the sentence frame in which the description occurs. These uses will not interest us, but it is necessary to point them out if only to set them aside.

An obvious example would be the sentence 'The present king of France does not exist', used, say, to correct someone's mistaken impression that de Gaulle is the king of France.

A more interesting example is this. Suppose someone were to ask, 'Is de Gaulle the king of France?' This is the natural form of words for a person to use who is in doubt as to whether de Gaulle is king or president of France. Given this background to the question, there seems to be no presupposition or implication that someone is the king of France. Nor is the person attempting to refer to someone by using the definite description. On the other hand, reverse the name and description in the question and the speaker probably would be thought to presuppose or imply this. 'Is the king of France de Gaulle?' is the natural question for one to ask who wonders whether it is de Gaulle rather than someone else who occupies the throne of France.[8]

Many times, however, the use of a definite description does carry a presupposition or implication that something fits the description. If definite descriptions do have a referring role, it will be here. But it is a mistake, I think, to try, as I believe both Russell and Strawson do, to settle this matter without further ado. What is needed, I believe, is the distinction I will now discuss.

III

I will call the two uses of definite descriptions I have in mind the attributive use and the referential use. A speaker who uses a definite description attributively in an assertion states something about whoever or whatever is the so-and-so. A speaker who uses a definite description referentially in an assertion, on the other hand, uses the description to enable his audience to pick out whom or what he is talking about and states something about that person or thing. In the first case the definite description might be said to occur essentially, for the speaker wishes to assert something about whatever or whoever fits that description; but in the referential use the definite description is merely one tool for doing a certain job – calling attention to a person or thing – and in general any other device for doing the same job, another description or a name, would do as well. In the attributive use, the attribute of being the so-and-so is all-important, while it is not in the referential use.

To illustrate this distinction, in the case of a single sentence, consider the sentence, 'Smith's murderer is insane'. Suppose first that we come upon poor Smith foully murdered. From the brutal manner of the killing and the fact that Smith was the most lovable person in the world, we might exclaim, 'Smith's murderer is insane.' I will assume, to make it a simpler case, that in a quite ordinary sense we do not know who murdered Smith (though this is not in the end essential to the case). This, I shall say, is an attributive use of the definite description.

The contrast with such a use of the sentence is one of those situations in which we expect and intend our audience to realize whom we have in mind when we speak of Smith's murderer and, most importantly, to know that it is this person about whom we are going to say something.

For example, suppose that Jones has been charged with Smith's murder and has been placed on trial. Imagine that there is a discussion of Jones's odd behavior at his trial. We might sum up our impression of his behavior by saying, 'Smith's murderer is insane.' If someone asks to whom we are referring, by using this description, the answer here is 'Jones'. This, I shall say, is a referential use of the definite description.

That these two uses of the definite description in the same sentence are really quite different can perhaps best be brought out by considering the consequences of the assumption that Smith had no murderer (for example, he in fact committed suicide). In both situations, in using the definite description 'Smith's murderer', the speaker in some sense presupposes or implies that there is a murderer. But when we hypothesize that the presupposition or implication is false, there are different results for the two uses. In both cases we have used the predicate 'is insane', but in the first case, if there is no murderer, there is no person of whom it

could be correctly said that we attributed insanity to him. Such a person could be identified (correctly) only in case someone fitted the description used. But in the second case, where the definite description is simply a means of identifying the person we want to talk about, it is quite possible for the correct identification to be made even though no one fits the description we used.[9] We were speaking about Jones even though he is not in fact Smith's murderer and, in the circumstances imagined, it was his behavior we were commenting upon. Jones, might, for example, accuse us of saying false things of him in calling him insane and it would be no defense, I should think, that our description, 'the murderer of Smith', failed to fit him.

It is, moreover, perfectly possible for our audience to know to whom we refer, in the second situation, even though they do not share our presupposition. A person hearing our comment in the context imagined might know we are talking about Jones even though he does not think Jones guilty.

Generalizing from this case, we can say, I think, that there are two uses of sentences of the form, 'The ϕ is ψ.' In the first, if nothing is the ϕ then nothing has been said to be ψ. In the second, the fact that nothing is the ϕ does not have this consequence.

With suitable changes the same difference in use can be formulated for uses of language other than assertions. Suppose one is at a party and, seeing an interesting-looking person holding a martini glass, one asks, 'Who is the man drinking a martini?' If it should turn out that there is only water in the glass, one has nevertheless asked a question about a particular person, a question that it is possible for someone to answer. Contrast this with the use of the same question by the chairman of the local Teetotalers Union. He has just been informed that a man is drinking a martini at their annual party. He responds by asking his informant, 'Who is the man drinking a martini?' In asking the question the chairman does not have some particular person in mind about whom he asks the question; if no one is drinking a martini, if the information is wrong, no person can be singled out as the person about whom the question was asked. Unlike the first case, the attribute of being the man drinking martini is all-important, because if it is the attribute of no one, the chairman's question has no straightforward answer.

This illustrates also another difference between the referential and the attributive use of definite descriptions. In the one case we have asked a question about a particular person or thing even though nothing fits the description we used; in the other this is not so. But also in the one case our question can be answered; in the other it cannot be. In the referential use of a definite description we may succeed in picking out a person or

thing to ask a question about even though he or it does not really fit the description; but in the attributive use if nothing fits the description, no straightforward answer to the question can be given.

This further difference is also illustrated by commands or orders containing definite descriptions. Consider the order, 'Bring me the book on the table.' If 'the book on the table' is being used referentially, it is possible to fulfill the order even though there is no book on the table. If, for example, there is a book *beside* the table, though there is none *on* it, one might bring that book back and ask the issuer of the order whether this is 'the book you meant'. And it may be. But imagine we are told that someone has laid a book on our prize antique table, where nothing should be put. The order, 'Bring me the book on the table' cannot now be obeyed unless there is a book that has been placed on the table. There is no possibility of bringing back a book which was never on the table and having it be the one that was meant, because there is no book that in that sense was 'meant'. In the one case the definite description was a device for getting the other person to pick the right book; if he is able to pick the right book even though it does not satisfy the description, one still succeeds in his purpose. In the other case, there is, antecedently, no 'right book' except one which fits the description; the attribute of being the book on the table is essential. Not only is there no book about which an order was issued, if there is no book on the table, but the order itself cannot be obeyed. When a definite description is used attributively in a command or question and nothing fits the description, the command cannot be obeyed and the question cannot be answered. This suggests some analogous consequence for assertions containing definite descriptions used attributively. Perhaps the analogous result is that the assertion is neither true nor false: this is Strawson's view of what happens when the presupposition of the use of a definite description is false. But if so, Strawson's view works not for definite descriptions used referentially, but for the quite different use, which I have called the attributive use.

I have tried to bring out the two uses of definite descriptions by pointing out the different consequences of supposing that nothing fits the description used. There are still other differences. One is this: when a definite description is used referentially, not only is there in some sense a presupposition or implication that someone or something fits the description, as there is also in the attributive use, but there is a quite different presupposition: the speaker presupposes of some *particular* someone or something that he or it fits the description. In asking, for example, 'Who is the man drinking a martini?' where we mean to ask a question about that man over there, we are presupposing that that man over there is drinking a martini – not just that *someone* is a man drinking

a martini. When we say, in a context where it is clear we are referring to Jones, 'Smith's murderer is insane', we are presupposing that Jones is Smith's murderer. No such presupposition is present in the attributive use of definite descriptions. There is, of course, the presupposition that someone *or other* did the murder, but the speaker does not presuppose of someone in particular – Jones or Robinson, say – that he did it. What I mean by this second kind of presupposition that someone or something in particular fits the description – which is present in a referential use but not in an attributive use – can perhaps be seen more clearly by considering a member of the speaker's audience who believes that Smith was not murdered at all. Now in the case of the referential use of the description, 'Smith's murderer', he could accuse the speaker of mistakenly presupposing both that someone or other is the murderer and that also Jones is the murderer, for even though he believes Jones not to have done the deed, he knows that the speaker was referring to Jones. But in the case of the attributive use, he can accuse the speaker of having only the first, less specific presupposition; he cannot pick out some person and claim that the speaker is presupposing that that person is Smith's murderer. Now the more particular presuppositions that we find present in referential uses are clearly not ones we can assign to a definite description in some particular sentence in isolation from a context of use. In order to know that a person presupposes that Jones is Smith's murderer in using the sentence 'Smith's murderer is insane', we have to know that he is using the description referentially and also to whom he is referring. The sentence by itself does not tell us any of this.

IV

From the way in which I set up each of the previous examples it might be supposed that the important difference between the referential and the attributive use lies in the beliefs of the speaker. Does he believe of some particular person or thing that he or it fits the description used? In the Smith murder example, for instance, there was in the one case no belief as to who did the deed, whereas in the contrasting case it was believed that Jones did it. But this is, in fact, not an essential difference. It is possible for a definite description to be used attributively even though the speaker (and his audience) believes that a certain person or thing fits the description. And it is possible for a definite description to be used referentially where the speaker believes that nothing fits the description. It is true – and this is why, for simplicity, I set up the examples the way I did – that if a speaker does not believe that anything fits the description or does not believe that he is in a position to pick out what does fit the description, it is likely that he is not using it referentially.

It is also true that if he and his audience would pick out some particular thing or person as fitting the description, then a use of the definite description is very likely referential. But these are only presumptions and not entailments.

To use the Smith murder case again, suppose that Jones is on trial for the murder and I and everyone else believe him guilty. Suppose that I comment that the murderer of Smith is insane, but instead of backing this up, as in the example previously used, by citing Jones's behavior in the dock, I go on to outline reasons for thinking that *anyone* who murdered poor Smith in that particularly horrible way must be insane. If now it turns out that Jones was not the murderer after all, but someone else was, I think I can claim to have been right if the true murderer is after all insane. Here, I think, I would be using the definite description attributively, even though I believe that a particular person fits the description.

It is also possible to think of cases in which the speaker does not believe that what he means to refer to by using the definite description fits the description, or to imagine cases in which the definite description is used referentially even though the speaker believes *nothing* fits the description. Admittedly, these cases may be parasitic on a more normal use; nevertheless, they are sufficient to show that such beliefs of the speaker are not decisive as to which use is made of a definite description.

Suppose the throne is occupied by a man I firmly believe to be not the king, but a usurper. Imagine also that his followers as firmly believe that he is the king. Suppose I wish to see this man. I might say to his minions, 'Is the king in his countinghouse?' I succeed in referring to the man I wish to refer to without myself believing that he fits the description. It is not even necessary, moreover, to suppose that his followers believe him to be the king. If they are cynical about the whole thing, know he is not the king, I may still succeed in referring to the man I wish to refer to. Similarly, neither I nor the people I speak to may suppose that *anyone* is the king and, finally, each party may know that the other does not so suppose and yet the reference may go through.

V

Both the attributive and the referential use of definite descriptions seem to carry a presupposition or implication that there is something which fits the description. But the reasons for the existence of the presupposition or implication are different in the two cases.

There is a presumption that a person who uses a definite description referentially believes that what he wishes to refer to fits the description.

Because the purpose of using the description is to get the audience to pick out or think of the right thing or person, one would normally choose a description that he believes the thing or person fits. Normally a misdescription of that to which one wants to refer would mislead the audience. Hence, there is a presumption that the speaker believes *something* fits the description – namely, that to which he refers.

When a definite description is used attributively, however, there is not the same possibility of misdescription. In the example of 'Smith's murderer' used attributively, there was not the possibility of mis-describing Jones or anyone else; we were not referring to Jones nor to anyone else by using the description. The presumption that the speaker believes *someone* is Smith's murderer does not arise here from a more specific presumption that he believes Jones or Robinson or someone else whom he can name or identify is Smith's murderer.

The presupposition or implication is borne by a definite description used attributively because if nothing fits the description the linguistic purpose of the speech act will be thwarted. That is, the speaker will not succeed in saying something true, if he makes an assertion; he will not succeed in asking a question that can be answered, if he has asked a question; he will not succeed in issuing an order that can be obeyed, if he has issued an order. If one states that Smith's murderer is insane, when Smith has no murderer, and uses the definite description nonreferentially, then one fails to say anything *true*. If one issues the order 'Bring me Smith's murderer' under similar circumstances, the order cannot be obeyed; nothing would count as obeying it.

When the definite description is used referentially, on the other hand, the presupposition or implication stems simply from the fact that normally a person tries to describe correctly what he wants to refer to because normally this is the best way to get his audience to recognize what he is referring to. As we have seen, it is possible for the linguistic purpose of the speech act to be accomplished in such a case even though nothing fits the description; it is possible to say something true or to ask a question that gets answered or to issue a command that gets obeyed. For when the definite description is used referentially, one's audience may succeed in seeing to what one refers even though neither it nor anything else fits the description.

VI

The result of the last section shows something to be wrong with the theories of both Russell and Strawson; for though they give different accounts of the implication or presupposition involved, each gives only one. Yet, as I have argued, the presupposition or implication is present

for a quite different reason, depending upon whether the definite description is used attributively or referentially, and exactly what presuppositions or implications are involved is also different. Moreover, neither theory seems a correct characterization of the referential use. On Russell's there is a logical entailment: 'The ϕ is ψ' entails 'There exists one and only one ϕ'. Whether or not this is so for the attributive use, it does not seem true of the referential use of the definite description. The 'implication' that something is the ϕ, as I have argued, does not amount to an entailment; it is more like a presumption based on what is *usually* true of the use of a definite description to refer. In any case, of course, Russell's theory does not show – what is true of the referential use – that the implication that *something* is the ϕ comes from the more specific implication that *what is being referred to* is the ϕ. Hence, as a theory of definite descriptions, Russell's view seems to apply, if at all, to the attributive use only.

Russell's definition of denoting (a definite description denotes an entity if that entity fits the description uniquely) is clearly applicable to either use of definite descriptions. Thus whether or not a definite description is used referentially or attributively, it may have a denotation. Hence, denoting and referring, as I have explicated the latter notion, are distinct and Russell's view recognizes only the former. It seems to me, moreover, that this is a welcome result, that denoting and referring should not be confused. If one tried to maintain that they are the same notion, one result would be that a speaker might be referring to something without knowing it. If someone said, for example, in 1960 before he had any idea that Mr Goldwater would be the Republican nominee in 1964. 'The Republican candidate for president in 1964 will be a conservative,' (perhaps on the basis of an analysis of the views of party leaders) the definite description here would *denote* Mr Goldwater. But would we wish to say that the speaker had referred to, mentioned, or talked about Mr Goldwater? I feel these terms would be out of place. Yet if we identify referring and denoting, it ought to be possible for it to turn out (after the Republican Convention) that the speaker had, unknown to himself, referred in 1960 to Mr Goldwater. On my view, however, while the definite description used did *denote* Mr Goldwater (using Russell's definition), the speaker used it *attributively* and did not *refer* to Mr Goldwater.

Turning to Strawson's theory, it was supposed to demonstrate how definite descriptions are referential. But it goes too far in this direction. For there are nonreferential uses of definite descriptions also, even as they occur in one and the same sentence. I believe that Strawson's theory involves the following propositions:

(1) If someone asserts that the ϕ is ψ he has not made a true or false statement if there is no ϕ.[10]

(2) If there is no ϕ then the speaker has failed to refer to anything.[11]

(3) The reason he has said nothing true or false is that he has failed to refer.

Each of these propositions is either false or, at best, applies to only one of the two uses of definite descriptions.

Proposition (1) is possibly true of the attributive use. In the example in which 'Smith's murderer is insane' was said when Smith's body was first discovered, an attributive use of the definite description, there was no person to whom the speaker referred. If Smith had no murderer, nothing true was said. It is quite tempting to conclude, following Strawson, that nothing true *or* false was said. But where the definite description is used referentially, something true may well have been said. It is possible that something true was said of the person or thing referred to.[12]

Proposition (2) is, as we have seen, simply false. Where a definite description is used referentially it is perfectly possible to refer to something though nothing fits the description used.

The situation with proposition (3) is a bit more complicated. It ties together, on Strawson's view, the two strands given in (1) and (2). As an account of why, when the presupposition is false, nothing true or false has been stated, it clearly cannot work for the attributive use of definite descriptions, for the reason it supplies is that reference has failed. It does not then give the reason why, if indeed this is so, a speaker using a definite description attributively fails to say anything true or false if nothing fits the description. It does, however, raise a question about the referential use. Can reference fail when a definite description is used referentially?

I do not fail to refer merely because my audience does not correctly pick out what I am referring to. I can be referring to a particular man when I use the description 'the man drinking a martini', even though the people to whom I speak fail to pick out the right person or any person at all. Nor, as we have stressed, do I fail to refer when nothing fits the description. But perhaps I fail to refer in some extreme circumstances, when there is nothing that *I* am willing to pick out as that to which I referred.

Suppose that I think I see at some distance a man walking and ask, 'Is the man carrying a walking stick the professor of history?' We should perhaps distinguish four cases at this point. (a) There is a man carrying a walking stick; I have then referred to a person and asked a question about him that can be answered if my audience has the information.

(b) The man over there is not carrying a walking stick, but an umbrella; I have still referred to someone and asked a question that can be answered, though if my audience sees that it is an umbrella and not a walking stick, they may also correct my apparently mistaken impression. (c) It is not a man at all, but a rock that looks like one; in this case, I think I still have referred to something, to the thing over there that happens to be a rock but that I took to be a man. But in this case it is not clear that my question can be answered correctly. This, I think, is not because I have failed to refer, but rather because, given the true nature of what I referred to, my question is not appropriate. A simple 'No, that is not the professor of history' is at least a bit misleading if said by someone who realizes that I mistook a rock for a person. It may, therefore, be plausible to conclude that in such a case I have not asked a question to which there is a straightforwardly correct answer. But if this is true, it is not because nothing fits the description I used, but rather because what I referred to is a rock and my question has no correct answer when asked of a rock. (d) There is finally the case in which there is nothing at all where I thought there was a man with a walking stick; and perhaps here we have a genuine failure to refer at all, even though the description was used for the purpose of referring. There is no rock, nor anything else, to which I meant to refer; it was, perhaps, a trick of light that made me think there was a man there. I cannot say anything, 'That is what I was referring to, though I now see that it's not a man carrying a walking stick.' This failure of reference, however, requires circumstances much more radical than the mere nonexistence of anything fitting the description used. It requires that there be nothing of which it can be said, 'That is what he was referring to.' Now perhaps also in such cases, if the speaker has asserted something, he fails to state anything true or false if there is nothing that can be identified as that to which he referred. But if so, the failure of reference and truth value does not come about merely because nothing fits the description used. So (3) may be true of some cases of the referential use of definite descriptions; it may be true that a failure of reference results in a lack of truth value. But these cases are of a much more extreme sort than Strawson's theory implies.

I conclude, then, that neither Russell's nor Strawson's theory represents a correct account of the use of definite descriptions – Russell's because it ignores altogether the referential use, Strawson's because it fails to make the distinction between the referential and the attributive and mixes together truths about each (together with some things that are false).

VII

It does not seem possible to say categorically of a definite description in a particular sentence that it is a referring expression (of course, one could say this if he meant that it *might* be used to refer). In general, whether or not a definite description is used referentially or attributively is a function of the speaker's intentions in a particular case. 'The murderer of Smith' may be used either way in the sentence 'The murderer of Smith is insane'. It does not appear plausible to account for this, either, as an ambiguity in the sentence. The grammatical structure of the sentence seems to me to be the same whether the description is used referentially or attributively: that is, it is not syntactically ambiguous. Nor does it seem at all attractive to suppose an ambiguity in the meaning of the words; it does not appear to be semantically ambiguous. (Perhaps we could say that the sentence is pragmatically ambiguous: the distinction between roles that the description plays is a function of the speaker's intentions.) These, of course, are intuitions; I do not have an argument for these conclusions. Nevertheless, the burden of proof is surely on the other side.

This, I think, means that the view, for example, that sentences can be divided up into predicates, logical operators, and referring expressions is not generally true. In the case of definite descriptions one cannot always assign the referential function in isolation from a particular occasion on which it is used.

There may be sentences in which a definite description can be used only attributively or only referentially. A sentence in which it seems that the definite description could be used only attributively would be: 'Point out the man who is drinking my martini'; I am not so certain that any can be found in which the definite description can be used only referentially. Even if there are such sentences, it does not spoil the point that there are many sentences, apparently not ambiguous either syntactically or semantically, containing definite descriptions that can be used either way.

If it could be shown that the dual use of definite descriptions can be accounted for by the presence of am ambiguity, there is still a point to be made against the theories of Strawson and Russell. For neither, so far as I can see, has anything to say about the possibility of such an ambiguity and, in fact, neither seems compatible with such a possibility. Russell's does not recognize the possibility of the referring use, and Strawson's, as I have tried to show in the last section, combines elements from each use into one unitary account. Thus the view that there is an ambiguity in such sentences does not seem any more attractive to these positions.

VIII

Using a definite description referentially, a speaker may say something true even though the description correctly applies to nothing. The sense in which he may say something true is the sense in which he may say something true about someone or something. This sense is, I think, an interesting one that needs investigation. Isolating it is one of the by-products of the distinction between the attributive and referential uses of definite descriptions.

For one thing, it raises questions about the notion of a statement. This is brought out by considering a passage in a paper by Leonard Linsky in which he rightly makes the point that one can refer to someone although the definite description used does not correctly describe the person:

> ... said of a spinster that 'Her husband is kind to her' is neither true nor false. But a speaker might very well be referring to someone using these words, for he may think that someone is the husband of the lady (who in fact is a spinster). Still, the statement is neither true nor false, for it pre-supposes that the lady has a husband, which she has not. This last refutes Strawson's thesis that if the presupposition of existence is not satisfied, the speaker has failed to refer.[13]

There is much that is right in this passage. But because Linsky does not make the distinction between the referential and the attributive uses of definite descriptions, it does not represent a wholly adequate account of the situation. A perhaps minor point about this passage is that Linsky apparently thinks it sufficient to establish that the speaker in his example is referring to someone by using the definite description 'her husband', that he *believes* that someone is her husband. This will only approximate the truth provided that the 'someone' in the description of the belief means 'someone in particular' and is not merely the existential quantifier, 'there is someone or other'. For in both the attributive and the referential use the belief that someone *or other* is the husband of the lady is very likely to be present. If, for example, the speaker has just met the lady and, noticing her cheerfulness and radiant good health, makes his remark from his conviction that these attributes are always the result of having good husbands, he would be using the definite description attributively. Since she has no husband, there is no one to pick out as the person to whom he was referring. Nevertheless, the speaker believed that *someone or other* was her husband. On the other hand, if the use of 'her husband' was simply a way of referring to a man the speaker has just met whom he assumed to be the lady's husband, he would have referred to that man even though neither he nor anyone else fits the description. I think it is likely that in this passage Linsky did mean by 'someone', in his descrip-

tion of the belief, 'someone in particular'. But even then, as we have seen, we have neither a sufficient nor a necessary condition for a referential use of the definite description. A definite description can be used attributively even when the speaker believes that some particular thing or person fits the description, and it can be used referentially in the absence of this belief.

My main point, here, however, has to do with Linsky's view that because the presupposition is not satisfied, the *statement* is neither true nor false. This seems to me possibly correct *if* the definite description is thought of as being used attributively (depending upon whether we go with Strawson or Russell). But when we consider it as used referentially, this categorical assertion is no longer clearly correct. For the man the speaker referred to may indeed be kind to the spinster; the speaker may have said something true about that man. Now the difficulty is in the notion of 'the statement'. Suppose that we know that the lady is a spinster, but nevertheless know that the man referred to by the speaker is kind to her. It seems to me that we shall, on the one hand, want to hold that the speaker said something true, but be reluctant to express this by 'It is true that her husband is kind to her.'

This shows, I think, a difficulty in speaking simply about 'the statement' when definite descriptions are used referentially. For the speaker stated something, in this example, about a particular person, and his statement, we may suppose, was true. Nevertheless, we should not like to agree with his statement by using the sentence he used; we should not like to identify the true statement via the speaker's words. The reason for this is not so hard to find. If we say, in this example, 'It is true that her husband is kind to her', *we* are now using the definite description either attributively or referentially. But we should not be subscribing to what the original speaker truly said if we use the description attributively, for it was only in its function as referring to a particular person that the definite description yields the possibility of saying something true (since the lady has no husband). Our reluctance, however, to endorse the original speaker's statement by using the definite description referentially to refer to the same person stems from quite a different consideration. For if we too were laboring under the mistaken belief that this man was the lady's husband, we could agree with the original speaker, using his exact words. (Moreover, it is possible, as we have seen, deliberately to use a definite description to refer to someone we believe not to fit the description.) Hence, our reluctance to use the original speaker's words does not arise from the fact that if we did we should not succeed in stating anything true or false. It rather stems from the fact that when a definite description is used referentially there is a presumption that the

speaker believes that what he refers to fits the description. Since we, who know the lady to be a spinster, would not normally want to give the impression that we believe otherwise, we would not like to use the original speaker's way of referring to the man in question.

How then would we express agreement with the original speaker without involving ourselves in unwanted impressions about our beliefs? The answer shows another difference between the referential and attributive uses of definite descriptions and brings out an important point about genuine referring.

When a speaker says, 'The ϕ is ψ', where 'the ϕ' is used attributively, if there is no ϕ, we cannot correctly report the speaker as having said *of* this or that person or thing that it is ψ. But if the definite description is used referentially we can report the speaker as having attributed ψ to something. And *we* may refer to what the speaker referred to, using whatever description or name suits our purpose. Thus, if a speaker says, 'Her husband is kind to her', referring to the man he was just talking to, and if that man is Jones, we may report him as having said *of Jones* that he is kind to her. If Jones is also the president of the college, we may report the speaker as having said *of the president of the college* that he is kind to her. And finally, if we are talking to Jones, we may say, referring to the original speaker, 'He said of you that *you* are kind to her.' It does not matter here whether or not the woman has a husband or whether, if she does, Jones is her husband. If the original speaker referred to Jones, he said of him that he is kind to her. Thus where the definite description is used referentially, but does not fit what was referred to, we can report what a speaker said and agree with him by using a description or name which does fit. In doing so we need not, it is important to note, choose a description or name which the original speaker would agree fits what he was referring to. That is, we can report the speaker in the above case to have said truly of Jones that he is kind to her even if the original speaker did not know that the man he was referring to is named Jones or even if he thinks he is not named Jones.

Returning to what Linsky said in the passage quoted, he claimed that, were someone to say 'Her husband is kind to her', when she has no husband, *the statement* would be neither true nor false. As I have said, this is a likely view to hold if the definite description is being used attributively. But if it is being used referentially it is not clear what is meant by 'the statement'. If we think about what the speaker said about the person he referred to, then there is no reason to suppose he has not said something true or false about him, even though he is not the lady's husband. And Linsky's claim would be wrong. On the other hand, if we do not identify the statement in this way, what is the statement that the

speaker made? To say that the statement he made was that her husband is kind to her lands us in difficulties. For we have to decide whether in using the definite description here in the identification of the statement, we are using it attributively or referentially. If the former, then we misrepresent the linguistic performance of the speaker; if the latter, then we are ourselves referring to someone and reporting the speaker to have said something of that person, in which case we are back to the possibility that he did say something true or false of that person.

I am thus drawn to the conclusion that when a speaker uses a definite description referentially he may have stated something true or false even if nothing fits the description, and that there is not a clear sense in which he has made a statement which is neither true nor false.

IX

I want to end by a brief examination of a picture of what a genuine referring expression is that one might derive from Russell's views. I want to suggest that this picture is not so far wrong as one might suppose and that strange as this may seem, some of the things we have said about the referential use of definite descriptions are not foreign to this picture.

Genuine proper names, in Russell's sense, would refer to something without ascribing any properties to it. They would, one might say, refer to the thing itself, not simply the thing in so far as it falls under a certain description.[14] Now this would seem to Russell something a definite description could not do, for he assumed that if definite descriptions were capable of referring at all, they would refer to something only in so far as that thing satisfied the description. Not only have we seen this assumption to be false, however, but in the last section we saw something more. We saw that when a definite description is used referentially, a speaker can be reported as having said something *of* something. And in reporting what it was of which he said something we are not restricted to the description he used, or synonyms of it; we may ourselves refer to it using any descriptions, names, and so forth, that will do the job. Now this seems to give a sense in which we are concerned with the thing itself and not just the thing under a certain description, when we report the linguistic act of a speaker using a definite description referentially. That is, such a definite description comes closer to performing the function of Russell's proper names than certainly he supposed.

Secondly, Russell thought, I believe, that whenever we use descriptions, as opposed to proper names, we introduce an element of generality which ought to be absent if what we are doing is referring to some particular thing. This is clear from his analysis of sentences containing definite descriptions. One of the conclusions we are supposed to draw

from that analysis is that such sentences express what are in reality completely general propositions: there is a ϕ and only one such and any ϕ is ψ. We might put this in a slightly different way. If there is anything which might be identified as reference here, it is reference in a very weak sense – namely, reference to *whatever* is the one and only one ϕ, if there is any such. Now this is something we might well say about the attributive use of definite descriptions, as should be evident from the previous discussion. But this lack of particularity is absent from the referential use of definite descriptions precisely because the description is here merely a device for getting one's audience to pick out or think of the thing to be spoken about, a device which may serve its function even if the description is incorrect. More importantly perhaps, in the referential use as opposed to the attributive, there is a *right* thing to be picked out by the audience and its being the right thing is not simply a function of its fitting the description.

Notes and References

1. I should like to thank my colleagues, John Canfield, Sydney Shoemaker, and Timothy Smiley, who read an earlier draft and gave me helpful suggestions. I also had the benefit of the valuable and detailed comments of the referee for the paper, to whom I wish to express my gratitude.

2. 'On Denoting', reprinted in Bertrand Russell, *Logic and Knowledge*, ed. Robert C. Marsh (London: Allen & Unwin, 1956), p. 51.

3. 'On Referring', reprinted in Charles C. Caton (ed.), *Philosophy and Ordinary Language*, (Urbana: University of Illinois Press, 1963), pp. 162–3.

4. Ibid., p. 162.

5. Ibid., p. 170.

6. Here and elsewhere I use the disjunction 'presuppose or imply' to avoid taking a stand that would side me with Russell or Strawson on the issue of what the relationship involved is. To take a stand here would be beside my main point as well as being misleading, since later on I shall argue that the presupposition or implication arises in a different way depending upon the use to which the definite description is put. This last also accounts for my use of the vagueness indicator, 'in some sense'.

7. In a footnote added to the original version of 'On Referring' (op. cit., p. 181) Strawson seems to imply that where the presupposition is false, we still succeed in referring in a 'secondary' way, which seems to mean 'as we could be said to refer to fictional or make-believe things'. But his view is still that we cannot refer in such a case in the 'primary' way. This is, I believe, wrong. For a discussion of this modification of Strawson's view, see Charles C. Caton, 'Strawson on referring', *Mind*, 68 (1959), pp. 539–44.

8. This is an adaptation of an example (used for a somewhat different purpose)

given by Leonard Linsky in 'Reference and Referents', in *Philosophy and Ordinary Language*, p. 80.

9. In 'Reference and Referents' (pp. 74–5, 80), Linsky correctly points out that one does not fail to refer simply because the description used does not in fact fit anything (or fits more than one thing). Thus he pinpoints one of the difficulties in Strawson's view. Here, however, I use this fact about referring to make a distinction I believe he does not draw, between two uses of definite descriptions. I later discuss the second passage from Linsky's paper.

10. In 'A Reply to Mr Sellars', *Philosophical Review*, 63 (1954), pp. 216–31, Strawson admits that we do not always refuse to ascribe truth to what a person says when the definite description he uses fails to fit anything (or fits more than one thing). To cite one of his examples, a person who said, 'The United States Chamber of Deputies contains representatives of two major parties,' would be allowed to have said something true even though he had used the wrong title. Strawson thinks this does not constitute a genuine problem for his view. He thinks that what we do in such cases, 'where the speaker's intended reference is pretty clear, is simply to amend his statement in accordance with his guessed intentions and assess the amended statement for truth or falsity; we are not awarding a truth value at all to the original statement' (p. 230).

The notion of an 'amended statement', however, will not do. We may note, first of all, that the sort of case Strawson has in mind could arise only when a definite description is used referentially. For the 'amendment' is made by seeing the speaker's intended reference. But this could happen only if the speaker had an intended reference, a particular person or thing in mind, independent of the description he used. The cases Strawson has in mind are presumably not cases of slips of the tongue or the like; presumably they are cases in which a definite description is used because the speaker believes, though he is mistaken, that he is describing correctly what he wants to refer to. We supposedly amend the statement by knowing to what he intends to refer. But what description is to be used in the amended statement? In the example, perhaps, we could use 'the United States Congress'. But this description might be one the speaker would not even accept as correctly describing what he wants to refer to, because he is misinformed about the correct title. Hence, this is not a case of deciding what the speaker meant to say as opposed to what he in fact said, for the speaker did not mean to say 'the United States Congress'. If this is so, then there is no bar to the 'amended' statement containing any description that does correctly pick out what the speaker intended to refer to. It could be, e.g., 'The lower house of the United States Congress'. But this means that there is no one unique 'amended' statement to be assessed for truth value. And, in fact, it should now be clear that the notion of the amended statement really plays no role anyway. For if we can arrive at the amended statement only by first knowing to what the speaker intended to refer, we can assess the truth of what he said simply by deciding whether what he intended to refer to has the properties he ascribed to it.

11. As noted earlier (n. 7), Strawson may allow that one has possibly referred in a 'secondary' way, but, if I am right, the fact that there is no ϕ does not preclude one from having referred in the same way one does if there is a ϕ.

12. For a further discussion of the notion of saying something true *of* someone or something, see section VIII.

13. 'Reference and Referents', p. 80. It should be clear that I agree with Linsky in holding that a speaker may refer even though the 'presupposition of existence' is not satisfied. And I agree in thinking this an objection to Strawson's view. I think, however, that this point, among others, can be used to define two distinct uses of definite description which, in turn, yields a more general criticism of Strawson. So, while I develop here a point of difference, which grows out of the distinction I want to make, I find myself in agreement with much of Linsky's article.

14. Cf. 'The Philosophy of Logical Atomism', reprinted in Russell, *Logic and Knowledge*, p. 200.

II

SAUL KRIPKE

(1940–)

The American logician and philosopher of language Saul Kripke was born in New York but grew up in Omaha, Nebraska. He showed early signs of brilliance when, at the age of eighteen, he published 'A Completeness Theorem in Modal Logic' (1959). Kripke studied at Harvard and teaches at Princeton University. Among his most important contributions to philosophy are the development of a semantics for quantified modal logic, the discussion of Wittgenstein's private-language argument and rule-following considerations, a new approach to the ancient topic of essentialism, and the development of the causal account of reference; contributions which have had far-reaching implications for metaphysics, philosophy of mind and philosophy of science, as well as for philosophy of language.

The following extract from the first chapter of Kripke's *Naming and Necessity* (1980) is concerned with his account of reference. Kripke constructs his views in opposition to Russell's descriptivist view and Frege's theory that the sense of a term determines the reference of that term, a view that probably mistakenly, he closely aligns with Russell's theory. Contra Russell, Kripke argues that names cannot be disguised descriptions, on three grounds:

(a) There are numerous instances where a name is not associated with any uniquely identifying description or cluster of descriptions.

(b) A person may know how to use a proper name without knowing the appropriate set of descriptions associated with that name. Speakers often legitimately use proper names to refer to individuals without having the required information which would uniquely identify that individual to them.

(c) Certain names, proper names and natural kind terms in particular, act as rigid designators, in the sense that will be explained below, and are not disguised description.

Kripke distinguishes between rigid and non-rigid designators. Proper names, he argues are rigid designators, that is, expressions that refer to the same object in all possible worlds and times in which that object exists. Most descriptions are non-rigid designators because they can be satisfied by different objects in different possible worlds. It should be added that for Kripke 'possible worlds' are just the ways the world might have been, and consequently their descriptions and plausibility are largely determined by our commonsensical intuitions. Thus, to take a favourite example, Kripke argues that there could be possible worlds in which Aristotle was not the teacher of Alexander, but there cannot be a possible world in which Aristotle was not Aristotle (is such a man existed in that world).

On Kripke's account, objects, as well as persons, are given their proper names by an act of original baptism through which those given names acquire their references. These names are passed on through a causal chain from speaker to speaker; each speaker uses the term successfully if he uses it with the intention of referring to the same individual as in the previous links of this causal chain. According to Kripke, the story of names goes something like this: 'Someone, let's say a baby, is born; his parents call him by a certain name. They talk about him to their friends. Other people meet him. Through various sorts of talk the name is spread from link to link as if by a chain' (*Naming and Necessity*, p. 91). So the reason that the name 'Aristotle' for instance, picks out or refers to the person Aristotle is that there exists a long chain of causal relationships between the name and the person Aristotle.

Kripke applies the causal account of reference not just to proper names but also to common names which stand for natural kinds (kinds or types of things that occur in nature, e.g., water, tiger, lemon, gold). According to this approach, natural kind terms, like proper names, are rigid designators, and they pick out certain objects because of causal, communicative ties between the term and the object to which it refers, rather than a cluster of descriptions that may be associated with the term. Furthermore, the essential properties of each natural kind object are microstructural rather than phenomenal. For instance, gold is anything which has the atomic number 79 and not whatever looks like gold. (An analogous theory, developed independently by Hilary Putnam, will be discussed in chapter 12.)

In the course of this first chapter of *Naming and Necessity* Kripke also discusses the traditional distinction between a priori, analytic, and necessary truths. He demonstrates that philosophers have failed to take sufficient note of the differences between aprioriticity, which is an epistemological notion, pertaining to how we know things, and analyticity

which is a metaphysical issue. According to him, some necessary truths are knowable only a posteriori. The truth of the sentence 'The morning star is identical to the evening star' can be established by empirical observation only. Some contingent truths, on the other hand, can be known a priori: for example, 'The standard metre in Paris is one metre long'. There are truths about our empirical world having to do with natural kinds that should be seen as necessary but a posteriori. The sentence 'Water is H_2O' is true across all possible worlds because 'water' and 'H_2O' are rigid designators; it expresses an identity relation that is necessarily true but knowable only a posteriori through scientific discoveries.

Kripke's views on natural kinds, rigid designators and reference also led him to adopt an essentialist metaphysical framework. He argues that it is essential to an object to have the particular origin that it does and this is true of both natural kind objects and artefacts: Aristotle would not have been Aristotle if he had not had his exact genetic and physical origins.

Kripke's work has been greatly influential, not only in opening new avenues of thought and research in philosophy of language but also in setting the agenda for debates on metaphysical issues, a branch of philosophy which was pronounced to be defunct in the 1930s by the logical positivists.

Also of great importance is his discussion of Wittgenstein's private-language argument. Kripke's interpretation of Wittgenstein, known as the 'Kripkenstein argument', emphasizes the publicity of linguistic rules and hence precludes the possibility of there being a Cartesian private language used by a single individual only. It also highlights the normative elements involved in applying the rules of linguistic usage.

Works by Kripke

1959 'A Completeness Theorem in Modal Logic', *Journal of Symbolic Logic*, 24, pp. 1–14.
1971 'Identity and Necessity', in M. K. Munitz (ed.), *Identity and Individuation*. New York: New York University Press.
1975 'Outline of a Theory of Truth', *Journal of Philosophy*, 72, pp. 690–716.
1977 'Speaker's Reference and Semantic Reference', in Peter A. French, T. E. Uehling and H. K. Wettstein (eds), *Studies in Semantics*. Minneapolis: University of Minnesota Press.
1980 *Naming and Necessity* (rev. and enl. edn). Oxford : Blackwell; Cambridge, MA: Harvard University Press.
1982 *Wittgenstein on Rules and Private Language*. Oxford: Blackwell.

Works on Kripke

Devitt, Michael and Sterelny, Kim, *Language and Reality*. Oxford: Blackwell,
 1987.
Forbes, Graeme, *The Metaphysics of Modality*. Oxford: Clarendon Press, 1985.
McCulloch, G., *The Game of the Name*, Oxford: Clarendon Press, 1989.
Salmon, Nathan, *Reference and Essence*. Oxford: Blackwell, 1982; Princeton:
 Princeton University Press, 1975.
Schwartz, Stephen P. (ed.), *Naming, Necessity, and Natural Kinds*. Ithaca,
 NY/London: Cornell University Press, 1977.

Naming and Necessity
from Lecture I

Many people have said that the theory of Frege and Russell is false, but, in my opinion, they have abandoned its letter while retaining its spirit, namely, they have used the notion of a cluster concept. Well, what is this? The obvious problem for Frege and Russell, the one which comes immediately to mind, is already mentioned by Frege himself. He said,

> In the case of genuinely proper names like 'Aristotle' opinions as regards their sense may diverge. As such may, e.g., be suggested: Plato's disciple and the teacher of Alexander the Great. Whoever accepts this sense will interpret the meaning of the statement 'Aristotle was born in Stagira', differently from one who interpreted the sense of 'Aristotle' as the Stagirite teacher of Alexander the Great. As long as the nominatum remains the same, these fluctuations in sense are tolerable. But they should be avoided in the system of a demonstrative science and should not appear in a perfect language.[1]

So, according to Frege, there is some sort of looseness or weakness in our language. Some people may give one sense to the name 'Aristotle', others may give another. But of course it is not only that; even a single speaker when asked 'What description are you willing to substitute for the name?' may be quite at a loss. In fact, he may know many things about him; but any particular thing that he knows he may feel clearly expresses a contingent property of the object. If 'Aristotle' meant *the man who taught Alexander the Great*, then saying 'Aristotle was a teacher of Alexander the Great' would be a mere tautology. But surely it isn't; it expresses the fact that Aristotle taught Alexander the Great, something we could discover to be false. So, *being the teacher of Alexander the Great* cannot be part of [the sense of] the name.

The most common way out of this difficulty is to say 'really it is not a weakness in ordinary language that we can't substitute a *particular* description for the name; that's all right. What we really associate with the name is a *family* of descriptions.' A good example of this is (if I

can find it) in *Philosophical Investigations*, where the idea of family resemblances is introduced and with great power.

> Consider this example. If one says 'Moses did not exist', this may mean various things. It may mean: the Israelites did not have a *single* leader when they withdrew from Egypt – or: their leader was not called Moses – or: there cannot have been anyone who accomplished all that the Bible relates of Moses – … But when I make a statement about Moses, – am I always ready to substitute some *one* of those descriptions for 'Moses'? I shall perhaps say: by 'Moses' I understand the man who did what the Bible relates of Moses, or at any rate, a good deal of it. But how much? Have I decided how much must be proved false for me to give up my proposition as false? Has the name 'Moses' got a fixed and unequivocal use for me in all possible cases?[2]

According to this view, and a *locus classicus* of it is Searle's article on proper names,[3] the referent of a name is determined not by a single description but by some cluster or family. Whatever in some sense satisfies enough or most of the family is the referent of the name. I shall return to this view later. It may seem, as an analysis of ordinary language, quite a bit more plausible than that of Frege and Russell. It may seem to keep all the virtues and remove the defects of this theory.

Let me say (and this will introduce us to another new topic before I really consider this theory of naming) that there are two ways in which the cluster concept theory, or even the theory which requires a single description, can be viewed. One way of regarding it says that the cluster or the single description actually gives the meaning of the name; and when someone says 'Walter Scott', he means *the man such that such and such and such and such*.

Now another view might be that even though the description in some sense doesn't give the *meaning* of the name, it is what *determines its reference* and although the phrase 'Walter Scott' isn't *synonymous* with 'the man such that such and such and such and such', or even maybe with the family (if something can be synonymous with a family), the family or the single description is what is used to determine to whom someone is referring when he says 'Walter Scott'. Of course, if when we hear his beliefs about Walter Scott we find that they are actually much more nearly true of Salvador Dali, then according to this theory the reference of this name is going to be Mr Dali, not Scott. There are writers, I think, who explicitly deny that names have meaning at all even more strongly than I would but still use this picture of how the referent of the name gets determined. A good case in point is Paul Ziff, who says, very emphatically, that names don't have meaning at all, [that] they are

not a part of language in some sense. But still, when he talks about how we determine what the reference of the name was, then he gives this picture. Unfortunately I don't have the passage in question with me, but this is what he says.[4]

The difference between using this theory as a theory of meaning and using it as a theory of reference will come out a little more clearly later on. But some of the attractiveness of the theory is lost if it isn't supposed to give the meaning of the name; for some of the solutions of problems that I've just mentioned will not be right, or at least won't clearly be right, if the description doesn't give the meaning of the name. For example, if someone said 'Aristotle does not exist' *means* 'there is no man doing such and such', or in the example from Wittgenstein, 'Moses does not exist', *means* 'no man did such and such', that might depend (and in fact, I think, does depend) on taking the theory in question as a theory of the meaning of the name 'Moses', not just as a theory of its reference. Well, I don't know. Perhaps all that is immediate now is the other way around: if 'Moses' means the same as 'the man who did such-and-such' then to say that Moses did not exist is to say that the man who did such-and-such did not exist, that is, that no one person did such-and-such. If, on the other hand, 'Moses' is not synonymous with any description, then even if its reference is in some sense determined by a description, statements containing the name cannot in general be *analyzed* by replacing the name by a description, though they may be materially equivalent to statements containing a description. So the analysis of singular existence statements mentioned above will have to be given up, unless it is established by some special argument, independent of a general theory of the meaning of names; and the same applies to identity statements. In any case, I think it's false that 'Moses exists' means that at all. So we won't have to see if such a special argument can be drawn up.[5]

Before I go any further into this problem, I want to talk about another distinction which will be important in the methodology of these talks. Philosophers have talked (and, of course, there has been considerable controversy in recent years over the meaningfulness of these notions) [about] various categories of truth, which are called '*a priori*', 'analytic', 'necessary' – and sometimes even 'certain' is thrown into this batch. The terms are often used as if *whether* there are things answering to those concepts is an interesting question, but we might as well regard them all as meaning the same thing. Now, everyone remembers Kant (a bit) as making a distinction between '*a priori*' and 'analytic'. So maybe this distinction is still made. In contemporary discussion very few people, if any, distinguish between the concepts of statements being *a priori* and

their being necessary. At any rate I shall *not* use the terms '*a priori*' and 'necessary' interchangeably here.

Consider what the traditional characterizations of such terms as '*a priori*' and 'necessary' are. First the notion of a prioricity is a concept of epistemology. I guess the traditional characterization from Kant goes something like: *a priori* truths are those which can be known independently of any experience. This introduces another problem before we get off the ground, because there's another modality in the characterization of '*a priori*', namely, it is supposed to be something which *can* be known independently of any experience. That means that in some sense it's *possible* (whether we do or do not in fact know it independently of any experience) to know this independently of any experience. And possible for whom? For God? For the Martians? Or just for people with minds like ours? To make this all clear might [involve] a host of problems all of its own about what sort of possibility is in question here. It might be best therefore, instead of using the phrase '*a priori* truth', to the extent that one uses it at all, to stick to the question of whether a particular person or knower knows something *a priori* or believes it true on the basis of *a priori* evidence.

I won't go too much further into the problems that might arise with the notion of a prioricity here. I will say that some philosophers somehow change the modality in this characterization from *can* to *must*. They think that if something belongs to the realm of *a priori* knowledge, it couldn't possibly be known empirically. This is just a mistake. Something may belong in the realm of such statements that *can* be known *a priori* but still may be known by particular people on the basis of experience. To give a really common-sense example: anyone who has worked with a computing machine knows that the computing machine may give an answer to whether such-and-such a number is prime. No one has calculated or proved that the number is prime; but the machine has given the answer: this number is prime. We, then, if we believe that the number is prime, believe it on the basis of our knowledge of the laws of physics, the construction of the machine, and so on. We therefore do not believe this on the basis of purely *a priori* evidence. We believe it (if anything is *a posteriori* at all) on the basis of *a posteriori* evidence. Nevertheless, maybe this could be known *a priori* by someone who made the requisite calculations. So '*can* be known *a priori*' doesn't mean '*must* be known *a priori*'.

The second concept which is in question is that of necessity. Sometimes this is used in an epistemological way and might then just mean *a priori*. And of course, sometimes it is used in a physical way when people distinguish between physical and logical necessity. But what I am con-

cerned with here is a notion which is not a notion of epistemology but of metaphysics, in some (I hope) nonpejorative sense. We ask whether something might have been true, or might have been false. Well, if something is false, it's obviously not necessarily true. If it is true, might it have been otherwise? Is it possible that, in this respect, the world should have been different from the way it is? If the answer is 'no', then this fact about the world is a necessary one. If the answer is 'yes', then this fact about the world is a contingent one. This in and of itself has nothing to do with anyone's knowledge of anything. It's certainly a philosophical thesis, and not a matter of obvious definitional equivalence, either that everything *a priori* is necessary or that everything necessary is *a priori*. Both concepts may be vague. That may be another problem. But at any rate they are dealing with two different domains, two different areas, the epistemological and metaphysical. Consider, say, Fermat's last theorem – or the Goldbach conjecture. The Goldbach conjecture says that an even number greater than 2 must be the sum of two prime numbers. If this is true, it is presumably necessary, and, if it is false, presumably necessarily false. We are taking the classical view of mathematics here and assume that in mathematical reality it is either true or false.

If the Goldbach conjecture is false, then there is an even number, n, greater than 2, such that for no primes p_1 and p_2, both $< n$, $= p_1 + p_2$. This fact about n, if true, is verifiable by direct computation, and thus is necessary if the results of arithmetical computations are necessary. On the other hand, if the conjecture is true, then every even number exceeding 2 is the sum of two primes. Could it then be the case that, although in fact every such even number is the sum of two primes, there might have been such an even number which was not the sum of two primes? What would that mean? Such a number would have to be one of 4, 6, 8, 10 ...; and, by hypothesis, since we are assuming Goldbach's conjecture to be true, each of these can be shown, again by direct computation, to be the sum of two primes. Goldbach's conjecture, then, cannot be contingently true or false; whatever truth value it has belongs to it by necessity.

But what we can say, of course, is that right now, as far as we know, the question can come out either way. So, in the absence of a mathematical proof deciding this question, none of us has any *a priori* knowledge about this question in either direction. We don't know whether Goldbach's conjecture is true or false. So right now we certainly don't know anything *a priori* about it.

Perhaps it will be alleged that we *can* in principle know *a priori* whether it is true. Well, maybe we can. Of course an infinite mind which

can search through all the numbers can or could. But I don't know whether a finite mind can or could. Maybe there just is no mathematical proof whatsoever which decides the conjecture. At any rate this might or might not be the case. Maybe there is a mathematical proof deciding this question; maybe every mathematical question is decidable by an intuitive proof or disproof. Hilbert thought so; others have thought not; still others have thought the question unintelligible unless the notion of intuitive proof is replaced by that of formal proof in a single system. Certainly no one formal system decides all mathematical questions, as we know from Gödel. At any rate, and this is the important thing, the question is not trivial; even though someone said that it's necessary, if true at all, that every even number is the sum of two primes, it doesn't follow that anyone knows anything *a priori* about it. It doesn't even seem to me to follow without some further philosophical argument (it is an interesting philosophical question) that anyone *could* know anything *a priori* about it. The 'could', as I said, involves some other modality. We mean that even if no one, perhaps even in the future, knows or will know *a priori* whether Goldbach's conjecture is right, in principle there is a way, which *could* have been used, of answering the question *a priori*. This assertion is not trivial.

The terms 'necessary' and '*a priori*', then, as applied to statements, are *not* obvious synonyms. There may be a philosophical argument connecting them, perhaps even identifying them; but an argument is required, not simply the observation that the two terms are clearly interchangeable. (I will argue below that in fact they are not even coextensive – that necessary *a priori* truths, and probably contingent *a priori* truths, both exist.)

I think people have thought that these two things must mean the same for these reasons:

First, if something not only happens to be true in the actual world but is also true in all possible worlds, then, of course, just by running through all the possible worlds in our heads, we ought to be able with enough effort to see, if a statement is necessary, that it is necessary, and thus know it *a priori*. But really this is not so obviously feasible at all.

Second, I guess it's thought that, conversely, if something is known *a priori* it must be necessary, because it was known without looking at the world. If it depended on some contingent feature of the actual world, how could you know it without looking? Maybe the actual world is one of the possible worlds in which it would have been false. This depends on the thesis that there can't be a way of knowing about the actual world without looking that wouldn't be a way of knowing the same thing about every possible world. This involves problems of epistemology and

the nature of knowledge; and of course it is very vague as stated. But it is not really *trivial* either. More important than any particular example of something which is alleged to be necessary and not *a priori* or *a priori* and not necessary, is to see that the notions are different, that it's not trivial to argue on the basis of something's being something which maybe we can only know *a posteriori*, that it's not a necessary truth. It's not trivial, just because something is known in some sense *a priori*, that what is known is a necessary truth.

Another term used in philosophy is 'analytic'. Here it won't be too important to get any clearer about this in this talk. The common examples of analytic statements, nowadays, are like 'Bachelors are unmarried'. Kant (someone just pointed out to me) gives as an example 'Gold is a yellow metal', which seems to me an extraordinary one, because it's something I think that can turn out to be false. At any rate, let's just make it a matter of stipulation that an analytic statement is, in some sense, true by virtue of its meaning and true in all possible worlds by virtue of its meaning. Then something which is analytically true will be both necessary and *a priori*. (That's sort of stipulative.)

Another category I mentioned was that of certainty. Whatever certainty is, it's clearly not obviously the case that everything which is necessary is certain. Certainty is another epistemological notion. Something can be known, or at least rationally believed, *a priori*, without being quite certain. You've read a proof in the math book; and, though you think it's correct, maybe you've made a mistake. You often do make mistakes of this kind. You've made a computation, perhaps with an error.

There is one more question I want to go into in a preliminary way. Some philosophers have distinguished between essentialism, the belief in modality *de re*, and a mere advocacy of necessity, the belief in modality *de dicto*. Now, some people say: Let's *give* you the concept of necessity.[6] A much worse thing, something creating great additional problems, is whether we can say of any particular that it has necessary or contingent properties, even make the distinction between necessary and contingent properties. Look, it's only a *statement* or a *state of affairs* that can be either necessary or contingent! Whether a *particular* necessarily or contingently has a certain property depends on the way it's described. This is perhaps closely related to the view that the way we refer to particular things is by a description. What is Quine's famous example? If we consider the number 9, does it have the property of necessary oddness? Has that number got to be odd in all possible worlds? Certainly it's true in all possible worlds, let's say, it couldn't have been otherwise, that *nine* is odd. Of course, 9 could also be equally well picked out as *the number of planets*. It is *not* necessary, not true in all possible worlds,

that the number of planets is odd. For example if there had been eight planets, the number of planets would not have been odd. And so it's thought: Was it necessary or contingent that Nixon won the election? (It might seem contingent, unless one has some view of some inexorable processes ...) But this is a contingent property of Nixon only relative to our referring to him as 'Nixon' (assuming 'Nixon' doesn't mean 'the man who won the election at such and such a time'). But if we designate Nixon as 'the man who won the election in 1968', then it will be a necessary truth, of course, that the man who won the election in 1968, won the election in 1968. Similarly, whether an object has the same property in all possible worlds depends not just on the object itself, but on how it is described. So it's argued.

It is even suggested in the literature, that though a notion of necessity may have some sort of intuition behind it (we do think some things could have been otherwise; other things we don't think could have been otherwise), this notion [of a distinction between necessary and contingent properties] is just a doctrine made up by some bad philosopher, who (I guess) didn't realize that there are several ways of referring to the same thing. I don't know if some philosophers have not realized this; but at any rate it is very far from being true that this idea [that a property can meaningfully be held to be essential or accidental to an object independently of its description] is a notion which has no intuitive content, which means nothing to the ordinary man. Suppose that someone said, pointing to Nixon, 'That's the guy who might have lost.' Someone else says, 'Oh no, if you describe him as "Nixon", then he might have lost; but, of course, describing him as the winner, then it is not true that he might have lost.' Now which one is being the philosopher, here, the unintuitive man? It seems to me obviously to be the second. The second man has a philosophical theory. The first man would say, and with great conviction, 'Well, of course, the winner of the election *might have been someone else.* The actual winner, had the course of the campaign been different, might have been the loser, and someone else the winner; or there might have been no election at all. So, such terms as "the winner" and "the loser" don't designate the same objects in all possible worlds. On the other hand, the term "Nixon" is just a *name of this man.*' When you ask whether it is necessary or contingent that *Nixon* won the election, you are asking the intuitive question whether in some counterfactual situation, *this man* would in fact have lost the election. If someone thinks that the notion of a necessary or contingent property (forget whether there *are* any nontrivial necessary properties [and consider] just the *meaningfulness* of the notion[7]) is a philosopher's notion with no intuitive content, he is wrong. Of course, some philosophers

think that something's having intuitive content is very inconclusive evidence in favor of it. I think it is very heavy evidence in favor of anything, myself. I really don't know, in a way, what more conclusive evidence one can have about anything, ultimately speaking. But, in any event, people who think the notion of accidental property unintuitive have intuition reversed, I think.

Why have they thought this? While there are many motivations for people thinking this, one is this: The question of essential properties so-called is supposed to be equivalent (and it is equivalent) to the question of 'identity across possible worlds'. Suppose we have someone, Nixon, and there's another possible world where there is no one with all the properties Nixon has in the actual world. Which one of these other people, if any, is Nixon? Surely you must give some criterion of identity here! If you have a criterion of identity, then you just look in the other possible worlds at the man who is Nixon; and the question whether, in that other possible world, Nixon has certain properties, is well defined. It is also supposed to be well defined, in terms of such notions, whether it's true in all possible worlds, or there are some possible words in which Nixon didn't win the election. But, it's said, the problems of giving such criteria of identity are very difficult. Sometimes in the case of numbers it might seem easier (but even here it's argued that it's quite arbitrary). For example, one might say, and this is surely the truth, that if position in the series of numbers is what makes the number 9 what it is, then if (in another world) the number of planets had been 8, the number of planets would be a different number from the one it actually is. You wouldn't say that that number then is to be identified with our number 9 in this world. In the case of other types of objects, say people, material objects, things like that, has anyone given a set of necessary and sufficient conditions for identity across possible worlds?

Really, adequate necessary and sufficient conditions for identity which do not beg the question are very rare in any case. Mathematics is the only case I really know of where they are given even *within* a possible world, to tell the truth. I don't know of such conditions for identity of material objects over time, or for people. Everyone knows what a problem this is. But, let's forget about that. What seems to be more objectionable is that this depends on the wrong way of looking at what a possible world is. One thinks, in this picture, of a possible world as if it were like a foreign country. One looks upon it as an observer. Maybe Nixon has moved to the other country and maybe he hasn't, but one is given only qualities. One can observe all his qualities, but, of course, one doesn't observe that someone is Nixon. One observes that something has red hair (or green or yellow) but not whether something is Nixon.

So we had better have a way of telling in terms of properties when we run into the same thing as we saw before; we had better have a way of telling, when we come across one of these other possible worlds, who was Nixon.

Some logicians in their formal treatment of modal logic may encourage this picture. A prominent example, perhaps, is myself. Nevertheless, intuitively speaking, it seems to me not to be the right way of thinking about the possible worlds. A possible world isn't a distant country that we are coming across, or viewing through a telescope. Generally speaking, another possible world is too far away. Even if we travel faster than light, we won't get to it. A possible world is *given by the descriptive conditions we associate with it*. What do we mean when we say 'In some other possible world I would not have given this lecture today?' We just imagine the situation where I didn't decide to give this lecture or decided to give it on some other day. Of course, we don't imagine everything that is true or false, but only those things relevant to my giving the lecture; but, in theory, everything needs to be decided to make a total description of the world. We can't really imagine that except in part; that, then, is a 'possible world'. Why can't it be part of the *description* of a possible world that it contains *Nixon* and that in that world *Nixon* didn't win the election? It might be a question, of course, whether such a world *is* possible. (Here it would seem, *prima facie*, to be clearly possible.) But, once we see that such a situation is possible, then we are given that the man who might have lost the election or did lose the election in this possible world is Nixon, because that's part of the description of the world. 'Possible worlds' are *stipulated*, not *discovered* by powerful telescopes. There is no reason why we cannot *stipulate* that, in talking about what would have happened to Nixon in a certain counterfactual situation, we are talking about what would have happened to *him*.

Of course, if someone makes the demand that every possible world has to be described in a purely qualitative way, we can't say, 'Suppose Nixon had lost the election', we must say, instead, something like, 'Suppose a man with a dog named Checkers, who looks like a certain David Frye impersonation, is in a certain possible world and loses the election.' Well, does he resemble Nixon enough to be identified with Nixon? A very explicit and blatant example of this way of looking at things is David Lewis's counterpart theory,[8] but the literature on quantified modality is replete with it.[9] Why need we make this demand? That is not the way we ordinarily think of counterfactual situations. We just say 'suppose this man had lost'. It is *given* that the possible world contains *this man*, and that in that world, he had lost. There may be a problem about what intuitions about possibility come to. But, if we have

such an intuition about the possibility of *that* (*this man's* electoral loss), then it is about the possibility of *that*. It need not be identified with the possibility of a man looking like such-and-such, or holding such-and-such political views, or otherwise qualitatively described, having lost. We can point to the *man*, and ask what might have happened to *him*, had events been different.

It might be said, 'Let's suppose that this is true. It comes down to the same thing, because whether Nixon could have had certain properties, different from the ones he actually has, is equivalent to the question whether the criteria of identity across possible worlds include that Nixon does not have these properties.' But it doesn't really come to the same thing, because the usual notion of a criterion of transworld identity demands that we give purely qualitative necessary and sufficient conditions for someone being Nixon. If we can't imagine a possible world in which Nixon doesn't have a certain property, then it's a necessary condition of someone being Nixon. Or a necessary property of Nixon that he [has] that property. For example, supposing Nixon is in fact a human being, it would seem that we cannot think of a possible counterfactual situation in which he was, say, an inanimate object; perhaps it is not even possible for him not to have been a human being. Then it will be a necessary fact about Nixon that in all possible worlds where he exists at all, he is human or anyway he is not an inanimate object. This has nothing to do with any requirement that there be purely qualitative *sufficient* conditions for Nixonhood which we can spell out. And should there be? Maybe there is some argument that there should be, but we can consider these questions about *necessary* conditions without going into any question about *sufficient* conditions. Further, even if there were a purely qualitative set of necessary and sufficient conditions for being Nixon, the view I advocate would not demand that we find these conditions *before* we can ask whether Nixon might have won the election, nor does it demand that we restate the question in terms of such conditions. We can simply consider *Nixon* and ask what might have happened to *him* had various circumstances been different. So the two views, the two ways of looking at things, do seem to me to make a difference.

Notice this question, whether Nixon could not have been a human being, is a clear case where the question asked is not epistemological. Suppose Nixon actually turned out to be an automaton. That might happen. We might need evidence whether Nixon is a human being or an automaton. But that is a question about our knowledge. The question of whether Nixon might have not been a human being, given that he is one, is not a question about knowledge, *a posteriori* or *a priori*. It's a

question about, even though such-and-such things are the case, what might have been the case otherwise.

This table is composed of molecules. Might it not have been composed of molecules? Certainly it was a scientific discovery of great moment that it was composed of molecules (or atoms). But could anything be this very object and not be composed of molecules? Certainly there is some feeling that the answer to that must be 'no'. At any rate, it's hard to imagine under what circumstances you would have this very object and find that it is not composed of molecules. A quite different question is whether it is in fact composed of molecules in the actual world and how we know this. (I will go into more detail about these questions about essence later on.)

I wish at this point to introduce something which I need in the methodology of discussing the theory of names that I'm talking about. We need the notion of 'identity across possible worlds' as it's usually and, as I think, somewhat misleadingly called,[10] to explicate one distinction that I want to make now. What's the difference between asking whether it's necessary that 9 is greater than 7 or whether it's necessary that the number of planets is greater than 7? Why does one show anything more about essence than the other? The answer to this might be intuitively, 'Well, look, the number of planets might have been different from what it in fact is. It doesn't make any sense though, to say that nine might have been different from what it in fact is'. Let's use some terms quasi-technically. Let's call something a *rigid designator* if in every possible world it designates the same object, a *nonrigid* or *accidental designator* if that is not the case. Of course we don't require that the objects exist in all possible worlds. Certainly Nixon might not have existed if his parents had not gotten married, in the normal course of things. When we think of a property as essential to an object we usually mean that it is true of that object in any case where it would have existed. A rigid designator of a necessary existent can be called *strongly rigid*.

One of the intuitive theses I will maintain in these talks is that *names* are rigid designators. Certainly they seem to satisfy the intuitive test mentioned above: although someone other than the US President in 1970 might have been the US President in 1970 (e.g., Humphrey might have), no one other than Nixon might have been Nixon. In the same way, a designator rigidly designates a certain object if it designates that object wherever the object exists; if, in addition, the object is a necessary existent, the designator can be called *strongly rigid*. For example, 'the President of the US in 1970' designates a certain man, Nixon; but someone else (e.g., Humphrey) might have been the President in 1970, and Nixon might not have; so this designator is not rigid.

In these lectures, I will argue, intuitively, that proper names are rigid designators, for although the man (Nixon) might not have been the President, it is not the case that he might not have been Nixon (though he might not have been *called* 'Nixon'). Those who have argued that to make sense of the notion of rigid designator, we must antecedently make sense of 'criteria of transworld identity' have precisely reversed the cart and the horse; it is *because* we can refer (rigidly) to Nixon, and stipulate that we are speaking of what might have happened to *him* (under certain circumstances), that 'transworld identifications' are unproblematic in such cases.[11]

The tendency to demand purely qualitative descriptions of counterfactual situations has many sources. One, perhaps, is the confusion of the epistemological and the metaphysical, between a prioricity and necessity. If someone identifies necessity with a prioricity, and thinks that objects are named by means of uniquely identifying properties, he may think that it is the properties used to identify the object which, being known about it *a priori*, must be used to identify it in all possible worlds, to find out which object is Nixon. As against this, I repeat: (1) Generally, things aren't 'found out' about a counterfactual situation, they are stipulated; (2) possible worlds need not be given purely qualitatively, as if we were looking at them through a telescope. And we will see shortly that the properties an object has in every counterfactual world have nothing to do with properties used to identify it in the actual world.[12]

Does the 'problem' of 'transworld identification' make any sense? Is it *simply* a pseudo-problem? The following, it seems to me, can be said for it. Although the statement that England fought Germany in 1943 perhaps cannot be *reduced* to any statement about individuals, nevertheless in some sense it is not a fact 'over and above' the collection of all facts about persons, and their behavior over history. The sense in which facts about nations are not facts 'over and above' those about persons can be expressed in the observation that a description of the world mentioning all facts about persons but omitting those about nations can be a *complete* description of the world, from which the facts about nations follow. Similarly, perhaps, facts about material objects are not facts 'over and above' facts about their constituent molecules. We may then ask, given a descriptions of a non-actualized possible situation in terms of people, whether England still exists in that situation, or whether a certain nation (described, say, as the one where Jones lives) which would exist in that situation, is England. Similarly, given certain counterfactual vicissitudes in the history of the molecules of a table, *T*, one may ask whether *T* would exist, in that situation, or whether a certain bunch of

molecules, which in that situation would constitute a table, constitute the very same table *T*. In each case, we seek criteria of identity across possible worlds for certain particulars in terms of those for other, more 'basic', particulars. If statements about nations (or tribes) are not *reducible* to those about other more 'basic' constituents, if there is some 'open texture' in the relationship between them, we can hardly expect to give hard and fast identity criteria; nevertheless, in concrete cases we may be able to answer whether a certain bunch of molecules would still constitute *T*, though in some cases the answer may be indeterminate. I think similar remarks apply to the problem of identity over time; here too we are usually concerned with determinacy, the identity of a 'complex' particular in terms of more 'basic' ones. (For example, if various parts of a table are replaced, is it the same object?)[13]

Notes and References

1. Gottlob Frege, 'On Sense and Nominatum', trans. Herbert Feigl in Herbert Feigl and Wilfrid Sellars (eds) *Readings in Philosophical Analysis*, (New York: Appleton-Century-Crofts, 1949), p. 86.

2. Ludwig Wittgenstein, *Philosophical Investigations*, trans. G. E. M. Anscombe (Oxford Blackwell, 1953), §79.

3. John R. Searle, 'Proper Names', *Mind*, 67 (1958), pp. 166–73.

4. Ziff's most detailed statement of his version of the cluster-of-descriptions theory of the reference of names is in 'About God', reprinted in *Philosophical Turnings* (Ithaca, NY: Cornell University Press,/London: Oxford University Press, 1966), pp. 94–6. A briefer statement is in his *Semantic Analysis* (Ithaca, NY: Cornell University Press, 1960), pp. 102–5 (especially pp. 103–4). The latter passage suggests that names of things with which we are acquainted should be treated somewhat differently (using ostension and baptism) from names of historical figures, where the reference is determined by (a cluster of associated descriptions. On p. 93 of *Semantic Analysis* Ziff states that 'simple strong generalization(s) about proper names' are impossible; 'one can only say what is so for the most part ...' Nevertheless Ziff clearly states that a cluster-of-descriptions theory is a reasonable such rough statement, at least for historical figures. For Ziff's view that proper names ordinarily are not words of the language and ordinarily do not have meaning, see pp. 85–9 and 93–4 of *Semantic Analysis*.

5. Those determinists who deny the importance of the individual in history may well argue that had Moses never existed, someone else would have arisen to achieve all that he did. Their claim cannot be refuted by appealing to a correct philosophical theory of the meaning of 'Moses exists'.

6. By the way, it's a common attitude in philosophy to think that one shouldn't introduce a notion until it's been rigorously defined (according to some

popular notion of rigor). Here I am just dealing with an intuitive notion and will keep on the level of an intuitive notion. That is, we think that some things, though they are in fact the case, might have been otherwise. I might not have given these lectures today. If that's right, then it is *possible* that I wouldn't have given these lectures today. Quite a different question is the epistemological question, how any particular person knows that I gave these lectures today. I suppose in that case he does know this is *a posteriori*. But, if someone were born with an innate belief that I was going to give these lectures today, who knows? Right now, anyway, let's suppose that people known this *a posteriori*. At any rate, the two questions being asked are different.

7. The example I gave assets a certain property – electoral victory – to be *accidental* to Nixon, independently of how he is described. Of course, if the notion of accidental property is meaningful, the notion of essential property must be meaningful also. This is not to say that there *are* any essential properties – though, in fact, I think there are. The usual argument questions the *meaningfulness* of essentialism, and says that whether a property is accidental or essential to an object depends on how it is described. It is thus *not* the view that all properties are accidental. Of course, it is also not the view, held by some idealists, that all properties are essential, all relations internal.

8. David K. Lewis, 'Counterpart Theory and Quantified Modal Logic', *Journal of Philosophy*, 65 (1968), pp. 113–26. Lewis's elegant paper also suffers from a purely formal difficulty: on his interpretation of quantified modality, the familiar law (y) $((x)A(x) \supset A(y))$ fails, if $A(x)$ is allowed to contain modal operators. (For example, $(\exists y)$ $((x) \Diamond (x \neq y))$ is satisfiable but $(\exists y)$ $\Diamond (y \neq y)$ is not.) Since Lewis's formal model follows rather naturally from his philosophical views on counterparts, and since the failure of universal instantiation for modal properties is intuitively bizarre, it seems to me that this failure constitutes an additional argument against the plausibility of his philosophical views. There are other, lesser, formal difficulties as well. I cannot elaborate here.

Strictly speaking, Lewis's view is not a view of 'transworld identification'. Rather, he thinks that similarities across possible worlds determine a counterpart relation which need be neither symmetric nor transitive. The counterpart of something in another possible world is *never* identical with the thing itself. Thus if we say 'Humphrey might have won the election (if only he had done such-and-such)', we are not talking about something that might have happened to *Humphrey* but to someone else, a 'counterpart'. Probably, however, Humphrey could not care less whether someone *else*, no matter how much resembling him, would have been victorious in another possible world. Thus, Lewis's view seems to me even more bizarre than the usual notions of transworld identification that it replaces. The important issues, however, are common to the two views: the supposition that other possible worlds are like other dimensions of a more inclusive universe, that

The title says it all

they can be given only by purely qualitative descriptions, and that therefore either the identity relation or the counterpart relation must be established in terms of qualitative resemblance.

Many have pointed out to me that the father of counterpart theory is probably Leibniz. I will not go into such a historical question here. It would also be interesting to compare Lewis's views with the Wheeler–Everett interpretation of quantum mechanics. I suspect that this view of physics may suffer from philosophical problems analogous to Lewis's counterpart theory; it is certainly very similar in spirit.

9. Another *locus classicus* of the views I am criticizing, with more philosophical exposition than Lewis's paper, is a paper by David Kaplan on transworld identification. Unfortunately, this paper has never been published. It does not represent Kaplan's present position.

10. Misleadingly, because the phrase suggests that there is a special problem of 'transworld identification', that we cannot trivially stipulate whom or what we are talking about when we imagine another possible world. The term 'possible world' may also mislead; perhaps it suggests the 'foreign country' picture. I have sometimes used 'counterfactual situation' in the text; Michael Slote has suggested that 'possible state (or history) of the world' might be less misleading than 'possible world'. It is better still, to avoid confusion, not to say 'In some possible world, Humphrey would have won' but rather, simply, 'Humphrey might have won.' The apparatus of possible words has (I hope) been very useful as far as the set-theoretic model-theory of quantified modal logic is concerned, but has encouraged philosophical pseudo-problems and misleading pictures.

11. Of course I don't imply that language contains a name for every object. Demonstratives can be used as rigid designators, and free variables can be used as rigid designators of unspecified objects. Of course when we specify a counterfactual situation, we do not describe the whole possible world, but only the portion which interests us.

12. See Lecture I (on Nixon), *Naming and Necessity*, p. 53, and Lecture II, pp. 74–7.

13. There is some vagueness here. If a chip, or molecule, of a given table had been replaced by another one, we would be content to say that we have the same table. But if too many chips were different, we would seem to have a different one. The same problem can, of course, arise for identity over time.

Where the identity relation is vague, it may seem intransitive; a chain of apparent identities may yield an apparent non-identity. Some sort of 'counterpart' notion (though not with Lewis's philosophical underpinnings of resemblance, foreign-country worlds, etc.), may have some utility here. One could say that strict identity applies only to the particulars (the molecules), and the counterpart relation to the particulars 'composed' of them, the tables. The counterpart relation can then be declared to be vague and intransitive. It seems, however, utopian to suppose that we will ever reach a level of ultimate, basic particulars for which identity relations are

never vague and the danger of intransitivity is eliminated. The danger usually does not arise in practice, so we ordinarily can speak simply of identity without worry. Logicians have not developed a logic of vagueness.

12

HILARY PUTNAM

(1927–)

The American philosopher Hilary Putnam was born in Chicago but spent the early years of his life in France. He was educated at the University of Pennsylvania and UCLA. He is a Cogan University Professor of Philosophy at Harvard, where he has been a colleague of Quine since 1965. Putnam's wide-ranging contribution to philosophy is unusual, not least because of the significant changes of position and style in his recent work. His early writing centred mainly on philosophy of mathematics, science, logic, language and mind, and his views were marked by strong realism and physicalism. Among Putnam's major contributions in that period were 'functionalism' – the theory that the human mental states can be seen as computational states (*Mind, Language and Reality*, 1975) and the causal theory of reference.

In his recent work Putnam has repudiated reductive versions of naturalism and certain versions of realism, as well as functionalism. He contrasts his new philosophical position, a view which he initially labelled 'internal realism' and more recently has called 'pragmatic realism', with 'metaphysical realism'. The pragmatic realist believes that there cannot be a god's-eye view of reality and denies those versions of correspondence theory of truth which carry heavy metaphysical commitments. There are significantly different ways in which reality can be described, he now maintains, and all such descriptions take place within the parameters of man-made conceptual schemes. This view is influenced by Kant's transcendental idealism and the later Wittgenstein's approach to language. Although Putnam has maintained an interest in philosophy of language, science and mind, his recent writings have also shown increased concern with ethical, religious and metaphilosophical issues, as well as the influence of various continental philosophers.

A common thread connecting Putnam's early and late views is the advocacy of 'semantic externalism' and his opposition to Cartesian methodological solipsism. According to this way of thinking, meanings

are not a subjective matter: rather, the meaning of utterances is determined, to a large extent, by objects and events that are external to the speakers. His famous slogan states: ' "Meanings" just ain't in the *head*!' – that is, the internal thinking procedures in the speaker's head do not determine the meaning and reference of what he or she says or thinks.

As we have seen (chapter 2), in Bertrand Russell's view ordinary names are shorthand for longer descriptions and these descriptions determine to what the names refer. What defines 'gold', for example, is a conjunction of properties, its colour, texture, weight, etc., so 'gold' is a shorthand term standing for a longer description enumerating these properties. The contemporary version of this theory – the cluster theory of reference – is held by the American philosopher John Searle. A proper name, according to this view, stands for a cluster of descriptions.

According to Putnam, the description theory does not capture what our words mean because, for a certain type of term, natural kind terms in particular, the reference of a name is determined by a causal interaction between objects in the world and the referring minds.

The full statement of Putnam's semantic externalism can be found in his epoch-making article 'The Meaning of "Meaning" ', an extract of which is reproduced in this chapter. The members of a natural kind object, e.g. a substance or a biological kind, Putnam argues typically have in common an underlying chemico-physical or genetic structure. It is a feature of our linguistic practices that a reference to an object implicitly carries the intention to refer to things that have a common constitution. For instance, the name 'gold' was originally designated in a haphazard fashion for an object with certain underlying physical properties. When speakers refer to gold they are referring to the stuff that is individuated by its underlying structure, even if they still have no actual knowledge of the make-up of that structure.

In his famous Twin Earth thought experiment Putnam uses the example of water and twater. Water on earth has the underlying molecular structure and combination that we call H_2O. Even though they had no knowledge of chemistry the reference to H_2O was fixed at the time when our ancestors dubbed a particular substance 'water'. Imagine if we were to go to an alien planet in almost every way similar to our own – Putnam calls it 'the Twin Earth'. There we come across a substance with all the secondary qualities of water: the taste, the smell, the feel, and found in what look like lakes, seas, etc. If we subscribe to a version of the description theory or cluster theory of reference, we will believe that the substance we have discovered is water. But, upon further analysis, the substance turns out to have completely different chemical properties, which can be expressed by a long and complex chemical formula,

abbreviated to XYZ, and not the Earth water chemical structure H_2O. Are we still to call this thing 'water'? Putnam's reply is that, even though it superficially resembles water, this substance is twater (Twin Earth water) and not water. Like Kripke, he believes that the term 'water' is a rigid designator, with the same reference in all the possible worlds in which the term succeeds to refer.

A further important aspect of Putnam's theory is the introduction of the idea of the division of linguistic labour. Putnam notes that he, like many others, is incapable of distinguishing between elms and beeches. His use of the terms 'beech' and 'elm' is dependent on practices established by a class of experts, horticulturists in this particular instance, who can tell the difference between elms and beeches and know what their distinguishing features are. As a rule, speakers bow to the views of experts in all problematic cases.

Putnam's externalist theory of meaning has had a great impact on philosophy in general and on the philosophy of language and mind in particular, as the subsequent selections in this volume will demonstrate.

Works by Putnam

1975 *Mathematics, Matter and Method: Philosophical Papers*, vol. 1. Cambridge: Cambridge University Press.
1975 *Mind, Language and Reality: Philosophical Papers*, vol 2. Cambridge: Cambridge University Press.
1978 *Realism and Reason: Philosophical Papers*, vol 3. Cambridge: Cambridge University Press.
1978 *Meaning and the Moral Sciences*. Boston, MA/London: Routledge.
1981 *Reason, Truth and History*. Cambridge: Cambridge University Press.
1987 *The Many Faces of Realism*. La Salle, IL: Open Court.
1988 *Representation and Reality*. Cambridge, MA: MIT Press.
1990 *Realism With a Human Face*. Cambridge, MA: Harvard University Press.
1992 *Renewing Philosophy*. Cambridge, MA: Harvard University Press.
1995 *Pragmatism*. Oxford: Blackwell.

Works on Putnam

Boolos, George (ed.), *Meaning and Method: Essays in Honor of Hilary Putnam*. Cambridge: Cambridge University Press, 1990.
Clark, Peter and Hale, Bob (eds), *Reading Putnam*. Oxford: Blackwell, 1994.
Pessin, A. and Goldberg, S. (eds), *The Twin Earth Chronicles*. London: M. E. Sharpe, 1996.
Philosophical Topics, ed. C. S. Hill, vol. 20, no. 1, *The Philosophy of Hilary Putnam*. Fayetteville: University of Arkansas Press, 1992.

From The Meaning of 'Meaning'

Language is the first broad area of human cognitive capacity for which we are beginning to obtain a description which is not exaggeratedly oversimplified. Thanks to the work of contemporary transformational linguists,[1] a very subtle description of at least some human languages is in the process of being constructed. Some features of these languages appear to be *universal*. Where such features turn out to be 'species-specific' – 'not explicable on some general grounds of functional utility or simplicity that would apply to arbitrary systems that serve the functions of language' – they may shed some light on the structure of mind. While it is extremely difficult to say to what extent the structure so illuminated will turn out to be a universal structure of *language*, as opposed to a universal structure of innate general learning strategies,[2] the very fact that this discussion can take place is testimony to the richness and generality of the descriptive material that linguists are beginning to provide, and also testimony to the depth of the analysis, insofar as the features that appear to be candidates for 'species-specific' features of language are in no sense surface or phenomenological features of language, but lie at the level of deep structure.

The most serious drawback to all of this analysis, as far as a philosopher is concerned, is that it does not concern the meaning of words. Analysis of the deep structure of linguistic forms gives us an incomparably more powerful description of the *syntax* of natural languages than we have ever had before. But the dimension of language associated with the word 'meaning' is, in spite of the usual spate of heroic if misguided attempts, as much in the dark as it ever was.

In this essay, I want to explore why this should be so. In my opinion, the reason that so-called semantics is in so much worse condition than syntactic theory is that the *prescientific* concept on which semantics is based – the prescientific concept of *meaning* – is itself in much worse shape than the prescientific concept of syntax. As usual in philosophy,

skeptical doubts about the concept do not at all help one in clarifying or improving the situation any more than dogmatic assertions by conservative philosophers that all's really well in this best of all possible worlds. The reason that the prescientific concept of meaning is in bad shape is not clarified by some general skeptical or nominalistic argument to the effect that meanings don't exist. Indeed, the upshot of our discussion will be that meanings don't exist in quite the way we tend to think they do. But electrons don't exist in quite the way Bohr thought they did, either. There is all the distance in the world between this assertion and the assertion that meanings (or electrons) 'don't exist'.

I am going to talk almost entirely about the meaning of words rather than about the meaning of sentences because I feel that our concept of word-meaning is more defective than our concept of sentence-meaning. But I will comment briefly on the arguments of philosophers such as Donald Davidson who insist that the concept of word-meaning *must* be secondary and that study of sentence-meaning must be primary. Since I regard the traditional theories about meaning as myth-eaten (notice that the topic of 'meaning' is the one topic discussed in philosophy in which there is literally nothing but 'theory' – literally nothing that can be labelled or even ridiculed as the 'common-sense view'), it will be necessary for me to discuss and try to disentangle a number of topics concerning which the received view is, in my opinion, wrong. The reader will give me the greatest aid in the task of trying to make these matters clear if he will kindly assume that *nothing* is clear in advance.

Meaning and Extension

Since the Middle Ages at least, writers on the theory of meaning have purported to discover an ambiguity in the ordinary concept of meaning, and have introduced a pair of terms – *extension* and *intension*, or *Sinn* and *Bedeutung*, or whatever – to disambiguate the notion. The *extension* of a term, in customary logical parlance, is simply the set of things the term is true of. Thus, 'rabbit', in its most common English sense, is true of all and only rabbits, so the extension of 'rabbit' is precisely the set of rabbits. Even this notion – and it is the *least* problematical notion in this cloudy subject – has its problems, however. Apart from problems it inherits from its parent notion of *truth*, the foregoing example of 'rabbit' *in its most common English sense* illustrates one such problem: strictly speaking, it is not a term, but an ordered pair consisting of a term and a 'sense' (or an occasion of use, or something else that distinguishes a term in one sense from the same term used in a different sense) that has an extension. Another problem is this: a 'set', in the mathematical sense, is

a 'yes–no' object; any given object either definitely belongs to S or definitely does not belong to S, if S is a set. But words in a natural language are not generally 'yes–no': there are things of which the description 'tree' is clearly true and things of which the description 'tree' is clearly false, to be sure, but there are a host of borderline cases. Worse, the line between the clear cases and the borderline cases is itself fuzzy. Thus the idealization involved in the notion of *extension* – the idealization involved in supposing that there is such a thing as the set of things of which the term 'tree' is true – is actually very severe.

Recently some mathematicians have investigated the notion of a *fuzzy set* – that is, of an object to which other things belong or do not belong with a given probability or to a given degree, rather than belong 'yes–no'. If one really wanted to formalize the notion of extension as applied to terms in a natural language, it would be necessary to employ 'fuzzy sets' or something similar rather than sets in the classical sense.

The problem of a word's having more than one sense is standardly handled by treating each of the senses as a different word (or rather, by treating the word as if it carried invisible subscripts, thus: 'rabbit$_1$' – animal of a certain kind; 'rabbit$_2$' – coward; and as if 'rabbit$_1$' and 'rabbit$_2$' or whatever were different words entirely). This again involves two very severe idealizations (at least two, that is): supposing that words have discretely many senses, and supposing that the entire repertoire of senses is fixed once and for all. Paul Ziff has recently investigated the extent to which both of these suppositions distort the actual situation in natural language;[3] nevertheless, we will continue to make these idealizations here.

Now consider the compound terms 'creature with a heart' and 'creature with a kidney'. Assuming that every creature with a heart possesses a kidney and vice versa, the extension of these two terms is exactly the same. But they obviously differ in meaning. Supposing that there is a sense of 'meaning' in which meaning = extension, there must be another sense of 'meaning' in which the meaning of a term is not its extension but something else, say the 'concept' associated with the term. Let us call this 'something else' the *intension* of the term. The concept of a creature with a heart is clearly a different concept from the concept of a creature with a kidney. Thus the two terms have different intension. When we say they have different 'meaning', meaning = intension. Something like the preceding paragraph appears in every standard exposition of the notions 'intension' and 'extension'. But it is not at all satisfactory. Why it is not satisfactory is, in a sense, the burden of this entire essay. But some points can be made at the very outset: first of all, what evidence is there that 'extension' *is* a sense of the word 'meaning'? The canonical

explanation of the notions 'intension' and 'extension' is very much like 'in one sense "meaning" means *extension* and in the other sense "meaning" means *meaning*. The fact is that while the notion of 'extension' is made quite precise, relative to the fundamental logical notion of *truth* (and under the severe idealizations remarked above), the notion of intension is made no more precise than the vague (and, as we shall see, misleading) notion 'concept'. It is as if someone explained the notion 'probability' by saying: 'in one sense "probability" means frequency, and in the other sense it means *propensity*'. 'Probability' *never* means 'frequency', and 'propensity' is at least as unclear as 'probability'.

Unclear as it is, the traditional doctrine that the notion 'meaning' possesses the extension/intension ambiguity has certain typical consequences. Most traditional philosophers thought of concepts as something *mental*. Thus the doctrine that the meaning of a term (the meaning 'in the sense of intension', that is) is a concept carried the implication that meanings are mental entities. Frege and more recently Carnap and his followers, however, rebelled against this 'psychologism', as they termed it. Feeling that meanings are *public* property – that the *same* meaning can be 'grasped' by more than one person and by persons at different times – they identified concepts (and hence 'intensions' or meanings) with abstract entities rather than mental entities. However, 'grasping' these abstract entities was still an individual psychological act. None of these philosophers doubted that understanding a word (knowing its intension) was just a matter of being in a certain psychological state (somewhat in the way in which knowing how to factor numbers in one's head is just a matter of being in a certain very complex psychological state).

Secondly, the timeworn example of the two terms 'creature with a kidney' and 'creature with a heart' does show that two terms can have the same extension and yet differ in intension. But it was taken to be obvious that the reverse is impossible: two terms cannot differ in extension and have the same intension. Interestingly, no argument for this impossibility was ever offered. Probably it reflects the tradition of the ancient and medieval philosophers who assumed that the concept corresponding to a term with just a conjunction of predicates, and hence that the concept corresponding to a term must *always* provide a necessary and sufficient condition for falling into the extension of the term.[4] For philosophers like Carnap, who accepted the verifiability theory of meaning, the concept corresponding to a term provided (in the ideal case, where the term had 'complete meaning') a *criterion* for belonging to the extension (not just in the sense of 'necessary and sufficient condition', but in the strong sense of *way of recognizing* if a given thing falls into the extension or not). Thus these positivistic philosophers were

perfectly happy to retain the traditional view on this point. So theory of meaning came to rest on two unchallenged assumptions:

(I) That knowing the meaning of a term is just a matter of being in a certain psychological state (in the sense of 'psychological state', in which states of memory and psychological dispositions are 'psychological states'; no one thought that knowing the meaning of a word was a continuous state of consciousness, of course).

(II) That the meaning of a term (in the sense of 'intension') determines its extension (in the sense that sameness of intension entails sameness of extension).

I shall argue that these two assumptions are not jointly satisfied by *any* notion, let alone any notion of meaning. The traditional concept of meaning is a concept which rests on a false theory.

'Psychological State' and Methodological Solipsism

In order to show this, we need first to clarify the traditional notion of a psychological state. In one sense a state is simply a two-place predicate whose arguments are an individual and a time. In this sense, *being five feet tall, being in pain, knowing the alphabet,* and even *being a thousand miles from Paris* are all states. (Note that the *time* is usually left implicit or 'contextual'; the full form of an atomic sentence of these predicates would be '*x is five feet tall at time t*', '*x is in pain at time t*', etc.) In science, however, it is customary to restrict the term state to properties which are defined in terms of the parameters of the individual which are fundamental from the point of view of the given science. Thus, being five feet tall is a state (from the point of view of physics); being in pain is a state (from the point of view of mentalistic psychology, at least); knowing the alphabet might be a state (from the point of view of cognitive psychology), although it is hard to say; but being a thousand miles from Paris would *not* naturally be called a *state*. In one sense, a psychological state is simply a state which is studied or described by psychology. In this sense it may be trivially true that, say *knowing the meaning of the word 'water'* is a 'psychological state' (viewed from the standpoint of cognitive psychology). But this is not the sense of psychological state that is at issue in the above assumption (I).

When traditional philosophers talked about psychological states (or 'mental' states), they made an assumption which we may call the assumption of methodological solipsism. This assumption is the assumption that no psychological state, properly so called, presupposes the existence of any individual other than the subject to whom that state is ascribed. (In fact, the assumption was that no psychological state presupposes the

existence of the subject's *body* even: if *P* is a psychological state, properly so called, then it must be logically possible for a 'disembodied mind' to be in *P.*) This assumption is pretty explicit in Descartes, but it is implicit in just about the whole of traditional philosophical psychology. Making this assumption is, of course, adopting a *restrictive program* – a program which deliberately limits the scope and nature of psychology to fit certain mentalistic preconceptions or, in some cases, to fit an idealistic reconstruction of knowledge and the world. Just *how* restrictive the program is, however, often goes unnoticed. Such common or garden variety psychological states as *being jealous* have to be reconstructed, for example, if the assumption of methodological solipsism is retained. For, in its ordinary use, *x is jealous of y* entails that *y* exists, and *x is jealous of y's regard for z* entails that both *y* and *z* exist (as well as *x*, of course). Thus *being jealous* and *being jealous of someone's regard for someone else* are not psychological states permitted by the assumption of methodological solipsism. (We shall call them 'psychological states in the wide sense' and refer to the states which are permitted by methodological solipsism as 'psychological states in the narrow sense'.) The reconstruction required by methodological solipsism would be to recon-strue *jealousy* so that I can be jealous of my own hallucinations, or of figments of my imagination, etc. Only if we assume that psychological states in the narrow sense have a significant degree of causal closure (so that restricting ourselves to psychological states in the narrow sense will facilitate the statement of psychological *laws*) is there any point in engaging in this reconstruction, or in making the assumption of metho-dological solipsism. But the three centuries of failure of mentalistic psychology is tremendous evidence against this procedure, in my opinion.

Be that as it may, we can not state more precisely what we claimed at the end of the preceding section. Let *A* and *B* be any two terms which differ in extension. By assumption (II) they must differ in meaning (in the sense of 'intension'). By assumption (I), *knowing the meaning of A* and *knowing the meaning of B* are psychological states *in the narrow sense* – for this is how we shall construe assumption (I). *But these psychological states must determine the extension of the terms A and B just as much as the meanings ('intensions') do.*

To see this, let us try assuming the opposite. Of course, there cannot be two terms *A* and *B* such that *knowing the meaning of A* is the same state as *knowing the meaning of B* even though *A* and *B* have different extensions. For *knowing the meaning of A* isn't just 'grasping the inten-sion' of *A*, whatever that may come to; it is also knowing that the 'intension' that one has 'grasped' *is* the intension of *A*. (Thus, someone who knows the meaning of 'wheel' presumably 'grasps the intension' of

its German synonym *Rad*; but if he doesn't know that the 'intension' in question is the intension of *Rad* he isn't said to 'know the meaning of *Rad*'.) If *A* and *B* are different terms, then *knowing the meaning of A* is a different state from *knowing the meaning of B* whether the meanings of *A* and *B* be themselves the same or different. But by the same argument, if I_1 and I_2 are different *intensions* and *A* is a term, then *knowing that* I_1 *is the meaning of A* is a different psychological state from *knowing that* I_2 *is the meaning of A*. Thus, there cannot be two different logically possible worlds L_1 and L_2 such that, say, Oscar is in the *same* psychological state (in the narrow sense) in L_1 and in L_2 (in all respects), but in L_1 Oscar understands *A* as having the meaning I_1 and in L_2 Oscar understands *A* as having the meaning I_2. (For, if there were, then in L_1 Oscar would be in the psychological state *knowing that* I_1 *is the meaning of A* and in L_2 Oscar would be in the psychological state *knowing that* I_2 *is the meaning of A*, and these are different and even – assuming that *A* has just *one* meaning for Oscar in each world – incompatible psychological states in the narrow sense.)

In short, if *S* is the sort of psychological state we have been discussing – a psychological state of the form *knowing that* I *is the meaning of A*, where *I* is an 'intension' and *A* is a term – then the *same* necessary and sufficient condition for falling into the extension of *A* 'works' in *every* logically possible world in which the speaker is in the psychological state *S*. For the state *S determines* the intension *I*, and by assumption (II) the intension amounts to a necessary and sufficient condition for membership in the *extension*.

If our interpretation of the traditional doctrine of intension and extension is fair to Frege and Carnap, then the whole psychologism/Platonism issue appears somewhat a tempest in a teapot, as far as meaning-theory is concerned. (Of course, it is a very important issue as far as general philosophy of mathematics is concerned.) For even if meanings are 'Platonic' entities rather than 'mental' entities on the Frege–Carnap view, 'grasping' those entities is presumably a psychological state (in the narrow sense). Moreover, the psychological state uniquely determines the 'Platonic' entity. So whether one takes the 'Platonic' entity or the psychological state as the 'meaning' would appear to be somewhat a matter of convention. And taking the psychological state to be the meaning would hardly have the consequence that Frege feared, that meanings would cease to be public. For psychological states are 'public' in the sense that different people (and even people in different epochs) can be in the *same* psychological state. Indeed, Frege's argument against psychologism is only an argument against identifying concepts with mental particulars, not with mental entities in general.

The 'public' character of psychological states entails, in particular, that if Oscar and Elmer understand a word *A* differently, then they must be in *different* psychological states. For the state of *knowing the intension of A to be, say I* is the *same* state whether Oscar or Elmer be in it. Thus two speakers cannot be in the same psychological state in all respects and understand the term *A* differently; the psychological state of the speaker determines the intension (and hence, by assumption (II), the extension) of *A*.

It is this last consequence of the joint assumptions (I), (II) that we claim to be false. We claim that it is possible for two speakers to be in exactly the *same* psychological state (in the narrow sense), even though the extension of the term *A* in the idiolect of the one is different from the extension of the term *A* in the idiolect of the other. Extension is *not* determined by psychological state.

This will be shown in detail in later sections. If this is right, then there are two courses open to one who wants to rescue at least one of the traditional assumptions; to give up the idea that psychological state (in the narrow sense) determines *intension*, or to give up the idea that intension determines extension. We shall consider these alternatives later.

Are Meanings in the Head?

That psychological state does not determine extension will now be shown with the aid of a little science-fiction. For the purpose of the following science-fiction examples, we shall suppose that somewhere in the galaxy there is a planet we shall call Twin Earth. Twin Earth is very much like Earth; in fact, people on Twin Earth even speak *English*. In fact, apart from the differences we shall specify in our science-fiction examples, the reader may suppose that Twin Earth is *exactly* like Earth. He may even suppose that he has a *Doppelgänger* – an identical copy – on Twin Earth, if he wishes, although my stories will not depend on this.

Although some of the people on Twin Earth (say, the ones who call themselves 'Americans' and the ones who call themselves 'Canadians' and the ones who call themselves 'Englishmen', etc.) speak English, there are, not surprisingly, a few tiny differences which we will now describe between the dialects of English spoken on Twin Earth and Standard English. These differences themselves depend on some of the peculiarities of Twin Earth.

One of the peculiarities of Twin Earth is that the liquid called 'water' is not H_2O but a different liquid whose chemical formula is very long and complicated. I shall abbreviate this chemical formula simply as XYZ. I shall suppose that XYZ is indistinguishable from water at

normal temperatures and pressures. In particular, it tastes like water and it quenches thirst like water. Also, I shall suppose that the oceans and lakes and seas of Twin Earth contain XYZ and not water, that it rains XYZ on Twin Earth and not water, etc.

If a spaceship from Earth ever visits Twin Earth, then the supposition at first will be that 'water' has the same meaning on Earth and on Twin Earth. This supposition will be corrected when it is discovered that 'water' on Twin Earth is XYZ, and the Earthian spaceship will report somewhat as follows:

'On Twin Earth the word "water" means XYZ.'

(It is this sort of use of the word 'means' which accounts for the doctrine that extension is one sense of 'meaning', by the way. But note that although 'means' does mean something like *has an extension* in this example, one would *not* say

'On Twin Earth the meaning of the word "water" is XYZ.'

unless, possibly, the fact that 'water is XYZ' was known to every adult speaker of English on Twin Earth. We can account for this in terms of the theory of meaning we develop below; for the moment we just remark that although the verb 'means' sometimes means 'has as extension', the nominalization 'meaning' *never* means 'extension'.)

Symmetrically, if a spaceship from Twin Earth ever visits Earth, then the supposition at first will be that the word 'water' has the same meaning on Twin Earth and on Earth. This supposition will be corrected when it is discovered that 'water' on Earth is H_2O, and the Twin Earthian spaceship will report:

'On Earth⁵ the word "water" means H_2O.'

Note that there is no problem about the extension of the term 'water'. The word simply has two different meanings (as we say): in the sense in which it is used on Twin Earth, the sense of water$_{TE}$, what *we* call 'water' simply isn't water; while in the sense in which it is used on Earth, the sense of water$_E$, what the Twin Earthians call 'water' simply isn't water. The extension of 'water' in the sense of water$_E$ is the set of all wholes consisting of H_2O molecules, or something like that; the extension of water in the sense of water$_{TE}$ is the set of all wholes consisting of XYZ molecules, or something like that.

Now let us roll the time back to about 1750. At that time chemistry was not developed on either Earth or Twin Earth. The typical Earthian speaker of English did not know water consisted of hydrogen and oxygen, and the typical Twin Earthian speaker of English did not know 'water'

consisted of XYZ. Let Oscar$_1$ be such a typical Earthian English speaker, and let Oscar$_2$ be his counterpart on Twin Earth. You may suppose that there is no belief that Oscar$_1$ had about water that Oscar$_2$ did not have about 'water'. If you like, you may even suppose that Oscar$_1$ and Oscar$_2$ were exact duplicates in appearance, feelings, thoughts, interior monologue, etc. Yet the extension of the term 'water' was just as much H_2O on Earth in 1750 as in 1950; and the extension of the term 'water' was just as much XYZ on Twin Earth in 1750 as in 1950. Oscar$_1$ and Oscar$_2$ understood the term 'water' differently in 1750 *although they were in the same psychological state*, and although, given the state of science at the time, it would have taken their scientific communities about fifty years to discover that they understood the term 'water' differently. Thus the extension of the term 'water' (and, in fact, its 'meaning' in the intuitive preanalytical usage of that term) is *not* a function of the psychological state of the speaker by itself.

But, it might be objected, why should we accept it that the term 'water' has the same extension in 1750 and in 1950 (on both Earths)? The logic of natural kind terms like 'water' is a complicated matter, but the following is a sketch of an answer. Suppose I point to a glass of water and say 'This liquid is called water' (or 'This is called water', if the marker 'liquid' is clear from the context). My 'ostensive definition' of water has the following empirical presupposition: that the body of liquid I am pointing to bears a certain sameness relation (say, *x is the same liquid as y*, or *x is the same$_L$ as y*) to most of the stuff I and other speakers in my linguistic community have on other occasions called 'water'. If this presupposition is false because, say, I am without knowing it pointing to a glass of gin and not a glass of water, then I do not intend my ostensive definition to be accepted. Thus the ostensive definition conveys what might be called a defeasible necessary and sufficient condition: the necessary and sufficient condition for being water is bearing the relation same$_L$ to the stuff in the glass; but this is the necessary and sufficient condition only if the empirical presupposition is satisfied. If it is not satisfied, then one of a series of, so to speak, 'fallback' conditions becomes activated.

The key point is that the relation same$_L$ is a *theoretical* relation: whether something is or is not the same liquid as *this* may take an indeterminate amount of scientific investigation to determine. Moreover, even if a 'definite' answer has been obtained either through scientific investigation or through the application of some 'common-sense' test, the answer is *defeasible*: future investigation might reverse even the most 'certain' example. Thus, the fact that an English speaker in 1750 might have called XYZ 'water', while he or his successors would not have

called XYZ water in 1800 or 1850 does not mean that the 'meaning' of 'water' changed for the average speaker in the interval. In 1750 or in 1850 or in 1950 one might have pointed to, say, the liquid in Lake Michigan as an example of 'water'. What changed was that in 1750 we would have mistakenly thought that XYZ bore the relation same$_L$ to the liquid in Lake Michigan, while in 1800 or 1850 we would have known that it did not (I am ignoring the fact that the liquid in Lake Michigan was only dubiously water in 1950, of course).

Let us now modify our science-fiction story. I do not know whether one can make pots and pans out of molybdenum; and if one can make them out of molybdenum, I don't know whether they could be distinguished easily from aluminum pots and pans. (I don't know any of this even though I have acquired the word 'molybdenum'.) So I shall suppose that molybdenum pots and pans *can't* be distinguished from aluminum pots and pans save by an expert. (To emphasize the point, I repeat that this could be true for all I know, and *a fortiori* it could be true for all I know by virtue of 'knowing the meaning' of the words *aluminum* and *molybdenum*.) We will now suppose that molybdenum is as common on Twin Earth as aluminum is on Earth, and that aluminum is as rare on Twin Earth as molybdenum is on Earth. In particular, we shall assume that 'aluminum' pots and pans are made of molybdenum on Twin Earth. Finally, we shall assume that the words 'aluminum' and 'molybdenum' are *switched* on Twin Earth: 'aluminum' is the name of *molybdenum* and 'molybdenum' is the name of *aluminum*.

This example shares some features with the previous one. If a spaceship from Earth visited Twin Earth, the visitors from Earth probably would not suspect that the 'aluminum' pots and pans on Twin Earth were not made of aluminum, especially when the Twin Earthians *said* they were. But there is one important difference between the two cases. An Earthian metallurgist could tell very easily that 'aluminum' was molybdenum, and a Twin Earthian metallurgist could tell equally easily that aluminum was 'molybdenum'. (The shudder quotes in the preceding sentence indicate Twin Earthians usages.) Whereas in 1750 no one on either Earth or Twin Earth could have distinguished water from 'water', the confusion of aluminum with 'aluminum' involves only a part of the linguistic communities involved.

The example makes the same point as the preceding one. If Oscar$_1$ and Oscar$_2$ are standard speakers of Earthian English and Twin Earthian English respectively, and neither is chemically or metallurgically sophisticated, then there may be no difference at all in their psychological state when they use the word 'aluminum'; nevertheless we have to say that 'aluminum' has the extension *aluminum* in the idiolect of Oscar$_1$

and the extension *molybdenum* in the idiolect of Oscar₂. (Also we have to say that Oscar₁ and Oscar₂ mean different things by 'aluminum', that 'aluminum' has a different meaning on Earth than it does on Twin Earth, etc.) Again we see that the psychological state of the speaker does *not* determine the extension (*or* the 'meaning', speaking preanalytically) of the word.

Before discussing this example further, let me introduce a *non-science* fiction example. Suppose you are like me and cannot tell an elm from a beech tree. We still say that the extension of 'elm' in my idiolect is the same as the extension of 'elm' in anyone else's, viz., the set of all elm trees, and that the set of all beech trees is the extension of 'beech' in *both* of our idiolects. Thus 'elm' in my idiolect has a different extension from 'beech' in your idiolect (as it should). Is it really credible that this difference in extension is brought about by some difference in our *concepts*? My *concept* of an elm tree is exactly the same as my concept of a beech tree (I blush to confess). (This shows that the identification of meaning 'in the sense of intension' with *concept* cannot be correct, by the way.) If someone heroically attempts to maintain that the difference between the extension of 'elm' and the extension of 'beech' in *my* idiolect is explained by a difference in my psychological state, then we can always refute him by constructing a 'Twin Earth' example – just let the words 'elm' and 'beech' be switched on Twin Earth (the way 'aluminum' and 'molybdenum' were in the previous example). Moreover, I suppose I have a *Doppelgänger* on Twin Earth who is molecule for molecule 'identical' with me (in the sense in which two neckties can be 'identical'). If you are a dualist, then also suppose my *Doppelgänger* thinks the same verbalized thoughts as I do, has the same sense data, the same dispositions, etc. It is absurd to think *his* psychological state is one bit different from mine: yet *he* 'means' *beech* when he says 'elm' and *I* 'mean' *elm* when I say elm. Cut the pie any way you like, 'meanings' just ain't in the *head*!

A Socio-linguistic Hypothesis

The last two examples depend upon a fact about language that seems, surprisingly, never to have been pointed out: that there is *division of linguistic labor*. We could hardly use such words as 'elm' and 'aluminum' if no one possessed a way of recognizing elm trees and aluminum metal; but not everyone to whom the distinction is important has to be able to make the distinction. Let us shift the example: consider *gold*. Gold is important for many reasons: it is a precious metal, it is a monetary metal, it has symbolic value (it is important to most people that the 'gold'

wedding rings they wear *really* consist of gold and not just *look* gold), etc. Consider our community as a 'factory': in this 'factory' some people have the 'job' of *wearing gold wedding rings*, other people have the 'job' of *selling gold wedding rings*, still other people have the 'job' of *telling whether or not something is really gold*. It is not at all necessary or efficient that everyone who wears a gold ring (or a gold cufflink, etc.), or discusses the 'gold standard', etc., engage in buying and selling gold. Nor is it necessary or efficient that everyone who buys and sells gold be able to tell whether or not something is really gold in a society where this form of dishonesty is uncommon (selling fake gold) and in which one can easily consult an expert in case of doubt. And it is *certainly* not necessary or efficient that everyone who has occasion to buy or wear gold be able to tell with any reliability whether or not something is really gold.

The foregoing facts are just examples of mundane division of labor (in a wide sense). But they engender a division of linguistic labor: everyone to whom gold is important for any reason has to *acquire* the word 'gold'; but he does not have to acquire the *method of recognizing* if something is or is not gold. He can rely on a special subclass of speakers. The features that are generally thought to be present in connection with a general name – necessary and sufficient conditions for membership in the extension, ways of recognizing if something is in the extension ('criteria'), etc. – are all present in the linguistic community *considered as a collective body*; but that collective body divides the 'labor' of knowing and employing these various parts of the 'meaning' of 'gold'.

This division of linguistic labor rests upon and presupposes the division of *non*linguistic labor, of course. If only the people who know how to tell if some metal is really gold or not have any reason to have the word 'gold' in their vocabulary, then the word 'gold' will be as the word 'water' was in 1750 with respect to that subclass of speakers, and the other speakers just won't acquire it at all. And some words do not exhibit any division of linguistic labor: 'chair', for example. But with the increase of division of labor in the society and the rise of science, more and more words begin to exhibit this kind of division of labor. 'Water', for example, did not exhibit it at all prior to the rise of chemistry. Today it is obviously necessary for every speaker to be able to recognize water (reliably under normal conditions), and probably every adult speaker even knows the necessary and sufficient condition 'water is H_2O', but only a few adult speakers could distinguish water from liquids which superficially resembled water. In case of doubt, other speakers would rely on the judgement of these 'expert' speakers. Thus the way of recognizing possessed by these 'expert' speakers is also, through them, possessed by the

collective linguistic body, even though it is not possessed by each individual member of the body, and in this way the most recherché fact about water may become part of the *social* meaning of the word while being unknown to almost all speakers who acquire the word.

It seems to me that this phenomenon of division of linguistic labor is one which it will be very important for sociolinguistics to investigate. In connection with it, I should like to propose the following hypothesis:

HYPOTHESIS OF THE UNIVERSALITY OF THE DIVISION OF LINGUISTIC LABOR: Every linguistic community exemplifies the sort of division of linguistic labor just described: that is, possesses at least some terms whose associated 'criteria' are known only to a subset of the speakers who acquire the terms, and whose use by the other speakers depends upon a structured cooperation between them and the speakers in the relevant subsets.

It would be of interest, in particular, to discover if extremely primitive peoples were sometimes exceptions to this hypothesis (which would indicate that the division of linguistic labor is a product of social evolution), or if even they exhibit it. In the latter case, one might conjecture that division of labor, including linguistic labor, is a fundamental trait of our species.

It is easy to see how this phenomenon accounts for some of the examples given above of the failure of the assumptions (I), (II). Whenever a term is subject to the division of linguistic labor, the 'average' speaker who acquires it does not acquire anything that fixes its extension. In particular, his individual psychological state *certainly* does not fix its extension; it is only the sociolinguistic state of the collective linguistic body to which the speaker belongs that fixes the extension.

We may summarize this discussion by pointing out that there are two sorts of tools in the world: there are tools like a hammer or a screwdriver which can be used by one person; and there are tools like a steamship which require the cooperative activity of a number of persons to use. Words have been thought of too much on the model of the first sort of tool.

Indexicality and Rigidity[6]

The first of our science-fiction examples – 'water' on Earth and on Twin Earth in 1750 – does not involve division of linguistic labor, or at least does not involve it in the same way the examples of 'aluminum' and 'elm' do. There were not (in our story, anyway) any 'experts' on water on Earth in 1750, nor any experts on 'water' on Twin Earth. (The example *can* be construed as involving division of labor *across time*, however. I shall not develop this method of treating the example here.)

The example *does* involve things which are of fundamental importance to the theory of reference and also to the theory of necessary truth, which we shall now discuss.

There are two obvious ways of telling someone what one means by a natural kind term such as 'water' or 'tiger' or 'lemon'. One can give him a so-called ostensive definition – 'this (liquid) is water'; 'this (animal) is a tiger'; 'this (fruit) is a lemon'; where the parentheses are meant to indicate that the 'markers' *liquid, animal, fruit,* may be either explicit or implicit. Or one can give him a *description*. In the latter case the description one gives typically consists of one or more markers together with a *stereotype* (see chapter 8 in *Mind, Language and Reality*) – a standardized description of features of the kind that are typical, or 'normal', or at any rate stereotypical. The central features of the stereotype generally are *criteria* – features which in normal situations constitute ways of recognizing if a thing belongs to the kind or, at least, necessary conditions (or probabilistic necessary conditions) for membership in the kind. Not all criteria used by the linguistic community as a collective body are included in the stereotype, and in some cases the stereotypes may be quite weak. Thus (unless I am a very atypical speaker), the stereotype of an elm is just that of a common deciduous tree. These features are indeed necessary conditions for membership in the kind (I mean 'necessary' in a loose sense; I don't think 'elm trees are deciduous' is *analytic*), but they fall far short of constituting a way of recognizing elms. On the other hand, the stereotype of a tiger does enable one to recognize tigers (unless they are albino, or some other atypical circumstance is present), and the stereotype of a lemon generally enables one to recognize lemons. In the extreme case, the stereotype may be *just* the marker: the stereotype of molybdenum might be *just* that molybdenum is a *metal*. Let us consider both of these ways of introducing a term into someone's vocabulary.

Suppose I point to a glass of liquid and say '*This* is water', in order to teach someone the word 'water'. We have already described some of the empirical presuppositions of this act, and the way in which this kind of meaning-explanation is defeasible. Let us now try to clarify further how it is supposed to be taken.

In what follows, we shall take the notion of 'possible world' as primitive. We do this because we feel that in several senses the notion makes sense and is scientifically important even if it needs to be made more precise. We shall assume further that in at least some cases it is possible to speak of the same individual as existing in more than one possible world.[7] Our discussion leans heavily on the work of Saul Kripke, although the conclusions were obtained independently.

Let W_1 and W_2 be two possible worlds in which I exist and in which

this glass exists and in which I am giving a meaning explanation by pointing to this glass and saying 'This is water'. (We do *not* assume that the *liquid* in the glass is the same in both worlds.) Let us suppose that in W_1 the glass is full of H_2O and in W_2 the glass is full of XYZ. We shall also suppose that W_1 is the *actual* world and that XYZ is the stuff typically called 'water' in the world W_2 (so that the relation between English speakers in W_1 and English speakers in W_2 is exactly the same as the relation between English speakers on Earth and English speakers on Twin Earth). Then there are two theories one might have concerning the meaning of 'water'.

(1) One might hold that 'water' was *world-relative* but *constant* in meaning (i.e., the word has a *constant relative meaning*). In this theory, 'water' *means the same in* W_1 and W_2; it's just that water is H_2O in W_1 and water is XYZ in W_2.

(2) One might hold that water is H_2O in all worlds (the stuff called 'water' in W_2 isn't water), but 'water' doesn't have the same meaning in W_1 and W_2.

If what was said before about the Twin Earth case was correct, then (2) is clearly the correct theory. When I say '*this* (liquid) is water', the 'this' is, so to speak, a *de re* 'this' – i.e., the force of my explanation is that 'water' is whatever bears a certain equivalence relation (the relation we called 'same$_L$' above) to the piece of liquid referred to as 'this' *in the actual world*.

We might symbolize the difference between the two theories as a 'scope' difference in the following way. In theory (1), the following is true:

(1′) (For every world W) (For every x in W) (x is water \equiv x bears same$_L$ to the entity referred to as 'this' in W)

while on theory (2):

(2′) (For every world W) (For every x in W) (x is water \equiv x bears same$_L$ to the entity referred to as 'this' *in the actual world* W_1).

(I call this a 'scope' difference because in (1′) 'the entity referred to as "this"' is within the scope of 'For every world W' – as the qualifying phrase 'in W' makes explicit, whereas in (2′) 'the entity referred to as "this"' means 'the entity referred to as "this" *in the actual world*', and has thus a reference *independent* of the bound variable 'W'.)

Kripke calls a designator 'rigid' (in a given sentence) if (in that sentence) it refers to the same individual in every possible world in which the designator designates. If we extend the notion of rigidity to substance names, then we may express Kripke's theory and mine by saying that the term 'water' is *rigid*.

The rigidity of the term 'water' follows from the fact that when I give the ostensive definition '*this* (liquid) is water' I intend (2') and not (1').

We may also say, following Kripke, that when I give the ostensive definition '*this* (liquid) is water', the demonstrative 'this' is *rigid*.

What Kripke was the first to observe is that this theory of the meaning (or 'use', or whatever) of the word 'water' (and other natural kind terms as well) has startling consequences for the theory of necessary truth.

To explain this, let me introduce the notion of a *cross-world relation*. A two-term relation R will be called *cross-world* when it is understood in such a way that its extension is a set of ordered pairs of individuals *not all in the same possible world*. For example, it is easy to understand the relation *same height as* as a cross-world relation: just understand it so that, e.g., if x is an individual in a world W_1 who is five feet tall (in W_1) and y is an individual in W_2 who is five feet tall (in W_2), then the ordered pair x, y belongs to the extension of *same height as*. (Since an individual may have different heights in different possible worlds in which that same individual exists, strictly speaking it is not the ordered pair x, y that constitutes an element of the extension of *same height as*, but rather the ordered pair x-*in-world*-W_1, y-*in-world*-W_2.)

Similarly, we can understand the relation $same_L$ (same liquid as) as a cross-world relation by understanding it so that a liquid in world W_1 which has the same important physical properties (in W_1) that a liquid in W_2 possesses (in W_2) bears $same_L$ to the latter liquid.

Then the theory we have been presenting may be summarized by saying that an entity x, in an arbitrary possible world, is *water* if and only if it bears the relation $same_L$ (construed as a cross-world relation) to the stuff *we* call 'water' in the *actual* world.

Suppose, now, that I have not yet discovered what the important physical properties of water are (in the actual world) – i.e., I don't yet know that water is H_2O. I may have ways of *recognizing* water that are successful (of course, I may make a small number of mistakes that I won't be able to detect until a later stage in our scientific development) but not know the microstructure of water. If I agree that a liquid with the superficial properties of 'water' but a different microstructure *isn't really water*, then my ways of recognizing water (my 'operational definition', so to speak) cannot be regarded as an analytical specification of *what it is to be* water. Rather, the operational definition, like the ostensive one, is simply a way of pointing out a standard – pointing out the stuff *in the actual world* such that for x to be water, in *any* world, is for x to bear the relation $same_L$ to the *normal* members of the class of *local* entities that satisfy the operational definition. 'Water' on Twin Earth is not water, even if it satisfies the operational definition, because it doesn't

bear $same_L$ to the *local* stuff that satisfies the operational definition, and local stuff that satisfies the operational definition but has a microstructure different from the rest of the local stuff that satisfies the operational definition isn't water either, because it doesn't bear $same_L$ to the *normal* examples of the local 'water'.

Suppose, now, that I discover the microstructure of water – that water is H_2O. At this point I will be able to say that the stuff on Twin Earth that I earlier *mistook* for water isn't really water. In the same way, if you describe not another planet in the actual universe, but another possible universe in which there is stuff with the chemical formula XYZ which passes the 'operational test' for *water*, we shall have to say that that stuff isn't water but merely XYZ. You will not have described a possible world in which 'water is XYZ', but merely a possible world in which there are lakes of XYZ, people drink XYZ (and not water), or whatever. In fact, once we have discovered the nature of water, nothing counts as a possible world in which water doesn't have that nature. Once we have discovered that water (in the actual world) is H_2O, *nothing counts as a possible world in which water isn't H_2O*. In particular, if a 'logically possible' statement is one that holds in some 'logically possible world', *it isn't logically possible that water isn't H_2O*.

On the other hand, we can perfectly well imagine having experiences that would convince us (and that would make it rational to believe that) water *isn't* H_2O. In that sense, it is conceivable that water isn't H_2O. It is conceivable but it isn't logically possible! Conceivability is no proof of logical possibility.

Kripke refers to statements which are rationally unrevisable (assuming there are such) as *epistemically necessary*. Statements which are true in all possible worlds he refers to simply as necessary (or sometimes as 'metaphysically necessary'). In this terminology, the point just made can be restated as: a statement can be (metaphysically) necessary and epistemically contingent. Human intuition has no privileged access to metaphysical necessity.

Since Kant, there has been a big split between philosophers who thought that all necessary truths were analytic and philosophers who thought that some necessary truths were synthetic *a priori*. But none of these philosophers thought that a (metaphysically) necessary truth could fail to be *a priori*: the Kantian tradition was as guilty as the empiricist tradition of equating metaphysical and epistemic necessity. In this sense Kripke's challenge to received doctrine goes far beyond the usual empiricism/Kantianism oscillation.

In this paper our interest is in theory of meaning, however, and not in theory of necessary truth. Points closely related to Kripke's have been

made in terms of the notion of *indexicality*.[8] Words like 'now', 'this', 'here', have long been recognized to be *indexical*, or *token-reflexive* – i.e., to have extension which varied from context to context or token to token. For these words no one has ever suggested the traditional theory that 'intension determines extension'. To take our Twin Earth example: if I have a *Doppelgänger* on Twin Earth, then when I think 'I have a headache', *he* thinks 'I have a headache'. But the extension of the particular token of 'I' in his verbalized thought is himself (or his unit class, to be precise), while the extension of the token of 'I' in *my* verbalized thought is *me* (or my unit class, to be precise). So the same word, 'I', has two different extensions in two different idiolects; but it does not follow that the concept I have of myself is in any way different from the concept my *Doppelgänger* has of himself.

Now then, we have maintained that indexicality extends beyond the *obviously* indexical words and morphemes (e.g., the tenses of verbs). Our theory can be summarized as saying that words like 'water' have an unnoticed indexical component: 'water' is stuff that bears a certain similarity relation to the water *around here*. Water at another time or in another place or even in another possible world has to bear the relation *same$_L$* to *our* water' *in order to be water*. Thus the theory that (1) words have 'intensions', which are something like concepts associated with the words by speakers; and that (2) intension determines extension – cannot be true of natural kind words like 'water' for the same reason the theory cannot be true of obviously indexical words like 'I'.

The theory that natural kind words like 'water' are indexical leaves it open, however, whether to say that 'water' in the Twin Earth dialect of English has the same *meaning* as 'water' in the Earth dialect and a different extension (which is what we normally say about 'I' in different idiolects), thereby giving up the doctrine that 'meaning (intension) determines extension'; or to say, as we have chosen to do, that difference in extension is *ipso facto* a difference in meaning for natural kind words, thereby giving up the doctrine that meanings are concepts, or, indeed, mental entities of *any* kind.

It should be clear, however, that Kripke's doctrine that natural kind words are rigid designators and our doctrine that they are indexical are but two ways of making the same point. We heartily endorse what Kripke says when he writes:

> Let us suppose that we do fix the reference of a name by a description. Even
> if we do so, we do not then make the name synonymous with the description,
> but instead we use the name rigidly to refer to the object so named, even in
> talking about counterfactual situations where the thing named would not
> satisfy the description in question. Now, this is what I think is in fact true

for those cases of naming where the reference is fixed by description. But, in fact, I also think, contrary to most recent theorists, that the reference of names is rarely or almost never fixed by means of description. And by this I do not just mean what Searle says: 'It's not a single description, but rather a cluster, a family of properties that fixes the reference.' I mean that properties in this sense are not used at all. (S. Kripke, 'Identity and Necessity', in M. Munitz (ed.), *Identity and Individuation* [New York: New York University Press, 1972], pp. 135–64.)

Notes and References

1. The contributors to this area are now too numerous to be listed: the pioneers were, of course, Zellig Harris and Noam Chomsky.
2. For a discussion of this question see H. Putnam, 'The Innateness Hypothesis' etc., *Synthése*, 17 (1967), pp. 12–22, and N. Chomsky, *Problems of Knowledge and Freedom* (New York: Random House, 1971), especially chapter I.
3. This is discussed by Ziff in *Understanding Understanding* (Ithaca, NY: Cornell University Press, 1972) especially chapter VIII.
4. This tradition grew up because *the* term whose analysis provoked all the discussion in medieval philosophy was the term 'God', and the term 'God' was thought to be defined through the conjunction of the terms 'Good', 'Powerful', 'Omniscient', etc. – the so-called 'Perfections'. There was a problem, however, because God was supposed to be a Unity, and Unity was thought to exclude His essence being complex in *any* way – i.e., 'God' was defined through a conjunction of terms, but God (without quotes) could not be the logical product of properties, nor could He be the unique thing exemplifying the logical product of two or more *distinct* properties, because even this highly abstract kind of 'complexity' was held to be incompatible with His perfection of Unity. This is a theological paradox with which Jewish, Arabic, and Christian theologians wrestled for centuries (e.g., the doctrine of the Negation of Privation in Maimonides and Aquinas). It is amusing that theories of contemporary interest, such as conceptualism and nominalism, were first proposed as solutions to the problem of predication in the case of God. It is also amusing that the favorite model of definition in all of this theology – the conjunction-of-properties model – should survive, at least through its consequences, in philosophy of language until the present day.
5. Or rather, they will report: 'On Twin Earth (*the Twin Earthian name for Terra* – H.P.) the word "water" means H_2O.'
6. The substance of this section was presented at a series of lectures I gave at the University of Washington (Summer Institute in Philosophy) in 1968, and at a lecture at the University of Minnesota.
7. This assumption is not actually needed in what follows. What is needed is that the same *natural kind* can exist in more than one possible world.
8. These points were made in my 1968 lectures at the University of Washington and the University of Minnesota.

13

GARETH EVANS

(1946–1980)

The British philosopher Gareth Evans studied under Peter Strawson at Oxford where he returned to lecture, becoming Wilde Reader in Mental Philosophy until his death at the age of thirty-four. He was part of a group of brilliant young Oxford philosophers, among whom were John McDowell, Christopher Peacocke and Crispin Wright, who since have left their distinctive marks on philosophy of language and mind in the English-speaking world. Evans's untimely death was a great loss for British philosophy. His major book, *The Varieties of Reference* (1982) published posthumously, was edited by his friend and colleague John McDowell and presents the most complete account of his views. Much of Evans's work centred on issues of meaning and reference, but his views of language also have repercussions for philosophy of mind and our self-understanding, for example, his discussion of questions of self-identification (chapter 7) where he demonstrates his radical anti-Cartesianism. According to Evans, thinking is necessarily grounded both in our bodily characteristics and abilities and in the external environment. Such a view precludes the Cartesian solipsistic view of mind and thought.

In his well-known earlier article 'The Causal Theory of Names' (reproduced in his *Collected Papers*, 1985), Evans develops his distinctive theory of reference by criticizing and refining Kripke's account of names. For Kripke, names preserve their reference after the initial act of dubbing by being used in a 'meaning-preserving' way. This, according to Evans, cannot account for instances where there have been unintended changes of meaning, nor for cases where a name changes its reference over time, or when the causal chain of a name's use breaks down. For instance, the name Madagascar was originally applied to a part of the African mainland. Subsequently it referred to an island off the coast of Africa, because of a mistake made by Marco Polo. Kripke's theory is incapable of explaining such changes: it would oblige us to think of Madagascar as referring to the mainland. Evans proposes that we should supplement the

Kripkean account with further considerations about the way individuals grasp the sense of a name when they use it. He distinguishes between the theory of what a speaker denotes by a name and the theory of what a name denotes, the description theory and the causal theory respectively, and finds both these views inadequate. The reference of a name is determined by the causal route involving the original dubbing and the subsequent uses of the name, but the beliefs and other information associated with the use of the term are also of relevance. Thus an intentional account of names is a necessary corrective to the purely causal account.

The extract which follows is from the concluding chapter of *The Varieties of Reference* where Evans pursues and refines some of the points touched upon in his earlier (1985) article. He addresses the question of proper names in particular, and discusses the issue of an appropriate theory of reference and meaning, and hence understanding, for them. Once again he argues for the necessity of appealing to facts beyond the elegant but over-simple Kripkean view. He first introduces a distinction between the 'producers' and the 'consumers' of a name. The producers of a name are those involved in the initial naming, maybe through baptism, of an object *x*. This group will have dealings with *x* and use the name when speaking of *x*. The 'consumers' of a name, on the other hand, will not be acquainted with *x* and will not be able to add new information about *x* to the practice of using the name *x*. Evans believes his position to be a refinement of Putnam's view on the division of linguistic labour (see chapter 12), since in this account it is made clear that the producers of a name are in no way dependent on the consumers for the use of the name, while the consumers are totally dependent on the producers. Evans emphasizes that we should regard communication through the use of a name as part of a larger picture involving other speakers, hearers, and various communicative episodes.

In addition, we should pay attention to the various stages in the history of the use of a name. Evans asks us to think of the activities of the producers of names when they use the name in connection with a given object or, as he calls it, 'the name-using practice'. He argues that the use we make of a name depends on the existence of shared, community-wide, coherent practices involving the use of that name to refer to a particular object. The importance of this departure from Kripke becomes clear when we consider instances, as in the above example, where the reference of a name changes within the community of the users without there having been an explicit intention or decision on the part of the speakers to bring about such a change. He also distinguishes between various phases of name-using practices. In the early stages, all the par-

ticipants in the name-using practice are likely to be producers. In the more mature phase, consumers are introduced to the practice and sustain it by continuing with that practice. In the last phase of the life of a name-using practice, all the participants are the consumers. Evans discusses the 'late phase of the life of name-using practice' (*The Varieties of Reference*, p. 391) in section 11.4 of 'Proper Names'. Sadly he was prevented from revising the arguments of this section. None the less Evans's work enhanced the social dimension of Kripke's and Putnam's externalist views of meaning and refined their initial broad-stroke approach.

Works by Evans

1976 Evans, Gareth and McDowell, John (eds), *Truth and Meaning*. Oxford: Clarendon Press.
1982 *The Varieties of Reference*, ed. John McDowell. Oxford: Clarendon Press.
1985 *Collected Papers*. Oxford: Clarendon Press.

Works on Evans

Blackburn, Simon, *Spreading the Word: Grounding in the Philosophy of Language*. Oxford: Clarendon Press, 1984.
McCulloch, G., *The Game of the Name*. Oxford: Clarendon Press, 1989.
Mark Sainsbury, 'Gareth Evans: The Varieties of Reference', *Mind*, 94 (1985), pp. 120–42.
Wright, Crispin, 'Theories of Meaning and Speaker's Knowledge', in his *Realism, Meaning and Truth*. Oxford: Oxford University Press, 1993 (2nd edn), pp. 204–38.

From 'Proper Names'

1. The Contrast with 'One-off' Devices

Hitherto we have considered what might be called 'one-off' referential devices: the functioning of such a device does not depend upon the existence of any practice, within the community, of using that device to refer to a given thing. The 'social dimension' of language is not wholly absent from these referential performances, since the speaker relies upon the existence of a practice, within the community, of using this or that expression (e.g., 'he') to refer to a certain sort of thing (e.g., a male thing). But the fact that an utterance involving a 'one-off' referential device represents a particular individual is clearly to be explained in terms of the thoughts and attitudes of those immediately involved with that particular utterance; whereas with proper names, it appears, we have linguistic symbols which represent particular individuals in something like the way in which concept-expressions represent concepts or functions; and so the fact that an utterance containing a proper name represents a particular individual is far less dependent upon the thoughts and attitudes of those immediately involved with that particular utterance. The contrast I am trying to draw in the case of singular terms can be discerned in the case of concept-expressions, if we compare the use of such utterances as 'It was red' and 'He had a limp' with the use of 'It had *that* colour' and 'He walked like *this*'.[1]

The fact that linguistic symbols are ambiguous means that the representational properties of particular utterances cannot be explained in complete independence of the thoughts and intentions of those involved with them. If a speaker is to say something using a proper name, he must make it clear which individual's name he is using. This has led some philosophers to assimilate the use of proper names to the various kinds of demonstrative reference we have previously been studying. 'Jack Jones is *F*' is interpreted as 'That Jack Jones is *F*', which itself amounts to

something like 'That man called "Jack Jones" is *F*'. The demonstrative element is presumably intended to suggest that the speaker is adverting to some information in common possession; the demonstrative may be a 'testimony demonstrative' or a 'memory demonstrative'.[2]

I do not have a knock-down argument against this view, but it does seem to me to fail to bring out the way in which utterances containing proper names are dependent upon the existence and coherence of a general practice of reference. Suppose, for example, that the speaker and the audience inhabit a community in which the name 'Jack Jones' was bestowed upon two individuals who happened to look alike, with the consequence that they were regularly confused. Instead of there being two separate name-using practices, it may be that information from both men has become merged, so that there is a single name-using practice with no one referent. In this community, I would maintain that the name 'Jack Jones' does not have a referent. Utterances involving the name are flawed because of a widespread confusion. And, it seems to me, this is the right thing to say about *any* utterance involving the name in this community, even when it so happens that the speaker and the audience both have in mind just one (the same one) of the men whom the community has confused. If we construed an utterance of 'Jack Jones is *F*' as involving a 'one-off' reference, we might have to suppose that the speaker had successfully let the audience know which person he had in mind (a person who, by hypothesis, 'is a Jack Jones'). But when we place the utterance in its social setting, we can see how the flaws in the practice are necessarily inherited by the utterance. The hearer may acquire a true thought about the person the speaker has in mind, but he has not been *told* something true: he has not been given some information, linguistically represented, which he can take away from the utterance and put to use in further conversations.

Hilary Putnam once wrote:

> ... there are two sorts of tools in the world: there are tools like a hammer or a screwdriver which can be used by one person; and there are tools like a steamship which require the cooperative activity of a number of persons to use. Words have been thought of too much on the model of the first sort of tool.[3]

I do not think Putnam has identified quite the right parallel, since the traditional position has always been to regard words as instruments for communication, and hence as tools which two people 'use'; a better contrast would be one between a steamship or a factory on the one hand and a double-handed saw on the other. Nevertheless, I think Putnam's contrast is clear; and while a viewpoint which takes the two-person

communicative situation as basic seems appropriate for 'one-off' referential discourse, it seems to me absolutely correct to regard interpersonal communication involving a name as essentially a fragment of a larger picture: something which can be understood only when the other elements of that picture – other speakers, hearers, and communicative episodes – are taken into account.

The change in viewpoint I am recommending forces us to think about two interconnected things. We have to ask: What makes it the case that a symbol has the property of representing, or referring to, a particular individual? Is the connection with the thoughts and attitudes of users of the expression wholly severed? And if, as seems likely, it is not, then we have to ask two related questions. First, how are the social facts (e.g., the fact that such-and-such an expression is a name of such-and-such an object) dependent upon facts about the psychology of individuals? Secondly, and conversely, what is the role of linguistic symbols, whose semantic properties are a social matter, in the psychology of the individuals who use them? These are instances of general problems in the theory of language, but we cannot assume that the answers are going to be the same in all cases.

2. *Proper-name-using Practices*

Let us consider an ordinary proper-name-using practice, in which the name 'NN' is used to refer to the person x.[4] The distinctive mark of any such practice is the existence of a core group of speakers who have been introduced to the practice via their acquaintance with x. They have on some occasion been told, or anyway have come to learn, a truth which they could then express as 'This is NN', where 'This' makes a demonstrative reference to x. Once a speaker has learned such a truth, the capacity to re-identify persons over time enables him to recognize later occasions on which the judgement 'this is NN' may be made, and hence in connection with which the name 'NN' may be used. To have an effective capacity to 'go on' in this way would normally require a recognitional capacity for x, in the sense of chapter 8 [of *The Varieties of Reference*], and an association of the name 'NN' with that capacity (i.e., the subject can recognize x as NN); though we must remember that x himself may have a capacity to use his own name from time to time. Members of this core group, whom I shall call 'producers' (for a reason that will become apparent), do more than merely use the name to refer to x; they have dealings with x from time to time, and use the name in those dealings – they know x, and further, they know x as NN. They use the name in speaking to x, in giving each other commands and

instructions in connection with situations in which x has been encountered, and in transmitting information gained from their encounters with x.

The practice of using the name may originate in a baptism, or in a situation where a speaker manifestly uses an expression which is not x's given name as if it were x's name, whether knowingly (a nickname) or unknowingly (a mistake). But the expression does not become a name for x unless it has a certain currency among those who know x – only then can we say that x is *known as NN*.

Any producer can introduce another person into the name-using practice as a producer by an introduction ('This is NN'), and x may introduce himself. But a formal introduction is not necessary; the name may be picked up by observing the practice of other speakers ('Now NN has got the ball; let's see if he can do anything with it'). And there is no special importance in the first encounter an individual has with a name. A practice of using the name will normally be continually reinforced by the manifestly harmonious practice of others, and subsequent acquaintance with the practice of others can override an erroneous introduction to the use of the name.

Perhaps in the early stages of its existence all the participants in the name-using practice will be producers, but this is unlikely to remain so for long. Others, who are *not* acquainted with x, can be introduced into the practice, either by helpful explanations of the form 'NN is the ϕ', or just by hearing sentences in which the name is used. I shall call these members 'consumers', since on the whole they are not able to inject new information into the practice, but must rely upon the information-gathering transactions of the producers. What counts as an adequate introduction of a consumer into the practice is something I shall discuss below (see §3); all that matters for the general outline I am presenting is that it be acknowledged that there are non-producing participants. A speaker may be introduced into a name-using practice as a consumer by either a producer or a consumer, and once again there is no particular weight to be attached to the *first* introduction.

Although it is inexact in some respects, I have chosen the 'producer/consumer' analogy, rather than Putnam's related analogy of 'the division of linguistic labour', because his analogy suggests a mutual dependence between the two groups of name users which does not seem to me to exist. Producers stand in no need of consumers; while the dependence of consumers on producers is absolutely plain.[5] A consumer who hears and accepts a sentence of the form 'NN is the ϕ' knows, if he takes 'NN' to be an ordinary proper name, that the statement amounts to a substantial hypothesis about a particular person, a person known as NN, and that,

if it can be known to be true, this will be either because an individual observed to be the ϕ is recognized or identified as NN, or because it can be warranted by propositions known in this way. Knowing 'NN' to be an ordinary proper name, no one would dream of responding to a challenge to the statement 'NN is the ϕ' by saying 'Oh! I was under the impression that "NN" is just our name for whoever is the ϕ.'[6] When someone hears the claim 'NN is the ϕ', and takes 'NN' to be an ordinary proper name, he supposes that there is (or was) a person going about the world known as NN; and that the claim embodies not only information that there is something that is uniquely ϕ, but also an identification of that object as the object *known as NN*. It follows that a consumer who takes 'NN' to be an ordinary proper name knows that simply by being led to accept various sentences employing the name, he cannot have been given a *complete* introduction to the use of the name. He has been given certain propositions which require defence, without the means, on his own, of providing that defence. (Only a producer can provide the defence.)

Thus I am claiming that there is a difference *in kind* between the introduction to a name-using practice which a producer receives and the introduction which a consumer receives. One might say that an ordinary proper name is used subject to a convention, but that it is only the producers who can be credited with knowledge of this convention. Contrast a descriptive proper name: the convention is to use 'NN' to refer to whatever is the ϕ, and this leaves no work to be done by a distinction between producers and consumers. This convention might (though it need not) have been explicitly expressed in stipulation which initiated the practice: 'Let us use "NN" to refer to the ϕ.' Analogously, we might envisage the convention which governs an ordinary proper name as explicitly expressed in a practice-initiating stipulation: 'Let us use "NN" to refer to this man.' Knowledge of *this* convention could be manifested only in judging, from time to time, 'This man is NN'; this is something only a producer is in a position to do. If someone is introduced to the use of an ordinary name by means of an 'introduction', 'This is NN', he comes to know the convention, and thereby comes to have a knowledge of the use of the name which *does* admit of a semantical defence: he can sensibly respond to a challenge to his later utterances of 'This is NN' by saying 'Oh! I was under the impression that "NN" is just our name for this man.'

A name-using practice is sustained by two mutually reinforcing general propensities on the part of members of a speech community. First, people make an effort to learn and remember the names of persons in whom they have, or feel they might have, any interest. Second, people generally

use the name of a person (if they know it) when they are speaking of him. There are exceptions, for instance when it is taken to be common knowledge between speaker and hearer that the person spoken of bears the name he does: if a person well known to both of them is plainly visible, the speaker need not say, 'NN is up early'; he may simply say, 'He is up early'. Again, there are little communities in which the practice is to refer to a person (whose name is known) by some salient description (e.g., 'Father', 'Mother'). But, such situations apart, when there is common knowledge that a speaker does know the name, 'NN', of an individual, the failure to use that name will generate a strong implication, either that there is some special point being made by the chosen mode of reference (as in 'I'm not going to dine with the person who insults my wife'), or that the speaker does not believe that the individual referred to *is* NN.

The second of these tendencies is *self*-reinforcing, for the more people conform to it, the sharper will be the sense of unwanted associations attendant on failure to use the name, and hence the stronger the motive to use the name. But it is clear that the two tendencies are mutually reinforcing. The more it is the practice of speakers to refer to persons by name, the more important it will be, for those wishing to gain information about, or enter into discussions of, a person, to know his name. Conversely, the more people can be relied upon to know the names of individuals, the more speakers will be provided with a motive to use those names, rather than cast about for other ways of identifying the referent of their remarks for their audience.

Underlying these tendencies is the fact that generally speaking there will not be a naturally arising overlap between the information possessed by different people, adequate to ensure that any pair of people who possess information from an individual, and who can profitably engage in discussion and exchange of information, will be able to do so using a description. Think, for example, of a fairly large factory. Two people who both have information from a certain worker may not *eo ipso* have any clear way of achieving communication about him. Even if they both have met him, most people are bad at describing someone's appearance (even when they have an effective recognitional capacity for the person in question); so unless the person has a highly distinctive appearance, no such description will serve. And it is easy to construct (and find) cases in which no other description will serve either. The institution of bestowing a name on someone – thereby producing an arbitrary distinguishing feature which everyone learns – certainly lessens the difficulty of achieving referential communication. (It is true that people share names, but the supplementation of a name by some other piece of information,

which by itself would have been virtually useless, is often adequate.)

Theoretically, names as we know them might be eliminated in favour of, say, dates of birth. We can imagine a community who make it a convention to learn some particular piece of antecedent information about people, for instance their dates of birth, and to use the dates in referring to people. But these linguistic devices would simply *become* names. The practice of referring to a person by a date of birth would not rely upon each participant's independently established information that the person in question was born on the day in question, with communication depending upon the likelihood that the person concerning whom X has received the information that he was born on that day is the same as the person concerning whom Y has received the information that he was born on that day. Communication would depend, rather, upon the probability that each participant has been properly initiated into the practice of using the expression to refer to a given person.[7]

An ordinary proper-name-using practice can be thought of as having a natural life-cycle. We have traced it from infancy to maturity. In its maturity, producers will gather information, which will then circulate more or less widely among both producers and consumers, being linked up with information previously acquired and circulated, so that some information which almost everyone associates with the name is the result of the information-gathering transactions of others. In its final phase, which may last for a very long time, the name-using practice has only consumers as participants, with the stock of information existing from the time of its maturity usually diminishing as time passes. I shall say something about the last phase of the life-cycle elsewhere; for the present, I shall concentrate upon ordinary proper-name-using practices in their maturity.

It is easy enough to understand what is meant by saying that a name-using practice *survives* over time; the practice survives through the introduction of new members by those who are already members. But something should be said about what is meant by 'a *single* name-using practice'. What differentiates practices is not the individuals named; intuitively, we can have a single practice which concerns two individuals, and two practices which concern the same individual. The first kind of case can come about in two rather different ways. A good number of the producers may regularly confuse two individuals; or, alternatively, the producers may divide into two groups, each regularly and consistently recognizing one of the two individuals, without this being known, so that information from two different individuals is pooled as information 'about NN'. (It would be extremely unlikely, though not impossible, for this fact to remain undiscovered.) A most vivid example of the second kind of case is found in R. L. Stevenson's *Dr Jeckyll and Mr Hyde*, in

which two names, believed to refer to different persons, are in fact used of the same person. But the distinctness of the names is not essential for the distinctness of the practices: Stevenson could easily have told the story with the same name used in two distinct practices, with no one having the least idea that the nice Mr Hyde and the terrible Mr Hyde are one and the same person. So what is it for there to be one rather than two 'Hyde'-using practices? Intuitively, there exist two distinct practices involving the use of the name 'NN' if uses of the name can be associated with two distinct networks of communication in the community, such that information circulates through each network, but does not pass between the networks.

3. The Determination of the Reference of a Proper Name

It seems reasonable to suggest that what makes it the case that an ordinary proper-name-using practice involving the name 'NN' concerns a particular individual is that that individual should be *known to the producers in the practice as NN*. It is the actual pattern of dealings the producers have had with an individual – identified from time to time by the exercise of their recognitional capacities in regard to that individual – which ties the name to the individual. The information circulating in the practice will normally provide good evidence for which individual it is that has been recognized from time to time as NN by the producers in the practice, for much of it will be a trace of some encounter between a producer and an individual, although countless equally relevant identifications of an individual as NN will leave no permanent trace upon the practice.

To see the actual pattern of recognition and identification by the *producing* members of the practice as the fundamental mechanism whereby ordinary proper names are endowed with a reference is to see a parallel between those names and the ordinary words we have for *natural kinds* of things and stuffs. It is an essential feature of the practices associated with terms like 'elm', 'diamond', 'leopard', and the like that there exist members – producers – who have a *de facto* capacity to recognize instances of the kind when presented with them. I mean by this an effective capacity to distinguish occasions when they are presented with members of that kind, from occasions when they are presented with members of any other kinds which are represented in any strength in the environment they inhabit. This recognitional capacity is all that is required for there to be consistent pattern among the objects which are *in fact* identified as elms, or whatever, by members of the speech community – for all the objects *called* 'elms' to fall into a single natural

kind – and no more is required for a natural-kind-term practice to concern a particular natural kind.[8] Although many utterances of producers, and all utterances of consumers, in the kind-term practice have other functions, there will be a subset of utterances involving the term in which some particular tree or trees may be said to have been (authoritatively) *called* by that term. It is these utterances involving the term – which may be regarded as the point of contact between the practice and the world – that determine which kind the term, as used throughout the practices, refers to. If the predicate 'called "an elm" ' is understood in such a way that trees which have never been perceived cannot satisfy the predicate, then it is correct and illuminating to say that something falls into the kind referred to by 'elm' if and only if it is of the same kind as the trees called 'elms'.[9]

I am suggesting that we attribute just as much importance to the analogous point of contact between a name-using practice and the world – that we regard a name-using practice as concerned with the object (if any) which is regularly *called* 'NN' by *producing* members of the practice. Provided that some one individual is consistently and regularly identified by producers as NN (known as NN), that individual is the referent of the name as used by participants in the practice. And it is in terms of this notion of a name's having a reference that we should seek to understand particular utterances involving the name, *whether uttered by producers or by consumers*. For when a speaker refers to an object by using a name, this will be because he intentionally utters a name which in fact has that object as its referent.

The precise statement of the way in which individual utterances exploit the general practices of the community must be a little complicated, because of the possibility of there being several distinct practices in the community involving the same name. If a speaker is to refer to something by using a name, then it is necessary that he manifest *which* name-using practice he intends to be, and to be taken to be, participating in.

It would be a mistake to regard this intentional element simply as the application to the case of names of the general requirement we have encountered previously (*Varieties of Reference*, 9.2), that the speaker manifest which *object* he intends to be (taken to be) referring to. It may help to grasp the point I am making if we think of individuating the words of a language not only phonetically but also by reference to the practices in which they are used. In these terms, the requirement on a speaker using a proper name is not that he indicate which *object* he intends to be (taken to be) referring to, but that he indicate which *name* he intends to be (taken to be) using. (Cf. 3.2.)

It is true that the conception which the speaker has of the referent of

a name – the information which he has associated with the name – will be relevant in determining what he refers to by using the name. But this will be not by directly indicating which object he means (in the manner of a 'one-off' referential device), but by making it clear which name-using practice he intends to be (taken to be) participating in. This is why, if the speaker says (in further explanation after an utterance of 'NN is F') that NN is the ϕ, we do not necessarily conclude that by 'NN' in his utterance of 'NN is F' he meant to refer to the ϕ. We use his statement that NN is the ϕ as evidence for which name-using practice he has come into contact with, and thereby which name-using practice he intends to be (taken to be) participating in. If 'NN is the ϕ' expresses a piece of misinformation widely disseminated in a practice in which 'NN' is used as a name for x, then we shall conclude that the speaker intended to use x's name, even though x is *not* the ϕ.[10]

It is quite easy to see how *all* the information in possession of a *consumer* may be false of the referent of the name. In fact a tremendous amount of false and quite groundless information may be circulating in the community, about NN, without there being any change in the kind of facts which determine an individual as the referent of the name. Malicious rumours, or absurdly inflated claims, equally baseless, may circulate, and such misinformation may be all that ends up associated with the name in the minds of consumers. Nevertheless, they have got hold of rumours and claims *about a particular man*. As it was used in conveying the misinformation to them, and as it is used by them in further transmitting that misinformation, the name has, and is understood by the consumers to have, a quite definite reference, provided for it by the practice of those who know some individual as NN (namely the producers). So it would be generally understood than an enquiry into the truth or falsity of those rumours and claims would require an identification of the object which is known as NN: a procedure which leaves open the possibility of the discovery that the rumours and claims are false. What would begin to undermine the link between the name-using practice and the individual is misidentification of another individual as NN by some producers, and I shall discuss this kind of change in a moment. But it is clear that wholly baseless information can end up associated with a name in the minds of consumers, without any such disturbance to the practice of calling an individual by that name.

There are two different ingredients, then, in my account of reference by names: first, an account of the mechanism whereby a *community-wide* name-using practice concerns a particular object (and hence whereby a name is endowed with a reference); and second, an account in terms of the notion of a name's having a reference in a community, of how

individual speakers refer by the use of the name. These two ingredients can be regarded as corresponding roughly to two elements in Saul Kripke's picture of reference by names.[11] Corresponding to the first ingredient is Kripke's idea that names are endowed with a reference by an initial baptism, or at least a decision on the part of some person or persons to initiate a practice of using a name in a certain way. And secondly, individual uses of a name are assigned a reference, according to Kripke, in terms of this fundamental mechanism, by an appeal to what we might call the Recursive Principle: namely, that if someone acquires his use of a name from a speaker (or speakers), and is speaking in causal consequence of that acquisition, then the name on his lips will refer to whatever was referred to by that speaker (or those speakers) in those name-using episodes from which his use of the name derives.[12]

This picture of Kripke's is extremely simple and elegant. In particular, it is simpler than mine in making no appeal to the idea of a name-using *practice*. However, I do not believe that an appeal to this idea can be avoided. For the use we make of a name depends upon the existence in our community of coherent practice of using that name to refer to a particular object. If the name-using practice in which I participate by my use of a name has come to concern two different individuals, because the producers now regularly confuse two men, then my use of the name is without a referent, no matter what the facts are about the origin of my own particular use of the name. For example, when the name-using practice originated, it may have concerned no one but x, and I may have been initiated into the practice, as a consumer, at that time. Since I acquired my use of the name from people who used the name to refer to x, Kripke would hold that in my present uses of the name I am myself referring to x, even if the presence of a similar-looking person, y, has, for a considerable length of time, confused the producers. But this is surely incorrect: I cannot be insulated from the deficiency of the practice to which I must inevitably appeal.

Kripke's Recursive Principle was designed to capture the intuition that a *consumer* who acquired his use of the name 'NN' by hearing remarks, 'NN is F', 'NN is G', etc., from others would, in his subsequent uses of the name 'NN' depending upon this initiation, refer to whichever individual those others were referring to. Now, I have already implicitly claimed that the Recursive Principle gives conditions too weak for reference by name, since I have insisted that it is a necessary condition that the speaker be able to *make manifest* which name-using practice he intends to be participating in – which name he intends to use. If someone overhears a snatch of conversation, say, 'Harry Lyons was angry last night', that being the entirety of his introduction to the 'Harry Lyons'

practice, then he is not in a position to use the name in order to make statements – he has not been adequately introduced into the practice. An adequate introduction must, surely, enable a speaker to go on on his own, using the name in the transmission of information to other members of the practice who are unacquainted with the particular facts of his introduction into the practice; whereas the person who picks up the name by overhearing a snatch of conversation is not an adequate link in any chain of transmission of knowledge.

This is not, ultimately, a very significant departure from Kripke, since I do not think that any support for the theories to which Kripke is opposed can be derived from it.[13] Even so, I should like to dispense with the Recursive Principle, because it seems wrong to invoke a principle specifically concerned with reference to explain the fact – which is not specifically concerned with reference – that individual speakers exploit general practices. The general principle is this: if a speaker uses a word with the manifest intention to participate in such-and-such a practice, in which the word is used with such-and-such semantic properties, then the word, as used by him, will possess just those semantic properties. This principle has as much application to the use by speakers of words like 'agronomist', 'monetarism', and the like as to their use of proper names. And it can be used to explain the intuition which the Recursive Principle was designed to explain, since it is reasonable to attribute to a speaker the intention to participate, by his use of a name, in the same practice as was being participated in by those speakers from whose use of the name the information he has associated with the name derives.

In giving an account of the mechanism whereby a name is endowed with a reference, I have also found it necessary to appeal to a richer and more complicated set of facts than Kripke's initial baptism, or deliberate reference-initiating act: namely, the activities of the producers, in their practice of using the name in connection with their encounters with a particular object. One of the ways to see the importance of this range of facts in determining the reference of a name is to imagine a case in which they change: a case in which there is an alteration in the identity of the individual which the producers recognize as NN. Such a change can, at the very least, bring it about that a name ceases to have a referent in the community, and, when the circumstances are right, such a change can lead to the name's acquiring a new referent in the community. A transition of this kind can take place without anyone deciding or intending to initiate a new practice with the name. I think it worth studying such a hypothetical change in detail, for only in this way can we be sure that the two ingredients in my account of reference by names work together in a plausible and coherent way.

Let us begin, then, with a mature name-using practice, built around a core group of speakers who regularly and reliably recognize an individual, x, as NN. We may assume that they are surrounded by a group of consumers, and that information derived from their encounters with x is distributed throughout the practice. Subsequently, let us suppose, x disappears from the scene, and, at the same time, some producers begin to misidentify a different but similar-looking individual, y, as NN. At this early point, of course, the name 'NN', as used by anyone who participates in this practice, still refers to x. All these uses of the name involve a manifest intention to be participating in a practice which undeniably concerns x, since the previous and well-established use of the name by the producers in the practice determined x as the referent of the name in that practice. This will remain the case even if, as we shall suppose, the mistake spreads to a large number of the producers. Someone can discover what has gone on, and report his discovery by referring to y and saying 'This is not NN'.

Suppose now that the substitution of y for x goes unnoticed,[14] and that y is recognized by the producers of the practice as NN for as long a period as x formerly was. Information from y is now disseminated around the practice, and, given the normal operation of human memory, such information is likely (though not certain) to outweigh information derived from x, though, presumably, a good deal of that information remains. At this point, I think we can say that the name 'NN', as used in this practice, no longer has a referent. The persistent identification of y as NN has undermined the connection which tied the name uniquely to x. It is certainly no longer possible to report what has happened by referring to y and saying 'This is not NN.' Indeed, such a remark will not have any definite truth value.

Somewhat artificially, we can think of progress to this mid-point in the history of the name-using practice as consisting in a sequence of uses of the name, u_1, u_2, \ldots, u_n, commencing at the disappearance of x. Each u_i can be thought of as involving the manifest intention to be participating in the practice to which the previous utterances belonged. In the normal course of events, this would mean that each u_i would have the same referent as the previous uses. But the course of events we have described is not normal, for the practice is changing in precisely the respects which endow the name it concerns with a referent. The practice with which u_n associates itself, comprising, as it does, many uses of the name in consequence of identification of y as NN, is not one which uniquely concerns x, as did the practice with which u_1 associated itself. We must remember that a use of a name by a producer has two aspects. One is the purely semantical aspect – enquired into by the question 'To what

does this use of the name refer?' The other might be described (very vaguely) as an epistemological aspect: it is enquired into by the question, 'Which object's identification as NN underlies this use?' Now my account of the reference of a name in a practice makes it dependent upon the *second* of these two aspects. I do not say that the reference of a name in a practice is a function of the *reference* which the name had in prior uses by producers; this principle is a recursive principle which would preclude precisely the kind of change which I am attempting to describe. What I say is that, although those early mistaken uses, u_1, u_2, ... etc. involved reference to x, they were beginning, by their second, epistemological aspect, to undermine the semantical connection between the name and x, which has, by the point we are describing, finally snapped.

Although the name has, by this mid-point, ceased to refer to x, I do not think that we can yet say that it has become a name for y. A good many of the producers will retain information from their encounters with x – will remember x – and so will be prepared to acknowledge (if the facts come out) that their use of the name involves some confusion. And, even if we imagine the gradual replacement of producers who knew x with new members of the practice, introduced into it as producers by reference to y, so that a point is reached at which only people who are thinking unconfusedly of y are producing members of the practice, still it does not seem to me to follow that the name has become a name for y. For there may remain, embodied in the practice, a good deal of information derived from x, and these are traces of the practice, in the past, of using the name to refer to x.[15] So long as any serious quantity of these traces remains, the practice can still reasonably be said to embody a confusion: facts about the past use of the name to refer to x will not be of purely etymological significance. This explains why a change in the reference of a proper name is so much more difficult than a change in the extension of a natural kind term; for natural kind terms carry with them relatively little information about the kind.[16] It also explains why a change in the reference of a name for a place is so much easier to imagine than a change in the reference of a name for a person.[17]

Nevertheless, there is no theoretical obstacle to the loss of all information derived from x; and when this happens, the name may finally be regarded as a name of y. There is a group of speakers who call y 'NN' – who know y as NN – and no group of speakers who know anything else as NN is relevant any longer. From the point of view of the users of the name, it is as though the previous practice – the one concerning x – had never existed. If someone attempts at this point to say, of y, 'This is not NN', there is nothing in the practice itself to which he can appeal. All he can do is tell a story about how y got his name.

Notes and References

1. There are difficulties in assimilating proper names to symbols belonging to a language (like 'red' or 'limp'), just because the groups of people who know these expressions are often so small. (There is clearly *some* useful notion of the English language according to which proper names are not parts of it, but at best parts of particular idiolects.)

2. For this account of proper names, see Tyler Burge, 'Reference and Proper Names', *Journal of Philosophy*, 70 (1973), pp. 425–39.

3. H. Putnam, *Mind, Language and Reality*, (Cambridge: Cambridge University Press, 1975), p. 229.

4. Since writing this chapter, I have found the terminology of 'proper-name-using practices' used, with a different meaning, by Michael McKinsey, 'Names and Intentionality', *Philosophical Review*, 87 (1978), pp. 171–200. (He takes as basic the notion of an *individual's* practice with a name.) The model I shall generally follow is that of personal proper names; but it seems to apply fairly well to proper names for animals, places, buildings, pieces of music, ... – cases in which, although 'recognition' is perhaps not always the right word, there is *presentation* of an object.

5. 'Consumers' is here used to mean 'non-producing consumers': in a wider use of the term, producers of information are themselves consumers.

6. Throughout *The Varieties of Reference* (but see especially 1.7, 1.8, 2.3), I have emphasized that there is nothing incoherent in the idea of a proper name for which this kind of response would be appropriate, and examples actually occur: 'Jack the Ripper' is the name bestowed on whoever performed certain gruesome murders, and 'Deutero-Isaiah' is the name scholars use to refer to whoever it was who wrote the second part of the Book of Isaiah. But these are definitely not ordinary proper names.

7. This case brings out the fact that what matters is not that the name has been *assigned* to the thing but that it is used for the thing. (Cf. G. E. M. Anscombe, *An Introduction to Wittgenstein's Tractatus* ([London: Hutchinson, 1959], p. 41.) [The linguistic devices in question might have the syntactic form of definite descriptions: 'the man born on ...' On that supposition, the case is an example of the use of definite descriptions in a way that makes them approximate to proper names, a discussion of which is promised in 9.3 of *The Varieties of Reference*.]

8. I have not attempted to give a full account of what a capacity to recognize members of a kind consists in. A capacity to recognize elms *does* require a capacity to distinguish elms from all other trees growing in appreciable numbers in the community's environment, but it does not require a capacity to distinguish elms from every other kind of tree in the universe. I believe that the concept of knowledge holds the key to the principle at the bottom of this intuition (cf. *Varieties of Reference*, 8.3). Someone who has acquired the capacity to recognize members of a kind from his encounters with some of them must be able to be regarded as expressing *knowledge* when he

groups a new tree with these previously encountered trees. And the existence of elm-like trees which are not elms in small numbers in his environment, or in large numbers outside his environment, does not prevent us from regarding a producer as knowing that a new tree is of the same kind as the previously encountered trees. The claim to knowledge extends further. For if the producer had learned in previous encounters, concerning the kind, that its members are F (e.g., that they burn well), then we shall wish to allow that he knows of the new tree that it is F too. This is, no doubt, the basis of our concern for underlying structure, for if a new instance is only superficially similar to previously encountered instances, then it will be only an accident if it too is F.

9. This proposal is often wrongly conflated with the genuinely circular proposal: something falls into the kind referred to by 'elm' if and only if it is capable of being correctly called 'an elm'.

10. We shall not conclude even that the speaker's intended referent was *that ϕ* (i.e., the source of the particular information he has received). For information from some other object may become wrongly attached to a name, as in those many cases in which legends of minor individuals have become attributed to more important figures. (We are here reminded once more of how superficial the notion of *identifying for an audience* is. See *Varieties of Reference*, 6.4.)

11. See S. Kripke, 'Naming and Necessity' in D. Davidson and G. Harman (eds), *Semantics of Natural Language* (Dordrecht: Reidel, 1972).

12. I have eliminated from this formulation of Kripke's views the suggestion, which must surely have been unintended, that only the first contact of the speaker with the name-using practice matters for determining the reference of the name as used by him.

13. To be in a position to make clear which name-using practice you intend to be participating in, it is neither necessary nor sufficient that you have a discriminating conception of the relevant object, in the sense of Chapter 4 of *The Varieties of Reference*. I have allowed the adequacy of information which is wholly false of the object in making one's name-using intentions clear; while sentences linking a name with a perfectly good discriminating description, like 'NN is the man my father quarrelled with last night', may not be adequate introductions to a name-using practice.

14. If the proper names are names for persons, then, in order to tell a plausible story of this kind, we must explain why y does not himself point out the error. Perhaps y is suffering from amnesia.

15. Misinformation retailed about x but without any source will not be relevant.

16. Some examples of changes in the reference of natural-kind terms: 'albatross' derives from the Spanish 'alcatraz' ('pelican'); 'buffalo' is from a Greek word for a North African antelope; 'daffodil' is from 'asphodel', but the daffodil does not grow in Greece; 'turkey' was originally applied to the guinea fowl, which was brought to Western Europe via Turkey – the bird we now call 'turkey' is native to the New World; 'birch' derives from a

word meaning 'white, bright tree', originally applied to the mountain ash; 'oil' derives from a word for the olive tree; 'grouse' was once applied to bustards; 'apple' was formerly used for all fruit other than berries, and 'cobra' for all snakes.

17. These considerations do not necessitate any substantial change in our description of the mechanism whereby a name is endowed with a reference. They simply suggest that the group of producers whose use of the name is relevant should include both such contemporary producers as there are and also those producers whose identification of something as NN has left a trace upon the practice.

14

RUTH BARCAN MARCUS

(1921–)

Ruth Barcan Marcus is Reuben Post Halleck Professor of Philosophy at Yale University where she also did her graduate work under the supervision of Frederic B. Fitch. She was a post-doctoral fellow (1947–8) in Chicago where she attended Rudolf Carnap's seminars. She also set up a new Department of Philosophy in the University of Illinois' Chicago campus in the mid-1960s. She is best known for her ground-breaking work in the area of modal logic. In a series of articles, published in the *Journal of Symbolic Logic* in 1946 and 1947, Marcus (then Barcan) pioneered a system of quantified modal logic (a formal system which contains both modal operators, *possibly* and *necessarily*, as well as the quantifiers, *some* and *all*). Marcus's fame in the area of modal logic is, in part, due to the Barcan formula which, in one version, states: 'If it is possible for some *x* that *x* is A then there is some *x* that possibly is A'.

These papers, which contained the famous proof of the necessity of identity for a system of second-order quantified modal logic, precipitated a long-drawn-out and highly influential debate with Quine on the very possibility of modal logic and what came to be called 'the varied sorrows of modality' (*Modalities*, 1993, p. 5). The thesis of the necessity of identity, which was subsequently defended by Kripke as well, states that if *a* and *b* are identical then they are necessarily identical, for example, if the morning star is identical with, or the same as, the evening star, then it is necessarily so. Quine complained that this view commits us to essentialism, the view that there are sortal attributes which are essential to all the individual members of a natural kind, and various other unwelcome metaphysical commitments. Professor Marcus defends modal logic because, she suggests, 'Modal logic is worthy of defense, for it is useful in connection with many interesting and important questions, such as the analysis of causation, entailment, obligation, and belief statements, to name only a few' (*Modalities*, p. 7). Marcus also defends

a type of Aristotelian essentialism (p. 57) and thus anticipates aspects of the later work of Kripke and Putnam (chapters 11 and 12).

In 1961 Barcan Marcus presented 'Modalities and Intensional Languages' to the Boston Colloquium and Quine commented on the paper. The paper contains many of the main points of Barcan Marcus's work on logical, semantical and metaphysical issues related to modal logic. Her views on reference and meaning are in line with the anti-descriptionist approaches explored in the preceding chapters of this book. She draws a sharp distinction between names and descriptions and argues that 'a proper name has no meaning. It is not strongly equatable with any of the singular descriptions of the thing …' (*Modalities*, p. xiii). Rather, she sees proper names as tags that are attached to objects (p. 33). This view anticipates the direct reference theory which was later developed independently by several other philosophers, including Kaplan. It also entails Kripke's thesis of rigid designation (chapter 11).

'Some Revisionary Proposals About Belief and Believing – reproduced in this collection –' represents some of Marcus's most recent thinking on the issue of belief. Marcus's target is what she calls the 'language-centred theories of belief' according to which 'the objects of believing are always linguistic or quasi-linguistic entities such as Frege's propositions or "thoughts" or Davidson's interpreted sentences' (*Modalities*, p. 234). In an earlier article Marcus had argued that one cannot believe the impossible: one cannot have beliefs in the necessarily non-actual, for instance, contradictory states of affairs (*Modalities*, p. 146). In the present paper she contends that a belief is a relation to a possibly non-actual state of affairs whose constituents are actual objects. In addition to its positive contribution to our understanding of beliefs, the paper is important as a corrective measure to certain extremist tendencies in modern philosophy of language. Marcus singles out Donald Davidson (chapter 9), and Jerry Fodor, in particular, for their extreme views on the relationship between language and thought. As we have seen, Davidson claims that non-language users cannot have beliefs, desires, or, more generally, thoughts. Fodor, (*The Language of Thought*, 1975) also believes that the objects of belief are linguistic entities that are inscribed in the mentalese, or the language of thought. Marcus argues that language-centred approaches to belief fail on several fronts: they exclude belief attribution to non-language users, they are incapable of making sense of unconscious beliefs, and they cannot give an adequate account of rationality. Marcus's criticism will apply equally to Michael Dummett's claim (see chapter 16) that language is the necessary condition for thought, and hence that philosophy of language is the *first* philosophy.

Works by Marcus

1946 'A Functional Calculus of First Order Based on Strict Implication,' *Journal of Symbolic Logic*, 11, pp. 1–16.
1947 'The Identity of Individuals in a Strict Functional Calculus of Second Order', *Journal of Symbolic Logic*, 12, pp. 12–15.
1993 *Modalities: Philosophical Essays*. New York: Oxford University Press.

Works on Marcus

Linksy, Leonard (ed.), *Reference and Modality*. London: Oxford University Press, 1971. (Also contains Marcus's article 'Extensionality'.)
Quine, W. V. O., 'Reference and Modality', in *From a Logical Point of View*. Cambridge, MA: Harvard University Press, 1953.
Quine, W. V. O., *The Ways of Paradox and Other Essays*. New York: Random House, 1966. (This book contains articles relevant to the Barcan–Quine debate on modality.)
Sinnott-Armstrong, Walter (ed.) (in collaboration with Diana Raffman and Nicholas Asher), *Modality, Morality, and Belief: Essays in Honor of Ruth Barcan Marcus*. Cambridge: Cambridge University Press, 1995.
Wartofsky, M. (ed.), *Boston Studies in the Philosophy of Science*. Dordrecht: Reidel, 1963.

Some Revisionary Proposals
about Belief and Believing

There is consensus about some general conditions on a theory of believing and belief, such as (1) believing is a relation between a subject, the believer, and an object or set of objects as given in the grammatical form of the sentence, '*x* believes that *S*'; (2) beliefs, whatever they are, can be acquired, replaced, or abandoned; (3) beliefs enter, along with desires, needs, wants, and other particular circumstances, into the explanation of action; and (4) for some circumstances and for some beliefs, it is appropriate to describe a subject's beliefs as justified or unjustified, rational or irrational, and the like.

But such general features are in contrast to a tangle of unreconciled views that appear when one tries to flesh out a theory or give the concepts more content. There is disagreement about the nature of the belief state of the subject, the nature of the object of the believing relation, the efficacy or causal role of belief in shaping actions, and the role of language in an account of belief. There is disagreement about whether there can be unconscious beliefs, about where one draws the line between believing and acting, and about whether non-language users can have beliefs. The inventory is large.

This tangle has led some philosophers[1] to claim that discourse about belief is folk psychology to be replaced by proper science. The language of belief, they say, will fall into disuse, just as the theory of humors as an account of emotions fell into disuse.

I should like in this paper to sketch an account that may resolve some of the disagreements. In so doing I depart from some received views,[2] and hence the account may seem revisionary as an explication of belief. But it is not so revisionary as to be wholly without precedent or flagrantly out of accord with features of our ordinary understanding.

What is central in the account here presented is the departure from the dominant, language-oriented accounts of belief, which take it that the objects of believing are always linguistic or quasi-linguistic entities

such as Frege's propositions or 'thoughts' or Davidson's interpreted sentences. Since Frege, the preoccupation with belief claims, belief reports, which *are* linguistic, and the efforts of formal semanticists to provide a semantics for sentences with epistemological verbs have sometimes obscured our understanding.

We are concerned to give an account of '*x* believes that *S*'. I should like to begin with a critical examination of language-oriented views.

Language-centered Theories of Belief and Some Difficulties with Such Theories

In 'Thought and Talk', Donald Davidson[3] argues that '*x* believes that *S*' is equivalent to '*x* holds a certain sentence true' in a shared interpreted language. That sentence is '*S*' or some translation of '*S*' in the shared interpreted language. Believing is a conscious relation of subjects to their utterances. Davidson goes further and claims that even desires relate a subject to utterances. No language, then no desires or beliefs. And finally, a non-language user, he says, cannot even have thoughts.

There is a further-stated baffling claim: that we cannot have thoughts, beliefs, and even desires, without the *concepts* of thought, of belief, and of desire. With respect to belief, Davidson says, 'Can a creature have a belief if it does not have the concept of a belief? It seems to me it cannot and for this reason. Someone cannot have a belief unless he understands the possibility of being mistaken and this requires grasping the contrast between truth and error – true belief and false belief. But this contrast I have argued can emerge only in the context of interpretation [of a language].'

The view on reflection is implausible. Consider the following example: A subject, call him 'Jean', and his dog, call him 'Fido', are stranded in a desert. Both are behaving as one does when one needs and desires a drink. What appears to be water emerges into view. It is a mirage for which there is a physical explanation: such a mirage occurs when lower air strata are at a very different temperature from higher strata, so that the sky is seen as if by reflection, creating the optical illusion of a body of water in the distance. Both hurry toward it.

On what possible ground can we deny Fido a desire to drink, a belief that there is something potable there? Jean and Fido *are* both mistaken, but only a language user, Jean for example, has the concept of a mistake and can report it *as* a mistake. That does not require on the dog's part a *concept* of belief, a *concept* of desire, a *concept* of truth and error. The preverbal child hears familiar footsteps and believes a person known to her is approaching, a person who perhaps elicits behavior anticipatory

of pleasure. It may not be the anticipated person, and when the child sees this, her behavior will mark the mistake. But must there be some linguistic *obbligato* in the child if we are to attribute to her a mistaken belief or a disappointment? Must an agent have the *concept* of a mistake to *be* mistaken?

The important kernel of truth in such a linguistic view is that arriving at a *precise* verbal description of another's beliefs and desires is difficult, and especially so when the attribution cannot be verbally confirmed by the subject. We will not go far wrong in attributing thirst to the dog Fido, or the belief that there is the appearance of something potable. Whether we can attribute to the dog the recognition of *water* would depend in part on whether dogs can select water from other liquids to roughly the phenomenological extent that we can. That is an empirical question. Of course, to *attribute* a belief, a desire, a thought to oneself or others, or to assert that someone has a desire or a belief or a thought, requires language. But, in the example given, Fido and Jean need not be making verbal claims, vocalized or non-vocalized, about what they desire, what their thoughts and beliefs are. What this language-based view entails is that without a verbal *obbligato* or without an identifiable *linguistic* representation there are no thoughts, desires, or beliefs. Nor does the problem of correct belief attribution disappear among language users, particularly if linguistic confirmation from the believer is unavailable. It is, of course, considerably reduced.

To decline to attribute desires and beliefs to non-language users is reminiscent of Descartes's declining to attribute pain to higher non-human animals despite the similarity with the causes of pain and with pain behavior in nonhuman animals and language users. The case of belief is analogous. Descartes argue that, in the absence of conscious introspective thoughts about our states, such as pain thoughts or belief thoughts, we do not have those pains and beliefs. In the revamped current version it is the absence of language, rather than of mind, that deprives a subject of thoughts and beliefs.

Not all who have language-oriented theories of belief take so strong a stand. Some, like F. P. Ramsey, saw the distinction, but attributed it to an ambiguity in the notion of belief. It is of interest to note that Ramsey[4] allows a sense of 'belief' in which we may, using his curious example, attribute a belief to a chicken who has acquired an aversion to eating a species of caterpillar on account of prior unpleasant experiences. Here again an overly rich attribution is difficult to avoid. We surely cannot attribute to the chicken the belief that the caterpillar is *poisonous*, but surely we will not go too far afield if we attribute the belief that the caterpillar is not for eating. And, indeed, if presented with a caterpillar

that had the appearance of the despised kind but was in fact of an edible kind, the chicken would be mistaken about its inedibility.

Still, although acknowledging a nonlinguistic use of 'belief', Ramsey finally concludes that believing as it occurs in language users is so disparate from that of non-language users that the term 'belief' is ambiguous. He goes on to say, 'Without wishing to depreciate the importance of this kind of belief, ... I prefer to deal with those beliefs which are expressed in words ... *consciously* asserted or denied ... The mental factors of such a belief I take to be words spoken aloud or to oneself or merely imagined, connected together and accompanied by a feeling or feelings of belief ...' For Ramsey then, 'assenting to a sentence "*S*" ', 'asserting that *S*' and 'believing that *S*' are equivalent alternative usages. Ramsey takes those utterances, spoken aloud or to oneself, as *mental* factors; hence, the objects of belief, the *S* in '*x* believed that *S*', are events of a linguistic character, sentences spoken or thought. Those are the sentences toward which we have an assenting attitude, a feeling, for Ramsey. This attitude or feeling performs in Ramsey's work the role of 'holding true' in Davidson's.

The identification of the objects of believing with sentence-like objects has some familiar consequences. The believer, the subject, has those beliefs. But how does the subject have them? Ramsey singles out those 'mental factors', sentences spoken aloud or to oneself or imagined. To say instead with Frege that they are the quasi-linguistic entities, the propositional *contents* of sentences, does not alter the picture in a helpful way. Such propositions mimic the structure of sentences. They have properties that interpreted sentences have, like truth and validity. Sets of them can be consistent or inconsistent. They can be contradictory. They can enter into the consequence relation, and so on.

Frege[5] had the view that propositions are the abstract nonmental contents of sentences toward which we have mental attitudes. But the mind-centered locus of the objects of belief is not wholly evaded. We 'have them in mind' when we entertain them, believe them, disbelieve them. He did after all call them 'thoughts'. A recent account that claims to demystify Frege's propositions and is more explicitly language-centered may be described as the *computational model*.[6] Highly simplified, the subject is seen as having an internal register of basic concepts and basic sentences that are mental representations of actual sentences in his language. Syntactical rules for mental-representation sentences generate complex sentences; deductive rules generate consequences of sets of sentences. Mental-representation sentences are associated with mental analogues of yes-or-no responses on appropriate cues that will generate mental yes-or-no responses to more complex sentences on appropriate

cues. The subject is said to believe that S just in case his correlated mental-representation sentence elicits a mental yes response. Jerry Fodor[7] presents such a view, which I have much simplified. He says straight out that attitudes toward propositions are in fact attitudes toward formulas in 'mentalese', the language of thought, formulas that are internally codified and are correlated with the external sentences of a given language. Propositions have given way to sentences in mentalese. The objects of belief are linguistic entities placed squarely in the mind.

There are failings in such language-centered, wholly mind-centered accounts of belief. These accounts exclude belief attributions to non-language users or, alternatively, insist that *if* one can make such attributions and if the manifestations of a public language are absent, the language of thought sententially organized must indeed be there in the nonverbal child or the dumb animal's mind or brain. Such accounts also create difficulties for making sense of unconscious beliefs. The exclusion of unconscious beliefs is explicit in Ramsey and, it would seem, in the Davidson of 'Thought and Talk'. For Fodor, there remains the question of what would count evidentially in the attribution of an unconscious belief to an agent. Is it unconscious assent to a sentence in mentalese?

Language-centered views also tend to define rationality in terms of attitudes toward sentences (or propositions) that are consistent, contradictory, logically true, or related by deducibility and the like. Since it is agreed that rational, language-using agents as ordinarily viewed are not omniscient or perfect logicians, they may still be rational to a point yet fail to believe *all* the consequences of their beliefs, and hence may even come to hold true or assent to a sentence that is equivalent to a blatant contradiction. Where to draw the line and yet preserve the attribution of normal rationality is difficult to decide. But this is not an insurmountable problem. Nor am I suggesting that considerations of consistency and validity of inference are irrelevant to an account of rationality. The point is rather that there is a broader notion of rationality and irrationality that language-centered theories are incapable of accommodating. There is, for example, the irrationality of the subject who sincerely avows that S, or holds 'S' true, but whose nonverbal actions belie it. Such cases need not be centered, although they often are, around questions of *akrasia*, such as that of the subject who sincerely avows that smoking is harmful yet continues to smoke. There are plausible psychological claims that our explicit avowals of belief, our sincerely stated claims about our own states, such as our desires and fears, or about the objects of our affections and disaffections, often do not serve us as beliefs are supposed to in the explanation of action. Actions may belie our most sincerely reported 'beliefs'. These are not cases of

deliberate deception or insincerity and may have some explanation in theories of self-deception or false consciousness. But those latter theories are often grounded in the absence of an agent's conscious formulations in language of the contrary implicit beliefs that explain the dissonant actions.

Consider the subject who assents to all the true sentences of arithmetic with which he is presented and rejects the false ones; who can perform the symbolic operations that take him from true sentences of arithmetic to true sentences of arithmetic, and who also has toward them the belief feeling. Yet if you ask him to bring you two oranges and three apples, he brings you three oranges and five apples. He never makes correct change. Are his assents and assertions sufficient for ascribing to him correct arithmetic beliefs? Shouldn't nonverbal behavior also count as an indicator or a counterindicator of belief?

And then there is the obvious fact, alluded to in the example of the thirsty desert wanderers, that we often, very likely more often than not, do not consciously entertain propositions or sentences we hold true when acting, even when our actions are explicable as consequences of beliefs and desires. Language users may assert such 'propositions' if they are asked why they are acting as they are. Indeed, being asked why we are acting as we are may lead us to discover or describe a belief that had never been verbalized. I usually walk a route to my office that is not the shortest and am asked why. It requires some thought. It isn't out of habit, I decide. I finally realize that I believe it to be the most scenic route. Verbalization as a necessary *condition* of believing precludes our discovering and then reporting what we may already believe.

An Object-Centered Account

We are concerned here with beliefs purported to be about the actual world, not about fiction or myth or the like. This is not to deny the use of 'belief' locutions in discourse about fiction. Their role will be understood from the context. If I am asked what it was that was converted into a chariot by Cinderella's godmother, I might respond that 'I believe it was a pumpkin that was converted into a chariot', but contextual cues make it clear that I am not making a historical claim about the actual world.

What follows is a sketch of the world-centered, object-centered account that may be better fitted to our understanding of some epistemological attitudes.[8] Believing is understood to be a relation between a subject or agent and state of affairs that is not necessarily actual but that has actual objects as constituents. We may think of states of affairs

as structures of actual objects: individuals as well as properties and relations. The structure into which those objects enter need not be an actual world structure. The state of affairs described by the sentence 'Socrates is human' is a structure containing Socrates and the property of being human. Since believing is taken to be a relation of an agent to a state of affairs not necessarily actual, the believing subject may also be related to the constituents of the structure.[9] Analogously, my ancestors may be structured as a set. I as a descendant am related to that structure and also to each of its constituents.

Believing has often been called a *propositional* attitude. On the present account, if we wish to retain the locution 'proposition' for an object of believing, that usage is atypical. Since a proposition is more commonly viewed as a linguistic or quasi-linguistic entity, it is best to deploy other terms such as 'state of affairs' or 'structure'. One recognizes here a Russellian thrust.[10] In one of Russell's early accounts of epistemological attitudes, constituents of propositions are actual objects, including abstract objects such as properties and relations. One of the departures from Russell herein is that no reductionism for constituents need be supposed. Ordinary individuals, properties, and relations may be constituents of states of affairs.

On the subject or agent side of the relation we give a dispositional account.[11]

> D: x believes that S just in case, under certain *agent-centered circumstances* including x's desires and needs as well as *external circumstances*, x is disposed to act as if S, that actual or nonactual state of affairs, obtains.

Note the absence of a truth predicate in D. Actual or nonactual states of affairs are not truth bearers. If we employed the truth predicate as in 'disposed to act as if "S" were true', S *would* have to be a linguistic or quasi-linguistic entity. It was Russell's continued use of truth and falsity as properties of his propositions that made the intrusion of Mont Blanc into one of Russell's 'propositions' so baffling to Frege.[12]

Ways in Which Such an Account Accommodates Some Natural Views of Belief

(1) On the proposed view speech acts, public or private, are only a part of the range of behavior that manifests belief; they are not, as they are in language-centered views, necessary conditions. Accordingly, beliefs can be attributed to non-language users. Naturally non-language users will fail to have beliefs that are possible only to language users – beliefs about language, for example. Linguistic items, whether type or token,

are objects and can be constituents of states of affairs, but they are inaccessible to non-language users *as* linguistic items. Non-language users will, therefore, not have beliefs *about* describing or referring, about truth or falsity, validity or logical consequences, about grammar, and the like. Inference as a *psychological* phenomenon will be severely limited in non-language users, since complicated inference would seem to require stating, describing, or reporting what we believe; setting it out in language. Prediction, deception, counterfactual speculation, and long-range planning of a certain level of complexity might also seem to require language, as would second-order beliefs (although there are recent empirical studies that claim that non-language users can and do plan and make long-range decisions and practice deception). But that is not to deny beliefs to non-language users altogether.

(2) There is ample evidence that when we act out of belief we need not precede or accompany such actions with verbal, sentential accompaniments. We need not be *entertaining before the mind* sentences or meanings. Jean, the desert wanderer, is racing to the water he believes to be out there. Both Jean and Fido have a belief in that they are related to a (nonactual) state of affairs and, given their circumstances, act accordingly.

(3) Such an account of belief views believing as a relation between a subject and a state of affairs not necessarily actual, where the subject, in the grip of psychological states such as wants and needs and in the presence of other circumstances, will act as if that state of affairs obtained. Speech acts are *among* the acts that may and often do *manifest* a belief, and one such speech act when *x* believes *S* is that *x* may sincerely assent to a sentence descriptive of the state of affairs *S*. The account does not suppose that the act of sincere assent, even where it is evoked, *must* be an overriding indicator of belief.

A range of circumstances will evoke such a speech act of assent. The subject *x* may want to report his beliefs, to communicate them in language to others, to examine carefully what follows from them, to testify, and so on. If circumstances and desires are such that *x* wants to deceive, he may perhaps not assent to a sentence that describes his beliefs, even though that behavior would be counted as insincere. But deliberately denying a sentence that describes *what* one believes is not the only way a speech act may mislead others about one's beliefs. Given that speech acts are important in *reporting* beliefs, the agent's particular way of reporting is a function of local circumstances as well as of other beliefs that may not be shared by others. It is also a function of a subject's

mastery of the language. A language user of minimal competence may not even be able to perform a speech act that describes the state of affairs to which he is in the believing relation, but he is in that relation nevertheless. Indeed, despite the widespread assumption of privileged access to one's own beliefs, it could (and does) happen that someone other than the agent is better able to report an agent's beliefs than the believer. Also, others can often assist a believer to describe more accurately the state of affairs to which he is in the believing relation; that is a common phenomenon of language acquisition.

(4) The proposed view accommodates the possibility of unconscious beliefs. These may be the very beliefs I have but do not or (on some psychological theories) cannot report in a speech act. Reporting brings them into consciousness.

(5) It is a feature of the proposed non-language-centered view of belief that it permits a more adequate and natural account of rationality. Language-centered theories tend to define rationality in terms of sentences or sets of sentences or their quasi-linguistic 'contents'. On a language-centered account a rational agent is one who, for example, will not asset to surface contradictions; for a perfectly logical agent, belief is closed under logical consequences (*pace* Dretske and Nozick).[13] Given the empirical fact that we are not faultless logicians, belief for a rational agent is closed under logical consequence to some acceptable level of complexity of proof. A *norm* of consistency for sentences we assent to is preserved. We abandon assent to sentences *known* to be inconsistent or necessarily false. Extended to inductive reasoning, such an account of rationality still focuses on a relation between accepted sentences and probable conclusions. But this language-centered account is an impoverished view of rationality. It lacks explanatory force. *Why* should we dissent from known contradictions or inconsistent sets of sentences? A computer would pay no price for 'assenting', nor presumably would a brain in a vat.[14]

There is a wider notion of rationality than those of strongly language-centered views, where we say of a rational agent that such an agent also aims at making all the behavioral indicators of belief 'coherent' with one another. For example, the agent's assentings and avowals should be coherent with his choices, his bets, and the whole range of additional behavioral indicators of belief. We may say of someone who avows that he loves another yet often harms the one he claims to love that his behavior is 'dissonant'. He is, in a wider sense, irrational. He is not logically irrational in the narrow, language-centered sense. The set of

sentences he assents to are, so far as he knows, consistent. When he assents sincerely to a sentence 'I love *A*', he does not assent to a sentence 'I don't love *A*'. He would deny the latter if asked.

Agents who become aware of their incoherent behavior may try to 'rationalize' that behavior, make it coherent, get a better fit. On such awareness the ambivalent lover may no longer assent sincerely to 'I love *A*'. He may note that other actions are incoherent with his speech acts, or he may alter his cruel behavior to fit his avowals. He may argue that the concept of love is confused. That list does not exhaust the possibilities.

Such considerations are usually viewed as central to questions of *akrasia*. An agent might sincerely avow that smoking is harmful and that he wants to preserve his health but continue to smoke. Recurrent in the literature on *akrasia* are explanations of such seemingly irrational behavior. One explanation is that the akratic has conflicting beliefs, one belief conscious and reportable in a speech act, one unconscious and unreported, which is the action-guiding belief that overrides if he continues to smoke. A second[15] explanation is that the akratic agent has conflicting reportable beliefs, and, although the acknowledged grounds that justify one are stronger than the grounds that justify the other, he acts in accordance with the less justified belief. A third sees akratic action as action not grounded in belief at all, but as 'compulsive'. Still, in all such explanations of irrationality it is our nonverbal acts that belie our words.

Nor are we suggesting that adding coherence to strict logicality is exhaustive of a wider account of rationality. There are psychological syndromes, paranoia for example, in which an agent's actions may be described as remarkably coherent albeit irrational. A still wider account of rationality must also include acting in accordance with norms of evidence, norms of justification, and the like that warrant an agent's believing as he does. Our proposal is only that coherence is an important feature of a more general explication of rationality.

Assentings and avowals do play an important role in a wider notion of rationality, for an agent is often the best describer of what he believes, and an external judgement of coherence or incoherence is more determinate, given such speech behavior. But, more important, a wider notion that includes coherence is explanatory of why a norm of logical consistency is preserved. Why, for example, it is claimed that a rational agent does not assent to a *known* contradiction?

If a sentence '*S*' describes a specific state of affairs and if sincere assenting to '*S*' is taken as an act, a speech act, which marks our believing that *S* obtains, then if, without relinquishing our original assent, we also assented to 'not-*S*' under the same circumstances, we would be believing

that S both obtained and did not obtain in those circumstances – an objective impossibility that might render many of our actions incoherent and self-defeating.[16] Rationality in the wider sense is not preserved. If the assents to contradictions are not ferreted out, beliefs could lose their crucial role in guiding and explaining actions.

Belief, Assent, and the Disquotation Principle

The object-centered position sketched here – and it is just a sketch – does not preclude special relationships between some speech acts, such as acts of assent, and belief, under some conditions. What has been rejected is the idea that an agent's believing S – even if the agent is a language user among language users – entails that the agent performs or can perform an appropriate speech act of assent. There may be other markers of belief. We have also suggested that there are cases where sincere assent to a sentence even on the part of a competent, reflective language user need not be a sufficient condition, an overriding guarantee of believing, since it denies that a person's nonverbal actions that seem to run counter to his avowals can be evidence against his having that avowed belief. Briefly stated, we have questioned a principle generally accepted as noncontroversial;

Q: x's assent to a sentence 'S' *entails* that x believes that S, where the conditions on x of sincerity, linguistic competence, and reflectiveness obtain.

The widespread acceptance of the disquotation principle Q is not wholly without ground. My suggestion is that, on a broader view, other actions might belie the agent's words, and sincere assent might not be the privileged marker of believing. Let us suppose, however, for the discussion that follows, that our agent's other actions *are* coherent with his sincere assentings and he makes no logical mistakes. If that is the case, then, on principle Q, his sincere assenting to 'S' does go over into a belief, for it is assumed that a linguistically competent, reflective speaker can reliably report what he believes. Where conditions including coherence hold, it seems that there still remain, on the language-centered view, some puzzles that can be resolved where Q is viewed as falling under D, i.e., where in assenting to a sentence under the appropriate conditions an agent is acting as if a state of affairs described by that sentence obtains.

Q and a Puzzle about Beliefs in Nonexistence

In 'Speaking about Nothing' Keith Donnellan[17] recounts the actual case of *The Horn Papers*, which were purported to be the published diaries of one Jacob Horn, a colonial American, and were so viewed until historians disclosed that the *Papers* were a hoax. Consider someone, call her 'Sally', who, having read *The Horn Papers* and being unaware that they were part of a fabrication, sincerely assents to 'Jacob Horn lived in Washington County, Pennsylvania'. The syntactical proper name 'Jacob Horn' is not a genuine referring name but an invention of the hoaxster. Elaborating on Donnellan's views, the act of assenting to what seems a perfectly formed sentence 'Jacob Horn lived in Washington County, Pennsylvania' should not carry over into a belief. Backtracking her acquisition of the name does not terminate in a person named 'Jacob Horn'. But Sally need not know that. It is simply that the purported state of affairs described is not a complete state of affairs. It is as if she had assented to 'z lived in Washington County, Pennsylvania' where 'z' is a variable. What she assented to does not describe a closed structure. Of course, Washington County, Pennsylvania, *is* a constituent, and lived in *is* a relation; the partial structure does not wholly lack constituents, but it lacks a constituent needed to make it count as a state of affairs. Yet Sally's was a sincere assent to 'Jacob Horn lived in Washington County, Pennsylvania'. She is competent, not conceptually confused, and reflective. We have also assumed that she makes no logical errors and is broadly rational. She just lacks the relevant knowledge that 'Jacob Horn' is without a referent. In such a case, on disclosure that the syntactical name 'Jacob Horn' does not refer, Sally should say, on my proposed analysis, that she only *claimed* to believe that Jacob Horn was a resident of Washington County, Pennsylvania, in the first instance. Of course the disquotation principle simply has an antecedent 'x assents to "S"', and it may be an implicit assumption of the disquotation principle Q that linguistic competence and absence of conceptual confusion will rule out assent to a sentence that is not fully interpreted. But, as in the present example, that is unjustified. A rational competent agent can, on the psychological side of the believing relation, appear to 'hold' a sentence 'true' that lacks a truth value altogether. Nor will interjecting Jacob Horn as a possible person work, for reasons discussed elsewhere.[18] Suffice it to say that Sally took 'Jacob Horn lived in Washington County, Pennsylvania' to be making a historical claim, as the author of *The Horn Papers* intended.

Of course, in the context of the example, Sally may assent to related sentences that *are* fully interpreted, such as 'There was a person named

"Jacob Horn" born in Washington, Pennsylvania, who kept a diary', which will carry over into a belief. Her nonverbal behavior may also be affected in predictable ways. She may engage in what she believes to be historical research, such as searching out "facts" not narrated in *The Horn Papers* about the purported person, as she might have done had there been such a person. On the present object-centered view, her behavior is rational and explicable, although she could not have believed that Jacob Horn was born in Washington, Pennsylvania. Principle Q requires an additional condition: that '*S*' be a fully interpreted sentence.

In the case of failed reference, as in the above example, what goes wrong is that the troublesome sentences *appear* to have a 'content' that they do not have. In discourse that purports to be about our actual world it is presupposed that proper names, when used as in the above example, do refer.[19] Sentences with such reference failures mislead. In such cases we should disclaim having had a belief, despite sincere assenting.

It should be noted that this case of reference failure does not present a problem for a Davidsonian language-centered view of Q, since Davidson requires that '*S*' be fully interpreted, and, in the absence of a referent of 'Jacob Horn', the sentence 'Jacob Horn was born in Washington, Pennsylvania' lacks a complete interpretation despite appearances and is not a truth bearer.

Q and a Puzzle about Identity and Contradiction

Although for the purposes of discussion of puzzles we have assumed that the epistemological agent is rational and a faultless logician, it *appears* to follow from Q on a language-centered view that such agents can come to 'believe' a contradiction. What I want to argue is that, under D and the object-centered view, that does not follow. At worst, what may occur is that a rational, logical agent may be in a believing relation to an impossible state of affairs.

Consider the following example.[20] Someone, call her 'Sally', is rational in the wide sense and an impeccable logician. She also succeeds in maintaining in her actions, including her speech acts, a norm of coherence. In such a case we can normally take her sincere assentings as privileged markers of believing.

In the 1930s Sally became acquainted with Alexis Saint-Léger of the French Foreign Office. On the basis of information available to her she assents to the sentence 'Alexis Saint-Léger is not a poet'. Some years later Sally meets a poet, St-Jean Perse, at the United States Library of Congress. Time has not been kind. St-Jean Perse is not recognizably Alexis Saint-Léger, and Sally assents to the sentence 'St-Jean Perse is a poet'. Since

unbeknownst to her 'Alexis Saint-Léger' and 'St-Jean Perse' name the same person, he *is* the constituent in the states of affairs encoded into or described by the sentences 'Alexis Saint-Léger is not a poet' and 'St-Jean Perse is a poet'. Each of those sentences taken separately describes a possible state of affairs. Saint-Léger might not have written poetry. Circumstances could have prevented that, as well as his serving in the French Foreign Office. Given that Sally is logical, she will also assent to the sentence 'Alexis Saint-Léger is not a poet and St-Jean Perse is a poet', which unbeknownst to her describes an impossible state of affairs. Given that she knows about the identicals having to have all properties in common, including uniqueness, she assents to 'Alexis Saint-Léger is not St-Jean Perse', which on the necessity of identity also describes an impossible state of affairs. She would of course not assent to 'Alexis Saint-Léger is not Alexis Saint-Léger', which unbeknownst to her describes the same impossible state of affairs as 'Alexis Saint-Léger is not St-Jean Perse'. She would also assent to ' "Alexis Saint-Léger" and "St-Jean Perse" name different persons', but that sentence is not descriptive of an impossible state of affairs. Our background theory requires only that names, once *given*, retain a fixed value.

This puzzle is irksome to those who hold the language- centered view of belief in which the objects of believing are either sentences or those propositions that mimic sentences in having properties like true, false, contradictory, valid, and the like. On that account, given the disquotation principle, Sally's assentings to 'Alexis Saint-Léger is not identical to St-Jean Perse' and 'Alexis Saint-Léger is not a poet and St-Jean Perse is a poet', go over into beliefs. But on the language- or proposition-centered views, the objects of believing are sentences or propositions. Since, semantically speaking and unbeknownst to her, the same person is assigned to both names, the assentings go over into *contradictory* sentences or propositions; so she seems to believe contradictions. Yet she has justification for arriving at her beliefs and has made no logical errors. She lacks other information. Why should the mere lack of information lead one to believe contradictions although one began with only seemingly justifiable albeit some false premises?

The language-centered theorist is baffled. What *does* Sally believe, he asks? If she believed that Alexis Saint-Léger is not a poet, then that is the same *proposition* as that St-Jean Perse is not a poet. Does she or does she not believe that St-Jean Perse is a poet?

But note how differently our presently proposed view accommodates the language-centered theorist's puzzle. Sally was introduced to Alexis Saint-Léger in the French Foreign Office. The individual in the state of affairs described by the sentence she assents to, i.e., 'Alexis Saint-Léger

is not a poet' is that person: not the essence of Alexis Saint-Léger, not the concept Alexis Saint-Léger, not the sense of the name 'Alexis Saint-Léger'.

When later she meets St-Jean Perse, he, that person, is a constituent in the state of affairs described by the sentence 'St-Jean Perse is a poet'. What Sally lacks is information that would permit her to *reidentify* Saint-Léger. The sentences she assents to are not surface contradictions. The syntactical *form* of some of the sentences she assents to that describe impossibilities do not have the surface form of logical falsehoods. It is surely possible for different syntactical names to name the same thing.

Sally acquired the names 'Alexis Saint-Léger' and 'St-Jean Perse' on two different occasions and under different circumstances, as very likely did Saint-Léger. The chain of communication in the public language will carry the second name into the first and finally to the object named. The value of those names, if they refer, is fixed, but not by some known set of identifying descriptions that permitted a determination by the agent. As a practical matter, even a chain of communication may be practically irretrievable. Unlike the evidence in the Jacob Horn case or the Saint-Léger/Perse case, historical records may not be available sufficient to make a determination of reference or absence of reference. It is such situations that prompt research (often frustrated) into, for example, the historical Homer or the historical Robin Hood.

On our proposed view of believing, x believes that S when x has a disposition to act as if a certain state of affairs obtained. A sincere assenting to 'S' by a rational, logically impeccable, but nonomniscient agent can often serve as a privileged marker of believing that S. But, unlike linguistic propositions, states of affairs obtain or do not obtain, must obtain or cannot obtain. They are not true or false, contradictory, valid or invalid. Some of the sentences Sally unwittingly assents to would seem to lead her to be in a believing relation to an impossible state of affairs, but, though she *assents* to a sentence translatable into a logically false sentence, she doesn't *believe* a contradiction, as demanded by the language-centered account.

Note that, on the dispositional account given by principle D, agent-centered circumstances as well as external circumstances are conditions on x's being disposed to act as if S, that state of affairs, obtained. There are (1) circumstances under which Sally is disposed to act as if Alexis Saint-Léger (i.e., St-Jean Perse) is not a poet, and (2) circumstances under which she is disposed to act as if Alexis Saint-Léger (i.e., St-Jean Perse) is a poet. Indeed, among those circumstances in (1) are those in which she also assents to 'Alexis Saint-Léger is not a poet' and does not assent

to 'St-Jean Perse is not a poet'. Similarly for the circumstances in (2) under which she assents to 'St-Jean Perse is a poet' and does not assent to 'St-Jean Perse is not a poet'. Note that assenting is a speech act that occurs at a time and place and *under circumstances*. Under those variant circumstances her assents, in accordance with Q, each go over into a belief. Indeed on Q, the above assents *each* carry over into a believing relation to a possible state of affairs.

But Sally will also assent in some circumstances to 'St-Jean Perse is a poet and Alexis Saint-Léger is not a poet' and, on Q, that would put her into a believing relation to an impossible state of affairs. In assenting to a sentence that, given still unknown reidentifications, might come, on logical grounds but unbeknownst to her, to have on substitution the form of a surface contradiction, she is on D disposed to act as if an impossible state of affairs obtained.

On such a theory, and given Q, the answer to the question of what Sally believes about Alexis Saint-Léger and St-Jean Perse is straightforward. If, as we have proposed, the objects of believing are not linguistic entities, then, on the disquotation principle, we can say that she believes what she says she believes: that Saint-Léger is not a poet and that St-Jean Perse is a poet, and, given that she will assent to logical consequences of sentences assented to, she may also act as if some impossible states of affairs obtained, to the extent that such actions are describable. Her assents, her logical reasoning, and her evidential grounds are *not* incompatible with having such dispositions. She is not omniscient. So, seeing no incompatibility between rationality in the narrow sense and believing impossibilities, should we not let the matter rest? A puzzle has been solved. Furthermore, there seems to be ample other evidence that impossibilities are believed.

A Controversial Proposal

Given the present account so far, we are led not to the puzzling conclusion that a logically rational agent 'believes a contradiction' but only to the conclusion that under certain circumstances she is in the believing relation to an impossible state of affairs, held to be describable by a sentence to which she assents. A puzzle has been solved. Nevertheless I should like to propose, on other considerations, a modification of Q, which disallows believing impossibilities. On that proposal, an agent can *claim* to have such beliefs but will be mistaken in so claiming. Just as norms of truth lead to retroactively revisable knowledge claims, norms of rationality should lead to retroactively revisable belief claims. What is being proposed is that, whatever the psychological dimension of the

belief state, on disclosure of impossibility that belief *claim* should be viewed as mistaken.

Despite prevailing views to the contrary, the thesis that one cannot believe impossibilities has its advocates. Berkeley[21] argues that to believe propositions that entail contradictions is illusory. He says of such propositions that 'they are an instance wherein men impose upon themselves by *imagining* they believe those propositions'.

There is, of course, agreement that a rational agent does not *assent* to simple formal surface contradictions such as '*S* and not *S*', but in such a case of assenting to an overtly and formally contradictory sentence one can claim that a condition on the disquotation principle had not been met. The agent is said to be *conceptually confused*. He has not grasped the meaning, and he does not comprehend the semantics of words like 'not', 'and', and so on.

Cases of deductive failure that lead to assenting to sentences that are equivalent on substitution to contradictions can sometimes be attributed to mistakes in calculation. But, among those like Berkeley, Wittgenstein, and some positivists who rejected belief in impossibilities that are represented by logically or formally false sentences, there was an underlying argument for rejecting such beliefs that would seem to apply to all cases of impossibility, including those that have their origin, as in Sally's case, in deficient information.

Wittgenstein[22] is concerned in the *Tractatus* with those necessities and impossibilities that are given by tautologies and contradictory propositions of *whatever* complexity. He argues that a *significant* proposition has to describe, a definite situation such that the situation may or may not obtain. A proposition must admit an alternative truth value. Where a proposition does not admit of alternative values, i.e., is not contingent, he says it lacks sense, although he adds that it isn't exactly nonsense either. 'Tautologies and contradictions ... do not represent possible situations.' 'The truth of a tautology is certain, of contradiction impossible', and therefore instances of both lack significance. If '*S*' is senseless, then '*x* knows that *S*' is senseless even where '*S*' is a tautology. On the same ground he should say that '*x* believes *S*' where '*S*' is a contradiction is also senseless. But if what informs his argument is that it is the impossibility of a proposition *S* being false or the impossibility of a proposition *S* being true that makes it an improper object of a propositional attitude, then the *origin* of those attitudes should not matter. A false identity claim, for example, is necessarily false, never mind how it was arrived at.

A later Wittgenstein[23] softened somewhat toward the range of significant propositions. Necessary truths and falsehoods are no longer

denied sense. But he does hint at a distinction between believing and claiming to believe impossibilities. He says, 'I feel a temptation to say one can't believe $13 \times 13 = 196$... But at any rate I can *say* "I believe it" and act accordingly' (italics mine). That hint, if it is a hint, can be elaborated into a proposal. Present received views insist that if we say of an agent that he knows that S and S turns out not to be the case, we alter our ascription. This can be done retroactively. Disclosure of the falsity of 'S' would falsify the knowledge claims of all who ever claimed they knew that S. But it would seem that we do not likewise retroactively disclaim belief in impossibilities – unless we take something like Wittgenstein's early radical view that impossible states of affairs are not states of affairs at all and hence not proper objects of epistemological attitudes. There were after all those who thought that angles could be trisected with a compass and a ruler, or that the consistency of arithmetic was provable on some canonical criterion of proof, or that Shakespeare was the Earl of Oxford. Those propositions are necessarily false, yet what is claimed seems to have been believed. But I do see an advantage to a revision of the disquotation principle; not Wittgenstein's early radical proposal (for tautologies and contradictions are surely meaningful) but a proposal that allows a distinction between believing and claiming to believe. We propose a modification of Q as follows. In addition to linguistic competence, sincerity, and reflectiveness of the agent, we add the condition that her actions, including her speech acts, are coherent and preserve a norm of rationality in the wide sense. The additional condition is required if assenting is to count as an *overriding* marker of belief.

> Q': (1) x assents to 'S', (2) 'S' is a fully interpreted sentence in x's language, and (3) S is possible, together entail that x believes that S, where conditions of sincerity, competence, and reflectiveness obtain.

If conditions (2) and (3) are not met, x's assenting does not carry over into a belief. The two puzzling cases are accommodated. In *The Horn Papers* example, (2), the condition of complete interpretation of 'S', is not met. Nevertheless a rational account can be given of why Sally *claimed* to have a belief that Jacob Horn lived in Washington County, Pennsylvania, despite the absence of a fully structured state of affairs that is a proper object of believing. In the Alexis Saint-Léger/St-Jean Perse example the state of affairs is properly constituted. Here the disclosure of the truth of an identity sentence, e.g., 'St-Jean Perse is identical to Alexis Saint-Léger', would reveal the logical falsehood of some sentences to which Sally assents. In such a case Sally might say that she only claimed to believe that Alexis Saint-Léger was not the same as

St-Jean Perse, for such a belief comes to believing of a thing that it is not the same as itself and that does not meet logical norms of rationality. Just as the falsehood of '*P*' excludes knowing that *P*, the necessary falsehood of '*P*' excludes believing that *P*, whatever the agent's knowledge claims or belief claims, respectively.

The revisionary proposal places conditions on when a *speech* act of assent goes over into a belief. It does not place a possibility condition on the beliefs of non-language-using agents. The condition of possibility is grounded in norms of rationality just as, with respect to knowledge, the condition of actuality is grounded in norms of truth. Such norms would seem to require second-order conceptualization and reflection open only to language users.[24]

If believing *S* is minimally a disposition to act as if a certain state of affairs obtained and if such a state of affairs could not possibly obtain, a rational language-using epistemological agent is in a position to ask what would count as acting as if it did obtain. Many actions would be rendered incoherent, many ends frustrated. If the speech act of assenting is one of those actions that mark our believing, then we would be acting as if '*S*' were true. But what sense can we make of 'acting as if "*S*" were true' when either '*S*' has no truth value or '*S*' is necessarily false? Of course, on the revisionary proposal, we could not ascribe belief to those who claimed to believe that the Fountain of Youth is in Florida (where 'Fountain of Youth' is mistakenly taken to be a directly referring name) or that an angle can be trisected with compass and straight edge or that Shakespeare is identical with the Earl of Oxford. We could say only that they claimed to have these beliefs. They were not irrational agents, and we can explain why they made those claims. This revision does not do too much violence to plausible usage, for these agents did have other proper beliefs that explained (1) their assent to sentences that described impossible states of affairs, (2) their assent to sentences that, appearances to the contrary, are not fully interpreted.[25]

Notes and References

1. See S. P. Stich, *From Folk Psychology to Cognitive Science: The Case against Belief* (Cambridge, MA: MIT Press, 1983). Also, D. Dennett, 'Beyond Belief', in A. Woodfield (ed.), *Thought and Object* (Oxford: Clarendon Press, 1982).

2. The present paper in later sections amplifies and revises my 'Proposed Solution to a Puzzle about Belief', *Midwest Studies in Philosophy: Foundation of Analytic Philosophy*, 6, ed. P. French et al. (1981), pp. 501–10, and 'Rationality and Believing the Impossible,' this volume. Those papers

focused on S. Kripke's 'A Puzzle about Belief' in A. Margalit (ed.), *Meaning and Use* (Dordrecht: Reidel, 1979). The disquotation principle discussed below was set out by Kripke.

3. In S. Guttenplan (ed.), *Mind and Language* (Oxford: Clarendon Press, 1975), pp. 7–23. The quotation is from pp. 22–3.

4. *The Foundations of Mathematics* (New York: Humanities Press, 1950), p. 144. Ramsey also claimed that such introspective feelings are an insufficient guide when it comes to judging the *difference* between believing more firmly and believing less firmly.

5. See 'On Sense and Nomination' and other essays in G. Frege, *Translations from the Philosophical Writings*, trans. P. Geach and M. Black (Oxford: Blackwell, 1952). The present discussion of propositions as linguistic entities mapped by sentences that 'express' them does not apply to those more recent accounts of propositions as functions from words to truth values.

6. Computer scientists concerned with such 'artificial intelligence' models actually use the language of belief in discussing their programs.

7. See Fodor, *The Language of Thought* (New York: Crowell, 1975) and *Representations* (Cambridge, MA: MIT Press, 1981).

8. Bertrand Russell maintained throughout his work an object-oriented view of epistemological attitudes that is sometimes obscured by his use of the term 'proposition', which normally has a linguistic connotation. 'Propositions' for Russell contain nonlinguistic constituents.

9. For Russell, believing relates the agent to the *constituents* of the proposition, not to the proposition. This suggests that one relation precludes the other, but it need not.

10. See the papers mentioned in note 2 above. Also, R. Chisholm, 'Events and Propositions', *Noûs*, 4, 1 (1970), pp. 15–24; the recent work of J. Perry and J. Barwise on 'Situation Semantics', e.g., *Situations and Attitudes* (Cambridge, MA: MIT Press, 1983); N. Salmon, *Frege's Puzzle* (Cambridge, MA: MIT Press, 1986).

11. R. B. Braithwaite, in 'The Nature of Believing', *Proceedings of the Aristotelian Society*, 33 (1932–3), 129–46, has a dispositional account, but it is also a language-bound account. For Braithwaite '*x* believes *S*' is analyzed as follows: *S* (a proposition) must be *entertained*, and, under relevant internal and external circumstances, *x* is disposed to act as if *S* were *true*. Such a language-oriented dispositional account excludes unconscious beliefs, excludes beliefs of non-language users, and supposes that believing always entails entertaining linguistic or quasi-linguistic objects. The dispositional account I am proposing also differs from Quine's in that Quine does not take states of affairs as objects of believing.

12. G. Frege, *Philosophical and Mathematical Correspondence* (Chicago: University of Chicago Press, 1980), p. 169.

13. F. I. Dretske, 'Epistemic Operators', *Journal of Philosophy*, 75 (1970), pp. 1007–23, and later R. Nozick, *Philosophical Explanations* (Cambridge: Harvard University Press, 1981), question the claim that belief is closed

under logical consequence, but their purported counterexamples are not critical in our present account.

14. Andrew Hodges, in *Alan Turing: The Enigma* (New York: Simon and Schuster, 1983), p. 154, reports a conversation between Turing and Wittgenstein on contradiction that includes the following exchange:

WITTGENSTEIN (citing the paradox of the liar): It doesn't matter ... it is just a useless language game ...

TURING: What puzzles one is that one usually uses a contradiction as a criterion for having done something wrong. But in this case one cannot find anything done wrong.

WITTGENSTEIN: Yes – and more: nothing has been done wrong ... where will the harm come?

TURING: The real harm will not come in unless there is an application in which a bridge may fall down or something of that sort.

WITTGENSTEIN: ... But nothing need go wrong, and if something does go wrong – if the bridge breaks down – then your mistake was of the kind of using a wrong natural law ...

TURING: Although you do not know that the bridge will fall down if there are no contradictions, yet it is almost certain that if there are contradictions it will go wrong somewhere.

15. D. Davidson, 'How Is Weakness of the Will Possible?' in J. Feinberg (ed.), *Moral Concepts* (Oxford: Oxford University Press, 1969).

16. It is difficult to make a case for rejecting contradictions unless we see the connections between rationality, coherent action, and plausible outcomes. A computer programmed with proper deductive rules and a contradiction will allow any sentence in its register of affirmations. In the absence of further action to be guided by those outputs, there is no problem of coherence as here described. Similar considerations apply to examples of brains in vats. See note 14 above.

17. *Philosophical Review*, 83 (1974), pp. 3–30. *The Horn Papers* was launched as history; hence the characterization 'hoax' rather than 'fiction'.

18. 'Dispensing with Possibilia', *Proceedings of the American Philosophical Association*, 49 (1976), pp. 39–51. Also 'Possibilia and Possible Worlds', *Modalities*, pp. 190–203.

19. In 'Modalities and Intensional Languages', *Modalities*, pp. 5–23, such a directly referential view of proper names was proposed. There, I say, 'To give a thing a proper name is different from giving a unique description. This [identifying] tag, a proper name, has no meaning [as contrasted with having reference]. It simply tags. It is not strongly equatable with any of the singular descriptions of the thing.' It should be noted that, on this view, proper names are *not* assimilated to descriptions, even 'rigid' descriptions. Kripke, in 'Naming and Necessity', in D. Davidson and G. Harman (eds), *Semantics of Natural Language* (Dordrecht: Reidel, 1972), classifies proper names as 'rigid designators' along with rigid descriptions, thereby obscuring the difference in semantic relationship between a proper name and the

object named as compared with the relationship between a rigid description and the object described. Kripke in 'Discussion', *Modalities*, pp. 24–35, interpreted my views as including the position that 'the tags are the essential denoting phrases for individuals'. That was not part of my account, but we can see in those 1961 remarks Kripke's move toward his theory of 'rigid designators'.

20. See Kripke, 'A Puzzle about Belief'. My example is an analogue of Kripke's case of Pierre's coming to believe a 'contradiction'.

21. C. M. Turbayne (ed.), *Principles of Human Knowledge* (Indianapolis: Bobbs-Merrill, 1970), p. 273.

22. *Tractatus Logico-Philosophicus* (London: Kegan Paul, 1921). See especially 4.461–6, 5.1362, 5.142, 5.43a, 6.11.

23. *Remarks on the Foundations of Mathematics* (Oxford: Blackwell, 1956), 1.106, p. 31.

24. This is what seems to be at the center of Davidson's view mentioned at the outset of this paper.

25. See 'Possibilia and Possible Worlds', *Modalities*, pp. 190–203.

15
NOAM CHOMSKY
(1928–)

The American linguist, philosopher and political activist Noam Chomsky was born in Philadelphia and educated at the University of Pennsylvania. He has been a professor of linguistics at MIT since 1955. Chomsky is the most influential linguist of this, or probably any other, century. His review of B. F. Skinner's *Verbal Behavior* (in *Language*, 1959) was a watershed in overturning the ascendancy of behaviourism in psychology. His theory of generative linguistics not only changed the face of this particular field but also had profound implications for psychology and philosophy. In addition, Chomsky is also widely recognized and admired for his political writings and activism.

The scientific discipline of linguistics, according to Chomsky, should concentrate on studying the invariant underlying structure of all human languages, and not merely the superficial, surface traits of particular languages. In Chomsky's view, a person who speaks a language has developed a certain system of knowledge, which is represented in the mind and ultimately in the brain in some physical configuration. A generative grammar, or a system of explicit and well-defined rules which state how language is used, specifies the state of mind/brain of a person who knows a particular language.

Empirical evidence shows the presence of a number of constant and universal features of the human capacity to acquire and use language:

(1) We know that no other living organism that we have come across uses anything like a human language.

(2) Almost every human being learns their native language by the age of five.

(3) The stages of the development of various linguistic abilities and the acquisition of linguistic skills seem to be more or less uniform across the various languages of the world.

(4) Speakers of all languages seem to acquire complex linguistic skills

without much difficulty and after being exposed to very limited evidence of use of language, and with little or no relevant correction. Thus, children at a very young age and with very little instruction are able to understand complex sentences upon first hearing them.

(5) Speakers of any language, from a very young age, are able to make correct judgements about sentences they have never encountered before.

These universal features, Chomsky argues, show that there must be some genetic component to our language acquisition; i.e., human babies are predisposed towards learning complex languages while other animals are not. According to Chomsky, one part of our brain, the so-called 'language faculty', is specifically designed for language and is innate to all (normal) human beings. Its 'initial state', an expression of our genetic make-up, is the topic of the theory of universal grammar (UG). The states attained in the course of experience are 'internal language', each a particular system of knowledge described by a generative grammar. UG is common to all humankind and the rules or parameters it specifies would hence enter into all human languages and their generative grammar.

The theory of UG is needed to explain how it is that children do not make certain types of grammatical mistakes. To take an example: children learn to use sentences such as 'I surprised myself' but do not use sentences such as 'Myself was surprised by I', despite the fact that they are not specifically instructed to avoid such ungrammatical constructions. According to Chomsky, children have a tacit knowledge of deep grammatical rules which enables them to differentiate between correct and incorrect grammatical transformations such as the above. The behaviourists had argued that a child acquires the correct use of grammatical rules by listening and mimicking adults. But this is not a satisfactory explanation because children come across only a small sample of instances of the use of sentences. They receive only very scanty information on the form and meaning of words and more complex expressions, yet they understand and use novel ones over an unbounded range, in accordance with rules that their minds have constructed. Behaviourism has no way of dealing with these phenomena.

UG is a 'theory of our biological endowment' and this endowment places limits on what human languages can be like. It provides a range of options which sets limits to humanly possible languages. These options are called parameters; the metaphor used by Chomsky in more recent times is that of switches that are set in a certain way which enables the choice of various possible generative grammars. All particular languages,

such as French, English, and Japanese, are constructed from this biological endowment and obey the principles of Universal Grammar.

Chomsky also distinguishes between competence and performance. According to him all (non-brain-damaged) human beings have competence in language, which is a feature of the language faculty. Even in cases where performance is impaired, linguistic competence can remain intact, as in the case of brain-damaged patients with memory loss. Traditionally philosophers have seen language, primarily, as a means of communication. But Chomsky argues that communication, if we can ever make sense of the notion, is just one 'function' of language. The wedge between linguistic competence and performance is based on the distinction between knowledge which underlies, and is responsible for, a certain type of behaviour and the behaviour itself. This position is in stark contrast to that of Quine who thinks that there is nothing but behaviour, stimulus and response involved in language. Chomsky advocates what he calls an internalist and modular view of language, positions which, as he himself emphasizes, are at odds with the externalist and holist views of language advocated by Davidson, Putnam, and Tyler Burge.

The article 'Form and Meaning in Natural Languages', reproduced here, is a clear and highly accessible statement of some of the main points of Chomsky's evolving position on the above issues.

Works by Chomsky

1965 *Aspects of the Theory of Syntax*. Cambridge, MA: MIT Press.

1966 *Cartesian Linguistics: A Chapter in the History of Rationalist Thought*. New York/London: Harper & Row.

1968; enl. edn 1972 *Language and Mind*. New York: Harcourt Brace Jovanovich.

1975 *The Logical Structure of Linguistic Theory*. New York: Plenum Press.

1975 *Reflections on Language*. London: Temple Smith; New York: Pantheon.

1979 *Language and Responsibility*. New York: Pantheon.

1980 *Rules and Representations*. Oxford: Blackwell; New York: Columbia University Press.

1986 *Knowledge of Language*. New York: Praeger.

1988 *Language and Problems of Knowledge*: The Managua Lectures. Cambridge MA: MIT Press.

1993 'Explaining Language Use', in *Philosophical Topics*, ed. C. S. Hill, 20:1, pp. 205–33.

1994 'Naturalism and Dualism in the Study of Language and Mind', *International Journal of Philosophical Studies*, 2:2, pp. 181–209.

1996 *The Minimalist Program*. Cambridge, MA: MIT Press.

Works on Chomsky

D'Agostino, Fred, *Chomsky's System of Ideas*. Oxford: Clarendon Press, 1986.
Barsky, Robert F., *Noam Chomsky: A Life of Dissent*. Cambridge, MA: MIT Press, 1997.
George, Alexander (ed.), *Reflections on Chomsky*. Oxford: Blackwell, 1989.
Kasher, Asa (ed.), *The Chomskyan Turn*. Oxford: Blackwell, 1991.
John Lyons, *Chomsky*. London: Fontana, 1977 (rev. edn).

Form and Meaning
in Natural Languages

When we study human language, we are approaching what some might call the 'human essence', the distinctive qualities of mind that are, so far as we know, unique to man and that are inseparable from any critical phase of human existence, personal or social. Hence the fascination of this study, and, no less, its frustration. The frustration arises from the fact that despite much progress, we remain as incapable as ever before of coming to grips with the core problem of human language, which I take to be this: Having mastered a language, one is able to understand an indefinite number of expressions that are new to one's experience, that bear no simple physical resemblance and are in no simple way analogous to the expressions that constitute one's linguistic experience; and one is able, with greater or less facility, to produce such expressions on an appropriate occasion, despite their novelty and independently of detectable stimulus configurations, and to be understood by others who share this still mysterious ability. The normal use of language is, in this sense, a creative activity. This creative aspect of normal language use is one fundamental factor that distinguishes human language from any known system of animal communication.

It is important to bear in mind that the creation of linguistic expressions that are novel but appropriate is the normal mode of language use. If some individual were to restrict himself largely to a definite set of linguistic patterns, to a set of habitual responses to stimulus configurations, or to 'analogies' in the sense of modern linguistics, we would regard him as mentally defective, as being less human than animal. He would immediately be set apart from normal humans by his inability to understand normal discourse, or to take part in it in the normal way – the normal way being innovative, free from control by external stimuli, and appropriate to new and ever-changing situations.

It is not a novel insight that human speech is distinguished by these qualities, though it is an insight that must be recaptured time and time

again. With each advance in our understanding of the mechanisms of language, thought, and behavior, comes a tendency to believe that we have found the key to understanding man's apparently unique qualities of mind. These advances are real, but an honest appraisal will show, I think, that they are far from providing such a key. We do not understand, and for all we know, we may never come to understand what makes it possible for a normal human intelligence to use language as an instrument for the free expression of thought and feeling; or, for that matter, what qualities of mind are involved in the creative acts of intelligence that are characteristic, not unique and exceptional, in a truly human existence.

I think that this is an important fact to stress, not only for linguists and psychologists whose research centers on these issues, but, even more, for those who hope to learn something useful in their own work and thinking from research into language and thought. It is particularly important that the limitations of understanding be clear to those involved in teaching, in the universities, and even more important, in the schools. There are strong pressures to make use of new educational technology and to design curriculum and teaching methods in the light of the latest scientific advances. In itself, this is not objectionable. It is important, nevertheless, to remain alert to a very real danger: that new knowledge and technique will define the nature of what is taught and how it is taught, rather than contribute to the realization of educational goals that are set on other grounds and in other terms. Let me be concrete. Technique and even technology is available for rapid and efficient inculcation of skilled behavior, in language teaching, teaching of arithmetic, and other domains. There is, consequently, a real temptation to reconstruct curriculum in the terms defined by the new technology. And it is not too difficult to invent a rationale, making use of the concepts of 'controlling behavior', enhancing skills, and so on. Nor is it difficult to construct objective tests that are sure to demonstrate the effectiveness of such methods in reaching certain goals that are incorporated in these tests. But successes of this sort will not demonstrate that an important educational goal has been achieved. They will not demonstrate that it is important to concentrate on developing skilled behavior in the student. What little we know about human intelligence would at least suggest something quite different: that by diminishing the range and complexity of materials presented to the inquiring mind, by setting behavior in fixed patterns, these methods may harm and distort the normal development of creative abilities. I do not want to dwell on the matter. I am sure that any of you will be able to find examples from your own experience. It is perfectly proper to try to exploit genuine advances in knowledge, and within some given field of study, it is inevitable, and quite proper, that

research should be directed by considerations of feasibility as well as considerations of ultimate significance. It is also highly likely, if not inevitable, that considerations of feasibility and significance will lead in divergent paths. For those who wish to apply the achievements of one discipline to the problems of another, it is important to make very clear the exact nature not only of what has been achieved, but equally important, the limitations of what has been achieved.

I mentioned a moment ago that the creative aspect of normal use of language is not a new discovery. It provides one important pillar for Descartes' theory of mind, for his study of the limits of mechanical explanation. The latter, in turn, provides one crucial element in the construction of the anti-authoritarian social and political philosophy of the Enlightenment. And, in fact, there were even some efforts to found a theory of artistic creativity on the creative aspect of normal language use. Schlegel, for example, argues that poetry has a unique position among the arts, a fact illustrated, he claims, by the use of the term 'poetical' to refer to the element of creative imagination in any artistic effort, as distinct, say, from the term 'musical', which would be used metaphorically to refer to a sensual element. To explain this asymmetry, he observes that every mode of artistic expression makes use of a certain medium and that the medium of poetry – language – is unique in that language, as an expression of the human mind rather than a product of nature, is boundless in scope and is constructed on the basis of a recursive principle that permits each creation to serve as the basis for a new creative act. Hence the central position among the arts of the art forms whose medium is language.

The belief that language, with its inherent creative aspect, is a unique human possession did not go unchallenged, of course. One expositor of Cartesian philosophy, Antoine Le Grand, refers to the opinion 'of some people of the East Indies, who think that Apes and Baboons, which are with them in great numbers, are imbued with understanding, and that they can speak but will not for fear they should be employed, and set to work'. If there is a more serious argument in support of the claim that human language capacity is shared with other primates, then I am unaware of it. In fact, whatever evidence we do have seems to me to support the view that the ability to acquire and use language is a species-specific human capacity, that there are very deep and restrictive principles that determine the nature of human language and are rooted in the specific character of the human mind. Obviously arguments bearing on this hypothesis cannot be definitive or conclusive, but it appears to me, nevertheless, that even in the present stage of our knowledge, the evidence is not inconsiderable.

There are any number of questions that might lead one to undertake a study of language. Personally, I am primarily intrigued by the possibility of learning something, from the study of language, that will bring to light inherent properties of the human mind. We cannot now say anything particularly informative about the normal creative use of language in itself. But I think that we are slowly coming to understand the mechanisms that make possible this creative use of language, the use of language as an instrument of free thought and expression. Speaking again from a personal point of view, to me the most interesting aspects of contemporary work in grammar are the attempts to formulate principles of organization of language which, it is proposed, are universal reflections of properties of mind; and the attempt to show that on this assumption, certain facts about particular languages can be explained. Viewed in this way, linguistics is simply a part of human psychology: the field that seeks to determine the nature of human mental capacities and to study how these capacities are put to work. Many psychologists would reject a characterization of their discipline in these terms, but this reaction seems to me to indicate a serious inadequacy in their conception of psychology, rather than a defect in the formulation itself. In any event, it seems to me that these are proper terms in which to set the goals of contemporary linguistics, and to discuss its achievements and its failings.

I think it is now possible to make some fairly definite proposals about the organization of human language and to put them to empirical test. The theory of transformational-generative grammar, as it is evolving along diverse and sometimes conflicting paths, has put forth such proposals; and there has been, in the past few years, some very productive and suggestive work that attempts to refine and reconstruct these formulations of the processes and structures that underlie human language.

The theory of grammar is concerned with the question, What is the nature of a person's knowledge of his language, the knowledge that enables him to make use of language in the normal, creative fashion? A person who knows a language has mastered a system of rules that assigns sound and meaning in a definite way for an infinite class of possible sentences. Each language thus consists (in part) of a certain pairing of sound and meaning over an infinite domain. Of course, the person who knows the language has no consciousness of having mastered these rules or of putting them to use, nor is there any reason to suppose that this knowledge of the rules of language can be brought to consciousness. Through introspection, a person may accumulate various kinds of evidence about the sound–meaning relation determined by the rules of the language that he has mastered; there is no reason to suppose that he can go much beyond this surface level of data so as to discover, through

introspection, the underlying rules and principles that determine the relation of sound and meaning. Rather, to discover these rules and principles is a typical problem of science. We have a collection of data regarding sound–meaning correspondence, the form and interpretation of linguistic expressions, in various languages. We try to determine, for each language, a system of rules that will account for such data. More deeply, we try to establish the principles that govern the formation of such systems of rules for any human language.

The system of rules that specifies the sound–meaning relation for a given language can be called the 'grammar' – or, to use a more technical term, the 'generative grammar' – of this language. To say that a grammar 'generates' a certain set of structures is simply to say that it specifies this set in a precise way. In this sense, we may say that the grammar of a language generates an infinite set of 'structural descriptions', each structural description being an abstract object of some sort that determines a particular sound, a particular meaning, and whatever formal properties and configurations serve to mediate the relation between sound and meaning. For example, the grammar of English generates structural descriptions for the sentences I am now speaking; or, to take a simpler case for purposes of illustration, the grammar of English would generate a structural description for each of these sentences:

(1) John is certain that Bill will leave.
(2) John is certain to leave.

Each of us has mastered and internally represented a system of grammar that assigns structural descriptions to these sentences; we use this knowledge, totally without awareness or even the possibility of awareness, in producing these sentences or understanding them when they are produced by others. The structural descriptions include a phonetic representation of the sentences and a specification of their meaning. In the case of the cited examples (1) and (2), the structural descriptions must convey roughly the following information: They must indicate that in the case of (1), a given psychological state (namely, being certain that Bill will leave) is attributed to John; whereas in the case of (2), a given logical property (namely, the property of being certain) is attributed to the proposition that John will leave. Despite the superficial similarity of form of these two sentences, the structural descriptions generated by the grammar must indicate that their meanings are very different: One attributes a psychological state to John, the other attributes a logical property to an abstract proposition. The second sentence might be paraphrased in a very different form:

(3) That John will leave is certain.

For the first there is no such paraphrase. In the paraphrase (3) the 'logical form' of (2) is expressed more directly, one might say. The grammatical relations in (2) and (3) are very similar, despite the difference of surface form; the grammatical relations in (1) and (2) are very different, despite the similarity of surface form. Such facts as these provide the starting point for an investigation of the grammatical structure of English – and more generally, for the investigation of the general properties of human language.

To carry the discussion of properties of language further, let me introduce the term 'surface structure' to refer to a representation of the phrases that constitute a linguistic expression and the categories to which these phrases belong. In sentence (1), the phrases of the surface structure include: 'that Bill will leave', which is a full proposition; the noun phrases 'Bill' and 'John'; the verb phrases 'will leave' and 'is certain that Bill will leave', and so on. In sentence (2), the surface structure includes the verb phrases 'to leave' and 'is certain to leave'; but the surface structure of (2) includes no proposition of the form 'John will leave', even though this proposition expresses part of the meaning of 'John is certain to leave', and appears as a phrase in the surface structure of its paraphrase, 'that John will leave is certain'. In this sense, surface structure does not necessarily provide an accurate indication of the structures and relations that determine the meaning of a sentence; in the case of sentence (2), 'John is certain to leave', the surface structure fails to indicate that the proposition 'John will leave' expresses a part of the meaning of the sentence – although in the other two examples that I gave the surface structure comes rather close to indicating the semantically significant relations.

Continuing, let me introduce the further technical term 'deep structure' to refer to a representation of the phrases that play a more central role in the semantic interpretation of a sentence. In the case of (1) and (3), the deep structure might not be very different from the surface structure. In the case of (2), the deep structure will be very different from the surface structure, in that it will include some such proposition as 'John will leave' and the predicate 'is certain' applied to this proposition, though nothing of the sort appears in the surface structure. In general, apart from the simplest examples, the surface structures of sentences are very different from their deep structures.

The grammar of English will generate, for each sentence, a deep structure, and will contain rules showing how this deep structure is related to a surface structure. The rules expressing the relation of deep and surface structure are called 'grammatical transformations'. Hence the term 'transformational-generative grammar'. In addition to rules

defining deep structures, surface structures, and the relation between them, the grammar of English contains further rules that relate these 'syntactic objects' (namely, paired deep and surface structures) to phonetic representations on the one hands, and to representations of meaning on the other. A person who has acquired knowledge of English has internalized these rules and makes use of them when he understands or produces the sentences just given as examples, and an indefinite range of others.

Evidence in support of this approach is provided by the observation that interesting properties of English sentences can be explained directly in terms of the deep structures assigned to them. Thus consider once again the two sentences (1) ('John is certain that Bill will leave') and (2) ('John is certain to leave'). Recall that in the case of the first, the deep structure and surface structure are virtually identical, whereas in the case of the second, they are very different. Observe also that in the case of the first, there is a corresponding nominal phrase, namely, 'John's certainty that Bill will leave (surprised me)'; but in the case of the second, there is no corresponding nominal phrase. We cannot say, 'John's certainty to leave surprised me.' The latter nominal phrase is intelligible, I suppose, but it is not well formed in English. The speaker of English can easily make himself aware of this fact, though the reason for it will very likely escape him. This fact is a special case of a very general property of English: Namely, nominal phrases exist corresponding to sentences that are very close in surface form to deep structure, but not corresponding to such sentences that are remote in surface form from deep structure. Thus 'John is certain that Bill will leave', being close in surface form to its deep structure, corresponds to the nominal phrase 'John's certainty that Bill will leave'; but there is no such phrase as 'John's certainty to leave' corresponding to 'John is certain to leave', which is remote from its deep structure.

The notions of 'closeness' and 'remoteness' can be made quite precise. When we have made them precise, we have an explanation for the fact that nominalizations exist in certain cases but not in others – though were they to exist in these other cases, they would often be perfectly intelligible. The explanation turns on the notion of deep structure: In effect, it states that nominalizations must reflect the properties of deep structure. There are many examples that illustrate this phenomenon. What is important is the evidence it provides in support of the view that deep structures which are often quite abstract exist and play a central role in the grammatical processes that we use in producing and interpreting sentences. Such facts, then, support the hypothesis that deep structures of the sort postulated in transformational-generative grammar are real

mental structures. These deep structures, along with the transformation rules that relate them to surface structure and the rules relating deep and surface structures to representations of sound and meaning, are the rules that have been mastered by the person who has learned a language. They constitute his knowledge of the language; they are put to use when he speaks and understands.

The examples I have given so far illustrate the role of deep structure in determining meaning, and show that even in very simple cases, the deep structure may be remote from the surface form. There is a great deal of evidence indicating that the phonetic form of a sentence is determined by its surface structure, by principles of an extremely interesting and intricate sort that I will not try to discuss here. From such evidence it is fair to conclude that surface structure determines phonetic form, and that the grammatical relations represented in deep structure are those that determine meaning. Furthermore, as already noted, there are certain grammatical processes, such as the process of nominalization, that can be stated only in terms of abstract deep structures.

The situation is complicated, however, by the fact that surface structure also plays a role in determining semantic interpretation.[1] The study of this question is one of the most controversial aspects of current work, and, in my opinion, likely to be one of the most fruitful. As an illustration, consider some of the properties of the present perfect aspect in English – for example, such sentences as 'John has lived in Princeton'. An interesting and rarely noted feature of this aspect is that in such cases it carries the presupposition that the subject is alive. Thus it is proper for me to say 'I have lived in Princeton' but, knowing that Einstein is dead, I would not say 'Einstein has lived in Princeton.' Rather, I would say 'Einstein lived in Princeton.' (As always, there are complications, but this is accurate as a first approximation.) But now consider active and passive forms with present perfect aspect. Knowing that John is dead and Bill alive, I can say 'Bill has often been visited by John', but not 'John has often visited Bill'; rather, 'John often visited Bill.' I can say 'I have been taught physics by Einstein' but not 'Einstein has taught me physics'; rather, 'Einstein taught me physics.' In general, active and passive are synonymous and have essentially the same deep structures. But in these cases, active and passive forms differ in the presuppositions they express; put simply, the presupposition is that the person denoted by the surface subject is alive. In this respect, the surface structure contributes to the meaning of the sentence in that it is relevant to determining what is presupposed in the use of a sentence.

Carrying the matter further, observe that the situation is different when we have a conjoined subject. Thus given that Hillary is alive and

Marco Polo dead, it is proper to say 'Hillary has climbed Mt Everest'
but not 'Marco Polo has climbed Mt Everest'; rather, again, 'Marco
Polo climbed Mt Everest.' (Again, I overlook certain subtleties and
complications.) But now consider the sentence 'Marco Polo and Hillary
(among others) have climbed Mt Everest.' In this case, there is no
expressed presupposition that Marco Polo is alive, as there is none in
the passive 'Mt Everest has been climbed by Marco Polo (among others).'
 Notice further that the situation changes considerably when we shift
from the normal intonation, as in the cases I have just given, to an
intonation contour that contains a contrastive or expressive stress. The
effect of such intonation on presupposition is fairly complex. Let me
illustrate with a simple case. Consider the sentence 'The Yankees played
the Red Sox in Boston.' With normal intonation, the point of main stress
and highest pitch is the word 'Boston' and the sentence might be an
answer to such questions as 'Where did the Yankees play the Red Sox?'
('in Boston'); 'What did the Yankees do?' ('They played the Red Sox in
Boston'); 'What happened?' ('The Yankees played the Red Sox in
Boston'). But suppose that contrastive stress is placed on 'Red Sox', so
that we have 'The Yankees played the RED SOX in Boston.' Now, the
sentence can be the answer only to 'Who did the Yankees play in Boston?'
Note that the sentence presupposes that the Yankees played someone in
Boston; if there was no game at all, it is improper, not just false, to say
'The Yankees played the RED SOX in Boston.' In contrast, if there was
no game at all, it is false, but not improper, to say 'The Yankees played
the Red Sox in Boston', with normal intonation. Thus contrastive stress
carries a presupposition in a sense in which normal intonation does not,
though normal intonation also carries a presupposition in another sense;
thus it would be improper to answer the question 'Who played the Red
Sox in Boston?' with 'The Yankees played the Red Sox in Boston' (normal
intonation). The same property of contrastive stress is shown by the so-
called cleft sentence construction. Thus the sentence 'It was the YANKEES
who played the Red Sox in Boston' has primary stress on 'Yankees', and
presupposes that someone played the Red Sox in Boston. The sentence
is improper, not just false, if there was no game at all. These phenomena
have generally been overlooked when the semantic role of contrastive
stress has been noted.
 To further illustrate the role of surface structure in determining
meaning, consider such sentences as this: 'John is tall for a pygmy.' This
sentence presupposes that John is a pygmy, and that pygmies tend to be
short; hence given our knowledge of the Watusi, it would be anomalous
to say 'John is tall for a Watusi.' On the other hand, consider what
happens when we insert the word 'even' in the sentence. Inserting it

before 'John' we derive: 'Even John is tall for a pygmy.' Again, the presupposition is that John is a pygmy and that pygmies are short. But consider: 'John is tall even for a pygmy.' This presupposes that pygmies are tall; it is therefore a strange sentence, given our knowledge of the facts, as compared, say, to 'John is tall even for a Watusi', which is quite all right. The point is that the position of 'even' in the sentence 'John is tall for a pygmy' determines the presupposition with respect to the average height of pygmies.

But the placement of the word 'even' is a matter of surface structure. We can see this from the fact that the word 'even' can appear in association with phrases that do not have any representation at the level of deep structure. Consider, for example, the sentence 'John isn't certain to leave at 10; in fact, he isn't even certain to leave at all.' Here, the word 'even' is associated with 'certain to leave', a phrase which, as noted earlier, does not appear at the level of deep structure. Hence in this case as well properties of surface structure play a role in determining what is presupposed by a certain sentence.

The role of surface structure in determining meaning is illustrated once again by the phenomenon of pronominalization.[2] Thus if I say 'Each of the men hates his brothers', the word 'his' may refer to one of the men; but if I say 'The men each hate his brothers', the word 'his' must refer to some other person, not otherwise referred to in the sentence. However, the evidence is strong that 'each of the men' and 'the men each' derive from the same deep structure. Similarly, it has been noted that placement of stress plays an important role in determining pronominal reference. Consider the following discourse: 'John washed the car; I was afraid someone ELSE would do it.' The sentence implies that I hoped that John would wash the car, and I'm happy that he did. But now consider the following: 'John washed the car; I was AFRAID someone else would do it.' With stress on 'afraid', the sentence implies that I hoped that John would not wash the car. The reference of 'someone else' is different in the two cases. There are many other examples that illustrate the role of surface structure in determining pronominal reference.

To complicate matters still further, deep structure too plays a role in determining pronominal reference. Thus consider the sentence 'John appeared to Bill to like him.' Here, the pronoun 'him' may refer to Bill but not John. Compare 'John appealed to Bill to like him.' Here, the pronoun may refer to John but not Bill. Thus we can say 'John appealed to Mary to like him', but not 'John appeared to Mary to like him', where 'him' refers to 'John'; on the other hand, we can say 'John appeared to Mary to like her', but not 'John appealed to Mary to like her', where 'her' refers to Mary. Similarly, in 'John appealed to Bill to like himself',

the reflexive refers to Bill; but in 'John appeared to Bill to like himself', it refers to John. These sentences are approximately the same in surface structure; it is the differences in deep structure that determine the pronominal reference.

Hence pronominal reference depends on both deep and surface structure. A person who knows English has mastered a system of rules which make use of properties of deep and surface structure in determining pronominal reference. Again, he cannot discover these rules by introspection. In fact, these rules are still unknown, though some of their properties are clear.

To summarize: The generative grammar of a language specifies an infinite set of structural descriptions, each of which contains a deep structure, a surface structure, a phonetic representation, a semantic representation, and other formal structures. The rules relating deep and surface structure – the so-called 'grammatical transformations' – have been investigated in some detail, and are fairly well understood. The rules that relate surface structure and phonetic representation are also reasonably well understood (though I do not want to imply that the matter is beyond dispute; far from it). It seems that both deep and surface structure enter into the determination of meaning. Deep structure provides the grammatical relations of predication, modification, and so on, that enter into the determination of meaning. On the other hand, it appears that matters of focus and presupposition, topic and comment, the scope of logical elements, and pronominal reference are determined, in part at least, by surface structure. The rules that relate syntactic structures to representations of meaning are not at all well understood. In fact, the notion 'representation of meaning' or 'semantic representation' is itself highly controversial. It is not clear at all that it is possible to distinguish sharply between the contribution of grammar to the determination of meaning, and the contribution of so-called 'pragmatic considerations', questions of fact and belief and context of utterance. It is perhaps worth mentioning that rather similar questions can be raised about the notion 'phonetic representation'. Although the latter is one of the best established and least controversial notions of linguistic theory, we can, nevertheless, raise the question whether or not it is a legitimate abstraction, whether a deeper understanding of the use of language might not show that factors that go beyond grammatical structure enter into the determination of perceptual representations and physical form in an inextricable fashion, and cannot be separated, without distortion, from the formal rules that interpret surface structure as phonetic form.

So far, the study of language has progressed on the basis of a certain

abstraction: Namely, we abstract away from conditions of use of language and consider formal structures and the formal operations that relate them. Among these formal structures are those of syntax, namely, deep and surface structures; and also the phonetic and semantic representations, which we take to be certain formal objects related to syntactic structures by certain well-defined operations. This process of abstraction is in no way illegitimate, but one must understand that it expresses a point of view, a hypothesis about the nature of mind, that is not a priori obvious. It expresses the working hypothesis that we can proceed with the study of 'knowledge of language' – what is often called 'linguistic competence' – in abstraction from the problems of how language is used. The working hypothesis is justified by the success that is achieved when it is adopted. A great deal has been learned about the mechanisms of language, and, I would say, about the nature of mind, on the basis of this hypothesis. But we must be aware that in part, at least, this approach to language is forced upon us by the fact that our concepts fail us when we try to study the use of language. We are reduced to platitudes, or to observations which, though perhaps quite interesting, do not lend themselves to systematic study by means of the intellectual tools presently available to us. On the other hand, we can bring to the study of formal structures and their relations a wealth of experience and understanding. It may be that at this point we are facing a problem of conflict between significance and feasibility, a conflict of the sort that I mentioned earlier in this paper. I do not believe that this is the case, but it is possible. I feel fairly confident that the abstraction to the study of formal mechanisms of language is appropriate; my confidence arises from the fact that many quite elegant results have been achieved on the basis of this abstraction. Still, caution is in order. It may be that the next great advance in the study of language will require the forging of new intellectual tools that permit us to bring into consideration a variety of questions that have been cast into the waste-bin of 'pragmatics', so that we could proceed to study questions that we know how to formulate in an intelligible fashion.

As noted, I think that the abstraction to linguistic competence is legitimate. To go further, I believe that the inability of modern psychology to come to grips with the problems of human intelligence is in part, at least, a result of its unwillingness to undertake the study of abstract structures and mechanisms of mind. Notice that the approach to linguistic structure that I have been outlining has a highly traditional flavor to it. I think it is no distortion to say that this approach makes precise a point of view that was inherent in the very important work of the seventeenth- and eighteenth-century universal grammarians, and that

was developed, in various ways, in rationalist and romantic philosophy of language and mind. The approach deviates in many ways from a more modern, and in my opinion quite erroneous, conception, that knowledge of language can be accounted for as a system of habits, or in terms of stimulus-response connections, principles of 'analogy' and 'generalization', and other notions that have been explored in twentieth-century linguistics and psychology, and that develop from traditional empiricist speculation. The fatal inadequacy of all such approaches, I believe, results from their unwillingness to undertake the abstract study of linguistic competence. Had the physical sciences limited themselves by similar methodological strictures, we would still be in the era of Babylonian astronomy.

One traditional concept that has reemerged in current work is that of 'universal grammar', and I want to conclude by saying just a word about this topic. There are two kinds of evidence suggesting that deep-seated formal conditions are satisfied by the grammars of all languages. The first kind of evidence is provided by the study of a wide range of languages. In attempting to construct generative grammars for languages of widely varied kinds, investigators have repeatedly been led to rather similar assumptions as to the form and organization of such generative systems. But a more persuasive kind of evidence bearing on universal grammar is provided by the study of a single language. It may at first seem paradoxical that the intensive study of a single language should provide evidence regarding universal grammar, but a little thought about the matter shows that this is a very natural consequence.

To see this, consider the problem of determining the mental capacities that make language acquisition possible. If the study of grammar – of linguistic competence – involves an abstraction from language use, then the study of the mental capacities that make acquisition of grammar possible involves a further, second-order abstraction. I see no fault in this. We may formulate the problem of determining the intrinsic characteristics of a device of unknown properties that accepts as 'input' the kind of data available to the child learning his first language, and produces as 'output' the generative grammar of that language. The 'output', in this case, is the internally represented grammar, mastery of which constitutes knowledge of the language. If we undertake to study the intrinsic structure of a language-acquisition device without dogma or prejudice, we arrive at conclusions which, though of course only tentative, still seem to me both significant and reasonably well-founded. We must attribute to this device enough structure so that the grammar can be constructed within the empirically given constraints of time and available data, and we must meet the empirical condition that different

speakers of the same language, with somewhat different experience and training, nevertheless acquire grammars that are remarkably similar, as we can determine from the ease with which they communicate and the correspondences among them in the interpretation of new sentences. It is immediately obvious that the data available to the child is quite limited – the number of seconds in his lifetime is trivially small as compared with the range of sentences that he can immediately understand and can produce in the appropriate manner. Having some knowledge of the characteristics of the acquired grammars and the limitations on the available data, we can formulate quite reasonable and fairly strong empirical hypotheses regarding the internal structure of the language-acquisition device that constructs the postulated grammars from the given data. When we study this question in detail, we are, I believe, led to attribute to the device a very rich system of constraints on the form of a possible grammar; otherwise, it is impossible to explain how children come to construct grammars of the kind that seem empirically adequate under the given conditions of time and access to data. But if we assume, furthermore, that children are not genetically predisposed to learn one rather than another language, then the conclusions we reach regarding the language-acquisition device are conclusions regarding universal grammar. These conclusions can be falsified by showing that they fail to account for the construction of grammars of other languages, for example. And these conclusions are further verified if they serve to explain facts about other languages. This line of argument seems to me very reasonable in a general way, and when pursued in detail it leads us to strong empirical hypotheses concerning universal grammar, even from the study of a particular language.

I have discussed an approach to the study of language that takes this study to be a branch of theoretical human psychology. Its goal is to exhibit and clarify the mental capacities that make it possible for a human to learn and use a language. As far as we know, these capacities are unique to man, and have no significant analogue in any other organism. If the conclusions of this research are anywhere near correct, then humans must be endowed with a very rich and explicit set of mental attributes that determine a specific form of language on the basis of very slight and rather degenerate data. Furthermore, they make use of the mentally represented language in a highly creative way, constrained by its rules but free to express new thoughts that relate to past experience or present sensations only in a remote and abstract fashion. If this is correct, there is no hope in the study of the 'control' of human behavior by stimulus conditions, schedules of reinforcement, establishment of habit structures, patterns of behavior, and so on. Of course, one can

design a restricted environment in which such control and such patterns can be demonstrated, but there is no reason to suppose that any more is learned about the range of human potentialities by such methods than would be learned by observing humans in a prison or an army – or in many a schoolroom. The essential properties of the human mind will always escape such investigation. And if I can be pardoned a final 'non-professional' comment, I am very happy with this outcome.

Notes and References

1. I discuss this matter in some detail in 'Deep Structure and Semantic Interpretation', in R. Jakobson, and S. Kawamoto (eds), *Studies in General and Oriental Linguistics*, commemorative volume for Shiro Hattori, TEC Corporation for Language and Educational Research (Tokyo, 1970).
2. The examples that follow are due to Ray Dougherty, Adrian Akmajian, and Ray Jackendoff. See my article in Jakobson and Kawamoto (eds), *Studies in General and Oriental Linguistics*, for references.

16

MICHAEL DUMMETT

(1925–)

The British philosopher Michael Dummett was educated at Oxford where he was Wykeham Professor of Logic from 1979 until his retirement in 1992. His work has been focused on philosophy of language, logic and mathematics and shows the influence of Frege, the logical positivists, and the later Wittgenstein. It has been said that Dummett, almost single-handedly, is pursuing the goals of analytic philosophy of language as set out by the founders of that tradition at the turn of the century. In recent years Dummett has also focused his attention on the historical questions about the origins of analytic philosophy and has instigated a wide-ranging discussion on the issues involved in tracing the ancestry of analytic and continental philosophy.

Dummett is best known for his arguments against semantic realism, or the view that identifies the meaning of a sentence with its truth conditions, and the development of a sophisticated anti-realist theory of meaning. The motivation for Dummett's anti-realism in philosophy of language stems, to a large extent, from his views on the dispute between the classical Platonist and intuitionist conceptions of mathematics. According to the former, every mathematical statement has a determinate truth value which is independent of our abilities to construct proofs for it. Intuitionists, on the other hand, hold the view that the truth or falsity of a mathematical statement cannot obtain independently of our having evidence or proof, for or against. Dummett applies this point to philosophy of language and theories of meaning. Realism in philosophy of language amounts to the claim that to understand a statement is to know its truth conditions. Dummett associates the meaning of a given sentence with its assertability conditions, so, to understand a statement means to know what counts as evidence for or against that sentence (in appropriate circumstances). A sentence is meaningful only if we can have evidence and justification for asserting it or its negation, 'and the truth of the statement can consist only in the existence of such evidence' (*Truth and*

Other Enigmas, p. 155). The underlying reasoning is that truth cannot be conceived of, or intelligibly apprehended, in an evidence-transcendent way. The point has a long and respectable history. The realists claim that truth is correspondence with mind-independent facts. However, there is no mind-independent means of our conceiving or comprehending a fact. Therefore the anti-realists of various hues argue that there is no intelligible way of talking about correspondence and mind independence.

The main tenets of Dummett's position can be summarized as:

(a) The central notion in a theory of meaning is the concept of justification. The logical positivists' principle of verification is the philosophical ancestor of this aspect of Dummett's work.
(b) Truth should at least in part be analysed in terms of justification.
(c) We cannot make sense of individualistic theories of meaning. Meaning is by definition public and social (a point which had been originally emphasized in Wittgenstein's later work).
(d) Any theory of thought has necessarily to be given in terms of a theory of meaning, because our capacity for thought is not separable from our ability to use language; that is, fully-fledged thought cannot be acquired before the acquisition of language. Because of this, as we have seen, Dummett holds the view that philosophy of language is 'first philosophy', or the foundation of all other philosophy: the goal of philosophy, he contends, is the analysis of the structure of thought and it is only by the analysis of language that we can analyse thought.

According to Dummett, anti-realism in any given domain consists of the view that the principle of bivalence fails in that domain. The principle of bivalence states that any given proposition is either true or false, and that there are no other possibilities. In his landmark article 'Truth' (1978), Dummett gives different examples of sentences which fail to meet the assertability condition, i.e., sentences for which we cannot have any evidence. Take, for instance, 'A female dinosaur roamed on this spot five million years ago', or 'A city will one day be built on this spot' – neither sentence, nor its negation, is justifiably assertable and, hence, we cannot have a genuine grasp or understanding of either its truth conditions or its meaning. Furthermore, no sense can be made of the suggestion that such sentences can be unknowably true. Rather, they should be correctly characterized as neither true nor false.

In the article reproduced in this collection, first published as a paper presented at the 1978 Centenary celebrations at Stockholm University, and reprinted in *The Seas of Language* (1993), Dummett reiterates and refines some of his long-standing views on the questions of meaning and

use. The central task of philosophy of language is to explain what meaning is, he argues. The question of meaning is inseparable from that of understanding and mastery of language. To have mastery of language, Dummett believes, is to have implicit knowledge of a theory of meaning. This implicit knowledge is manifested in the speaker's use of language. The understanding of a language always involves publicity or being open to external tests. Furthermore, the knowledge of a language must be completely manifested in the use of the language, or in the linguistic practices of the individual members of the language community. Thus, any theory of meaning will be inexorably linked with a correct account of the conditions under which assertions are made and language is used.

Works by Dummett

1973; 2nd edn **1981** *Frege: Philosophy of Language*. London: Duckworth.
1978 *Truth and Other Enigmas*. London: Duckworth.
1981 *The Interpretation of Frege's Philosophy*. London: Duckworth.
1991 *Frege: Philosophy of Mathematics*. London: Duckworth.
1991 *Frege and Other Philosophers*. Oxford: Clarendon Press.
1993 *The Seas of Language*. Oxford: Clarendon Press.
1993 *Origins of Analytical Philosophy*. London: Duckworth; Cambridge: Harvard University Press.

Works on Dummett

Heck, R. (ed.), *Logic, Language, and Reality: Essays in Honour of Michael Dummett*. Oxford: Oxford University Press (forthcoming).
Platts, Mark, *Ways of Meaning: An Introduction to a Philosophy of Language*. London: Routledge, 1979.
Taylor, B. (ed.), *Michael Dummett: Contributions to Philosophy*. Dordrecht/Lancaster: Nijhoff, 1987.
Wright, Crispin, *Realism, Meaning and Truth*. Oxford: Oxford University Press, 1993 (2nd edn).

What do I Know when I
Know a Language?

Our usual ways of thinking about the mastery of a language, or of this and that element of it, are permeated by the conception that this mastery consists in *knowledge*. To understand an expression is to know its meaning; we speak of knowing what an ostrich is, of knowing what 'credulous' means, and, above all, of knowing Swedish or Spanish. Are we to take seriously the use of the verb 'to know' in this connection? Is an ability to speak a language really a case of knowledge?

The verb 'to know' is used in connection with many practical abilities: in English we speak of '*knowing* how to swim/ride a bicycle' and in French, for example, one says 'Il *sait* nager' rather than 'Il *peut* nager'. But does the knowledge – the practical knowledge – involved in these cases *explain* the practical ability, or is it, rather, that the practical ability is all there is to the practical knowledge, that our appeal in these cases to the concept of knowledge is a mere manner of speaking, not to be taken seriously? And, if the latter view is correct, does not the same hold of the mastery of the language, which is also a practical ability?

A character in one of the novels of the English humorist P. G. Wodehouse, asked whether she can speak Spanish, replies, 'I don't know: I've never tried.' Where does the absurdity of this lie? Would there be the same absurdity in giving that answer to the question. 'Can you swim?' The suggestion that the absurdity would be the same in both cases amounts to the proposal that our use of the verb 'to know' in these two connections – 'knowing Spanish', 'knowing how to swim' – is due to the empirical fact that speaking Spanish and swimming are things no one can do unless he has been taught, that is, has been subjected to a certain training; 'to know', in these cases, means 'to have learned'. But is this right? It is *only* an empirical fact that we cannot swim unless we have been taught. It would not be magic if someone were, instinctively as we should say, to make the right movements the first time he found himself in water, and, indeed, I have heard it said that this is just what happens

when very small infants are put in water. But it seems natural to think that it would be magic if someone who had not been brought up to speak Spanish and had never learned it since were suddenly to start speaking it. If asked for an explanation of the difference, we should be inclined to say that, if you are to speak Spanish, there are a great many things that you have to *know*, just as there are many things that you have to know if you are to play chess.

The difference lies in the fact that speaking a language is a conscious process. We can conceive that someone, put in the water for the first time, might simply find himself swimming. He need not, in any sense, know what he is doing; he need not even know that he is swimming. But what are we imagining when we imagine that someone, arriving for the first time in his life in a Spanish-speaking country, should find himself speaking Spanish? There are two different cases, according as we suppose that he knows what he is saying or that he just hears the words coming out of his mouth without knowing what they mean. In either case, it is magic, but, in the latter case, although, miraculously, he *can* speak Spanish, he still does not *know* Spanish. Knowing Spanish, or knowing how to speak Spanish, is not, after all, to be compared with knowing how to swim. Both may be called practical capacities: but practical capacities are not all of one kind.

What do you not know if you have not learned to swim? You know what swimming is; you just do not know *how* to do it. And, if you found yourself in water, you might do it all the same, without knowing how you do it. You know what it is to swim; you can, for example, tell whether or not someone else is swimming: that is why, if you had to, you might try to swim, and you might find out that you could. But, if you have not learned Spanish, you do not even know what it is to speak Spanish; you could not tell (at least for sure) whether someone else was speaking it or not: and that is why you could not even try to speak Spanish. Indeed, when you learn Spanish, you do not learn a technique for accomplishing the already known end of speaking Spanish. There is no gap between knowing what it is to speak Spanish and knowing how to do so (save in special cases of a psychological inhibition or the like): you do not first learn what speaking Spanish is and then learn a means by which this feat can be executed.

There are degrees of consciousness with which a person may perform a skilled operation. At one extreme, he will formulate to himself the action to be carried out at each step and the manner in which it is to be done, as when someone unaccustomed to such tasks has memorized instructions how to cook a certain dish, or how to assemble a machine. This is the case in which a person has explicit knowledge how to perform

the operation, and appeals to that knowledge in the course of performing it. At the other extreme, someone may simply be unable to say what it is that he does, even on reflection or when he tries to observe himself very closely; notoriously, those who have acquired physical skills may be quite unable to explain to others how to perform those feats. This is the case in which, if we speak of him as knowing how to perform the operation (say, swimming or riding a bicycle), the expression 'knows how to do it' has only the force of 'can do it as the result of having learned to do it'. But there are also intermediate cases. In these, someone may be unable to formulate for himself the principles according to which he acts, but may nevertheless be capable of acknowledging, and willing to acknowledge, the correctness of a statement of those principles when it is offered to him.

In cases of this intermediate kind, it seems to me, we have to take more seriously the ascription of knowledge to someone who possesses the practical ability in question: 'knows how to do it' is not here a mere idiomatic equivalent of 'can do it'. Rather, we may say of the agent that he knows *that* certain things are the case, that he knows certain propositions about how the operation is to be performed; but we need to qualify this by conceding that his knowledge is not *explicit* knowledge, that is, knowledge which may be immediately elicited on request. It is, rather, *implicit* knowledge: knowledge which shows itself partly by manifestation of the practical ability, and partly by a readiness to acknowledge as correct a formulation of that which is known when it is presented. Consider, as an example, the knowledge of how to play chess. As a matter of fact, no one ever learns chess without being given some explicit information, such as that no piece except the knight may leap over another. Nevertheless, I can see no reason why it should be in principle unthinkable that someone should learn the game without ever being *told* anything, and without even framing rules to himself, simply by being corrected whenever he made an illegal move. Now, if we said, of such a person, that he knew how to play chess, should we be using the verb 'to know' solely in that sense which is involved in saying that someone knows how to swim? It appears to me that we should not. The reason is that it *would* be unthinkable that, having learned to obey the rules of chess, he should not then be able and willing to acknowledge those rules as correct when they were put to him, for example, to agree, perhaps after a little reflection, that only the knight could leap over another piece. Someone who had learned the game in this way could properly be said to know the rules *implicitly*. We might put the point by saying that he does not merely follow the rules, without knowing what he is doing: he is *guided* by them.

There now arises a further question, not so easy to answer or even to state. The central task of the philosopher of language is to explain what *meaning* is, that is, what makes a language *language*. Consider two speakers engaged in conversation. To immediate inspection, all that is happening is that sounds of a certain kind issue from the mouths of each alternately. But we know that there is a deeper significance: they are expressing thoughts, putting forward arguments, stating conjectures, asking questions, etc. What the philosophy of language has to explain is what gives this character to the sounds they utter: what makes their utterances expressions of thought and all these other things?

The natural answer is that what makes the difference is the fact that both speakers *understand* or *know* the language. Each has, so to speak, the same piece of internal (mental) equipment, which enables each to interpret the utterances of the other as an expression of thought, and to convert his own thoughts into sentences that the other can likewise understand. It thus seems as though the key to the explanation of the expressive power which makes a language a language is an individual speaker's mastery of the language; and this mastery, as we saw, requires the notion of knowledge for its explication.

This, then, becomes our second question: Is the significance of language to be explained in terms of a speaker's knowledge of his language? Philosophers before Frege assumed that it is; and they assumed, further, that what a speaker knows is a kind of code. Concepts are coded into words and thoughts, which are compounded out of concepts, into sentences, whose structure mirrors, by and large, the complexity of the thoughts. We need language, on this view, only because we happen to lack the faculty of telepathy, that is, of the direct transmission of thoughts. Communication is thus essentially like the use of a telephone: the speaker codes his thought in a transmittable medium, which is then decoded by the hearer.

The whole analytical school of philosophy is founded on the rejection of this conception, first clearly repudiated by Frege. The conception of language as a code requires that we may ascribe concepts and thoughts to people independently of their knowledge of language; and one strand of objection is that, for any but the simplest concepts, we cannot explain what it is to grasp them independently of the ability to express them in language. As Frege said, a dog will no doubt notice a difference between being set on by several dogs and being set on by only one, but he is unlikely to have even the dimmest consciousness of anything in common between being bitten by one larger dog and chasing one cat, which he would have to do were we to be able to ascribe to him a grasp of the concept we express by the word 'one'. Or, again, as Wittgenstein

remarked, a dog can expect his master to come home, but he cannot expect him to come home next week; and the reason is that there is nothing the dog could do to *manifest* an expectation that his master will come home next week. It makes no sense to attribute to a creature without language a grasp of the concept expressed by the words 'next week'.

It is, however, a serious mistake to suppose this to be the principal objection to the conception of language as a code. That conception involves comparing someone's mastery of his mother tongue with his mastery of a second language. His mastery of a second language may be represented as a grasp of a scheme of translation between it and his mother tongue: by appeal to this, he can associate expressions of the second language with expressions of his mother tongue. In a similar way, his mastery of his mother tongue is viewed, on this conception, as an ability to associate with each of its words the corresponding concept, and thus with each sentence of the language a thought compounded of such concepts.

The fundamental objection to this conception of language is that the analogy it uses breaks down. If we explain someone's knowledge of a second language as consisting in his grasp of a scheme of translation between it and his mother tongue, we tacitly presuppose that he understands his mother tongue; it then remains to be explained in what his understanding of his mother tongue consists. We can, in this way, proceed to explain his understanding of the second language in two stages – first, his ability to translate it into his mother tongue, and, secondly, his understanding of his mother tongue – precisely because, in principle, the ability to translate does not involve the ability to understand. In principle, we can imagine a person – or a very skilfully programmed computer – able to translate between two languages without understanding either. That is why, when we explain someone's knowledge of a second language as an ability to translate it into his mother tongue, we are not giving a circular account: the ability to translate does not, in itself, presuppose an understanding of the second language like the understanding someone has of his mother tongue. It is quite otherwise when we try to explain someone's understanding of his mother tongue after the same model, namely as consisting in his associating certain concepts with the words. For the question arises what it *is* to 'associate a concept with a word'. We know what it is to associate a word of one language with a word of another: asked to translate the one word, he utters, or writes down, the other. But the concept has no representation intermediate between it and its verbal expression. Or, if it does, we still have the question what makes it a representation of *that* concept. We cannot say that someone's

association of a particular concept with a given word consists in the fact that, when he hears that word, that concept comes into his mind, for there is really no sense to speaking of a concept's coming into someone's mind. All that we can think of is some image coming to mind which we take as in some way representing the concept, and this gets us no further forward, since we still have to ask in what his associating that concept with that image consists.

Rather, any account of what it is to associate a concept with a word would have to provide an explanation of one thing which might constitute a grasp of the concept. What is it to grasp the concept *square*, say? At the very least, it is to be able to discriminate between things that are square and those that are not. Such an ability can be ascribed only to one who will, on occasion, treat square things differently from things that are not square; one way, among many other possible ways, of doing this is to apply the word 'square' to square things and not to others. And it can only be by reference to some such use of the word 'square', or at least of some knowledge *about* the word 'square' which would warrant such a use of it, that we can explain what it is to associate the concept *square* with that word. An ability to use the word in such a way, or a suitable piece of knowledge about the word, would, by itself, *suffice* as a manifestation of a grasp of the concept. Even if we grant that there is no difficulty in supposing someone to have, and to manifest, a grasp of the concept antecedently to an understanding of the word, we can make no *use* of this assumption in explaining what it is to understand the word: we cannot appeal to the speaker's prior grasp of the concept in explaining what it is for him to associate that concept with that word. The question whether a grasp of the concepts expressible in language could precede a knowledge of any language thus falls away as irrelevant.

We have, therefore, to replace the conception of language as a code for thought by some account of the understanding of a language that makes no appeal to the prior grasp of the concepts that can be expressed in it. Such an account presents language, not just as a means of expressing thought, but as a *vehicle* for thought. The idea of a language as a code became untenable because a concept's coming to mind was not, by itself, an intelligible description of a mental event: thought *requires* a vehicle. And for this reason, the philosophical study of language assumes a far greater importance as being, not just a branch of philosophy, but the foundation of the entire subject, since it has to be, simultaneously, a study of *thought*. Only if we take language to be a code can we hope to strip off the linguistic clothing and penetrate to the pure naked thought beneath: the only effective means of studying thought is by the study of language, which is its vehicle.

The observation that there is no such mental event as a concept's coming to mind is paralleled by Wittgenstein's remark that understanding is not a mental process. One of the advantages of the approach to language as a vehicle of thought is that we do not need to look for any *occurrence* save the expression of the thought. Suppose that I am walking along the street with my wife, and suddenly stop dead and say (in English), 'I have left the address behind.' What constitutes my having at that moment had the thought I expressed need be no more than just the fact that I know English and said those words; there does not have to have been anything else that went on within me simultaneously with my utterance of the sentence. Wittgenstein said, 'To understand the sentence is to understand the language.' He did not mean that (as some American philosophers believe) you would not understand the sentence in the same way if you knew only a fragment of the language to which it belonged. He meant, rather, that, given you understand the *language*, that you are, as it were, in that *state* of understanding, nothing need happen, in which your understanding of the sentence consists, no *act* of understanding, other than your hearing that sentence.

This consideration only reinforces our initial idea, that the key to an account of language – and now, it seems, of thought itself – is the explanation of an individual speaker's mastery of his language. According to the conception of language as a vehicle of thought, this explanation must embody an account of what it is to have the concepts expressible in the language; and Frege, who originated this new approach, gave the outlines of an explanation of this kind. Naturally, I cannot here do more than gesture towards his theory: it involves distinguishing three different types of ingredient in meaning, sense (*Sinn*), force (*Kraft*) and colour (*Färbung*). The fundamental conception is that of the primacy of sentences. To a fair degree of approximation, we may say that what a speaker does by uttering a sequence of sentences is the sum of what he could do by uttering each sentence on its own. Nothing of the kind, however, holds good of the words that make up a single sentence: save in special contexts, nothing at all is conveyed by uttering a single word. The words do not make up the sentence in the same way that the sentences make up the paragraph. We indeed understand new sentences that we have never heard before because we already understand the words that compose them and the principles of sentence-construction in accordance with which they are combined. But we cannot explain the meanings of words independently of their occurrence in sentences, and then explain the understanding of a sentence as the successive apprehension of the meanings of the words. Rather, we have to have first a conception of what, in general, constitutes the meaning of a sentence, and

then to explain the meaning of each particular word as the contribution it makes to determining the meaning of any sentence in which it may occur. As regards that ingredient of meaning which Frege called *sense*, which is that which determines the specific content of a sentence, Frege proposed that to grasp the sense of a sentence is to know the condition for it to be true; the sense of a word consists in the contribution it makes to determining the truth condition of any sentence of which it forms part; and he went on to give a detailed theory concerning the manner in which the senses of words of different categories are given, so as jointly to determine the truth condition of any given sentence, the whole theory thus displaying the way in which the sense of a sentence is determined in accordance with its composition out of its component words.

I am not here concerned with the particular features of Frege's theory, but only with the general line of approach to the philosophy of language of which it was the earliest example. Frege's theory was the first instance of a conception that continues to dominate the philosophy of language, that of a *theory of meaning* for a specific language. Such a theory of meaning displays all that is involved in the investment of the words and sentences of the language with the meanings that they bear. The expression 'a theory of meaning' may be used in a quite general way to apply to any theory which purports to do this for a particular language: but I shall here use the phrase in a more specific sense. As I have here presented Frege's ideas, and as, I think, it is natural to conceive the matter from what he said about it, a theory of meaning is not a description from the outside of the practice of using the language, but is thought of as an object of *knowledge* on the part of the speakers. A speaker's mastery of his language consists, on this view, in his knowing a theory of meaning for it: it is this that confers on his utterances the senses that they bear, and it is because two speakers take the language as governed by the same, or nearly the same, theory of meaning that they can communicate with one another by means of that language. I shall reserve the phrase 'a theory of meaning' for a theory thus conceived as something known by the speakers. Such knowledge cannot be taken as explicit knowledge, for two reasons. First, it is obvious that the speakers do not in general have explicit knowledge of a theory of meaning for their language; if they did, there would be no problem about how to construct such a theory. Secondly, even if we could attribute to a speaker an explicit knowledge of a theory of meaning for a language, we should not have completed the philosophical task of explaining in what his mastery of the language consisted by stating the theory of meaning and ascribing an explicit knowledge of it to him. Explicit knowledge is manifested by the ability to *state* the content of the knowledge. This is a sufficient

condition for someone's being said to have that knowledge only if it is assumed that he fully understands the statement that he is making; and, even if we make this assumption, his ability to say what he knows can be invoked as an adequate explanation of what it is for him to have that knowledge only when we can take his understanding of the statement of its content as unproblematic. In many philosophical contexts, we are entitled to do this: but when our task is precisely to explain in what, in general, an understanding of a language consists, it is obviously circular. If we say that it consists in the knowledge of a theory of meaning for the language, we cannot then explain the possession of such knowledge in terms of an ability to state it, presupposing an understanding of the language in which the theory is stated. For this reason, the philosophical task of explaining in what a mastery of a language consists is not completed when we have set out the theory of meaning for the language. Whether the speaker's knowledge of that theory is taken to be explicit or merely implicit, we have to go on to give an account of what it is to have such knowledge. This account can only be given in terms of the practical ability which the speaker displays in using sentences of the language; and, in general, the knowledge of which that practical ability is taken as a manifestation may be, and should be, regarded as only implicit knowledge. I have already defended the conception of implicit knowledge, and argued that we need to invoke it in explaining certain, but not all, types of practical ability.

The conception of mastery of a language as consisting in the implicit knowledge of a theory of meaning is just as much in accordance with our original notion that what makes the utterances of a speaker to be expressions of thought is a piece of internal equipment that he has, namely his general understanding of the language, as was the conception of language as a code. Anyone who knows the writings of Frege will object that I have either misrepresented him or, at best, have expounded only half his thought on this subject: for when Frege writes, not in detail, but on the general principles governing the notion of sense, he strenuously combats what he calls 'psychologism', that is, the explanation of sense in terms of some inner psychological mechanism possessed by the speakers; and this seems in flat contradiction to the conception of a theory of meaning as I have expounded it.

The principle which Frege opposes to psychologism is that of the communicability of sense. Of some inner experience of mine, a sensation or a mental image, I can tell you what it is like. But, in the case of thought, I do not have to confine myself to telling you what it is like to have a thought that I have had: I can communicate to you that very thought. I do this by uttering a sentence which expresses that thought,

whose sense is that thought, without any auxiliary contact between mind and mind by any non-linguistic medium. Moreover, what enables me to express my thought by means of that sentence, and you to grasp the thought so expressed, lies open to view, as much so as the utterance of the sentence itself. The objection to the idea that our understanding of each other depends upon the occurrence in me of certain inner processes which prompted my utterance, the hearing of which then evokes corresponding inner processes within you, is that, if this were so, it would be no more than a *hypothesis* that the sense you attached to my utterance was the sense I intended it to bear, the hypothesis, namely, that the same inner processes went on within both of us. If such a hypothesis could not be established conclusively, if it were in the end an act of faith, then thought would not be in principle communicable: it would remain a possibility, which you could never rule out, save by faith, that I systematically attached different senses to my words from those you associated with them, and hence that the thoughts you took me to be expressing were not those I understood myself to be expressing. If, on the other hand, the hypothesis were one that could be conclusively established, either by asking me to elucidate my words or by attending to the uses I made of them on other occasions, then the hypothesis would not be needed. It would, in that case, amount to no more than the assumption, which is, indeed, required if we are to be able to communicate by means of our utterances, that we are talking the same language, a language that we both understand: but that in which our understanding of the language consisted would lie open to view, as Frege maintained that it does, in our use of the language, in our participation in a common practice.

This argument can be directed against the idea of a theory of meaning, conceived as the object of implicit knowledge by the speakers, as much as against an account in terms of psychological processes of the kind that was the immediate target of Frege's criticism. However, I have already answered such an argument: for I said earlier that implicit knowledge ascribed to the speakers must be manifested in their *use* of the language, and that it is part of the business of a philosopher of language to explain in what specific feature of this use a speaker's knowledge of each particular part of the theory of meaning is so manifested. There is no need for any act of faith.

But now it seems that the objection can be put in another way. If the speaker's implicit knowledge must be manifested by his actual use of the language, why not describe that use directly? Let us here make the well-known and often fruitful comparison of a language with a board-game. To immediate inspection, all that happens when two people play chess is that they alternately move pieces around the board, and sometimes

remove them. Nevertheless, a move in chess has a significance not apparent to immediate inspection, a significance grasped by the players in virtue of their knowledge of the rules. It is a legitimate philosophical enquiry in what an individual player's mastery of the rules consists. Can it be a mere practical ability, or must it rest on knowledge, and, if on knowledge, must that knowledge be explicit or can it be only implicit? For all that, we do not attempt to explain the significance of a move, that is, the character of the game as a game, by reference to the individual player's mastery of the rules: rather, we simply state the rules, that is, we describe the *practice* of playing the game. And, according to this objection, this is what we should do in the case of language. What an individual speaker's understanding of his language consists in is a legitimate philosophical enquiry; and it may be that, to explain this, we must invoke the notion of implicit knowledge. But to answer the central question of the philosophy of language, we do not need, on this view, to appeal to the notion of an individual speaker's mastery of the language: we simply describe the social practice in which that mastery enables him to participate, and so need not invoke the notion of knowledge at all.

We could express this argument in the following way. Suppose that someone wishes to represent a practical ability, say that of riding a bicycle, as consisting in practical knowledge: so he says, for example, that the bicycle-rider knows that, when he goes round a bend, he must incline at an angle that is such-and-such a function of his speed and of the radius of curvature. This is, of course, one of the cases about which I said that we do *not* need to invoke the idea of implicit knowledge. But at least the representation of the ability as a piece of knowledge is unperplexing, because we can so easily convert the account of what the bicycle-rider is supposed to know into a description of what he *does*: for example, when he goes round a bend, he does incline at such-and-such an angle. Now we can represent the objection to the conception of a theory of meaning by means of the following dilemma. If the theory of meaning can be converted into a direct description of actual linguistic practice, then it is better so converted; and we have then eliminated any appeal to the notion of knowledge. If, on the other hand, it cannot be converted into such a description, it ceases to be plausible that, by ascribing an implicit knowledge of that theory to a speaker, we have given an adequate representation of his practical ability in speaking the language. The appeal to the notion of knowledge is therefore either redundant or positively incorrect.

I believe this objection, though very powerful, to be mistaken. We can best see this by considering again the analogy with a game. The mistake in our discussion of this analogy lay in taking for granted the notion of

the *rules* of the game. What these rules are is also not given to immediate inspection: they do not, for instance, exhaust the observable regularities in play. Suppose that a Martian observes human beings playing a particular board-game, chess or some other. And suppose that he does not recognize the game to be a rational activity, nor the players to be rational creatures: he may perhaps lack the concept of a game. He may develop a powerful scientific theory of the game as a particular aspect of human behaviour: perhaps, after carrying out certain tests on the players, he is able to predict in detail the moves which each will make. He now knows a great deal more than anyone needs to know in order to be able to play the game. But he also knows *less*, because he cannot say what are the rules of the game or what is its object; he does not so much as have the conception of a lawful move or of winning and losing. He could simulate the play of a human player, but, for all the superior intelligence I am attributing to him, he could not play the game better than a human player, because he knows neither what is a lawful move nor what is a good move.

Any adequate philosophical account of language must describe it as a rational activity on the part of creatures to whom can be ascribed *intention* and *purpose*. The use of language is, indeed, the primary manifestation of our rationality: it is *the* rational activity *par excellence*. In asking for an explanation of what gives to a particular activity the character of a game, we are putting ourselves in the position of one who is trying to understand an unfamiliar game, and for some reason, cannot communicate with the players: he does not demand a theory that will enable him to predict the move that each player will make, even if there is such a theory to be had; he needs only so much as to comprehend the playing of the game as a rational activity. He wants, that is, to know just so much as anyone needs to know if he is to know how to play the game, and so to know what playing the game consists in. An account of language by means of a causal theory such as Quine appears to envisage, representing it as a complex of conditioned responses, is not the sort of theory that we need or should be seeking, even if we knew how to construct such a theory. To represent speech as a rational activity, we must describe it as something on to which the ordinary procedures of estimating overt motive and intention are brought to bear. This requires a place, for which a purely causal theory allows no room, for the distinction, essential to the comprehension of an utterance, between why a speaker says what he does and what it is that he says, that is, what his words mean, as determined by the linguistic conventions that have to be specially learned. The concept of intention can in turn be applied only against the background of a distinction between those regularities of

which a language speaker, acting as a rational agent engaged in conscious, voluntary action, *makes use* from those that may be hidden from him and might be uncovered by a psychologist or neurologist; only those regularities of which, in speaking, he makes use characterize the language as a language. He can make use only of those regularities of which he may be said to be in some degree aware; those, namely, of which he has at least implicit knowledge.

If this is right, it follows that the notion of knowledge cannot, after all, be extruded from the philosophy of language. It has also a further consequence for the criterion of success in constructing a theory of meaning for a language. For it follows that such a theory is not open to assessment in the same way as an ordinary empirical theory; it is not to be judged correct merely on the ground that it tallies satisfactorily with observed linguistic behaviour. Rather, the only conclusive criterion for its correctness is that the speakers of the language are, upon reflection, prepared to acknowledge it as correct, that is, as embodying those principles by which they are in fact guided. Such a theory cannot be arrived at by observation alone, but requires reflection; and it is by reflection that it must be decided whether it succeeds or fails.

17

TYLER BURGE

(1946–)

The American philosopher of language and mind Tyler Burge teaches at UCLA. His earlier work was a continuation of the Davidsonian project (see chapter 9), concentrating on issues of singular terms and demonstratives. Since the late 1970s Burge has also been contributing to the debate on externalism in meaning.

Burge argues that the contents of a thinker's beliefs, thoughts and other intentional states are fixed, at least in part, by social determinants. His position is known as anti-individualism, or externalism, according to which psychological states cannot be correctly understood or characterized independently of the relations between the individual and his or her physical and social environment. The content of mental states necessarily involves a reference to the objects and states of affairs in the world and/or practices of a community. The internalists, on the other hand, emphasize an individualistic view of the relationship between persons and the content and meaning of their propositional attitudes, their beliefs and desires. In the internalists' view, the content of our mental states should be identified primarily in a narrow sense in terms of the inner mental processes of the individual thinkers.

Burge's work follows up and expands the type of considerations Putnam introduced in his Twin Earth thought experiment (chapter 12). Putnam's argument emphasized the connection between what is said or thought (content) and how experts use specific words. Burge, on the other hand, identifies social usage of words as probably the most important source for determining content. According to his view, the content of utterances are fixed, at least in part, according to the conventions already adopted by the speaker's linguistic community. In his seminal article 'Individualism and the Mental' (1979) Burge discusses a thought experiment involving the example of a person who thinks he has arthritis in his thigh. In the actual world, someone who believes that he has arthritis in his thigh believes something false. In a different possible

world, where the term arthritis is applied to ailments in the thigh as well
as to the joints, a physical duplicate of the same person with the same
history would have a true belief. So Burge argues that the content of
propositional attitudes is at least in part determined by facts concerning
the individual's socio-linguistic background. In this way, he extends the
externalist theory of meaning and reference to the more general issue of
the individuation of the content of mental states.

 In 'The Philosophy of Language and Mind' (1992) Burge gives the
following summary of his position:

> Anti-individualism is the view that not all of an individual's mental state
> and events can be type-individuated independently of the nature of the
> entities in the individual's environment. There is, on this view, a deep
> individuative relation between the individual's being in mental states of
> certain kinds and the nature of the individual's physical or social environ-
> ment. (p. 47)

The article by Burge which appears in this chapter is from a collection
of essays written in honour of Noam Chomsky, who has defended an
internalist conception of meaning. Burge concedes the plausibility of the
suggestion that the psychological and linguistic habits and concepts of
the individual speaker are of importance to our understanding of lan-
guage. He also accepts that a high degree of idealization of language is
necessary for the construction of the Chomskian hypothesis of Universal
Grammar (see chapter 15). However, he argues that we cannot indi-
viduate, and so understand, the idiolect of a speaker in isolation from
the linguistic habits of other speakers with whom he or she interacts. We
need to take into account the role of social elements in semantics –
something that Chomskian internalism fails to do. According to Burge,
idiolects are social in two senses: firstly, we often have to defer to other
people in the interpretation or explication of our words. In language, as
in other areas of life, there are times when others may understand us
better than we understand ourselves. Secondly, how we individuate the
concepts we use can depend on our interactions with other people, from
whom we learn what our words mean and to what they refer.

 The type of externalism advocated by Burge has profound implications
for our understanding of the human mind and language. The Cartesian
paradigm which heralded the dawn of modern philosophy sees the
human mind as a private arena. Thinkers have privileged access to the
content of their own thoughts, or direct knowledge of what they are
thinking, and hence incorrigible authority over what their thoughts are
about. The externalist conception of the content of our mental states
casts doubt over this long-established paradigm. The implications of

externalism on questions of self-knowledge, as well as issues as diverse as scepticism, a priori knowledge and the normative elements of meaning are currently being worked out.

Works by Burge

1979 'Individualism and the Mental', *Midwest Studies in Philosophy*, IV, pp. 73–121.

1979 'Sinning Against Frege', *Philosophical Review*, 88, pp. 398–432.

1979 'Truth and Singular Terms', in Mark Platts (ed.), *Reference, Truth and Reality*, pp. 182–98. London: Routledge.

1984 'Frege on Extensions of Conceptions, from 1884 to 1903', *Philosophical Review*, 93, pp. 3–34.

1986 'Individualism and Psychology', *Philosophical Review*, 125, pp. 3–45.

1986 'Intellectual Norms and Foundations of Mind', *Journal of Philosophy*, 83, pp. 697–720.

1992 'The Philosophy of Language and Mind: 1950–1990', *Philosophical Review*, 101, pp. 3–51.

1995 'Our Entitlement to Self-Knowledge'. A symposium with Christopher Peacocke. *Proceedings of the Aristotelian Society*, 1995–6.

Works on Burge

Cassam, Quassim (ed.), *Self-Knowledge*. Oxford: Oxford University Press, 1994.

Woodfield, Andrew (ed.), *Thought and Object*. Oxford: Clarendon Press, 1982.

Wright, Crispin, et al. (eds), *Self-Knowledge*. Oxford: Oxford University Press (forthcoming).

Wherein is Language Social?

In this paper I will develop two limited senses in which the study of language, specifically semantics, is the study of a partly social phenomenon. These senses are compatible with the idea that the study of language is a part of individual psychology. I will argue for this standpoint from some obvious facts about human interaction together with elements from a view, which I have supported elsewhere, that the semantics of a language is partly dependent on relations between individual speakers and their physical environments. Most of what I say about language will apply to individual psychology. I begin by discussing two background senses in which language is social.

Language is social in that interaction with other persons is psychologically necessary to learn language. Some philosophers have made the further claim that there is some conceptually necessary relation between learning or having a language and being in a community. I do not accept this view. I assume only that it is a psychologically important fact that we cannot learn language alone.

Language is social in another sense. There is a rough, commonsensical set of languages – English, German, and so on – and dialects of these languages, that are in some vague sense shared by social groups. Of course, problems attend taking common-sense languages to be objects of systematic study. The normal divisions among languages correspond to no significant linguistic distinctions.

But this issue is really quite complex. In studying language or dialect in a systematic way, we commonly do not specify who uses the construction at issue, and we commonly assume that there is common ground among a large number of speakers – even though we are studying matters that are not species-wide. In historical studies, for example, we must abstract from individual usage in order to get any generality at all. We simply do not know enough about the quirks of individual usage to make an interesting subject matter: one must study such things as the

history of a word, understood more or less in the commonsensical, trans-individual way. In semantics, one provides theories of reference or meaning in natural language again in nearly total disregard of individual variations, even for phenomena that are by no means universal or species-wide.

These facts of theoretical usage suggest that there is some theoretical point to taking dialects or other linguistic units as abstractions from some sorts of social patterns. Perhaps the abstractions warrant thinking of individual variation as an interference to be accounted for after the primary theorizing is done. I think that there is something to this point of view. Nothing that I will say contradicts it. But the point of view is limited. It cannot provide anything like a complete picture.

One source of limitation derives from the wide variation among any group of individuals on numerous non-universal aspects of language use. People do not share exactly the same vocabulary, for example. People often use words in idiosyncratic ways that exempt them from evaluation by any socially accepted standard. Such quirks motivate the bromide that one should not invoke majority usage 'imperialistically' to fit individual variations into a standardized mold. These two points alone make it likely that no two people speak the same 'version' of any natural language or dialect.

There is a general reason for variation among individuals' language use. Languages depend on the experiences, usage, and psychological structures of individuals. Variation in individuals' word meaning, for example, is the natural result of the close relation between meaning and belief. Although the precise character of this relation is controversial and although intuitively meaning does not vary as freely as belief, some variation in meaning with individual belief is inevitable. The interplay between meaning and belief is a special case of the interplay between actual languages and psychology – about which similar points regarding individual variation could be made. It is therefore plausible that in studying language one must study the languages of individuals, idiolects.

These considerations suggest aiming for a science of universal aspects of language and for a study of non-universal aspects of language, both of which are tailored to the usage and psychology of individual speakers. I accept this much. Some have drawn the further inference that such a program's method of kind-individuation is independent of any considerations of social interaction among individuals. I will argue that this inference is unsound.

The inference just cited may be suggested by Chomsky's methodology for studying syntax. Actually, Chomsky is more cautious. What he is firm about is that there is a study of *universal grammar* which can be

investigated independently of the diversity among individuals, and that linguistics (at least the sort of linguistics he pursues) – both universal and individual – is a part of individual psychology.[1] I shall argue that social factors may enter in complex ways into individual psychology and the semantics of idiolects.

Unlike many philosophers, I do not find Chomsky's methodology misguided. His views that linguistic structures are real, that some of them are universal, and that they are mental structures seem to me substantially more plausible than alternatives.[2] Arguments that we may speak merely in accidental accord with the structures postulated in linguistics, or that there is no scientific way to investigate universality of syntax, or that generate linguistics has no direct place in psychology, seem to me unconvincing and indicative of mistaken methodology. I shall not review these arguments.

The study of universal grammar is informed by certain simplifying idealizations. The idealization most relevant to this discussion attempts to cut through the variation and 'noise' associated with usage in a community. The linguist considers an idealized 'speech community' that is 'uniform – internally consistent in its linguistic practice (cf. note 1). Without denying that individuals are members of a community, and without denying that they could develop into mature language users only because they are, the idealization attempts to study an individual in complete abstraction from the actual presence of others. Any given individual is taken as a representative having universal linguistic abilities or cognitive structures. The assumption is that underlying the variation among individuals, there is a common initial linguistic capacity that is specific enough to have certain definite structural features and that is capable of further linguistic development in certain delimited and specifiable ways. Variations in individual grammar are taken to be results of a fixing of parameters from a set of delimited alternatives.

For present purposes, I accept this idealization regarding universal grammar. It has received substantial support through its fruitful application both in pure linguistics and in developmental psycho-linguistics. (I will conjecture about a qualification on the idealization as applied to individual syntax later; cf. note 4.) I believe that the methodology accompanying this idealization has some application to universal and individual aspects of semantics. But here the situation is, I think, more complex. In particular, I think that relations to others do affect the individuation of some semantical kinds. To consider the role of social elements in semantics, I want to start further back.

In recent years I have argued that the natures of many of our thoughts are individuated *non-individualistically*. I shall have to presuppose these

arguments. But according to their common conclusion, the individuation of many thoughts, of intentional kinds, depends on the nature of the environment with which we interact. What information we process – for example, what perceptions we have – is dependent on the properties in the empirical world that members of our species normally interact with when they are having perceptual experiences. What empirical concepts we think with are fixed partly through relations to the kinds of things we think about.[3]

It is easy to confuse the view with another more obvious one. It is obvious that if we did not interact with the empirical or social worlds, we would not have the thoughts we do. Our thoughts and perceptions are causally dependent on the environment. My view concerns not merely causation; it concerns individuation.

Distinguishing the point about individuation from the point about causation is easiest to do by putting the point about individuation in terms of supervenience. Our thoughts do not supervene on the nature and history of our bodies, considered in isolation from the environment, in the following sense: It is in principle possible for one to have had different thoughts from one's actual thoughts, even though one's body had the same molecular history, specified in isolation from its relations to a broader physical environment. The same chemical effects on our bodies might have been induced by different antecedent conditions (perhaps, but not necessarily, including different causal laws). The point about individuation is not only that actual thoughts (like actual chemical effects) depend on the actual nature of the environment. Even if the effects had been chemically the same, it is possible in some cases for the thoughts, the information about the environment carried in our mental states, to have been different – if the environmental antecedents of those effects had been relevantly different. The kind of thought that one thinks is not supervenient on the physical make-up of one's body, specified in isolation from its relations to the environment. Thought kinds are individuated in a way that depends on relations one bears to kinds in one's physical environment. On this view individual psychology itself is not purely individualistic.

The failure of supervenience in no way casts doubt on investigations of neural or biological realizations of mental structures. The failure of supervenience requires only that the identity of certain mental structures be dependent on relations between the individual and the environment. The identity of a heart depends on its function in the whole body – on its relations to parts of the body outside the heart. In a crudely analogous way, the identities of some mental kinds depend on those kinds' relations to entities beyond the individual's body. They depend on cognitive

function, on obtaining information, in an environment, in something like the way the kind *heart* depends for its individuation on the function of the heart in the body that contains it.

The failure of supervenience also does not entail that an individual psychology that takes its kinds not to be supervenient on an individual's body must study – or make theoretical reference to – the relations between individual and environment that are presupposed in the individuation of its kinds. It is open to psychology to take such kinds as primitive, leaving their presupposed individuation conditions to some other science or to philosophy. I believe this often to be the right course.

The arguments for anti-individualistic individuation of mental kinds can be extended in relatively obvious ways to show that much of semantics is not purely individualistic.[4]

The claim that semantics is non-individualistic is not merely a claim that the *referents* of an individual's words could in principle vary even though the history of the individual's body, considered in isolation from the environment, were held constant.[5] The claim is more comprehensive. The empirical referents of an individual's word are obviously not themselves part of the individual's psychology, or point of view. Thoughts are the individual's perspective on the world. And meanings or senses are, very roughly speaking, a speaker's way of expressing such perspective in language. They are what an individual understands and thinks in the use of his words. My thesis is that even (many of) those aspects of semantics that would be reflected in meaning or sense, and that would be represented in an individual's thought processes, in his psychology, are non-individualistically individuated. What a word means, even in an individual's idiolect, can depend on environmental factors, beyond an individual's body, considered as a molecular structure.

I think it plausible that some meanings of words are universal to the species in that if a person has the requisite perceptual experience and acquires language normally, the person will have words with those meanings. A likely source of such universality is perceptual experience itself. It appears that early vision is language-independent and constant for the species. Because of the evolution of our species, we are fashioned in such a way that perceptual experience will automatically trigger the application of perceptual notions associated with innate dispositions. Linguistic expressions for such perceptual notions as 'edge', 'surface', 'shadow', 'under', 'curved', 'physical object', and so on, are likely to be tied to elementary, universal perceptual experience, or to innate states fixed by species-ancestors' perceptual interactions with the world.

Many such notions can be shown to be non-individualistically individuated. It is possible to construct hypothetical cases in which the

optical laws of the world are different, and the interactions of one's species with elements of the world are different, so that different perceptual notions, carrying different perceptual information, are innate or universally acquired. But in these same cases, one can coherently conceive an individual whose bodily history is molecularly identical to one whose perceptual notions are like ours. (The optical differences need not prevent, in certain special cases, a given individual from being affected in the same chemical way by different causal antecedents in the empirical world.) So the perceptual content or information of his experience is different – he has different perceptions – even though his body is, individualistically specified, the same. In such a case, it is clear that the meanings or senses of his words for objective, perceptual properties will also be different.[6]

Thus the view that certain concepts and meanings are non-individualistically individuated is compatible with those concepts and meanings being innate. The effect of the environment in determining psychological kinds may occur in the evolution of the species as well as in the experiential history of the individual.

Whether or not they are universal, virtually all concepts and meanings that are applied to public objects or events that we know about empirically are non-individualistically individuated. Such meanings attributed by semantics, and such concepts attributed by individual psychology, are non-individualistic to the core.

So far I have stated an anti-individualistic view of psychology and semantics that is entirely independent of social considerations. The failure of individualism derives, at this stage, purely from relations between the individual and the empirically known physical world. Now I want to use considerations that underlie this non-social anti-individualism to show how social elements enter the individuation of linguistic and psychological kinds. In a sense I will derive principles underlying social anti-individualistic thought experiments (see 'Individualism and the Mental', 1979) from obvious facts, together with some of the principles underlying non-social anti-individualistic thought experiments.

As a means of setting background, I begin with Chomsky's suggestion for incorporating social elements into semantics. Responding to Putnam's 'division of linguistic labor', he writes:[7]

> In the language of a given individual, many words are semantically indeterminate in a special sense: The person will defer to 'experts' to sharpen or fix their reference ... In the lexicon of this person's language, the entries [for the relevant words] will be specified to the extent of his or her knowledge, with an indication that details are to be filled in by others, an idea that can be made precise in various ways but without going beyond

the study of the system of knowledge of language of a particular individual. Other social aspects of language can be regarded in a like manner – although this is not to deny the possibility or value of other kinds of study of language that incorporate social structure and interaction.

Chomsky's proposal is certainly part of a correct account of the individual's reliance on others. I do not want to dispute the cases that he specifically discusses. I think, however, that the proposal cannot provide a complete account. My first concern is that it might be read to imply that in all relevant cases, the reference of an individual's own word is semantically indeterminate: determinateness only appears in the idiolects of the 'experts'. (I am not sure whether Chomsky intends the proposal in this way.) Sometimes the reference of a relevant term is incomplete or vague. But sometimes, even in cases where the individual's substantive *knowledge in explicating* features of the referent is vague, incomplete, or riddled with false belief, the reference is as determinate as anyone else's. The reference of an individual's word is not always dependent on what the individual knows or can specify about the referent. When the individual defers to others, it is not in all cases to sharpen or fix the reference, but to sharpen the individual's explicative knowledge of a referent that is already fixed. Our and the individual's own attitudes toward the specification of the reference often makes this clear (see note 5).

For present purposes, brief reflection on various natural-kind terms that we use without expert knowledge should make the point intuitive. One might use 'feldspar', 'tiger', 'helium', 'water', 'oak', or 'spider', with definite referents even though one cannot oneself use one's background knowledge to distinguish the referent from all possible counterfeits. Knowledge obtained from better-informed people – they need not be experts – often tells one more about the standard kinds we all refer to with these words. It does not *in general* change the referents of our words. (This is not to deny that sometimes experts' terms have a different, more technical meaning than lay usage of the same word forms.) The referents of such kind terms are simply not fixed entirely by the individual's background knowledge. Individuals often recognize this about their own terms. Although this point could be supported through numerous cases, and through more general considerations, I think that it is fairly evident on reflection. I shall assume it in what follows.

Even granted this qualification, Chomsky's proposal will not provide a complete account of the individual's own language – or even of the individual's knowledge of his or her idiolect. For in some cases, an individual's explicational ability not only does not suffice to fix the referent of the individual's word; it does not exhaust the meaning expressed by a word in the individual's idiolect.

I distinguish between a lexical item and the explication of its meaning that articulates what the individual would give, under some reflection, as his understanding of the word. Call the former 'the word' and the latter 'the entry for the word'. I also distinguish between the concept associated with the word and the concept(s) associated with the entry. Call the former 'the concept' and the latter 'the conceptual explication'. Finally, I distinguish between a type of meaning associated with the word 'translational meaning', and the meaning associated with its entry, 'explicational meaning'. For our purposes, the explicational meaning is the semantical analog of the conceptual explication. The translational meaning of a word can be articulated through exact translation and sometimes through such trivial thoughts as *My word 'tiger' applies to tigers*, but need not be exhaustively expressible in other terms in an idiolect.

A traditional view in semantics is that a word's explicational meaning and its translational meaning are, for purposes of characterizing the individual's idiolect, always interchangeable; and that the individual's conceptual explication always completely exhausts his or her concept. This view is incorrect. It is incorrect because of the role that the referent plays in individuating the concept and translational meaning, and because of the role that non-explicational abilities play in the individual's application of the word and concept. Accounting for a person's lexical entry or conceptual explication is relevant to determining the nature of a person's meaning or concept. But the two enterprises are not the same. I will try to give some sense for why this is so.

Let us begin by concentrating on the large class of nouns and verbs that apply to everyday, empirically discernible objects, stuffs, properties, and events. I have in mind words like 'tiger', 'water', 'mud', 'stone', 'tree', 'bread', 'knife', 'chair', 'edge', 'shadow', 'baby', 'walk', 'fight', and so on. Except for tense, these words are not and do not contain indexicals in any ordinary sense. Given only that their meaning in the language is fixed, their applications or referents are fixed. They do not depend for their applications on particular contexts of use; nor do they shift their applications systematically with context or with the referential intentions of speakers. Without contextual explication or relativization, we can trivially, but correctly, state their ranges of applications: 'tiger' applies to tigers; 'walk' applies to instances of walking; and so on. Contrast: 'then' applies to then. This latter explication requires a particular context to do its job, a particular, context-dependent application of 'then' to a salient time. The constancy of application of non-indexical words, within particular idiolects, is a feature of their meaning and of the way that they are understood by their users.

Although the reference of these words is not all there is to their semantics, their reference plays a constraint on their meaning, or on what concept they express. In particular, any such word w has a different meaning (or expresses a different concept) from a given word w' if their constant referents, or ranges of application, are different. That is part of what it is to be a non-indexical word of this type.[8]

The individual's explicational beliefs about the referents of such words, his conceptual explications, do not always fix such words' referents, even in his idiolect. So, by the considerations of the previous paragraph, they do not always fix such words' meanings or concepts in the individual's idiolect.

The point that explicational beliefs do not always fix reference is substantiated not only through the examples that have dominated the theory of reference for the last forty years (see note 5). It is also supported by considering the dialectic by which we arrive at conceptual explications, or lexical entries.

Sometimes such explications are meant to produce approximate synonymies (as in the explication of 'knife'). Other times, not ('tiger', 'water'). In the cases we are discussing, applications of the words are backed by and learned through perceptual experience. Perceptually-fixed examples typically determine the application of the word before conceptual explications do.[9]

Conceptual explications are typically inferences from these perceptual experiences, or general epithets derived from the remarks of others, or both. In attempting to articulate one's conception of one's concept, one's conceptual explication, one naturally alternates between thinking of examples and refining one's conceptual explication in order to accord with examples that one recognizes as legitimate. It is crucial here to note that the legitimacy of examples does not in general derive from one's attempts at conceptual explication. Although sometimes examples are shown to be legitimate or illegitimate by reference to such explications, the normal order – in the class of words that we are discussing – is the other way around. The examples, first arrived at through perception, tend to be the touchstone for evaluating attempts at conceptual explication.

Consider the sort of dialectic in which people try to arrive at an explication of the meanings of their words. First attempts are usually seen to be mistaken. Reflection on examples leads to improvements. The altered characterizations improve on one's characterization of a referent that is assumed to have been fixed. (They are not normally mere sharpenings of reference, or changes in the meanings of one's word.) They are equally improvements in one's conceptual understanding of one's own concept or meaning.

Such dialectic typically adds to one's knowledge. Suppose I explicate my word 'chair' in a way that requires that chairs have legs, and then come to realize that beach chairs, or deck-chairs bolted to a wall, or ski-lift chairs, are counterexamples. Or suppose that I learn more about how to discriminate water from other (possible or actual) colorless, tasteless, potable liquids. In such cases, I learn something about chairs or water that I did not know before. In these cases it is simply not true that the reference of my words 'chair' and 'water' must change. Although it is true that my conception – my explication – changes, it remains possible for me to observe (with univocal use of 'chair'): 'I used to think chairs had to have legs, but now know that chairs need not have legs.' It remains possible for me to have thoughts about water as water, knowing that there might be other liquids that I could not, by means other than use of my concept *water*, discriminate from it. Thus there is a sense in which the concept, and the translational meaning of the word in the idiolect, remain the same despite the changed discriminating ability, or change in explication.

Of course, my ability to come up with better explications by considering examples with which I am already familiar indicates that I have more to go on than my initial explications suggest. Perhaps I have 'tacitly cognized' more than what I give as my reflective explication, before I arrive consciously at a better explication.

I think that this view is right. But it would be a mistake to infer that I always already know the correct explication in some suppressed way. It would be an even more serious mistake to infer that our tacit conceptual explications exhaust our concepts. There are several reasons why these moves are unsound.

In the first place, the dialectic involves genuine reasoning – using materials at hand to form a better conception. Granting that we have the materials in our mental repertoires to form a better conception does not amount to granting that we have already put them together. Reflection on the examples seems to play a role in doing this. When I give a mistaken explication of 'chair', I may have failed to hold empirical information in my memory, or failed to put together things that I knew separately. I may have failed to believe at the time of the explication that there were legless chairs, even though I had experience and even perhaps knowledge from which I could have derived this belief. Thus the sort of unconscious or tacit cognition that is involved is not just an unconscious analog of having reflective knowledge of the proposition formed by linking the concept and the improved conceptual explication. Attribution of tacit cognition entails only that the mental structures for deriving the recognition of examples are in place and will (ideally) lead to such

recognition, when examples are presented.

In the second place, there is substantial evidence that some of the 'underlying' materials are stored in our perceptual capacities and are not, properly speaking, conceptualized (see note 9). We are often able to project our concept (e.g., *chair*) to new cases never before considered. Often this projection seems to be based on perceptual capacities that are modular and preconceptual. Thus the 'materials' that are put together and worked up into conceptual explications through the process of dialectic sometimes do not, before reflection begins, appear to be the right sort to count as criterial knowledge, even unconscious, criterial knowledge.

In the third place, even the perceptual abilities need not suffice to discriminate instances of the concept from every possible look-alike – from look-alikes that might have been normal in other environments, and which in that case might have determined other concepts; but which play no role in the formation of concepts in the speaker's actual environment. The explicated concepts are determined to be what they are by the actual nature of objects and events that we can perceptually discriminate from other relevantly similar things in the same environment. Thus even our perceptual abilities and our conceptual explications combined need not provide necessary and sufficient conditions for the correct application of our concepts in all possible environments in which the concepts have a definite application. They therefore need not fully exhaust the content of our concepts.

There is a more general reason why our explicational abilities, including our unconscious ones, do not in general and necessarily suffice to exhaust the concepts that they serve to explicate. One's cognitive relation to the examples that played an initial role in fixing one's concept is perceptual. That relation inherits the fallibility of perceptual experience. Since the concepts under discussion are not merely given by conceptual explications, but are partly fixed through examples in the environment, their conceptual explications must correctly describe the examples. Conceptual explications (and dictionary entries) are not normally true by logic and stipulation. They are true because they capture examples that are fixed partly through perceptual experience. But our cognitive relations to the examples are fallible. So the conceptual explications and dictionary entries that sum up our current discriminative abilities are fallible. The things that we perceive and that fix our concepts may not be just as we see and characterize them. Yet they may be genuine instances of the concepts. And we are subject to misidentifying other things that fit our perceptual schemas and conceptual explications as instances of our concepts, when they are not. So those schemas and explications do

not necessarily exhaust the concepts or meanings that they explicate.[10]

Our commitment to getting the examples right is part of our understanding of the relevant class of words and concepts. This commitment is illustrated in, indeed explains, many cases of our *standing corrected* by others in our attempts to explicate our own words and concepts. Such correction, by oneself or by others, is common in the course of the dialectic. One sees oneself as having made a mistake about the meaning of one's own word, in one's explication of one's own concept.

Some philosophers have characterized all cases of standing corrected as pliant shifts of communicative strategy. According to this view, I previously used 'chair' in my idiolect with a meaning that did in fact exclude legless chairs. But on encountering resistance from others, I tacitly shift my meaning so as to surmount practical obstacles to communication or fellowship that would result from maintaining an idiosyncratic usage.[11]

I agree, of course, that such practically motivated changes occur. But they cannot explain all cases of our standing corrected. For such correction is often – I would say, typically – founded on substantive, empirical matters about which there are cognitive rights and wrongs. We make mistakes, sometimes empirically correctable mistakes, that others catch, and that bear on the proper explication of the meaning of words in our idiolects. In such cases we come to understand our idiolects better.

Others are sometimes better placed than we are to judge the fit between our proposed lexical entries, or our conceptual explications, and the examples to which our words or concepts apply. Thus we may correctly see others as sometimes understanding our own idiolects better than we do. When we defer to someone else's linguistic authority, it is partly because the other person has superior empirical insight, insight that bears on the proper characterization of examples to which our words or concepts apply. The reason for their insight is not that they have made a study of us. It is also not that they are foisting some foreign, socially authorized standard on us. It is that they understand their idiolects better than we understand ours, and they have a right to assume that our idiolects are in relevant respects similar, or the same.

The justification of this assumption, also fallible, has two main sources. One is the publicity of the examples and our shared perceptual and inferential equipment. Given that we have been exposed to substantially similar knives, chairs, water, trees, mud, walkings, and fightings, and have heard these associated with the same words, it is to be expected that we project from actual examples in similar ways. Although our kind-forming abilities may differ in some instances, it is reasonable to expect that they will typically be the same, especially with concepts that

apply to entities of common perceptual experience. Normally we will be committed to the legitimacy of the same examples, and will be committed to characterizing those examples, correctly. Given that the examples are public, no one has privileged authority about their characteristics.

A second source of the assumption that others can correct one's explications is that a person's access to the examples – to the applications that help fix the relevant concept – is partly or fully through others. Words are initially acquired from others, who are already applying those words to cases. Word acquisition occurs in conjunction with acquisition of information, information from testimony, or communication with others, about those cases.

Of course, until the learner develops some minimal amount of background knowledge and likeness of application, he or she cannot be said to have acquired the word in the predecessor's sense, or with the predecessor's range of applications. But as we have seen in the preceding paragraphs, possession of an infallible explication is not required – because it is not possible.

The dependence on others for access to examples grows as one's linguistic and cognitive resources widen. In some cases we depend heavily on the perceptual experience of others (as with 'tiger', 'penguin' and 'rain', for those of us in California). In other cases we depend on theoretical background knowledge ('gene', 'cancer') or on more ordinary expertise ('arthritis', 'carburetor'). In many such cases, we intentionally take over the applications that others have made. We rely on their experience to supplement our own. And we accept corrections of our explications from them because they have better access to the examples which partly determine the nature of our concepts. Although the function of explication varies significantly in these various cases, the main points of the argument for social dependence apply equally, indeed even more obviously, to terms that are less closely associated with direct perception.

Since fixing examples – or more broadly, referents – that partly determine an individual's concept or translational meaning is sometimes dependent on the activity of others with whom he interacts, the individuation of an individual's concepts or translational meanings is sometimes dependent on his interaction with others. Even where the individual has epistemic access to the examples independently of others (for example, where he perceives instances directly), others may have superior knowledge of the examples. They may therefore have superior insight into the proper explication of the individual's words and concepts: they may have put together relevant cognitive materials in a way that provides standards for understanding the individual's words and concepts. In such cases, the individual's deference may be cognitively appropriate.

The cases in which the individual does and does not have independent access to the examples might seem to be significantly different. The former case might be seen as showing only that others may know more about the explication of the individual's meanings and concepts than he does, and that it is easier to understand an individual's idiolect by studying idiolects and attitudes of others. One might still insist, relative to this case, that the materials for determining the individual's concepts or meanings do not involve the individual's relations to others.

Though I need not contest this point for the sake of present argument, I doubt that it is correct. It is metaphysically possible for an individual to learn his idiolect in isolation from a community. But it is no accident, and not merely a consequence of a convenient practical strategy, that one obtains insight into an idiolect by considering the usage and attitudes of others. In learning words, individuals normally look to others to help set standards for determining the range of legitimate examples and the sort of background information used in explicating a word or concept. I believe that this is a psychological necessity for human beings.

The second case, where the individual has had limited relevant access to the examples independently of others, provides independent ground for thinking that individuation of an individual's concepts or meanings is sometimes dependent on the social interactions that the individual engages in. If others had provided access to a different range of examples, compatible with one's minimal background information, one would have had different meanings or concepts.

Let me summarize the argument that an individual's idiolect and concepts cannot be fully understood apart from considering the language and concepts of others with whom he interacts. Numerous empirically applicable words are non-indexical. Non-indexical words must have different translational meanings, and express different concepts, if their referents are different. Our explicational abilities, and indeed all our cognitive mastery, regarding the referents of such words and concepts do not necessarily fix the referents. Nor therefore (by the first premise) do they necessarily fix the translational meanings or concepts associated with the words. To be correct, our lexical entries and conceptual explications are subject to correction or confirmation by empirical consideration of the referents. Since such empirical consideration is fallible, our cognitive relations to the referents are fallible. Others are often in a better position to arrive at a correct articulation of our word or concept, because they are in a better position to determine relevant empirical features of the referents. This, for two reasons: the referents are public, so no one has privileged authority regarding their properties; and we are frequently dependent on others for linking our words to the referents

and for access to the referents. Since the referents play a necessary role in individuating the person's concept or translational meaning, individuation of an individual's concepts or translational meanings may depend on the activity of others on whom the individual is dependent for acquisition of and access to the referents. If the others by acting differently had put one in touch with different referents, compatible with one's minimum explicational abilities, one would have had different concepts or translational meanings.[12] Although I have argued only that this conclusion derives from obvious facts of social interaction, I have conjectured that it derives from psychological necessities for human beings.

The argument does not depend on assuming that people ever share the same concepts or translational meanings.[13] However, the argument makes it plausible that people in a community do often share concepts and translational meanings, despite differences in their beliefs about the world, and even differences in their explications of the relevant terms. Most empirically applicable concepts are fixed by three factors: by actual referents encountered through experience – one's own, one's fellows', or one's species ancestors', or indirectly through theory; by some rudimentary conceptualization of the examples – learned or innately possessed by virtually everyone who comes in contact with the terms; and by perceptual information, inferential capacities, and kind-forming abilities, that may be preconceptual. The referents are often shared, because of similarity of experience and because of intentional reliance on others for examples. So the concepts and translational meanings associated with many words will be shared. Shared idiolectal meanings and shared concepts derive from a shared empirical world and shared cognitive goals and procedures in coming to know that world.[14]

Traditional philosophy tended to ignore the first and third factors in concept determination, and to expand the second into the requirement of necessary and sufficient conditions that 'define' the meaning or concept and that must be believed if one is to have the relevant concept at all. The dissolution of this picture makes possible an appreciation of the dependence of the individuation of our empirical concepts on direct or indirect perceptual relations to our empirical environment.

Drawing on these ideas, together with obvious facts about social interaction, I have tried to show that idiolects are social in two senses. First, in many cases we must, on cognitive grounds, defer to others in the explication of our words. Second, the individuation of our concepts and meanings is sometimes dependent on the activity of others from whom we learn our words and on whom we depend for access to the referents of our words. The second sense grounds the view that individual

psychology and the study of the semantics of idiolects are not wholly independent of assumptions of interaction among individuals.

Notes and References

1. N. Chomsky, 1986, p. 18. Chomsky recognizes the possibility of 'other kinds of study of language that incorporate social structure and interaction'. Chomsky's methodology for studying language goes back to *Aspects of the Theory of Syntax*, 1965.

2. This view hinges not only on intuitive linguistic data but on studies of development, learning, psychological simplicity, language deficit, psychological processing, and so on. See, e.g., Chomsky, 1982, chapter 1.

3. 'Non-individualistic' in this context does not entail 'social'. The environment can be either physical surroundings or social surroundings. I begin with physical surroundings alone.

 The arguments against individualism that I shall be presupposing may be found in Burge, 1979; 1982; 1986 (a), (b) and (c). Different arguments bring out different environmental interdependencies.

4. Are syntactical elements and structures individualistically individuated? This question is close to the issue regarding the autonomy of syntax. But one should not identify the two questions. The discussions of the autonomy of syntax concern whether some non-syntactical parameter must be mentioned in stating syntactical generalizations. Our question concerns not the parameters mentioned in stating rules of syntax, but the individuation of the syntactical elements. Syntax could be non-individualistic and yet be autonomous (see the preceding paragraph in the text). Evidence has been suggesting that syntax is much more nearly autonomous than common sense might have realized. My reasons for thinking that individual psychology is non-individualistic in its individuation of some thought kinds have nothing directly to do with syntax. They derive purely from considerations that, within the study of language, would be counted semantic. What is at issue then is whether because of some functional relation to semantics, some syntactical kinds are non-individualistically individuated.

 I think it arguable that much of syntax is individualistically individuated, or at least no less individualistically individuated than ordinary neural or biological kinds are. But it seems likely that lexical items are individuated in a content-sensitive way. Words or morphemes with the same phonetic and structural-syntactic properties are distinguished because of etymological or other semantical differences. Even if it turned out that every such lexical difference were accompanied by other syntactic or phonological differences, it would seem plausible that the latter differences were dependent on the former. So it seems plausible that the lexical differences do not supervene (in our specified sense) on other syntactic or phonological differences.

 Although most philosophers write as if only word types are ambiguous, it is clear that word tokens are often ambiguous. It is arguable that *only*

word tokens, never word types, are ambiguous. I do not find this view plausible: words with different but etymologically and semantically related senses are individuated as the same word type. But the view is a useful antidote to habits in the philosophy of language. In any case, word individuation appears to be semantically dependent.

Assuming this to be true, and assuming that semantics is non-individualistic, it follows that what it is to be a given word sometimes depends (in the way that what it is to be a given meaning or concept depends) on relations between the individual and the objective, empirical world. *Whether* this is true about lexical items, and how far it might extend beyond the individuation of lexical items, is a question I leave open here. The answer will not very much affect the practice of generative grammar, since environmental relations need not be mentioned in syntax. But it will affect our understanding of the place of syntax in our wider theorizing about the world.

Similar issues might be raised about some universal syntactic categories (animate, agent, etc.). And as James Higginbotham has pointed out to me, analogous questions may be raised about the relation between phonology and ordinary perception. Ordinary perceptual kinds are not individualistically individuated (see note 6). It may be that this fact should affect our understanding of perception studies in phonology.

5. This view, though not trivial, is a consequence of a view that is widely accepted. It is a consequence of the work of Keith Donnellan and Saul Kripke, and indeed Wittgenstein, on reference. I will not defend it here. But I will develop a reason for its inevitability below. Numerous examples indicate that an individual's proper names, kind terms, demonstratives, and various other parts of speech have definite referents even though the individual could not, by other means, discriminate the referent from other possible or actual entities that might have been in an appropriate relation to the individual's words – other entities that might have been the referent even though the individual's body could have remained molecularly the same. See Kripke, 1980; Donnellan, 1972; Hilary Putnam, 1975; and numerous other works.

6. See D. Marr, 1982, for a very explicit statement of the non-individualistic methodology. For a more general review of the point that anti-individualistic individuation is implicit in all scientific theories of perception, see N. Stillings, 1987. For the cited philosophical arguments, see Burge 1986 (a) and (b). The former article discusses Marr's theory. For perception, the point is really pretty obvious even apart from philosophical argument: perceptual states are individuated by reference to physical properties that bear appropriate relations to the subjects' states or those of his species-ancestors.

Although Chomsky does not discuss non-individualistic features of the visual system, he clearly makes a place for psychological states that have a different genesis and different conditions for individuation from those psychological states that constitute the structures of universal grammar. He

counts such states part of the 'conceptual system' and uses vision as a prime example (see Chomsky, 1980).

7. Chomsky, 1986, p. 18. The relevant articles by Hilary Putnam are 1975 (a) and (b).

8. The ontology of meanings or concepts is unimportant for these purposes. But I assume the standard view that the meaning or concept should not be identified with the word – since different words could express the same meaning or concept, and the same word can express different meanings or concepts. I assume also that the meaning or concept should not be identified with the referent, since a meaning or concept is a way of speaking or thinking about the referent. Of course, sometimes words express meanings or concepts that have no referent. And meanings or concepts normally have vague boundaries of application.

 The point about non-indexicality can be established on purely linguistic grounds. I discuss the non-indexicality of the relevant words in more detail in Burge, 1982.

9. This point is now common not only in the philosophical literature (see Putnam, 1975(a) and (b) and Burge, 1982), but also in the psychological literature. Cf. Eleanor Rosch and Barbara Lloyd, 1978; Edward Smith and Douglas Medin, 1981. For excellent philosophical discussion of this literature, with criticism of some of its excesses, see Bernard Kobes (1986, chapter 6).

10. I have discussed other problems with exhaustive conceptual explications (1982; 1986c).

11. See Donald Davidson, 1987.

12. I think that this argument admits of an important extension. The argument derives non-individualistic variation in an individual's meanings or concepts from variation in empirical referents to which the community provides access. But the variation need not occur in the referents. It may depend on the nature of our cognitive access through the community to the examples. The variation may occur in the way the referents are approached in the community. Thus it may be that the referents are held fixed, but the community's cognitive access to them may vary in such a way as to vary the concept, without varying the effect on the individual's body or rudimentary explicational abilities. This extension is, I think, a corollary of the Fregean observation that referents (or examples) do not determine meanings or concepts. Since my purpose has been to establish a minimal sense in which language is social, I shall not illustrate or develop this extension here.

13. This is also true of the argument in Burge, 1979. The conclusion can rest on the mere assumption that the referents of the concepts in the actual and counterfactual communities are different. (Brian Loar, 1988, seems mistakenly and crucially to assume the contrary in his critical discussion of 'Individualism and the Mental'.) For all that, I know of no persuasive reason for thinking that in every relevant case the person in the actual community cannot share his concept or meaning (e.g. *arthritis*) with his fellows.

14. So it appears that there is an element of meaning that can remain constant
and common across individuals, despite the interdependence of meaning
and belief noted at the outset. It is notable that this constancy in no way
depends on the assumption of a distinction between sentences that are *true*
purely by virtue of their meaning and sentences that depend for their truth
on the way the subject matter is. (Like Quine, I find this distinction empty.)
See Burge 1986c. Belief in the relevant element of meaning does not even
depend on invocation of a distinction between critical or linguistic truths
and other sorts of truths (although like Chomsky and unlike Quine, I think
that this latter distinction, commonly conflated with the previous one, is
clearly defensible).

Another point about the semantics of word meaning bears emphasizing.
There is a relevant semantical distinction between cases in which the indi-
vidual has sufficient materials in his conceptual repertoire to construct a
given lexical entry, maximally faithful to the range of applications or
examples that he recognizes as legitimate, and cases in which the individual's
dependence on others is such that his repertoire allows only entries that are
less full than those of others. In the latter cases, it is *not true*, on my view,
that the 'communal' entry is the 'correct' entry within the person's idiolect.
I take it that lexical entries sum up an idealized conceptual understanding.
If the person lacks resources to arrive at some given entry, the entry is not
a part of his idiolect.

But it does not *follow* from this difference that the person does not have
the same concept, or the same translational meaning, that others have. To
think this would be to confuse concept and conceptual explication, or
translational meaning and explicational understanding. In not sharing this
explication with others, the person will not fully share an understanding of
the word (or the conception of the concept) with others. But lexical entries
(conceptual explications) do not determine the translational meaning
(concepts); they may even be mistaken, and only contingently related to it.
The person still has his or her perceptual abilities for picking out referents,
and the relevant referents may still be partly fixed by the person's reliance
on others. Thus as far as present considerations go, the person's concept
may be shared with others even though his or her conceptual explication or
lexical entry may differ.

Bibliography

Burge, Tyler, 1979: 'Individualism and the Mental', *Midwest Studies*, 4, pp.
 73–121.
 1982: 'Other Bodies', in A. Woodfield (ed.), *Thought and Object*. Oxford:
 Clarendon Press.
 1986 (a): 'Individualism and Psychology', *Philosophical Review*, 125, pp. 3–
 45.
 1986 (b): 'Cartesian Error and the Objectivity of Perception', in P. Pettit and

J. McDowell (eds), *Subject, Thought and Context*. Oxford: Clarendon Press.

1986 (c): 'Intellectual Norms and Foundations of Mind', *Journal of Philosophy*, 83, pp. 697–720.

Chomsky, Noam, 1965 *Aspects of the Theory of Syntax*. Cambridge, MA: MIT Press.

1980: *Rules and Representations*. Oxford: Blackwell.

1982: *Lectures on Government and Binding*. Dordrecht: Foris.

1986: *Knowledge of Language: Its Nature, Origin, and Use*. New York: Praeger.

Davidson, Donald, 1987: 'Knowing One's Own Mind', *Proceedings and Addresses of the American Philosophical Association*, 60.

Donnellan, Keith, 1972: 'Proper Names and Identifying Descriptions', in D. Davidson and G. Harman (eds), *Semantics of Natural Languages*. Dordrecht: Reidel.

Kripke, Saul, 1980: *Naming and Necessity*. Cambridge, MA: Harvard University Press.

Kobes, Bernard, 1986: 'Individualism and the Cognitive Sciences', unpublished dissertation. University of California at Los Angeles.

Loar, Brian, 1988: 'Social Content and Psychological Content', in Robert Grimm and Daniel Merrill (eds), *Contents of Thought*. Tucson: University of Arizona Press.

Marr, David, 1982: *Vision*. San Francisco: W. H. Freeman.

Putnam, Hilary, 1975 (a): 'Is Semantics Possible?', reprinted in *Philosophical Papers*, vol. 2. Cambridge: Cambridge University Press.

1975 (b): 'The Meaning of "Meaning"', reprinted in *Philosophical Papers*, vol. 2. Cambridge: Cambridge University Press.

Rosch, Eleanor and Lloyd, Barbara, 1978: *Cognition and Categorization*. Hillsdale, MI: Erlbaum.

Smith, Edward and Medin, Douglas, 1981: *Categories and Concepts*. Cambridge, MA: Harvard University Press.

Stillings, Neil, 1987: 'Modularity and Naturalism in Theories of Vision', in J. L. Garfield (ed.), *Modularity in Knowledge Representation and Natural-Language Understanding*. Cambridge, MA: MIT Press.

18

RUTH GARRETT MILLIKAN

(1933–)

The American philosopher Ruth Garrett Millikan was educated at Oberlin College and Yale University, where she obtained a Ph.D. in 1969. She currently teaches at the University of Connecticut. Her areas of specialization are philosophy of mind and of psychology, philosophy of language and philosophy of biology. Ruth Millikan's aim is to develop a completely naturalistic theory of meaning; to this end she applies an evolutionary biological perspective to the philosophical study of the human mind and language. She believes that philosophy of language cannot be separated from philosophy of mind, epistemology, or ontology: 'There is no way of making significant and convincing moves in one of these areas without adjusting simultaneously in the others' she argues in *Language, Thought, and Other Biological Categories* (1984, p. 14). Millikan represents a new generation of analytic philosophers who, although they are still concerned with questions pertaining to the traditional areas of philosophy of language such as meaning and reference, do not regard philosophy of language as in any sense prior to, or even separate from, philosophical and empirical enquiries into the mind.

The cornerstone of Millikan's work is her view of biological functions – those properties or powers which enable a biological entity or organism to survive and proliferate. Millikan's theory of functions is evolutionary, but the scope she assigns to it extends far beyond that of biological entities. In general, in order to discover the proper function of any device we should investigate the effects that device is designed to have. This is as true of the human heart and lung and language as of artefacts and objects. The important point as far as philosophy of language is concerned, is that Millikan treats meaning, intentionality, representation, words, sentences, concepts and judgements as biological categories. She draws parallels between what she calls the 'language devices', that is, 'words, surface syntactic forms, tonal infections, stress patterns, punctuations, and any other significant surface elements that a natural spoken

or written language may contain' (p. 3), and biological organs such as the heart. The proper function of the heart is to circulate blood. This function, in turn, has contributed to the survival of biological organisms which have a heart. In other words, hearts have survived and proliferated because their historical function of pumping blood has made a positive contribution to the reproduction of offsprings with hearts. In the same way, language devices have continued to proliferate because they have served a set of describable stable functions.

Thoughts and sentences, Millikan argues, are devices that exhibit intentionality or aboutness – they can be seen as 'inner intentional icons' which sometimes may take the form of inner sentences; their intentionality is to be explained in naturalistic, biological terms. Millikan distinguishes between 'indicative intentional icons' and 'imperative intentional icons'. Instances of the former are English statements and human beliefs; instances of the latter are English commands and human desires (*Language, Thought and Other Biological Categories*, chapter 6). In hugely simplified terms, the function of a belief or of an indicative statement is to map the world accurately or to represent certain states of affairs. The function of a desire, or a command, is to bring about certain states of affairs.

Millikan's view leads to 'robust realism' (she considers herself to be an Aristotelian realist), and the denial of what she calls 'meaning rationalism'. Meaning rationalism is the view that speakers have privileged access to the meanings of what they are saying. This view, according to Millikan, is part of our philosophical inheritance from Descartes, and despite strong currents of anti-Cartesianism in the philosophy of the past fifty years, it has not yet been wholly abandoned by contemporary philosophers of language. The extract from her work which appears here is the rather polemical Epilogue to her 1984 book in which Millikan argues that there can be no such thing as a priori knowledge and that nothing can be known by Cartesian introspection. It is a mistake to think that we can know, or discover, through self-reflection, what we mean by our words, or even that we do mean anything at all by our words. The attack on meaning rationalism is the cornerstone of Millikan's biological approach to language and thought. The idea underlying this attack is that we can have a biological, functional and evolutionary explanation of the intentionality of language without making any references to the individual psychological, intentional, episodes that are internal to the speakers. In the course of her discussion Millikan also engages in a critique of Putnam's externalism and his later rejection of 'metaphysical realism' (see chapter 12). Thus Millikan's work represents an important aspect of the crossover between philosophy of language and philosophy

of mind which has become the hallmark of much recent philosophy.

Works by Millikan

1984 *Language, Thought, and Other Biological Categories*. Cambridge, MA: MIT Press.

1993 *White Queen Psychology and Other Essays for Alice*. Cambridge, MA: MIT Press.

1993 'Explanation in Biopsychology', in John Heil and Alfred Mele (eds), *Mental Causation*. Oxford: Clarendon Press, pp. 211–32.

1993 'Knowing What I'm Thinking Of'. *The Aristotelian Society*, supplementary vol. 67, pp. 109–24.

1993 'On Mentalese Orthography', in Bo Dahlbom (ed.), *Dennett and His Critics*. Oxford: Blackwell, pp. 97–123.

Works on Millikan

Lyons, William. *Approaches to Intentionality*, chapter 3. Oxford: Clarendon Press, 1995.

Fodor, Jerry. *A Theory of Content and Other Essays*. Cambridge, MA: MIT Press, 1992.

Guttenplan, S. (ed.), *A Companion to Philosophy of Mind* (entry on Millikan). Oxford: Blackwell, 1994.

Epilogue

... there can exist nevertheless a certain material falsity in ideas, as when they present that which is nothing as though it were something. [But] ... this idea of God ... is very clear and distinct and contains more objective reality than does any other, so that there is no other which is more true from its very nature, nor which is less open to the suspicion of error and falsity.

Descartes, Third *Meditation*

Translate: knowledge that an idea has a sense is armchair knowledge.

It is an established maxim in metaphysics, *that whatever the mind clearly conceives includes the idea of possible existence*, or in other words *that nothing we can imagine is absolutely impossible.*

Hume, *A Treatise of Human Nature*, Part II, Section II

Translate: knowledge of logical possibility and knowledge that our ideas have sense is armchair knowledge.

In the very essence of an experience lies determined not only *that*, but also whereof it is a consciousness, and in what determinate or indeterminate sense it is this.

Husserl, *Ideas*, para. 36

Translate: consciousness provides its own affidavit both *that* it means and about *what* it means.

If the world had no substance, then whether a proposition had sense would depend on whether another proposition was true.

Wittgenstein, *Tractatus Logico-Philosophicus*, 2.0211

Wittgenstein of course denies the consequence of this hypothetical: that a proposition has sense *cannot* depend upon whether another proposition is true. In other words, that a proposition has sense must be a priori knowledge, or at least cannot be empirical knowledge.

The terms '9' and 'the number of the planets' name one and the same abstract entity but presumably must be regarded as unlike in meaning; for astronomical observation was needed, and not mere reflection on meanings, to determine the sameness of the entity in question.

Quine, 'Two Dogmas of Empiricism', *From a Logical Point of View*

Translate: knowledge of synonymy of terms must be a priori knowledge.

Cut the pie any way you like, 'meanings' just ain't in the *head*!

Hilary Putnam, 'Meaning and Reference', *Journal of Philosophy*, 70, 1973

A new line? Or only a sheep in new lion's clothing?

During the course of this book I have made many controversial claims. For the most part I have avoided engaging in polemics for fear of diverting the constructive argument or obscuring its central lines, difficult and complexly interwoven as they were. But if I had to fling down the gauntlet before just one opponent, that opponent would be the meaning rationalist. For the meaning rationalist stands behind nearly every other opponent.

This epilogue is headed with quotations from six meaning rationalists: Descartes, Hume, Husserl, Wittgenstein, Quine, and Putnam. Why Putnam is on the list I will soon explain. Why nearly every other philosopher who has ever written on language or on thought is not on the list is only that I didn't happen on a succinct quotation at the right time. Meaning rationalism has gone unquestioned to such a degree that, to my knowledge, no arguments have ever been advanced to support it.

Meaning rationalism is not a single doctrine but a syndrome. The paradigm meaning rationalist believes that intensions can't be wrong or mistaken and that mere (seeming) thoughts-of, as opposed to judgements about, cannot be senseless. Or at least he believes that any lapses from sense into nonsense are entirely avoidable given enough patient and intelligent armchair work. He also thinks that if one is careful enough, there need be no such thing as being confused about *what* one is thinking of. He thinks this, that is, if he thinks that thoughts have correspondents at all – if he thinks that thoughts are *of*. Otherwise, *of course* he thinks there is no problem about knowing what one is thinking of. He thinks that ambiguity in thought is determined by armchair reflection, and that synonymy or lack of synonymy between terms in one's idiolect is determined in the same way. He takes it that there is something called 'logical possibility' that is real, that is grasped by a priori reflection, and that is in no way rooted in how the world actually is. He believes some or all of these things, and as a result he may believe any of various other more obviously queer things as well.

To think of a thing, in the meaning rationalist view, implies knowing what one is thinking of, where 'knowing' is rationalist 'knowing'. That is, one's subjective certainty concerning what it is that one is thinking of must match an objective truth in this matter not just in fact but of necessity. How could this be possible? It would be possible of course if thinking of a thing were having it or its nature before diaphanous consciousness and nothing more, and if consciousness were fundamentally epistemic. If this is what thinking of a thing consists in, then there could not, in principle, be such a thing as making a mistake about what one was thinking of. Thus meaning rationalism motivates the classical realist view of the nature of the act of thinking-of, the consequences of which view we examined in Chapter 15 [of *Language, Thought, and Other Biological Categories*]. It motivated Platonic realism; it motivated phenomenalism; it motivated verificationism. Indeed, it helped to motivate philosophical analysis in nearly all of its classical and modern forms. But there are two contemporary doctrines or ways of thinking that it motivated in an especially direct and obvious way, without passing through classical realism, that I would like to mention.

If one cannot misunderstand *what* a term in one's idiolect represents, or be wrong in thinking *that* it represents, then whatever criteria one uses in applying it cannot of course be mistaken criteria. Rather they must *define* its meaning in the sense of stipulating it. The meaning rationalist thus is forced to take the meaning of a term to be determined by its intension. But ambiguity in meaning is discerned by a priori reflection. Hence, unless these are 'logically equivalent', no term can have two or more intensions. Each term must have a criter*ion*, not criter*ia*. Also, if the term is to have a determinate meaning, since whether it has a determinate meaning has to be knowable a priori, the intension that the term has must always amount to a 'necessary and sufficient definition'. 'Necessary and sufficient definitions' of terms are definitions that purport to cut cleanly not just between those *actual* things in the world that do and that do not fall under a term but between all 'logically possible' things. Compulsive searching for 'necessary and sufficient definitions' by which to define certain puzzling terms and engaging in the pastime of inventing fictitious 'counterexamples' to these definitions in one of the clearest symptoms of meaning rationalism.

A second doctrine or way of thinking that meaning rationalism motivates, though not quite so directly, is nominalism. According to the meaning rationalist, any lapses from sense into nonsense in thought, any confusions about what one is merely thinking *of*, must be detectable a priori. Hence if there is something that I *could* be mistaken about, even after careful reflection, it must be that, perhaps despite all appearances,

this something corresponds not to a thinking-of but to a judgement. So long as I am careful, concepts cannot err. All errors are errors of judgement. So, it appears, many things that we otherwise would have thought were mere concepts or thoughts-of must really be implicit judgements. For example, since I cannot tell just by a priori inspection that my apparent idea-of-Shakespeare is an idea of anything real, it must be that thinking of Shakespeare is really thinking *that* something having such-and-such characteristics exists. But judgements cannot be made without employing prior concepts. So not all concepts can be analyzed as implicit judgements. Some concepts at least must stand on their own feet. Some concepts, it seems, must be of things known to be real by a priori inspection. Traditionally these basic concepts were taken to be or at least to include all concepts of properties, simple and complex; exactly why need not concern us here. The important thing is that meaning rationalism led to the conclusion that all our genuine concepts are of things that have a most peculiar ontological status. They are things that *are* and that can be *known* to be, yet that have no necessary relation to the actual world. They are things that do not need the world about which we make ordinary judgements in order to be. They must be Platonic forms, or reified 'concepts' or reified 'meanings' or things having 'intentional inexistence' or reified 'possibilities' – or else they must be *nothing at all*!

Nominalists drew the only reasonable conclusion. These basic concepts correspond to nothing at all. Thinking-of, certainly thinking-of-properties, is not thinking *of* anything. Realism is just wrong.

I have argued that it is not realism that is wrong but meaning rationalism. Now, Hilary Putnam says boldly that ' "Meanings" just ain't in *the head*!'. Offhand one would think that if meaning were not in the head, then inspection of the contents of one's head would not be sufficient to determine whether or not one was meaning anything. One would think that *Putnam* at least was not a meaning rationalist. Yet Putnam too has finally forsaken realism. Has he found arguments against realism then that do not depend upon meaning rationalism?

In 'The Meaning of "Meaning" '[1] Putnam argues that, in the case at least of natural kind terms such as 'water' and 'gold', intensions do not determine extensions. Intensions of course are what is 'in the head'. He argues that it is possible that natural kind terms having identical intensions might still have different extensions. Assuming that terms that have different extensions must have different meanings, i.e., that whatever meaning is it *must* determine extension, he concludes that meaning is not in the head.

Putnam's argument here is that of a realist. The assumption that

whatever meaning is, it must determine reference or extension is the very essence of realism. The realist's position is that what it *is* for a term to mean is for it somehow to correspond to something – if not to something actual, at least to something *real* such as a Platonic form or a 'real possibility' or an extension. If the meaning of a term did not determine a referent or a real correspondent or at the very least an extension for it, realism would just be wrong. So if meanings are not intensions, then they must be shown to be something *else* that *can* determine reference or extension. Otherwise realism collapses.

Now Putnam asserts that the reason the intensions of natural-kind terms do not determine their extensions is that, despite appearances, natural kind terms are indexical. And indeed, the tradition that meanings are intensions has always had problems with indexicals. But there is no need to wrestle with tradition on this issue. (Indeed, tradition has left us shockingly little to wrestle with.) The thing that is utterly clear about indexicals is that their referents are determined in part by a relation between the term token (or the speaker) and the referent. And Putnam believes that the extension of 'water' or of 'gold' is likewise determined by a relation between the term token and its extension. That is why he (mistakenly) says that these terms are 'indexical'.

But saying that natural kind terms are 'indexical' is merely to label a problem, not to solve it. So a relation between the term 'gold' and its extension determines this extension. But *which* relation? (Putnam falls back upon the use of prior indexicals in discussing this.) And what determines which relation it must be between a term and the world that constitutes the reference relation? If this problem cannot be solved, realism collapses.

In 'Realism and Reason'[2] Putnam argues that this sort of problem cannot be solved, hence that 'metaphysical realism' does collapse. True, he defines 'metaphysical realism' in what is, to my mind, an odd way. The realist position of this book, for example, does not fit his description. But, I will soon argue, it fits his description of the alternative, 'internal realism', equally badly. In any event, Putnam argues that the notion that truth is correspondence to 'THE WORLD', and that our terms refer by corresponding one by one to elements in THE WORLD, is incoherent.

Putnam begins by pressing a problem that we first addressed in Chapter 5, namely, that a *pure* correspondence theory of truth is vacuous. A pure correspondence theory will not work because mathematical mapping relations are ubiquitous whereas representation-represented relations are not. The theory that truth consists merely in there being *a* mapping relation between a full set of true representations and the world is empty. If any correspondence theory of truth is to avoid vacuousness, it must

be a theory that tells what is different or special about the mapping relations that map representations on to representeds. – And so, Putnam asks, 'What further constraints on reference are there that could single out some [one] interpretation as [the] (uniquely) 'intended' [one]...?'

Putnam's characterization of the elusive correct interpretation or correct mapping function as the one that is 'intended' tips his hand. He is thinking that this relation must be one that is determined by being thought of or mirrored *in* the mind:

> Notice that a 'causal' theory of reference is not (or would not be) of any help here: for how 'causes' can uniquely refer is as much of a puzzle as how 'cat' can, on the metaphysical realist picture.
>
> The problem, in a way, is traceable back to Occam. Occam introduced the idea that concepts are (mental) *particulars.* If concepts are particulars ('signs'), then any concept we may have of the *relation* between a sign and its object is *another sign.* But it is unintelligible, from my point of view, how the sort of relation the metaphysical realist envisages as holding between a sign and its object can be singled out either by holding up the sign itself, thus
>
> $$\boxed{\text{COW}}$$
>
> *or* by holding up yet another sign, thus
>
> $$\boxed{\text{REFERS}}$$
>
> or perhaps
>
> $$\boxed{\text{CAUSES}}$$

Putnam has explicitly spelled out the meaning rationalist assumption: in order to mean something determinate in the world we must at the same time *know* that and what we mean and 'know' this with a rationalist gloss on 'know'. The entire relation *between* the head and the world that connects the world with the head must be mirrored in the head. And this entails that the relation between the mirror of that relation and that relation also be mirrored in the head, and so forth *ad infinitum.* The only way out of this regress would be, as Putnam immediately comments, 'to be led back to a direct (and mysterious) grasp of Forms'. That is, the only way out would be to put the relation between the head and the world that constitutes reference where the classical realist put it, namely, inside the head, by placing the referent (or its nature) directly before the mind. Then the relation need not be mirrored at all.

The position of this book has been that the relations between the head and the world that constitute reference and meaning are genuinely between the head and the world. Coming to understand just what these relations consist in does nothing toward *founding* meaning and reference;

these relations do not need to be intended or thought of in order for us to mean and to refer.

But it may be asked what *makes* these particular relations 'reference' and 'meaning' relations whereas other mapping relations are not. And then it may be asked why *this* is what makes them reference and meaning relations rather than something else.

Consider the original paradox: mapping relations are ubiquitous whereas representation-represented relations are not. Now surely one of the reasons that representation-represented relations are not ubiquitous is that *representations* are not ubiquitous. The category 'representation' is a very special category among things. And shouldn't it be obvious that there is no way of making out what determines the mapping rules that count as the reference rules and meaning rules for representations unless one first understands what representations are, what distinguishes them from other things, say, sneezes? My argument has been that to discover what a representation *is* is to discover that it is, by virtue of being a representation, supposed to map, and it is to discover what determines the mapping function in accordance with which it is supposed to map. It is because a representation is a *representation* that it is supposed to map and in accordance with certain rules and not others – rules that have been determined by the same history that makes it to be a representation at all.

Now I seem to see Putnam knowingly nodding his head. Your theory, he seems to say, of what a representation is, of what truth and reference are, is just *another theory*. What you have offered is merely an 'internal realism' – a theory of reference *within* our theory of the world. And that, I (Putnam) have been hoping we could do all along.

Certainly I have offered a theory of meaning, of reference of truth and hence *of what theories are* that places all these within the natural world. In that sense the theory I have offered is a theory 'within' our theory of the world. It is a theory that stands beside and hopefully in agreement with many of our other theories concerning what all is in the world. I have made *all* theories 'internal'; all our theories (as well as everything they are about) are in the world rather than in some prior place. Is there then some alternative to an 'internal' theory? Putnam holds a different theory of what a theory is – a theory that conflicts with mine. Is his theory also a theory about the place of theories *in the world*? If so, his theory of theories is 'internal' in exactly the same sense that mine is; his anti-metaphysical-realist position is an 'internal' theory too. If not, where *does* he think theories are? In what sort of prior place? Where does he think he is standing? On some ground that is *not* in the world?

Descartes and then Locke, it is said, opened an era in which phil-

osophers sought vainly to reach the world through a 'veil of ideas' (or, alternatively, to pull the world in behind the veil). They placed themselves behind this veil by beginning with a vision or theory of mind as a realm in which ideas lived but which was outside the world these philosophers wished to reach with their ideas – the world, at least, of nature. Today, influenced especially by Wittgenstein and Quine, there is a new school of philosophers who live behind a veil of 'theories', entangled in 'language games' or in the 'logical order'. They too have placed themselves behind a veil by beginning with a certain vision or theory, this time a theory about language; a theory about theories – a theory entailing that theories can be meaningful theories while (like old-fashioned 'ideas' and 'minds') floating loose from the rest of the world. This veil, I have suggested, is composed of (1) a rationalist theory of meaning, hence the absence of any solid theory of what representations are, hence of what theories are, *as attached parts of the world*, (2) an unnecessary and mistaken epistemological holism, and (3) the failure to see how logic might fit into the world of nature. I have thrown out an alternative view – a sketch of how we, our language and thought and theories too, are in the world, and of just *how* a theory must be attached to the rest of the world in order to be a theory at all. What would make such a sketch 'internal' or 'merely'? The fact that it cannot be given Cartesian foundations? The fact that we just never will KNOW? For surely someone *will* come along with *another* sort of theory?

Of course we could never KNOW in a rationalist or foundationalist sense that any such theory was true. Such a theory implies a theory of knowledge that emphatically excludes such a KNOWING. But having denied the very *sense* of the Cartesian quest is not at all the same as being left behind a veil, hence in the position of having to pull our realism inside after us. Rather, we can climb out on the shoulders of our realism. It supports us not by *grounding* our knowledge and certainly not by grounding it in some prior order – some order other than the natural order. It supports it by explaining what our knowledge is and what it is not and, schematically, how we came to have it. That such an explanation can be given does not *ground* anything. But certainly it should make us feel more comfortable. Put it negatively. If we could give no explanation at all of what our knowledge is or of how we come to have it, surely we would have reason to contemplate being skeptics.

To explain how knowledge is possible is to answer Kant's legitimate question. But to answer a legitimate question is not always to answer it in the exact spirit in which it was asked – within the same view of the possibilities for an answer that the questioner envisioned. Kant expected the answer to his question to supply a foundation for knowledge. And

in a certain sense our answer does, but not in the sense of propelling our knowledge to be any more real or closer to some ideal of knowledge than it was before. The answer supplies a foundation for our knowledge by enabling us to understand what foundation – what solid natural-world rock – it had been resting on all along.

Notes and References

1. Hilary Putnam, 'The Meaning of "Meaning",' in Keith Gunderson (ed.), *Minnesota Studies in the Philosophy of Science*, 7 (Minneapolis: University of Minnesota Press, 1975). An abbreviated version, from which the quotation at the head of this chapter was taken, appears as 'Meaning and Reference', *Journal of Philosophy*, 70 (1973).
2. Hilary Putnam, *Meaning and the Moral Sciences* (Boston, MA/London: Routledge, 1978).

GLOSSARY OF TERMS

a priori / a posteriori Terms used to classify and contrast types of proposition by the ways we come to know them. A proposition is **a priori** if it is knowable by reason alone and without recourse to any experiences of the world. A proposition is knowable **a posteriori** if it requires experience (sensory or perceptual) of the actual world.

analytic / synthetic In its contemporary usage an **analytic** statement is true, or false, by virtue of the meaning of the words contained in it. The truth or falsity of a **synthetic** statement depends on how things are in the world.

artificial languages Contrasted with natural languages, e.g., French, English, Chinese. Artificial languages, for instance computer languages, are usually constructed by known person(s) for a specific purpose. Consequently they have rigorously defined syntactical and semantical rules.

assertoric sentences Sentences or utterances which express an assertion or the claim that a proposition is true.

atomic sentence A sentence which cannot be broken down into simpler components and does not contain any logical constants.

bivalence In classical logic the principle of bivalence states that every proposition is either true or false and thus it can have no more than one of two truth values.

causal theory of names A theory of meaning stating that names acquire their meaning through a causal link between the use of the name and objects in the world.

cluster theory of reference The origins of this theory go back to Bertrand Russell who argued that the reference of a term is determined by descriptions associated with a given object. John Searle also maintains that the meaning of a term or sentence is associated with the relevant cluster of the beliefs of the speakers.

coherence theory of truth The view that a proposition is true if it coheres, and is consistent with, other propositions that belong to a group of propositions, or that a theory is true if it is internally coherent. Thus, truth consists in a relationship between truth-bearers, rather than truth-bearers and the world. The

coherence theory of truth has been traditionally held by idealist philosophers.

competence / performance Distinction introduced by Noam Chomsky between our knowledge of language and our ability to use it.

compositionality (of language) The thesis that the semantic properties of the larger, more complex, components of a language, e.g., sentences, are a function of the semantic properties of the simpler components, e.g., words.

conceptual scheme A set of concepts and propositions that are used for organizing the content of our sense experiences. On some alternative accounts, conceptual schemes provide a framework for describing reality.

connotation The connotation of a term is its meaning or sense.

constative A term for speech acts in which one says that something is the case, or makes a statement.

content The proposition expressed by a sentence, statement, or belief. **Narrow content** concerns the personal dimension of the content of a person's beliefs and other propositional attitudes. **Wide content** refers to the type of content that has a public or social dimension.

the context principle Introduced by Frege, this principle states that the meaning of a term can be discerned only in the context of a sentence in which it occurs.

contingent truths Contingent propositions depend for their truth on how things are in the world (see also **necessary truth**).

contradiction The conjunction of proposition and its negation.

Convention T A way of defining truth, proposed by Alfred Tarski. Also known as 'material adequacy condition', the Convention T sets out the definition of the truth predicate for any language.

conversational implicature A term proposed by Paul Grice for what is implied in an utterance beyond what is strictly said or conventionally implied.

correspondence theory of truth A sentence is true if it corresponds to, or matches with, how things are in the world. Correspondence theories of truth are held by realist philosophers.

de re and *de dicto* **necessity** The necessity of the properties of objects as opposed to the necessity of the truth of propositions.

deduction One of the two major subdivisions of logical argument, the other being induction. In deductive arguments the conclusion necessarily follows from a set of premises; thus, if the premises of the argument are true the conclusion will also be true.

definite description The description of an object as a singular and unique entity, as in 'the so-and-so'. Indefinite descriptions, on the other hand, have the form 'a so-and-so' (see Russell's theory of descriptions).

deflationary theories of truth The basic idea behind this theory is that 'P is true' is equivalent to P, e.g., 'It is true that it is raining' is equivalent to 'It is raining'. Thus, the predicate 'is true' can be eliminated without affecting the import or meaning of what is stated and hence the concept of truth turns out not to have any metaphysical depth and can be dispensed with. (See also **disquotational** and **redundancy theories of truth.**)

denotation The denotation of a term is the object that the term picks or to which the term applies.

designate To refer to or to denote.

direct reference The view that some terms such as proper names, demonstratives, and natural kind terms refer directly to their objects.

disquotational theory of truth The view that the statement 'S is true' says no more than S. See also **redundancy** and **deflationary theories of truth.**

domain In logic the domain of a quantifier (e.g., for all) is the set of things about which one is generalizing.

empiricism The view that knowledge of the world is primarily derived from sense experiences.

epistemology Theory of knowledge; the philosophical study of the nature of knowledge.

extension The extension of a predicate is the set of all objects that fall under that predicate. (See also **intension**)

externalism The view that the content of our beliefs and utterances is dependent on the external world and social usage.

family resemblance Wittgenstein proposed that not all terms can be defined by reference to a set of common features. The definition, instead, should proceed by tracing a network of similarities, or family resemblances, between the various members of the class covered by that term. (Analogous to the way in which members of a family may resemble each other without all necessarily sharing a single particular physical feature.)

holism (meaning-holism) The view that the meaning of a sentence depends on the meaning of other sentences in the language and the relationship between them. Consequently one cannot understand part of a language wholly, but only the whole of a language partly.

idiolect Language as used and understood by an individual speaker, as opposed to *sociolect* which is the language of a community.

incorrigible Not open to correction.

indeterminacy of translation A thesis introduced by Quine to the effect that incompatible schemes of translation can be equally correct and hence there is no uniquely correct scheme of translation for any given language.

indexicals Expressions such as 'I', 'here', 'now', 'this', the references of which will vary with the specific contexts in which they have been uttered.

indicative sentences Sentences which state a true or false proposition.

indiscernibility of identicals Leibniz's law = if x is identical with y then every property of x is a property of y.

induction Logical inference which moves from a limited number of cases as premise to a generalization or to a further case of the same type as conclusion.

inference The logical step involved in moving from a set of premises to a conclusion.

inscrutability of reference The doctrine introduced by Quine, according to which the totality of empirical evidence available cannot conclusively or uniquely determine the reference of a term (see also **indeterminacy of translation**).

intension The intension of a predicate is its meaning or connotation.

intuitionism (in mathematics) The position that the truth of any mathematical hypothesis depends on our ability to construct a proof.

language-game Wittgenstein gave currency to this term in his *The Blue and Brown Books*. The idea behind it is that linguistic practices are rule-governed, often self-contained, social activities that can be compared to games.

the law of excluded middle A law in logic according to which, for any proposition p, either p or its negation $-p$ (not p) is the case. It is usually distinguished from bivalence, which is explicitly about the truth and falsity of propositions. (See also **bivalence**.)

logical atomism The philosophy of Ludwig Wittgenstein and Bertrand Russell in the period 1918–22. According to this view, propositions are truth functions of atomic propositions. Through logico-philosophical analysis of language it is possible to arrive at the ultimate constituents or the atoms of language which correspond with the ultimate constituents or elements of the world.

logical constants The logical connectives: *and* (&), *or* (v), *if ... then* (->), *if and only if*, ((iff) (<->)), and negation (-), and other logical expressions such as the quantifiers: *some* (EX), *all* (x), and identity (=), and, arguably, the modal operators of possibility and necessity.

logical empiricism See **logical positivism**

logical positivism The philosophical views associated with the Vienna Circle. They believed in the unity of all sciences and saw philosophy as either one of

the sciences or as a tool for clarifying the logical structure of scientific explanations and theories. They dismissed all metaphysical speculations as nonsensical (see also **principle of verification**).

logically proper names According to Bertrand Russell, these are names that refer directly to objects with which we have an immediate acquaintance. Indexicals such as 'this' and 'I' are instances of logically proper names.

logicism The attempt by Frege and Russell to reduce mathematics to logical laws.

mass terms Terms such as 'gold' or 'water' which do not pick out individual objects but stand for quantities of the object concerned.

material implication In formal logic P->Q is false only if P is true and Q is false and true in every other case. This use of the conditional, it has been claimed, does not wholly reflect the ordinary-language occurrences of the conditional 'if ... then', hence the need for technical terminology.

metalanguage Tarski introduced the distinction between an *object language* and a *metalanguage*. A metalanguage is a language used to discuss or comment on the properties of another language (known as an object language).

methodological solipsism According to Hilary Putnam it consists of 'the assumption that no psychological state, properly so called, presupposes the existence of any individual other than the subject to whom that state is ascribed' (*Mind, Language and Reality*, 1975, p. 220).

modal operators Expressions such as 'necessarily', 'possibly'. Modal logic deals with the formal properties of necessity and possibility.

modal realism The view proposed by David Lewis, to the effect that possible worlds should be thought of as real worlds.

myth of the given Sellars' name for the view that sense data or sense experiences provide us with foundations for empirical knowledge.

naïve realism The view that we can directly perceive the external world as it is.

natural kind Kripke and Putnam have argued that nature divides itself into different kinds of stuff. Our natural kind terms pick out the kinds occurring in nature which share one or more essential properties.

natural language Ordinary languages developed and used by human societies as opposed to artificial languages devised for specific purposes.

naturalized epistemology The view advocated by Quine according to which we should study the formation of knowledge by empirical means. This view, in effect, reduces epistemology to empirical psychology.

necessary truth A proposition is necessarily true if no circumstances in the world can make it otherwise. (See also **contingent truth**.)

nominalism The view that there are no abstract entities or objects, such as numbers, concepts, sets (and in some versions universals), but only ways of talking about these putative objects.

nomological Nomological statements are statements of a scientific law.

ostensive definition The definition of a term by pointing to something which exemplifies that term.

performatives Term introduced by Austin for a class of utterances, such as 'I promise', which, under appropriate circumstances, count as the performance of an action.

phenomenalism A philosophical position advocated by logical empiricists according to which physical objects can be analysed as constructions from actual or possible sense experiences.

physicalism The view that the real world is constituted by physical entities only. Physicalism is a variety of naturalism or materialism and in philosophy of mind it amounts to the denial of the reality of the mental, in so far as it is construed as a non-material entity.

picture theory of meaning Proposed by Ludwig Wittgenstein in the *Tractatus Logico-Philosophicus*, this states that a meaningful sentence must have a pictorial form in common with an actual or possible state of affairs in the world.

Platonism The view that abstract objects, such as numbers, universals, propositions, sets, etc., are independently existing objects.

possible worlds Maximally specific ways that things could have been. Possible-world semantics is used by contemporary philosophers, particularly Kripke and David Lewis, to illuminate the modal concepts of necessity, possibility, etc. (See also **Twin Earth**.)

pragmatics Pragmatics is the study of the use of language by flesh-and-blood speakers. (See also **semantics**.)

Pragmatist theories of truth Pragmatist philosophers have emphasized the regulative role of truth. The American Pragmatists James, Dewey, Peirce and others have emphasized the connection between truth and what works or is useful. Truth is a property of the end result of successful scientific research which in turn enables us to have control over nature.

principle of charity According to Davidson's version of this principle, in interpreting the speech of a speaker we should maximize the ascription of true beliefs and minimize the ascription of false beliefs.

principle of verification A central tenet of logical positivism stating that the meaning of a proposition is its method of verification. In more recent years Michael Dummett has developed a sophisticated version of this view which analyses the meaning of statements in terms of the conditions under which they can be (justifiably) asserted.

private language Wittgenstein coined the term to attack the Cartesian view that we can have private, incorrigible and unique knowledge of our inner mental sensations and experiences.

proposition The true or false, declarative content of a sentence or a statement. One and the same proposition can be expressed by many different sentences and in different languages.

propositonal attitude Intentional states such as: believing that p, desiring that p, thinking that p.

protocol statements A technical term coined by the logical positivists for observation statements describing the immediate sense data. Also known as basic sentences.

Quine–Duhem thesis The view that a single scientific theory cannot be tested in isolation from other theories.

radical translation / radical interpretation Terms coined by Quine and Davidson, respectively, for translating or interpreting a language from scratch without recourse to a dictionary or a bilingual speaker.

realism and **anti-realism** At its most basic, realists believe that there are at least some truths which are mind-independent; anti-realists deny this. In philosophy of language, the debate is between the philosophers who believe that our language refers to objects, events, facts that exist independently of our ways of describing them (the realists), and those who deny this view.

recursive A procedure is recursive if it allows the reapplication of an operation to the results of its first application, and for this to be repeated an indefinite number of times.

redundancy theory of truth This theory, first fully developed by F. P. Ramsey, claims that 'P is true' is equivalent to P and hence the predicate 'is true' is redundant. See also **deflationary theory of truth**.

reference The relation between an expression, such as a name, and the thing for which it stands, for instance, the object which it names.

referential opacity Referentially opaque contexts are those in which two terms referring to the same thing cannot be substituted for each other without loss or change of meaning or truth value, e.g., in the sentence 'Robert believes that Orwell is a great writer' we cannot substitute the co-referential name 'Blair' for 'Orwell' and be sure to retain the truth of the sentence.

referential transparency Referentially transparent contexts are those where two terms referring to the same thing can be substituted for each other without any loss of meaning or change of truth value.

rigid designator A term introduced by Kripke. It applies, in particular, to proper names and natural kind terms (such as 'water') which have the same reference in every possible world.

semantic theory of truth Probably the most influential theory of truth in current philosophy of language. According to this approach, truth could be defined for a language by giving the conditions for the truth of all the sentences of that language in a metalanguage. (See also **Convention T** and **redundancy theory of truth.**)

semantics Philosophers of language distinguish between (a) semantics, (b) syntax, and (c) pragmatics of a language. Questions about the conditions of meaningfulness of the terms and sentences of a language are explained through semantical theories. (See also **syntax** and **pragmatics.**)

sense data The content of our immediate subjective experiences of the external world, e.g., the experience of colours, sounds, shapes, etc.

sortal terms A term used to pick out a sort or kind of individual thing, e.g., 'tiger'. Should be distinguished from mass terms such as 'gold'. (See also **mass terms.**)

speaker theories of reference According to this approach, the most important elements in any theory of reference are the beliefs and intentions of the speakers engaged in the act of referring.

success word Term coined by Ryle for words whose application, in appropriate circumstances, entails the achievement of a result, e.g., I perceive that p, I remember that p.

syntax The syntax of a language concerns the rules for forming correct, grammatical sentences of that language. It is contrasted with the semantics of a language which deals with the meaning of the constituent parts of a language.

theories of meaning Theories which attempt to state what sentences mean, the circumstances under which they are meaningful, and more generally, what the nature of meaning is.

truth conditional theories of meaning The main idea behind this type of theory is that what gives meaning to a sentence is the conditions under which the sentence is true.

truth conditions The conditions that must obtain in order for a proposition or assertion to be true.

truth function A proposition is truth-functional if its truth value is determined by the truth value of its components, in other words if the truth value of the proposition as a whole is a function of the truth value of its components.

truth value In classical logic every proposition has either the value true or false.

Twin Earth thought experiment A thought experiment introduced by Hilary Putnam about an imaginary counterpart to Earth where the stuff which looks, tastes, and smells exactly like water has a chemical structure completely unlike H_2o. Putnam uses this thought experiment to show that meaning is not subjective or in the head.

underdetermination The view that there is always more than one theory consistent with all the data and evidence available to an observer and hence that scientific theories are underdetermined by empirical evidence.

universal grammar (UG) The view, following Chomsky, that all human languages obey certain grammatical principles which must be embedded in the mind/brain of all language users.

use theory of meaning The view, suggested by the later Wittgenstein, that one important way of discovering the meaning of an utterance is to look at the various circumstances in which that utterance is used.

verificationist theory of meaning The theory states that the meaning of a sentence is given by the conditions under which it can be verified, thus, the verificationist theories establish a direct connection between meaning and human cognitive capabilities. See also **principle of verification** and **logical positivism.**

ACKNOWLEDGEMENTS

Many people have given me help and advice. My particular appreciation goes to David Berman and Hilary Laurie for commissioning me to prepare this book in the first place, and their efficient and helpful ways in the later stages of the work. Colleagues, friends and students in Ireland and elsewhere have advised me on the selections and have commented on parts or all of the earlier drafts of the material presented here: Noam Chomsky, Gayle Kenny, James Levine, Gregory McCulloch, Maíre O'Neill, Alex Orenstein, Hilary Putnam and Timothy Williamson are among them. I am grateful for their help. Friends and colleagues at UCD have been a constant source of support and encouragement. I am particularly indebted to Maeve Cooke, Ian Cornelius, Attracta Ingram, Richard Kearney and Dermot Moran. The completion of this project was made possible through a President's Research Award from UCD. I am grateful for having received it. My husband Hormoz Farhat, my son Robert, and my mother Gohar Baghramian have patiently borne the burdens that come with this type of work and have given me love and support at all times. Without them this book would not have been possible.

The editor and publishers wish to thank the following for permission to use copyright material:

Blackwell Publishers for Gottlob Frege, 'On Sense and Reference' in *Translations from the Philosophical Writings of Gottlob Frege*, 3rd edition, eds P. T. Geach and M. Black (1980) pp. 56–78; Ludwig Wittgenstein, *Philosophical Investigations*, 3rd edition (1973) pp. 2e–21e (Numbers 1–44); and with Harvard University Press for Saul Kripke, *Naming and Necessity* (1980) pp. 30–51. © 1972, 1980 by Saul A. Kripke;

Harcourt Brace & Company for Noam Chomsky, 'Form and Meaning in Natural Languages' in *Language and Mind* (1972) pp. 100–14. © 1972 by Harcourt Brace & Company;

Harvard University Press for Paul Grice, *Studies in the Way of Words*, pp. 312–39. © 1989 by the President and Fellows of Harvard College; and Willard Van

Orman Quine, *From a Logical Point of View*, pp. 312–29. © 1953, 1961, 1980 by the President and Fellows of Harvard College;

The MIT Press for Ruth Garrett Millikan, 'Epilogue' in *Language, Thought and Other Biological Categories* (1980) pp. 325–33;

Oxford University Press for Donald Davidson, *Inquiries into Truth and Interpretation*, Clarendon Press (1984) pp. 141–54; Gareth Evans, 'Proper Names' in *The Varieties of Reference*, ed. John MacDowell (1982) pp. 373–91; Michael Dummett, *The Seas of Language* (1993) pp. 94–105; and with Harvard University Press for J. L. Austin, *How to Do Things With Words* (1962, 1975) pp. 1–11. © 1962, 1975 by the President and Fellows of Harvard College;

Oxford University Press, Inc. for Ruth Barcan Marcus, *Modalities: Philosophical Essays*, pp. 234–255. © 1955 by Ruth Barcan Marcus;

Routledge for Bertrand Russell, 'Descriptions and Incomplete Symbols: Lecture VI of Lectures on the Philosophy of Logical Atomism' in *Logic and Knowledge*, Unwin Hyman and the Bertrand Russell Peace Foundation (1988) pp. 241–54;

Jan Tarski for A. Tarski, 'The Semantic Conception of Truth and the Foundations of Semantics', *Philosophy & Phenomenological Research*, 4 (1944) pp. 341–75;

The University of Chicago Press for Rudolf Carnap, *Meaning and Necessity*, pp. 205–21. © 1956 University of Chicago Press;

University of Minnesota Press for abridged version of Hilary Putnam, 'Meaning of Meaning' in *Language, Mind, and Knowledge*, Minnesota Studies in the Philosophy of Science, Vol. VII (1975);

Every effort has been made to trace the copyright holders but if any have been inadvertently overlooked the publishers will be pleased to make the necessary arrangement at the first opportunity.

INDEX